This presentation has been organized

by the

Solomon R. Guggenheim Museum

and is supported by an indemnity

from the

Federal Council on the Arts and the Humanities.

Air transportation has been provided by **Delta Air Lines, Inc**.

Picasso and the Age of Iron

Curated

by

Carmen Giménez

Essays

by

Dore Ashton
Francisco Calvo Serraller

March 19-May 16, 1993

GUGGENHEIM MUSEUM

Exhibition

Curated by
Carmen Giménez

With the collaboration of
Dore Ashton
Francisco Calvo Serraller

General coordination
Martina Rosa Schneider

Coordination in New York
Carole Perry
Joanne Chan
Essicka Kimberly

Installation design
Juan Ariño

Catalogue

Under the direction of
Carmen Giménez

Coordination
M. Dolores Jiménez-Blanco

Editorial
Anthony Calnek
Laura Morris
Jennifer Knox
Stephen Robert Frankel

Design
Juan Ariño

Translations
Sophie Hawkes
Alfred Mac Adam
Dwight Porter
Stephen Sartarelli

Production
Ediciones El Viso
Santiago Saavedra
Lola Gómez de Aranda

Cover: Pablo Picasso, *Head of a Man,* 1930. Musée Picasso, Paris

ISBN: 0-89207-103-6 (hardcover)
ISBN: 0-89207-104-4 (softcover)
D. L.: M-6753-1993
Published by the Guggenheim Museum
1071 Fifth Avenue
New York, New York 10128

Hardcover edition distributed by
Rizzoli International Publications, Inc.
300 Park Avenue South, New York, New York 10010

Printed in Spain

Thomas Krens

Preface

It would be impossible to imagine twentieth-century art history without Pablo Picasso, whose lifelong creative invention repeatedly changed the course of visual thinking. His defining influence is felt not only in painting and the graphic arts but also in sculpture, as this exhibition and catalogue demonstrate. Yet Picasso was only one of five great artists whose work, taken together, comprises the "Age of Iron," the period situated historically in the tumultuous years between the two world wars, and geographically between Europe and America. In the present exhibition, select sculptures by Picasso, Alexander Calder, Alberto Giacometti, Julio González, and David Smith are placed in a rare formal dialogue with each other—and with Frank Lloyd Wright's Guggenheim Museum.

Picasso developed many of his greatest ideas in the context of his association with other artists, most famously (in the case of Cubism) with Georges Braque. Another such encounter, also of groundbreaking importance, occurred from 1928 to 1931, during his collaboration with his Catalan compatriot González; together they developed the concept of "drawing in space." Picasso's and González's work in turn became a reference point for American sculptors Calder and Smith as they assimilated the ideas of European Modernism in and around Paris. Forging innovative approaches to the medium of iron sculpture, Calder and Smith helped lay the foundations for a new Modern art in the United States. At the same time, Swiss artist Giacometti employed the physically solid and durable medium in order to explore the elusive and immaterial realms of human psychology, equating sculpture and mental space.

Calder, Giacometti, González, Picasso, and Smith shared a passionate fascination with the ancient, mythical tradition of iron sculpture as well as the modern, tangible dynamics of "drawing in space." Their sculpture relies on an essential, elemental process—ores from the earth are transformed by fire through a liquid (water-like) state into sculpture that envelops air. Iron, finally, is as resistant and enduring as space is elastic and ephemeral. In a dialectic where material and space become equal, these sculptural objects are as irreducibly unique as they are part of the fabric of our environment.

Wright's Guggenheim Museum can be described in similar sculptural terms—the sinuous line of the spiral creates an interior of active space yielding at its dome to the sky and a universal cosmos. The museum has played host to works by these five great artists many times over the past decades. The Guggenheim introduced their work to generations of museum goers through landmark retrospective exhibitions devoted to Calder (1964), Giacometti (1955 and 1974), González (1983), and Smith (1969); of course, the Guggenheim's permanent collection is also one of the richest in its holdings of the work of Picasso.

And so it is fitting that the Guggenheim should bring together works by these five great artists who together wrote one vital chapter in art history. My thanks go to Carmen Giménez, Curator of Twentieth-Century Art, and her collaborators on this project, the art historians Dore Ashton and Francisco Calvo Serraller and the designer Juan Ariño, for the rigor of their selection and the visual poetry of their installation. We are all most grateful for the essential cooperation of the artists' families, which allowed the realization of *Picasso and the Age of Iron*. The result, I believe, truly represents the visual and historic drama of the "Age of Iron."

Carmen Giménez

Acknowledgments

Picasso and the Age of Iron has been realized through the generous cooperation of a number of people to whom we must express our deepest gratitude. First, we wish to thank the artists' families and heirs who aided our project. The children and grandchildren of Pablo Picasso—in particular Bernard Ruiz Picasso, Marina Picasso, Paloma Picasso-López and Rafael López-Cambil, and Maya Ruiz Picasso de Widmaier—have been a great help to us. The essential works of art that they have entrusted to the exhibition as well as their invaluable advice and information have been crucial. Carmen Martínez and Viviane Grimminger collaborated with the loan of important works by Julio González and also with vital documentation from the artist's personal archive. We sincerely appreciate Mary, Howard, and Holton Rower's consistent, generous support and tireless efforts, which testify to their deep esteem for and knowledge of Alexander Calder's oeuvre. Candida Smith offered an enthusiastic response to the exhibition, and, together with Peter Stevens and Rebecca Smith, actively participated in the various phases of its development and entrusted to it an important group of works by David Smith. Through their significant loans and counsel, the artists' families have allowed the exhibition to be realized.

We thank all of the participating private collectors, including those who chose to remain anonymous, for their invaluable loans that contribute so greatly to the success of the show; we would especially like to acknowledge Ernst and Hildy Beyeler, Dr. and Mrs. Arthur E. Kahn, and Jan Krugier and Tzila Krugier.

We received generous loans from each and every one of the participating

museums. We would like to recognize our debt to the following institutions, in particular: in Europe, to the Fondation Maeght, Saint-Paul-de-Vence; Alberto Giacometti Foundation, Zurich; Peggy Guggenheim Collection, Venice; the Estate of Hans Hartung; Instituto Valenciano de Arte Moderno, IVAM Centre Julio González; Kunsthaus Zürich; Kunstmuseum Basel; Wilhelm Lehmbruck Museum, Duisburg; Louisiana Museum, Humlebaek; Museum Ludwig, Cologne; Moderna Museet, Stockholm; Musée national d'art moderne, Centre Georges Pompidou, Paris; Musée Picasso, Paris; Tate Gallery, London; and, in the United States, to the Hirshhorn Museum and Sculpture Garden, Washington, D.C., The Museum of Modern Art, New York; National Gallery of Art, Washington, D.C.; and Whitney Museum of American Art, New York. We are especially grateful for the help of many directors and curators, among them Carmen Alborch, Felix Baumann, Dominique Bozo, Dr. Christoph Brockhaus, Magdalena Dabrowski, James T. Demetrion, Dieter Koepplin, Steingrim Laursen, Brigitte Léal, Franz Meyer, Richard Oldenburg, Earl A. Powell III, Jean-Louis Prat, Gérard Régnier, Cora Rosevear, David Ross, Margit Rowell, Philip Rylands, Mark Scheps, Katharina Schmidt, Hélène Seckel, Nicholas Serota, Björn Springfeldt, Vicente Todolí, Kirk Varnedoe, and Germain Viatte.

We would also like to express our gratitude to a great many people who made contributions through their patient research and their answers to countless questions. Among them are Douglas Baxter, who supported our undertaking from the beginning; David McKee, who afforded his great knowledge of Smith's work and spared no efforts toward our project's success; Joan Washburn, who always showed her generosity towards the exhibition; Jacques Dupin and Lisa Palmer, who proffered their help and resources with regard to the work of Giacometti; and Daniel Abadie, Heiner Bastian, Evelyne Ferlay, Alvin Lane, Claudia Neugebauer, and Catherine Thieck.

In addition, we wish to thank Juan Ariño, who designed the catalogue and exhibition, and Santiago Saavedra, who oversaw the various phases of the production of this publication, which exists as a result of his enthusiasm and constant efforts.

We are greatly indebted to Francisco Calvo Serraller, for his contribution to the concept of the exhibition and his catalogue essay; and to Dore Ashton, for not only her illuminating essay but also her irreplaceable ideas and advice for the show's development.

We would like to recognize some of the many Guggenheim Museum staff members who fulfilled the demands of the project. In Madrid, M. Dolores Jiménez-Blanco and Martina Schneider were essential to the development and coordination of both the exhibition and the catalogue. In New York, the support of Thomas Krens, Director; Michael Govan, Deputy Director; Gail Harrity, Deputy Director, Finance and Administration; Maryann Jordan, Director of External Affairs; Paul Schwartzbaum, Assistant Director for Technical Services and Chief Conservator; and Lisa Dennison, Curator of Collections, was invaluable to the exhibition. Carole Perry, Assistant to the Curator; Joanne Chan, former Assistant to the Curator; and Essicka Kimberly, former Administrative Assistant, contributed throughout different periods of the exhibition's development. Amy Husten, Manager of Budget and Planning, coordinated financial matters, and Lynne Addison, Associate Registrar, Exhibitions, handled the complex transportation arrangements.

Pamela L. Myers, Administrator for Exhibitions and Programming, oversaw the exhibition's installation and its many technical requirements. Scott Wixon, Manager of Installation and Collection Services; Peter Read, Manager of Fabrication Services; Laura Antonow, Senior Lighting Technician; and Ali Hocek, Architect, directed various aspects of the exhibition's production and installation. For their efforts, we would also like to thank the technical team that worked on the mounting of the exhibition.

To all of those contributing to the success of *Picasso and the Age of Iron*, museum staff as well as outside participants, we wish to convey our sincere gratitude.

Lenders to the Exhibition

Harry W. and Mary Margaret Anderson
Dr. Walter A. Bechtler, Zollikon
The Brooklyn Museum, New York
André Emmerich Gallery, New York
Fondation Marguerite et Aimé Maeght,
 Saint-Paul-de-Vence, France
Galerie Artcurial, Paris
Galerie Beyeler, Basel
Galerie Jan Krugier, Geneva
Alberto Giacometti Foundation, Zurich
Mr. John Githens and Ms. Ingeborg ten Haeff,
 New York
Estate of Julio González, Paris
Estate of Hans Hartung, France
Hirshhorn Museum and Sculpture Garden,
 Smithsonian Institution, Washington, D.C.
Mrs. Ruth Horwich, Chicago
Instituto Valenciano de Arte Moderno, IVAM Centre
 Julio González, Generalitat Valenciana, Valencia
Dr. and Mrs. Arthur E. Kahn
E. W. Kornfeld, Bern
Kunsthalle Bielefeld, Germany
Kunsthaus Zürich
Kunstmuseum Basel
Kunstmuseum Winterthur
Wilhelm Lehmbruck Museum, Duisburg
Mr. and Mrs. Samuel H. Lindenbaum
Louisiana Museum, Humlebaek
Marx Collection, Berlin
Moderna Museet, Stockholm
Munson-Williams-Proctor Institute Museum of Art,
 Utica, New York
Musée de Grenoble
Musée national d'art moderne,
 Centre Georges Pompidou, Paris
Musée Picasso, Paris
Museo Nacional Centro de Arte Reina Sofía, Madrid
Museum Ludwig, Cologne
The Museum of Modern Art, New York
National Gallery of Art, Washington, D.C.
New Orleans Museum of Art
Philadelphia Museum of Art
Bernard Ruiz Picasso, Paris
Collection Marina Picasso, Galerie Jan Krugier, Geneva

Paloma Picasso-López and Rafael López-Cambil
Mr. and Mrs. Orin Raphael, Oakmont, Pennsylvania
Denise and Andrew Saul
Barbara and Eugene Schwartz, New York
Candida and Rebecca Smith
Tate Gallery, London
The Weatherspoon Art Gallery,
 University of North Carolina at Greensboro
The Frederick R. Weisman Art Museum,
 University of Minnesota, Minneapolis
Whitney Museum of American Art, New York

Anonymous lenders

Contents

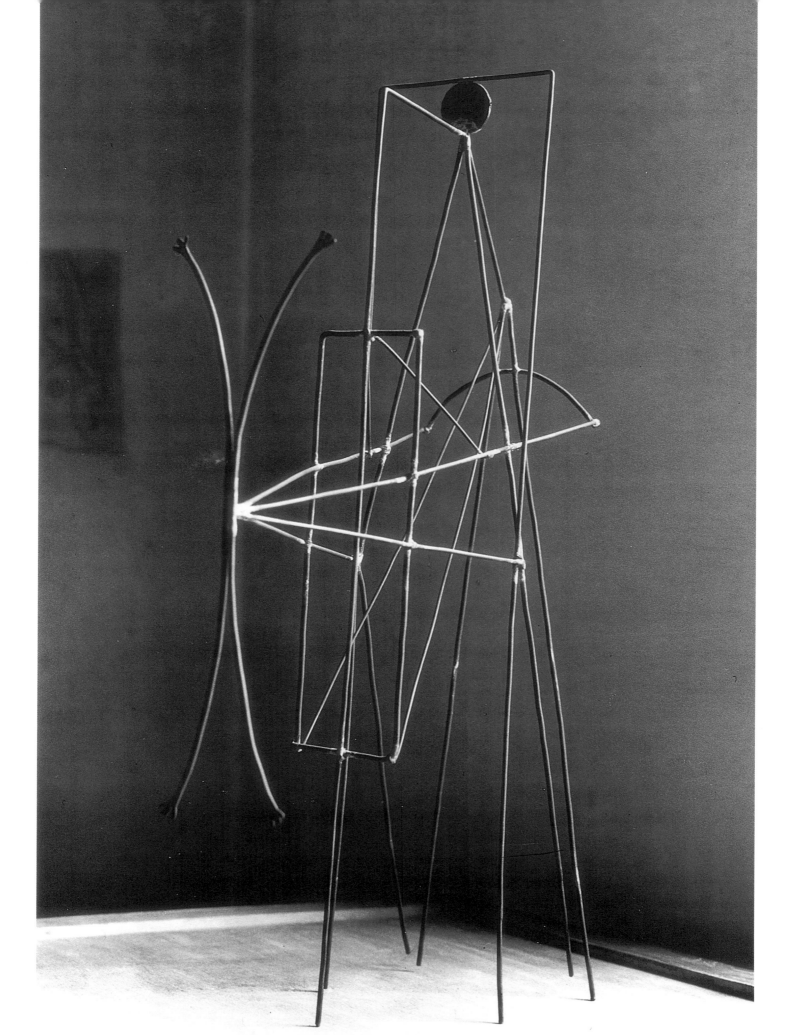

Carmen Giménez

Introduction

"Within this century, then, Julio González stands alone, the rare blend of an artist who is both modern and a humanist," wrote Leo Steinberg in 1956, when the Spanish sculptor had his first major American exhibition. "Modern he is because his forms are vital, open processes in space. He is a humanist, firstly, because man is his lasting theme, and his works, when they seem least anthropomorphic, remain anthropo-kinetic. And secondly, because the kind of kinesis he imputes to man tends to be proud, free, energetic, eliciting not pity or recoil but admiration."

At the time of that González exhibition at the Museum of Modern Art, New York, sculptor David Smith, who had first seen the Spanish artist's metal sculpture in the 1930s in John Graham's collection, wrote a letter to González's daughter Roberta, both to tell her of the impact that her father's exhibition was having on local artists and to express his conviction that González would be remembered "as the father of all iron sculpture of this century." While this is not the place to discuss the critical merits of such an emphatic judgment as Smith's, it is certainly a true reflection of González's importance to Smith's own subsequent development. In any event, even allowing for the slow process of critical recognition of the value of González's late works, it is quite surprising that, until now, there has not been an exhibition examining their historical and aesthetic context in order to fully reveal the contribution of those works to twentieth-century sculpture. Even more startling, given the almost tiresomely reiterated insistence on the close relationship between González and Smith, is that there has never been a specific exhibition making man-

< *Pablo Picasso's* Figure *(fall 1928), proposed by the artist as a monument to Guillaume Apollinaire.*

13

ifest not only those two artists' formal affinities but also their contrasting attitudes and world views, through which one addressed the sacred, the other the profane. For this as well as other reasons, I believe that an exhibition dealing with these issues would be welcomed, although a show restricted to these two artists alone would only yield a strictly correct academic approach. Without the tutelary presence of Picasso, such an exhibition would not only lack an essential historical context, but, more important, would not communicate the full dialectical strength of iron sculpture as *dessiner dans l'espace* (drawing in space), to borrow the much-quoted description used by González in one of his writings.

Almost all the experts who have studied the birth and development of this type of iron sculpture agree that the original conception came from Picasso and recognize the importance of González and Smith in creatively exploiting its syntax and vocabulary. Therefore, from the perspective of a strictly historical reconstruction, I believe that an exhibition based solely on the iron sculpture of these three great artists, Picasso, González, and Smith, would have been well justified in historiographic terms. However, I, and everyone else who has worked over the last several years on the project presented here under the title *Picasso and the Age of Iron*, feel that such a restriction would have resulted in an oversimplification, devoid of those complex aspects surely necessary to a full understanding of the work of the three sculptors and of their significance within twentieth-century sculpture.

The exhibition ranges from about 1925 to 1950, encompassing what in art history has been called the dramatic high point of the 1930s: the crisis of the avant-garde. In the 1930s, González's work finally matured, and Smith began to develop his later style; only Picasso seemed to be slightly ahead of them. The fact that in the early 1930s he was making iron sculpture as well as heavy, sensual, rounded stone pieces—the work that so impressed Brassaï and André Breton when they visited his Boisgeloup studio—confirms Picasso's creative restlessness.

The 1930s was not only the decade of "realisms," a term that has been used to summarize its spirit of politically committed art, but also a time of radical self-criticism by the European avant-garde, a process whose antecedents can be traced to Dada and Surrealism and to the first stage of the Soviet avant-garde. Along with the serious social and political events weighing so heavily on the era's more lucid minds, artists had to confront the widespread renunciation of artistic formalism and the institutionalization of the avant-garde. It is significant that the two domi-

nant avant-garde positions in the 1930s, the Abstraction-Création group and the second, "rational," wave of Surrealism, agreed upon the need to re-create and redefine the language of the avant-garde, with a new emphasis on its meaning.

In light of these underlying historical and artistic problems, is an exclusively formalist frame of reference sufficient to understand the meaning of the work of these innovators in iron and to encompass in the term "Age of Iron" all that they produced using that one metal? Although the Industrial Revolution, with its large-scale use of iron, had transformed the old material into a symbol of progress, it was also seen as a destroyer of traditional ways of life and culture, thus generating the false idea of a radical incompatibility between art and iron, similar to that understood to exist between art on one side and the machine and all industrial production on the other. The importance of iron in sculpture cannot be reduced merely to the avant-garde's desire to be provocative by using such an unconventional artistic material. It seems necessary to explain, therefore, that in these pages "iron" not only refers to the use of a specific material at a certain time in the evolution of Modern art, but also represents a metaphor for the crisis that arose in both society and the avant-garde itself between the two world wars.

Steinberg pointed out the dialectical tension between the modernist and humanist spirit in González's work, a tension that has also been noted by other critics, although they may interpret it differently. The simultaneous exhibition in Paris in 1937 of two such totally different works by González as *Montserrat* and *Woman with a Mirror* illustrates this duality. While it is often stressed that González was originally a craftsman and therefore interpreted modern ideas from a traditional, anthropomorphic viewpoint, even Picasso, that champion of the modern, always stubbornly opposed a totally abstract art. In fact, the majority of the Spanish avant-garde during the first third of the century felt this same reluctance toward complete abstraction, which may be explained by their forebear's anthropomorphic tradition.

Whatever importance we ascribe to them, cultural traditions alone cannot account for Picasso's and González's use of iron in sculpture, because a cosmopolitan language such as that of the avant-garde cannot be contained within a national culture. Perhaps the crises of the 1930s created a window of opportunity for a clear expression of cultural roots, both in Spain and abroad. In fact, as the institutionalized avant-garde established its own conventions, the reactions of Smith, Calder, and Giacometti to the return to the figurative were perfectly in tune with those of

Picasso and González, even though these five artists came from countries as distinct from each other as the United States, Switzerland, and Spain.

The decisive artistic question was posed by González in his "drawing in space," a phrase that sums up and clearly defines the styles of Picasso, González, Smith, Calder, and, to a lesser degree, Giacometti. Accordingly, although an academic approach would have advised a prudent limiting of our exhibition to certain works by Picasso, the later works of González, and the early sculpture of Smith, we decided that works by Calder and Giacometti—the real activators of that dialectic tension of sculpture as metallic drawing in space—should be included. Thus, while we realized the conceptual and practical complications of using five voices instead of three, we felt that it was worth the risk. This dialogue among five voices, moreover, confirmed the fluid exchange of ideas initiated by Picasso and González and extended by Calder, Giacometti, and Smith.

The inclusion of drawing and painting by Picasso is essential to this sculpture exhibition rather than merely complementary. His preliminary series of line and dot drawings from 1924 and 1926, as well as his series of drawings from sketchbooks 1044 and 021, both from 1928, are often invoked to explain the ideas that would be crystallized in his monument to Guillaume Apollinaire. Similarly, Picasso's paintings of the 1920s and 1930s reflect the problems that he addressed in his "drawing in space."

Pablo Picasso, pages 18, 19, 25, and 26 of Sketchbook 1044, July 27-December 17, 1928. Collection Marina Picasso, Galerie Jan Krugier, Geneva. >

It must be noted that the number of works by each of the artists varies in accordance with the ways in which each dealt with the underlying questions. The versatile and restless Picasso soon abandoned a form that was to constitute an obsession for the steadfast González and the focus of his most interesting and fruitful period. González and Smith were to devote their energies to developing the possibilities of iron for "drawing in space," in sharp contrast to Giacometti's approach. In addition, we were unable to obtain some works by Giacometti that undoubtedly would have improved the exhibition because their fragility or state of conservation prevented them from traveling.

Finally, it must also be mentioned that after this brief period in which the creative energies of these artists coalesced, all of them, except González (who died shortly afterward), began to develop very different styles. For this reason, we have included at least one later work by each artist, which can be seen either as the closing of one chapter or the opening of another.

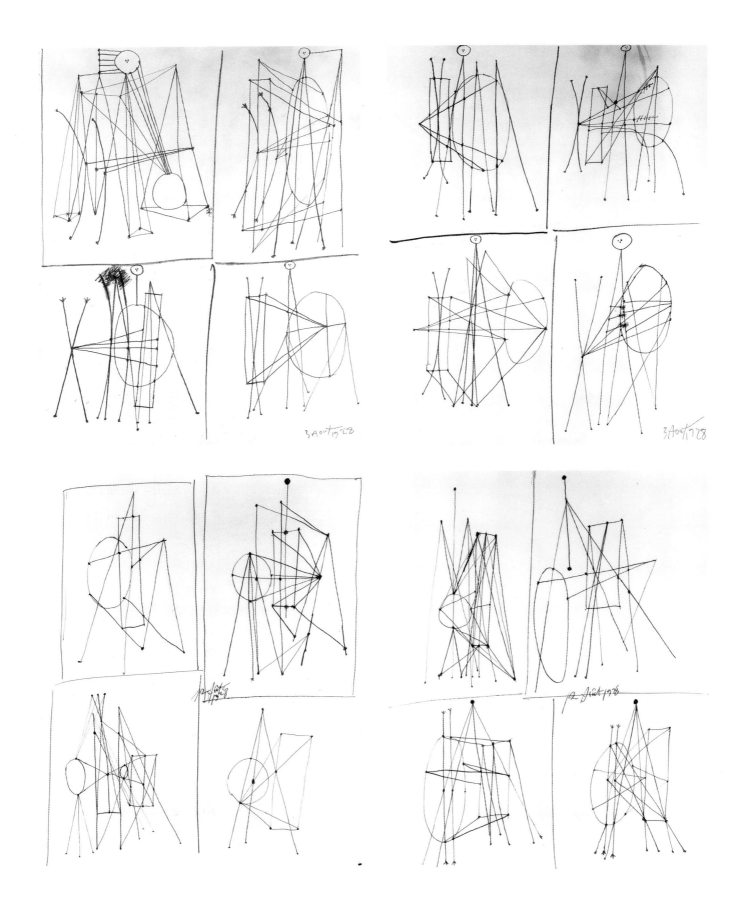

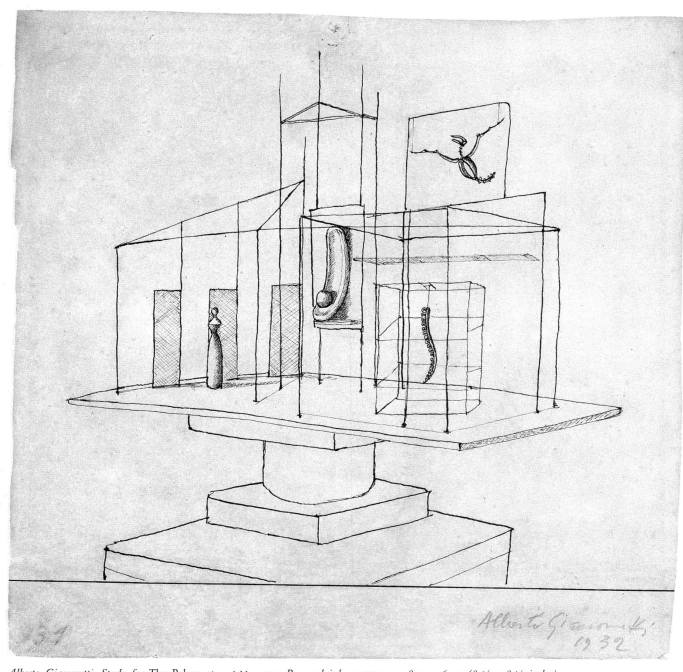

Alberto Giacometti, Study for The Palace at 4 A.M., *1932. Pen and ink on paper, 21.8 x 21.6 cm (8 ⁵/₈ x 8 ¹/₂ inches).*
The Museum of Modern Art, Gift of Pierre Matisse in memory of Patricia Kane Matisse.

Dore Ashton

The Forging of New Philosophical Armatures: Sculpture Between the Wars and Ever Since

Between the wars: "nothing durable, nothing solid"

During the uneasy years between the two world wars, Paris was still considered the incomparable crucible for new ideas, at least in the arts, as so many memoirs written by expatriate Argentineans, Japanese, Cubans, North Americans, and Scandinavians inform us. Yet, over the city hung a cumulus of vague but keenly sensed forebodings expressed again and again by French intellectuals and their foreign guests. A prolonged threnody wound through those troubled years until its predictable denouement in the eruption of World War II. As Europe edged toward disaster during the 1930s, the tone darkened: "These last twenty years have indeed witnessed the most considerable intellectual tumult imaginable. Nothing durable, nothing solid, nothing which is constructive; everything is crumbling, losing its vertebrae."[1] So said an unusual group of intellectuals, among them Roger Caillois and Georges Bataille, in their 1936 "Manifesto for a Sacred Sociology." That year, an erstwhile Surrealist, the actor and writer Antonin Artaud, told an eager audience at the University of Mexico that French youth were no longer content with ideologies, and that "these young people feel that Europe has lost its way, and they think that it is knowingly and one may say criminally that Europe has lost its way."[2] In another 1936 lecture he echoed what many other intellectuals in Paris were intoning in newspapers and journals:

> Anyone who knew Paris three years ago and returned there now would not recognize it. In appearance the city has changed little, but the life of Paris, everything that made it exciting, the youth, the movement, the zest, the

enjoyment, all this has changed terribly. . . . And French youth, left to themselves—I am speaking especially of the young painters, sculptors, actors, filmmakers, etc.—are on the edge of despair. [3]

This despair had been mounting year by year as the temporary relief just after World War I evaporated into what the sociologists had called intellectual tumult. No matter from what direction, the news was disheartening. In 1928, a scholar remote from the artistic circles Artaud moved in, Julien Benda, published his outcry *The Treason of the Intellectuals*, causing a furor by accusing the thinking caste of giving way to nationalism, xenophobia, and class hatred and of acquiescing to what he predicted would be a horrible conflagration, which indeed occurred a decade later. Benda rejected the blatant Surrealist attack on reason, and even though he was far from the artistic milieus that shared certain of his views, his belief that Europeans had betrayed the great tradition of disinterested thinking and spiritual values was widely shared.

While it is true that immediately after World War I there were optimistic voices heralding what Jean Cocteau called a *rappel à l'ordre*, it took only a few years for most intellectuals to begin to doubt the value of such order. By 1924, the Surrealists were mounting their energetic attack, and the rout of the "recall to order" was under way. There were great artistic battles, but somehow everyone was losing ground. The Surrealists, who proclaimed the value of "thought's dictation" and the free associations inspired by dream imagery, were opposed by artists schooled in the rigors of Cubism. In 1929, a motley international group of painters and sculptors formed a group, Cercle et Carré (Circle and Square), to defend the basic idea of "structure and abstraction." Among them, however, were artists who could just as easily have exhibited with the Surrealists, such as Jean Arp, who in fact sometimes did, and Joaquín Torres-García, whose sojourn in Paris from 1926 to 1932 brought him to consider the ancient symbols of pre-Columbian art, which also greatly interested the Surrealists. In 1931, another group, Abstraction-Création, was established by an important international group of artists numbering in the hundreds, to battle the pernicious Surrealist habit of smuggling realism into painting and sculpture, but even here a softening of principle was evident. Many practitioners of "abstraction" had already been seduced by the Surrealist notion of biomorphism. Theo van Doesburg could rant against what he called the "Jack the Ripper style" of the Surrealists, but their widespread incursions were apparent. (And van Doesburg him-

self, after all, had ambivalent loyalties when, a few years before, using the pseudonym I. K. Bonset, he had written Dada poetry for *De Stijl* magazine.) For all the passionate idealism of certain prominent members of Abstraction-Création, the group as a whole offered an amalgam of mixed idioms, even a fundamental confusion.

Sometimes, especially during the late 1920s, the commentators of quotidian artistic life would refer vaguely to the existence of a "crisis," and the word became ubiquitous in the 1930s. There were those who tried to put a healthy skew to the crisis in artistic values. When Christian Zervos founded *Cahiers d'art* in 1926, he watched the new generation closely for signs of vitality. His colleague E. Tériade kept trying to discern positive trends, as when he wrote in 1930 that both painters and sculptors often begin with plastic ideas of Cubism but now arrive at "a lyrical reality, exalted by memory and mysterious magic."[4] Far away, in the United States, the artistic life of Paris was watched very closely by anxious aspirants to the international avant-garde, but by 1936, even they were disillusioned:

> In 1936 it should have been apparent—heaven knows—that something was about to happen in art as in everything else. But there was a comfortable feeling at the time as though the critical years of revolution had already been surmounted. Most of the European innovators themselves gave indications of getting back to "normal"; certainly they produced nothing so insulting to tradition as in the stormy days of cubism and the fauves. In the light of subsequent developments it becomes difficult indeed to recall the precarious position of an experimental artist during the reactionary thirties.[5]

It was in the "reactionary thirties" that smoldering embers of rebellion would flare up in works of distinct originality—works strong enough to have survived and inspired generations of artists to come. To what extent the troubled epoch was responsible for the generation of such works is probably incalculable, yet we cannot discount the heated philosophical, social, and aesthetic arguments that engulfed artists in Paris during the late 1920s and 1930s. The *idées forces* of the time included the Surrealist assault on the strictures of classical reason and the rebel-Surrealist assault on classical idealism. André Breton exhorted artists to break free from all habits of thought by journeying to the deepest, the oldest sources, and by committing themselves to what Octavio Paz called a "stubborn belief in a paradisiac age, coupled with the vision of the primordial couple,"[6] exalting the powers, he said, of

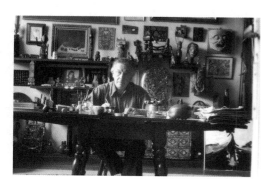
André Breton in his Paris studio, May 1960.

the word "love." Breton's affirmation of the original innocence of man, Paz said, distinguished him from all his contemporaries, including Bataille, for whom "eroticism, death and sin are interchangeable signs whose combinations repeat the same meaning again and again, with terrifying monotony: the nothingness of man, his irremediable abjection."[7]

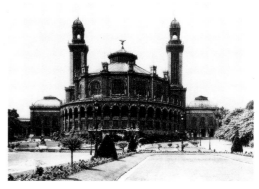

The Musée ethnographique du Trocadéro, Paris, 1923.

And yet, it was Bataille who instigated the manifesto for the Collège de Sociologie, devoted to a sacred sociology that would study three principal problems: "that of *power*, that of the *sacred*, and that of the *myth* . . . the total activity of the human being"—problems very much at the heart of Breton's own writings. Bataille's hyperbolic style was in many ways symmetrical with Breton's: Bataille, for example, wrote, "Le désespoir intellectuel n'aboutit ni à la veulerie ni au rêve, mais à la violence,"[8] while Breton wrote, "La beauté sera *convulsive* ou sera pas."[9] And the two *chefs d'école* both helped to provoke the immense renewal of interest in primitive artifacts, but, this time around, imbued with a scientific cast. In 1925, the Sorbonne established its Institut d'Ethnologie, where Marcel Mauss later taught the young poet Michel Leiris, whose life among avant-garde artists was legendary. By 1930, the old Musée ethnographique du Trocadéro, in whose musty halls Pablo Picasso, Georges Braque, and Henri Matisse had learned about so-called primitive art, was organized in a scientific way, and by 1938 was reorganized as the Musée de l'Homme, in which Leiris worked as a social scientist. From the late 1920s, the publications most important to the artistic community—Zervos's *Cahiers d'art*, Bataille's *Documents*, founded in 1929, and *Minotaure*, founded in 1933—published articles by some of the most distinguished ethnologists of the period, including Marcel Griaule, Abbé Breuil, Georges Henri Rivière, and Otto Frobenius, as well as serious reviews of the work of American anthropologist Franz Boas.

No doubt the level of scholarship of these articles was far less important to visual artists than the excellent reproductions that accompanied them, which provided a range and variety of inspiration, particularly for sculptors seeking ways to go beyond prewar Constructivist inventions. In 1930 alone, *Documents* published a substantial article with illustrations of the carvings of the Haida in the Pacific Northwest, and long essays by Frobenius on newly discovered works in Africa and on the elongated Etruscan bronzes; for its part, *Cahiers d'art* published articles on works from the Colima region in Mexico, from Vancouver, and from West Africa, and, perhaps most important, the rarely reproduced statuettes of elongated metal

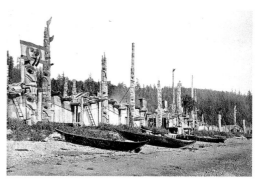

Totem poles at Skidegate, a Haida village, published in Documents, *no. 1 (1930).*

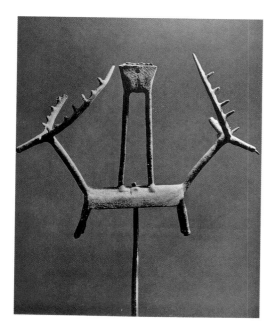

Votive sword with two stags from Abini, near Teti, Sardinia. Bronze. Museo Archeologico Nazionale, Cagliari, Sardinia.

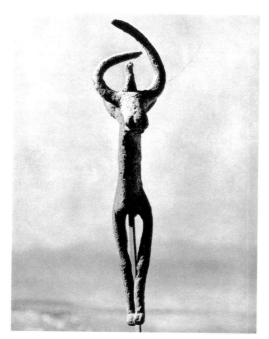

Chief or pontif. Bronze. Museo Archeologico Nazionale, Cagliari, Sardinia.

discovered by Zervos on the island of Sardinia.

Such concentrated interest in non-European art perhaps signals a kind of flight from the European malaise, a desperate rummaging for other traditions to fulfill deep psychological needs. A few prominent figures in the pre-World War I avant-garde followed up their initial interest in non-European art after the war by traveling to the fabled sites, while others stayed in Paris and associated with expatriates and visitors from those foreign cultures. In 1923, Blaise Cendrars made his pilgrimage to Brazil, where he experienced the wilder side of folk life. That same year, Brazilian composer Heitor Villa-Lobos came to Paris for a few years; at first he was scarcely noticed, but by 1927 Paris was avid for reports from other cultures and keen to experience the direct impact of what it imagined to be authentic primitive feeling. Chilean poet Vicente Huidobro had lived in Paris since 1916, and was a cofounder of the important postwar literary journal *Nord Sud*, along with Guillaume Apollinaire and Pierre Reverdy. After working for twelve years on his long poem *Altazor*, he published it in 1931 with the subtitle "Voyage in a Parachute," regaling such friends as Arp, Juan Gris, and Picasso with its hurtling spatial images and its magical message of flight, punctuated by the urgent refrain "there's no time to lose."[10]

The presence of innumerable eccentric personalities contributing to a shift in perspective in Paris certainly had an impact on restless artists, and notably on sculptors. The Surrealist preoccupation with objects naturally affected the kind of work made by sculptors, among whom the issue of objectness had become increasingly important since the turn of the century. In a penetrating study of the evolution of Modern sculpture, the sculptor William Tucker identified the issues:

> If one word captures the aspirations of modernism from about 1870 to the Second World War, it is surely *object*. Firstly in poetry and painting, then in sculpture, music, and architecture, the word came to denote an ideal condition of self-contained, self-generating apartness for the work of art, with its own rules, its own order, its own materials, independent of its maker, of its audience and of the world in general. . . . Sculpture, of its nature *is* object, in the world, in a way in which painting, music and poetry are not; thus, ambition of the poem-object, the *objet-tableau*, continued to be active. . . . In fact, the object-status of the poem or painting tended to release and enlarge the evocations and associations in the component words or depicted subject,

whereas the effect in sculpture was the reverse: as the sculpture-object of the poem approached the reality-object in the form of intention, the gap between them dwindled to the point at which all reasons for making sculpture and indeed art in general, seemed to disappear. This was the nature of the crisis that was experienced by advanced art in the 1920s, when most artists—including those who had been chiefly responsible in achieving the success of "the object" in sculpture and painting, Brancusi and Picasso—seem to have felt an impulse to move backwards or forwards violently.[11]

The spasmodic violence of this backward-and-forward movement was evident to many viewers, and, as was so often the case, was epitomized in the between-the-wars work of Picasso, whose 1932 retrospective revealed the extremes of his moods and techniques. Surely Breton found confirmation of his notion of the crisis of the object when he visited Picasso's studio in 1933, accompanied by the photographer Brassaï. The photographs that Brassaï shot there focused noticeably on objects, both those created by Picasso and those with which he surrounded himself in his environment, which together constituted what Breton would call Picasso's "element."[12] Breton had long understood the importance of Picasso's most radical gestures. It was he who insisted to his patron, collector Jacques Doucet, that *Les Demoiselles d'Avignon* was essential to his collection. He wrote to Doucet on November 6, 1923, "A single certitude: Les Demoiselles d'Avignon because one enters completely into Picasso's laboratory and because it is the mode of the drama, the center of all the conflicts Picasso has given birth to, and that will continue eternally." And a year later, on December 12, 1924, he wrote again, saying, "It seems to me impossible to talk about it other than in a mystical fashion. The question is only posed afterwards. . . . For me it is a pure symbol, like the Chaldean bull, an intense projection of the modern ideal that we begin to grasp bit by bit . . . it is for me a sacred image." Later, Breton, in an article entitled "The Crisis of the Object," located "the whole pathos of modern intellectual life" in the fact that it resides in an unremitting quest for objectification. In the article, he quoted the philosopher Gaston Bachelard, who, he said, asks what is the primordial metaphysical function of the real and answers that it is the conviction that "one will discover more in reality than in the immediate data surrounding it."[13]

Where else but in sculpture would the "objectification" Breton spoke about find its apotheosis? Judging by the pages of the most widely read reviews, sculpture

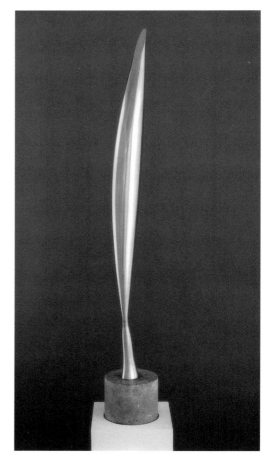

Constantin Brancusi, Bird in Space, *1932-40. Polished brass, 134.7 cm (53 inches) high. Peggy Guggenheim Collection, Venice.*

was at last finding the kind of serious critical attention it had long been denied. Picasso's reputation helped focus attention on sculpture once again when, beginning in the late 1920s, for the first time in years he turned his full attention to the making of three-dimensional objects. He heralded a widespread renewal of interest in experimental sculpture, not only in France but throughout the Western world. It was still Paris, and Picasso, to whom most artists in the Western hemisphere looked, and still Paris that provided the foundation for the work of those artists, even Americans who tried to resist the influence. Foundation, as Gertrude Stein illustrated in a cunning anecdote about Paris on the brink of World War II, was everything. A friend of hers, a captain, approached the garrison cook and said: "Will you, said Captain d'Aiguy, make us a good risotto, I cannot, my captain, said the soldier who was a cook in one of the big restaurants in Paris, because I have not the foundation for the sauce. Foundation for a sauce, said the captain, pale with fury, you have material to cook with, everything you want and you cannot make your sauce you have to have a foundation, what do you mean by a foundation. If you please, said the trembling cook, in Paris we always have a foundation for a sauce and we put that in and then mix the sauce."[14]

The new foundation being laid in Paris would provide the basis for many a piquant sauce, but also for genuine innovations. The general climate of thought, the necessity for violent changes—these were quickly communicated, with artists responding and retreating in different stages, and with constant realignments and shifts of direction. Into this continuum entered the five artists represented in this exhibition, each carrying his own art-historical influences and antecedents, and in each of whom the *idées forces* of the period worked differently. Quite aside from generational differences, there were differences in their formative encounters and their subsequent development that account for the diversity and strength of their contributions to Modern art history. That history, so difficult to elucidate, can be seen as more like a tide chart than as the trajectory of an arrow, full of the whorls, circles, and eddies, the digressions and shifts, that a tide chart documents. None of these five artists was a native Parisian, yet all of them drew upon the singular history of Paris between the wars for their independent artistic discoveries. It was above all Picasso whose initial moves were indisputably the source of the crisis in sculpture, and who initiated the metaphorical age of iron, with all the implications that this show documents.

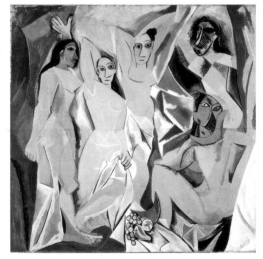

Pablo Picasso, Les Demoiselles d'Avignon, *Paris, June-July 1908. Oil on canvas, 243.8 x 233.7 cm (96 x 92 inches). The Museum of Modern Art, New York, Acquired through the Lillie P. Bliss Bequest.*

Picasso's many forked paths

Without speculating on the circumstances of Picasso's personal life—which was in turmoil—or on any of the intangibles that govern the moods of artists, one can see in his moves of the 1920s apparent trails leading toward his concentration on sculpture. After World War I, he had turned away from the logic of Analytic Cubism (a logic he sometimes stressed when he talked of African sculpture, although at other times he spoke of its "exorcist" powers). The conflict born in *Les Demoiselles* was sustained by Picasso in the work that followed, even as he continued his sporadic flirtation with classical art. He pursued many forked paths simultaneously, as when he painted the fiercely expressionist *The Dance* in June 1925, and the classicizing *Studio with Plaster Head* a few weeks later. Only a year before, in June 1924, he had created the scenery and costumes for the ballet *Mercure,* inventing for the tableau called "Night" a rattan framework within which he placed mobile cardboard shapes. It was perhaps the first indication that he would move toward three-dimensional wire sculpture, since his construction plan for the décor of "Night" looks very much like many of his subsequent sculptures. It was also a *succès de scandale.* The Surrealist band, led by Breton, at first condemned Picasso, and nearly caused a riot by hissing and booing the opening night. The next day, however, in *Paris-Journal,* they issued a public apology in which they praised Picasso for despising all sacrosanct convention, and for never pausing in his "perpetual creation of the disquiet, the searching anxiety of our modern days."[15] While many Picasso commentators have been at pains to insist on his remoteness from Surrealism, it is obvious that Picasso was keenly interested in the expansion of possibilities inherent in Surrealist notions. Moreover, because the original group consisted largely of poets—and he had always preferred the company of poets to artists—it was natural for him to warm to their advances. His close and lasting friendships with Leiris and Paul Eluard date from around this time, as does his closer relation with Breton, who published works by Picasso in almost every issue of *La Révolution surréaliste,* beginning with the first issue in 1924.

In the years immediately following the initial rapprochement with individual Surrealists, Picasso began to propose in his many sketchbooks a series of outlandish projects that appeared to echo the Surrealist preoccupation with metamorphosis, and that increasingly demanded a three-dimensional realization. These included, for

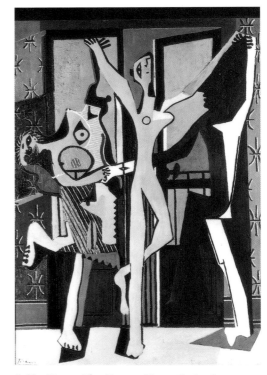

Pablo Picasso, The Dance, *Monte Carlo, June 1925. Oil on canvas, 215 x 142 cm (88 5/8 x 55 7/8 inches). Tate Gallery, London.*

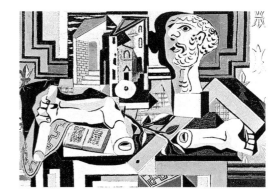

Pablo Picasso, Studio with Plaster Head, *Juan-les-Pins, summer 1925. Oil on canvas, 98.1 x 131.2 cm (38 5/8 x 51 5/8 inches). The Museum of Modern Art, New York, Purchase.*

Pablo Picasso, drawing for the maquette for "Night," a tableau in the ballet Mercure, *Paris, 1924.*

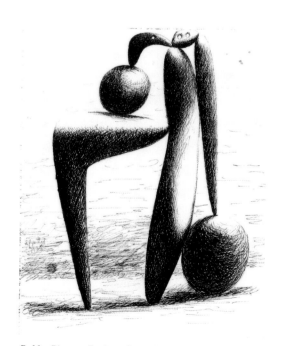

Pablo Picasso, Project for a Monument *(Sketchbook 1044, p. 1), Dinard, 1928. India ink and pencil on paper, 38 x 31 cm (14 ¹⁵/₁₆ x 12 ³/₁₆ inches). Collection Marina Picasso, Galerie Jan Krugier, Geneva.*

example, his 1927-28 drawings of heavily modeled, metamorphic figures that he explicitly thought of as monumental sculptures to be erected along the promenade in Cannes. During the summer of 1928 in Dinard, he saw the Surrealist poet Georges Hugnet almost daily while he was assiduously sketching the lineaments of his wire sculptures, which he produced as soon as he got back to Paris (cat. no. 27).

There, sculptor Julio González, Picasso's old friend from Barcelona, had also been living for many years. It is usually assumed that Picasso had renewed his friendship with González the previous spring with the specific purpose of acquiring techniques of welding. But why iron forging and welding, and why González? Surely there was a need that went beyond simple practicality. Throughout his life Picasso maintained relationships with fellow Spaniards, and most particularly, with Catalan artists. Since most commentaries on Picasso's oeuvre have been written by French, American, or European critics, the issue of his Spanish nostalgia is usually handled gingerly, if at all. The fact remains that he was careful to stay in touch with his earliest memories through relationships with such artists as Pablo Gargallo, Manolo Hugué, and González. The last wrote in a 1935 article that, although Picasso deserves to be claimed by every country, he is "ours":

> I have known Picasso for more than thirty years, and whenever I have seen him and talked to him—which has happened often—we have talked about Catalans, and he has spoken nostalgically of Barcelona, of Perpignan. He remembers their festivals, their traditions, *sardana*, dancing, fairs, demonstrations, and all kinds of events, and he remembers things in great detail. Everything Catalan is of interest to him.[16]

Picasso's earliest biographer and lifelong friend, Maurice Raynal, did not hesitate to attribute to him what he thought of as Spanish characteristics (such as a sense of tragedy, a characteristic that González confirmed) and commented:

> Though no chauvinist, Picasso is a Spaniard through and through. . . . For all his long years of residence in France, the country of his choice, he has remained deeply sensitive to events on the other side of the Pyrenees. I remember his bitter and outspoken indignation in 1909, early in the reign of Alphonso XIII, when Ferrer, one of the socialist leaders of the uprising in Barcelona, was hailed before a military court and summarily executed.[17]

One of the things Picasso never forgot, it seems, was his early exposure to the art of the ironworkers of Spain, among them Joan González, Julio's older brother,

whom Picasso knew in the years before his first trip to Paris in 1900. Perhaps an even more plausible source lay in his youthful admiration for Santiago Rusiñol, a Spanish artist who was twenty years older than he, and whose cultural center in Sitges was a magnet for the art students of Picasso's generation in the mid-to-late 1890s. Rusiñol was an enthusiast of the ironwork traditions and owned an extensive collection. In an 1893 lecture he had spoken of the forges of old Barcelona: "There, in the darkness of those sooty workshops, under the ringing chorus of constant hammering on the anvil, I think I see springing from the fire . . . an art without aesthetic rules or absurd restrictions, an art free as smoke, born from fire, and wrought in fire."[18]

González insisted in his article that Picasso was influenced above all by the "milieu of his formative years," a belief shared by most Spanish writers and by many Spanish artists who kept in touch with Picasso over many decades. He was, as so many remember him in the Barcelona days, an attentive listener, and, as young as he was, he knew where to go and whom to seek out. In 1901, for instance, he spent a few months in Madrid, where he met the Catalan writer Francisco de Asís Soler, with whom he decided to publish *Arte Joven*, a literary and art review. The first issue included poems by the venerated Miguel de Unamuno and an essay by Pío Baroja, both of them major figures in the Generation of '98 and probably a direct influence on the young Picasso. Unamuno's views, especially, were not only congenial to Picasso's temperament but were also used by others to describe or explain him in later writings; at the very least, they were an important component in the milieu of his formative years. In an introduction to a collection of Unamuno's writings, Salvador de Madariaga asks, "Who but Unamuno could have invented that title *Nada menos que todo un hombre*?" and describes the paradox of Unamuno as follows: "This apostle of life, this eloquent advocate of irrationality and experience versus reason and intellectualism lived mostly in the mind."[19] Unamuno unabashedly spoke of the "soul of the Spaniard," an aspect of himself and his countrymen that Madariaga explains in terms of "the deep tendency of the Spaniard to deny reality the right to be itself and to dare force it to adjust itself to our inner dream."[20]

The concatenation of events that brought Picasso to González's cluttered working atelier in 1928 included not only his technical needs but probably an instinctive need to retreat in the company of an old countryman who, as is always stressed, had an equable temperament and a modesty that appealed to Picasso. It was

while working side by side with the superb craftsman that Picasso remarked that he had not been so happy since 1912, a year of singular artistic efflorescence in his work. But that happiness was also a function of his strong sense that he was forging ahead, inventing new approaches to sculptural form. The liberation that he felt wielding the torch, and inventing an art "free as smoke," as Rusiñol had described the iron forger's art, had also been stimulated not only by his association with the Surrealists but by the increasingly frequent allusions in the art journals to the iron and bronze sculptures of other and often ancient sculptors. As Rusiñol had so presciently declared in 1893, "The tendency of most modern art is to drink at primal fountains."[21] Just a cursory glance at the art journals of that period indicates how very much the "primal" metal sculptures of all eras and cultures preceding the Modern epoch were the focus of renewed attention, including such diverse examples as wrought-iron animals from Luristan, Iberian pre-Roman heads, and Hispano-Arabic elongated, forged-and-hammered figures.

Finally, there was the Surrealist obsession with the found object, initiated by Marcel Duchamp, which by 1928 had been clearly articulated, and which was certainly not a foreign idea to Picasso. As early as 1912, he had used scraps of found materials in his collages and constructions, a practice that Apollinaire wrote about in 1913 in terms of the human associations evoked by the use of such materials. The Surrealists only spurred him to retrieve and develop certain of his early Cubist ideas. Picasso's long history of cutting shapes from cardboard, tin, and burlap in making bas-reliefs and sometimes sculpture in the round gave him a head start in his adventure in González's studio.

In fact, he had turned to González even earlier, modeling the singular *Cubist Head (Fernande)* of 1909 in his friend's studio. Speaking of that work, Picasso later told his biographer Roland Penrose: "'I thought the curves you see on the surface should continue in the interior. I had the idea of doing them in wire.' This solution, however, did not please him because, he added, 'It was too intellectual, too much like painting.'"[22] Whether or not this remark was an afterthought, the fact remains that his general approach in the early years tended toward the same economy and use of volume and space found in the iron sculptures from 1928 onward. The first work that he did with González—the painted construction *Head* of 1928 (cat. no. 26)—with its tripod metal armature and its double-image head, clearly derives from paintings of the period. Yet within a few months, the painterly source

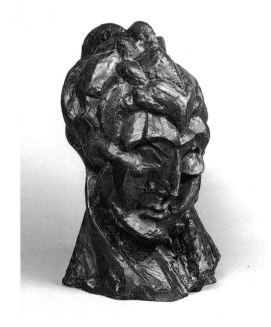

Pablo Picasso, Cubist Head (Fernande), *fall 1909. Bronze, 40.5 x 23 x 26 cm (15 ⁷/₈ x 9 ¹/₁₆ x 10 ¹/₄ inches). Musée Picasso, Paris.*

of his interest was transmuted. Picasso returned to the linear inventions he had once only imagined, this time carrying them out with intense concentration on the possibilities of the technique of assemblage. He had already partially explored this approach in such works as the wood construction *Mandolin and Clarinet* of 1913, in which one of the principal shapes is clearly a leftover from a piece of wood from which a curving shape had been sawed out; *Bottle of Bass, Glass, and Newspaper* of 1914, with its curving tin member; and a detailed sketch, a study for a construction with a guitar, clearly depicting a three-dimensional sculpture with strings or wires for the guitar, and a table or chairs, with legs of zig-zagging planes reminiscent of African sculptures. The way Picasso's mind worked even from that period is reflected clearly in remarks he made later to Hélène Parmelin:

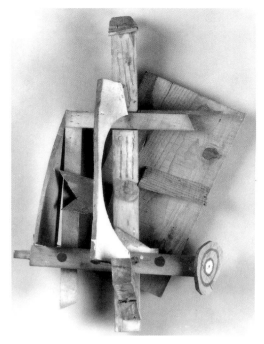

Pablo Picasso, Mandolin and Clarinet, *fall 1913. Pine, paint, and crayon, 58 x 36 x 23 cm (22 ⁷/₈ x 14 ¹/₈ x 9 ¹/₁₆ inches). Musée Picasso, Paris.*

> If I paste three bits of wood on a placard and if I say that that is painting, that does not represent freedom—in what way is that freedom? It's making something or other with three bits of wood. That has nothing to do with freedom. If there is a freedom in that which one makes, it is in the act of freeing something in oneself. And even that—that doesn't last.[23]

In González's studio, Picasso obviously freed something in himself—for instance, the impulse to work out intricate linear spatial games, a thought that had long ago occurred to him in the course of his playing the old draftsman's game of drawing a single line without lifting the pencil from the paper, as in his numerous 1918 drawings of harlequins in simple, open configurations of bent-wirelike lines. Or the impulse to whittle down shapes, played out also in the group of slender wood sculptures carved in 1931 from what were undoubtedly framing strips that he found around the studio. When working on a sculpture, his drive was to use a minimum of means to reveal highly suggestive shapes in space, or to let loose the characteristic tendency throughout his life to explore the uninhibited realm of the baroque. In this too, his Spanish formation certainly figures. In those café sessions of his student years, Picasso absorbed the lessons of the poets of Spain's golden age—particularly Góngora, whom he would later lovingly illustrate. One of Góngora's seventeenth-century admirers, the Jesuit Baltasar Gracián, characterized the Baroque mentality in his Third Discourse: "Uniformity limits, variety expands; and variety is sublimer to the degree that its noble perfections are multiplied."[24] In his iron sculptures, Picasso took great pleasure in the variety of effects he could achieve by bending iron to his formal will, as can be seen step by step. The initial resistance and

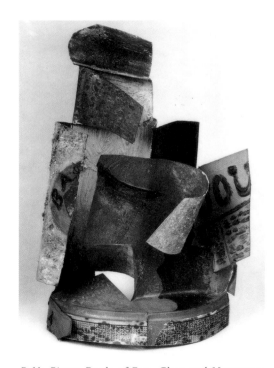

Pablo Picasso, Bottle of Bass, Glass, and Newspaper, *spring 1914. Painted white iron, sand, iron wire, and paper, 20.7 x 14 x 8.5 cm (10 ⁵/₈ x 5 ¹/₂ x 3 ⁵/₁₆ inches). Musée Picasso, Paris.*

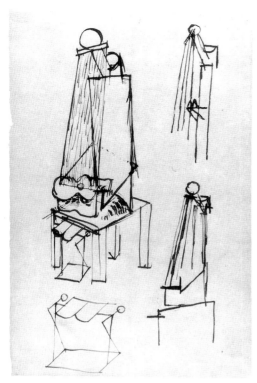

Pablo Picasso, Man with Guitar (Three Subjects) *(study for a sculpture), 1912. Ink on paper, 21 x 13 cm (8 ¹/₄ x 5 ¹/₈ inches). Musée Picasso, Paris.*

Pablo Picasso, Harlequin, *1918. Graphite on paper, 10.8 x 10.8 cm (4 ¹/₄ x 4 ¹/₄ inches). Musée Picasso, Paris.*

eventual ductility of the metal medium stimulated his imagination and, even more, enabled him to clarify his unremitting search for the essential sign, the reduction that yields imaginative amplification.

There is not a single sculpture by Picasso that cannot be found announced in his drawings. In drawing, he sought the "signs" that he said were the keys to his art. "Raphael's image of a woman is only a sign,"[25] he said, and "an artist should observe nature, but never confuse it with painting. It is only translatable into painting by signs."[26] Signs are extreme reductions, and often in Picasso's drawings, the human figure and its various parts are reduced to skeletal signs. At the moment he was drawn back to González's studio, he and many other artists were concerned with such reductions. His countryman Joan Miró, for instance, made statements after 1923 in which the French word *dépouiller* was repeatedly invoked: "to strip down to essentials." In Picasso's sketchbooks from the mid-1920s, there are numerous stripped-down drawings, including some, called Surrealist, in which the bony armature beneath human flesh is all that interests him. The hieroglyphics that were suggested to him in the course of working iron fortified many artists after him, including González, who, as we know from his commentaries on Picasso, watched closely and with intelligent analysis while Picasso worked.

The first few experiments with iron wire were worked out in scores of drawings that Picasso made in Dinard in the summer of 1928. Here, his initial idea of a figure near a beach cabana (which can be seen in paintings of that summer) evolves fancifully, looking back to earlier drawings in which he used a syntax of lines and dots linked up as in the parlor game, such as his illustrations for "The Unknown Masterpiece," and forward to paintings in which the suggestion of distance is made by making the sign for a woman's head the mere head of a pin. Looking at the progression of drawings over that summer, one sees Picasso seeking the means to fuse the figure and its environs (the latter in this case consisting of the horizon and the beach cabin), an old sculptural problem already addressed by Auguste Rodin, Medardo Rosso, and Umberto Boccioni. (For the exhibition catalogue for his show at the Galerie de la Boëtie in 1913, Boccioni had reprinted his 1912 "Technical Manifesto of Futurist Sculpture," in which he called for the "absolute and complete abolition of definite lines and closed sculpture, we break open the figure and enclose it in its environment."[27] Picasso himself was on the same track, and in 1914 had produced his *Glass of Absinthe*, in which the forces of the environment invade

the heart of the sculpture.) At the same time, the Dinard drawings play around the witty vision of the human body as an armature for its house of flesh, and of the whole environment as a house within which the body moves. The problem of creating an alternative to the usual monotonous base is also addressed, as Picasso suggests several points of contact for the gravitational pull of the figure, finding decidedly original solutions.

Perhaps one of the most interesting aspects of his solutions to these problems, particularly in the 1928 series of wire-sculpture maquettes for a proposed monument to Apollinaire, is the way he establishes a three-dimensional frame and thus introduces a pictorialism of a new order (for which many commentators have criticized him). In conventional sculpture there was always the notion of virtual enclosure suggested by the original quadrature of a block. Here, the intercession of complicated planes of perforated space simultaneously breaks the consistency of the quadrature and reinforces its inevitable perpetual presence, more or less on the Gestalt principle (i.e., where the overall configuration dominates one's attention to individual parts). Picasso's interest in preserving an interplay of form is evident in the slight variations of certain elements that he makes within this series, modifying the thickness of his iron wire and emphasizing or minimizing the slight curves produced in the soldered joints. While these sculptures are drawings in space, they are also highly complex sculptural evocations of space. The cat's-cradle complications of the drawings are sustained but clarified by a shaper's hand that unerringly draws out the form from line.

Picasso's initial collaborations with González inspired him, and, in works completed between 1930 and 1935, in which the use of found materials with their inevitable poetic (that is, metaphoric) associations becomes essential, he established a modern idiom that has had a lasting influence. One of the most influential sculptures was *Head of Woman* of 1929-30 (cat. no. 29), with its flexed legs, as in a Bambara or Bakota tribal piece, its prominent use of a found object (the colanders that he sent González to buy), and its hieroglyphic composite of wire springs and shaped metal to represent a rakelike sweep of hair. Widely reproduced, this work became the touchstone for countless artists embarking on assembled metal sculpture experiments, as did the more flamboyant *Woman in a Garden* of 1929-30 (cat. no. 28). The latter work, which Picasso hammered and welded without González's assistance, was the first sculpture assembled out of found iron parts of monumental

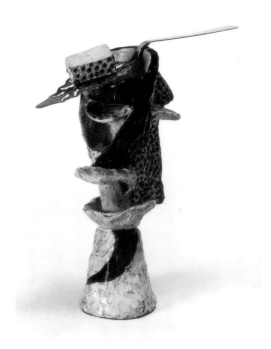

Pablo Picasso, Glass of Absinthe, *Paris, spring 1914. Painted bronze with absinthe spoon, 21.6 x 16.4 x 8.5 cm (8 ¹/₂ x 6 ¹/₂ x 3 ³/₈ inches); diameter at base 6.4 cm (2 ¹/₂ inches). The Museum of Modern Art, New York, Gift of Mrs. Bertram Smith.*

proportions—some of them almost seven feet high—and the first modern example of an environmental sculpture with a playful, and emphatically baroque, character. These pieces, which establish a line in the history of Modern sculpture from Picasso to González to David Smith to Mark di Suvero and onward, could never have been realized without the unique contribution of González, who himself carried a line from Barcelona to Paris and back again to Spain in the works of Eduardo Chillida and others. That line can only be traced if the importance of iron as a medium— and its variant, steel—is acknowledged.

It was not only Rusiñol who envisioned the possibilities. Paul Gauguin, in his notes on the Universal Exposition of 1889, called it "the triumph of iron," and his intuition concerning the tectonic and modern adaptability of iron has some bearing on Picasso's innovations in the medium:

> To the architect-engineer belongs a new decorative art, such as ornamental bolts, iron corners extending beyond the main line, a sort of gothic lacework of iron. . . . Imitation bronze statues clash alongside iron. Always imitation! Better to have monsters of bolted iron.[28]

Gauguin's vision of such monsters came into being in the more violent imagery of some of Picasso's 1931 sculptures and heralded works by artists such as Smith and Richard Stankiewicz.

González and the iron arabesque

González, who was fifty-two years old when Picasso engaged his services, was a thoughtful craftsman who had lent his skills to others to earn his bread, and had long harbored ambitions as a painter. Occasionally he had undertaken sculptural projects, but they were usually reliefs, or masks that grew directly out of his work as an ornamental ironworker. Without the experience of working side by side with Picasso, perhaps he would never have succeeded in liberating his latent talents as a major sculptor. Yet, as the American sculptor Smith wrote in a genial article on González, "The technical collaboration made neither change nor influence in the conception of either artist. During the several years it existed, each pursued his own work in his own way."[29]

What Picasso undoubtedly did teach González was the value of the large gesture, the free-spirited play of the *bricoleur*, and the role of chance in experimental

work. Where things are concerned, Picasso used to say, there are no class distinctions. With his fellow artist's entrance into his studio, González's lifelong habits as a meticulous craftsman, drawing objects in precise detail, cutting them from sheets of iron, and carefully welding them in seamless perfection, were disrupted critically. In complying with Picasso's needs, González discovered his own, and found the means to realize them not only through his own technical expertise but by giving free rein to his innate sculptural intelligence.

González was well aware of the sculptural ideas born in the new century's first decades and, in general, with the Modernist discussions animating Paris ever since he had arrived at the turn of the century. He had watched Picasso during the crucial Cubist years, and he had also learned from others, including Constantin Brancusi, for whom he worked during the 1920s, perhaps building armatures. His friendship with Torres-García, the Uruguayan artist who had studied in Barcelona alongside the González brothers, and had worked with Antoni Gaudí, was resumed when Torres-García settled in Paris in 1924. Torres-García was immensely gregarious and knew artists in many circles in Paris. The well-frequented Saturday afternoon gatherings in his studio brought González into contact with many spirited artists who were filled with energetic visions of aesthetic change. It was in Torres-García's studio in 1929 that the plans for the group Cercle et Carré were formed, and, although it was to be committed to the basic idea of "structure and abstraction," and some of the members were passionate and intolerant Neo-Plasticists, the presence of Arp, Georges Vantongerloo, and Torres-García himself assured fruitful differences. In fact, it was during this period that Torres-García began to work with pre-Columbian symbols, breaking with the rigorous non-objective principles of some of his colleagues.

The big discussion in those days hinged on the concept of space, which had already altered significantly during the first decades of the century. Since Paul Cézanne (and theoretically at least, since the Romantic period in the nineteenth century), space was not only perceived as a continuum through which matter articulated itself, but as almost a material in itself that could be shaped within a created work. González, as his statements make clear, was much preoccupied with the issue of space, approaching it from his long experience as a draftsman. Space became his partner. When he spoke of stars as points in the infinite, he conceived of them as points to be linked by means of "drawing in space." As a draftsman, he knew that

his hand sought points in space and a virtual axis in which to establish the composition, and from which to abstract the illusion of something now closer, now more distant from the perceiver. His "marriage of *material* and *space*" by the "union of real forms with imaginary forms, obtained and suggested by established points, or by perforation"[30] grew directly from the abstracting process every draftsman knows. When he discovered that he could translate those "established points" into his beloved material, iron, González discovered himself, just as Plato's child student discovered geometry.

The work of González's maturity, beginning around 1930, is often said to have introduced a new syntax, but probably his great strength lay not so much in changing syntax as in finding a fresh means to extend a long sculptural tradition. He did not linger with the Cubist planar vision, although his earliest experiments with cutting sheet iron around 1927 began there. Rather, he reached back to retrieve the character of sculpture-in-the-round developed during the Renaissance, but with new means. In his most compelling works, such as *Woman Combing Her Hair* (ca. 1931), the torsion is carefully calculated. Almost all of the larger works thereafter are conceived according to the *contrapposto* principle: Nothing is permitted to rest on a single plane; everything is contrived to turn in space, drawing space into itself through shaped perforations that constantly move. In his total integration of the surrounding space and his avoidance of frontality, González, as Margit Rowell has argued, advanced Modern sculpture perhaps even more than Picasso.[31]

And in González's own eyes, his means were derived from a great tradition, which he wanted to extend. His companion in the workshop, Picasso, was in his own way a great traditionalist, and the two shared the sensual pleasures in cutting into the slabs of iron and, by means of fire, forcing them into new configurations, both knowing the venerable artistic history of their material. González, who was religious, knew the history of ironsmithing back to the Old Testament at least, in which the prophet Jeremiah used the metaphor of iron as "stubbornly defiant" to describe his people.[32] To use this hallowed material as a means of "drawing in space" was a challenge to both artists. Tucker has captured the excitement of metalworking:

> The seed of Picasso's original Cubist constructions in wood bore fruit in steel in the hand of González: not only the assembly part by part, but the previous and separate shaping of parts—bar forged, drawn or bent, sheet rolled, cut or folded, volumes made by the enclosure of the void: the component thus

made, joined at points and edges, and situated in relation to gravity in ways inaccessible to the traditional materials of sculpture.[33]

González often returned to the carved slab of iron, which he had begun cutting, bending, and shaping in the reliefs of 1929. He extended his technique with a variation of Picasso's painterly conception of *The Kiss* (ca. 1930), which in its frontality, its clear superposition of planes, and curvilinear wire definition harks back to González's decorative masks of the mid-to-late 1920s. Eventually, as in *Head Called "The Swiss Woman"* of 1932 (cat. no. 39), he drew out the most expressive possibility of suggested massive volumes with minimal manipulation of the sheet of metal.

The great challenge for both artists lay in the mastery of the process itself, which entailed both careful imagining beforehand and improvisation in the event. Just as etching had intrigued Picasso, not in the least because it had to be imagined in stages and in reverse as well, so he became engaged in this process of working piece by piece, hammering, cutting, and torching. González must have been astonished at first by Picasso's way of surveying the studio and finding scraps that could be bent to his will. Postage stamps and bits of tin cans were one thing, iron another. What González learned about free association from Picasso during those long hours together in the studio was augmented by the art talk of the period. It was a time when the Surrealists were demonstrating the evocative power of fragments, and reproducing in their magazines the strange objects they turned up in the flea market. And it was also a time when, in other quarters, there was a lot of talk about truth to materials and about direct carving, for which Brancusi was the revered model. González might have felt a special kinship with Brancusi when he cut into his iron sheets and followed the internal demands of the metal he knew so well.

During the few years Picasso collaborated with him, González was assembling his working principles and his essential vocabulary. After *The Kiss*, González began to weld disparate, sometimes found bars or rods, together with cut-out shapes, as he had seen Picasso do in *Woman in a Garden*. He refined his execution (Picasso was not concerned with the elegance of the weld, or the discreet polish of a single part), and began to stress the arabesque, an abstract tendency quite foreign to Picasso. He also experimented with semienclosed shapes, as in *Head Called "The Tunnel"* (cat. no. 41), with its plays on dark and light of an entirely new character. Then, toward the mid-1930s, González developed an alternate way to use his materials by joining several slabs together to create hollow, boxlike volumes, as in *Seated Woman I* (cat.

no. 53). (Rowell attributes this new concept to his encounter with Alberto Magnelli, who, during the mid-1930s, was working with the imagery of split and piled stones.) In a sculpture of around 1935, *Large Standing Figure* (cat. no. 50), he returned to the iron rod, making a magisterial drawing in space in which the wrought-iron tradition of Spain found its modern fulfillment. Countless artists drew inspiration from the elements of González's practice between 1930 and 1935, and it was certainly González's adherence to abstract principles that made his work viable for others.

Around 1930, he stated:

> A painter or sculptor can give a form to something which has no concrete form: such as light, color, and idea. These forms will of course be imagined in reference to the human image. Difficult problems to be solved posed by these reinvented planes creating a new architecture.[34]

Such difficult problems called up all his inventive resources. What he learned from Picasso was important, but so was his dialogue with Torres-García, who believed that the human spirit could be conveyed through color, line, and form, spoke of the tradition of "Abstract Man," and believed, as he said to numerous acquaintances, that art was in a profound crisis and a moment of transition. Torres-García's concerns reinforced González's focus on the translation of abstract ideas of color and light, their references to the human image, and the tectonics involved as the primary issues that would find resolution in his sculpture of the 1930s.

The idea of the primacy of the material was not an ideological position for González as it was for so many others, but rather grew from his long experience with metal, an obdurate material compared with clay or plaster. There are only so many things that can be done with iron or steel. It can be cut, bent, forged, and soldered, and it almost always resists surface embellishment. The impetus for this new genre of sculpture came from González's recognition of the nature of his material, as well as his romantic temperament, which, in its idealizing tendency, was attracted to the abstract—to the arabesque, which had assumed such mystical importance ever since the Symbolist movement. In a way, this aligned him more with Matisse than Picasso. Irrespective of any influence or affinity, however, it was González who determined the idiom that so many since have explored, and he did it with a boldness and a subtlety rarely seen since. *The Dream, The Kiss* (cat. no. 46), for instance, is composed around an invisible vertical axis from which dilate just a few well-defined forms that nonetheless give the impression of complexity. The cup-shaped

node of forged, rounded elements is echoed in the crownlike, open shape, to which González has appended only the three strands of flying hair (an image he borrowed from Picasso and never relinquished) to indicate that it represents a head. At the crest of the major rod, another cluster of shapes suggests a hand. The sculpture's verticality insists on anthropomorphic identification, and the signs for hair and hand support this reading; but, as many commentators have noted, what ultimately gives the sculpture its expressive character is the naked beauty of the material, wrought formally with consummate skill.

González was at his best when he made the simplest, most linear sculptures in the period after Picasso had left the studio. Around 1934 he created one of his most splendid works, *Mane of Hair* (cat. no. 49), perhaps inspired by Charles Baudelaire's superb poem with the same title. Here, the forged arc surmounted by the strands of flying hair engulfs a beautifully rounded volume of space, while thrusting itself with great abandon into the space around it. Probably that same year, he made a variant, *Woman with a Mirror*, which, for all its classical figural elements (the bottle-shaped neck quite evidently represents a neck) is more of an abstraction, one could say, of a classical bust in the round. Sometimes, González fashions the finest, most tantalizing space, as in the nearly abstract *Forme très fine* of 1937 (cat. no. 59) and in several other pieces, by leaving infinitesimal space between two cut, flat planes of iron, to articulate a sense of rising movement. These narrowed apertures, joined ever so lightly by visible welds, are characteristic of his mature work, and distinguish his work from that of his imitators. Even in works such as *Seated Woman I*, with its enclosed volumes, González leaves small apertures between forms, opening his sculpture to crosscurrents of space; and at the same time, he calls attention to the innate beauty of the metal and the elegance with which he has married the edges of parts with his torch. Smith may have thought that "craft and smithery became submerged in the concept of sculpture" in González's mature period, but, in fact, what made González's unexpected concept of sculpture singular was his second sense, acquired through years of smithery.

From universe to universal

González began one of his published notes with a reference to "the age of iron," which, he said, began many centuries ago when iron was first used to produce beautiful objects but, unfortunately, was used thereafter mostly for making arms and, eventually, bridges and railroads. "It is time this metal ceased to be a murderer and the simple instrument of a supermechanical science," he declared, urging that it be "forged and hammered by the peaceful hands of an artist."[35] González's age of iron, with its implicit denial of the machine-age aesthetic and its contempt for supermechanical science, was a very different iron age from that envisioned by two Americans, Alexander Calder and Smith, who made iron and steel their province. Both had a healthy respect for industrial materials, were familiar with factory techniques, and had a keen interest in the sciences. However, neither of them had formulated an approach to his art as assured as those of seasoned artists such as Picasso or González, who had had Beaux-Arts training and had shared the cultural milieu of Paris for thirty years.

American artists in general, during the 1920s and 1930s, had had to contrive their artistic culture from a variety of sources, most of them secondhand from Europe, and thus often suffered from an uneasy sense of colonial inferiority. They suspected that Art was born in Europe, and that it continued to flourish there, and only there. So, during the 1920s, hundreds of expatriate Americans thronged boulevard cafés in Paris and hungrily sought the secrets of the Modern masters. They craved to get the feel of things as simple as what a "real" artist's studio looked like, and how artists really lived in the great and fabled bohemia that they had read about. Many had seen examples of European avant-garde art in New York exhibitions, and had seen magazine reproductions of it, but it was important to experience the ambience of an authentic artistic center—something New York had so far never succeeded in establishing. They came determined to feast at the grand buffet, and in many ways found it easier to ingest the various tendencies than expatriate Europeans, who often arrived in Paris with a more formed ideological interest in avant-garde tendencies.

Calder, who was by nature gregarious, found it simple to move from one milieu to another in Paris, and never really felt the need to take an aesthetic position in a sharply defined way. He seemed to wander about from studio to studio at

random, taking inspiration where he found it and picking up ideas that were, as they used to say, in the air. He was relatively innocent of the tensions that led to skirmishes between Cubists, Constructivists, and Surrealists, and was in a far better position than they to make a singular synthesis of their artistic convictions. In addition, the peculiarities of his own artistic formation shielded him from the peril of becoming just a second-generation epigone. The son and grandson of established and rather academic sculptors, Calder was not unduly awed by notions of bohemia, having known an American version in his own home through which various and sometimes eccentric American artists passed. His early mechanical aptitude had brought him to the Stevens Institute of Technology, one of America's leading engineering schools, where he completed his studies as a mechanical engineer before deciding to study art. He tumbled into art school in a rather casual way, where he studied mainly with his parents' friend John Sloan, a political radical and artistic aesthete, whose lessons were not completely lost on Calder. Certainly Sloan's insistence that his students should master contour-line drawing was vital to Calder's later work. Joan Marter quotes excerpts from student notes taken in Sloan's classes, in which Sloan describes line as "entirely a sign, a mental invention,"[36] and declares, in another passage, "An ideograph is better than the thing itself. A better work of art tries to say the thing rather than be the thing itself."[37] Calder carried this ideographic notion of line into his wire sculptures of the late 1920s.

It is true that at the Art Students League, where Calder was a student from 1923 to 1925, the emphasis on contour-line drawing was derived as much from Rodin and Matisse, and perhaps even Picasso, as it was from the teachings of the older generation of American realists; and it is even possible that Picasso's whimsical single-line drawings of clowns and harlequins of 1918, which look like prototypes of Calder's earlier wire-line caricatures, were known to Calder and his classmates. Still, the bias of most instructors toward realist illustration was probably the strongest element in Calder's training. Even at that early stage, however, the European orientation was not completely absent, for it appeared in Calder's life in the person of John Graham, the mysterious Russian cavalryman who, after a sojourn in Paris, turned up as a fellow student at the Art Students League. Graham was an exact contemporary of Picasso and was therefore an *eminence grise* for his much younger classmates, who listened with wonder to his tales of Europe and Russia and his eclectic theories of art. (Another Russian very much in view during Calder's student years

was Alexander Archipenko, who had arrived in 1923 and lost no time establishing himself as a teacher of avant-garde sculpture, a rare anomaly in America, where art schools were still moored in conventional approaches.)

In June 1926, Calder followed several of his classmates, including the irrepressible Graham, to Paris, where, like most other foreigners, he went to sketch classes at the Académie de la Grande Chaumière. By all accounts, that summer the twenty-eight-year-old Calder behaved more like a dilettante vacationer, sampling the delights of café life and making the most of chance encounters with the rather large international community then inhabiting Montparnasse. Often the behavior of the Americans, who were taking advantage of the extremely favorable exchange of francs and dollars during the mid-to-late 1920s, is described, somewhat denigratingly, as pragmatic. In reality, their attitude was identical to the attitudes of the other foreign artists who congregated in Paris during the years before the great stock-market crash of 1929: They had a language problem. They were unfamiliar with the small but significant differences in mores. They had to make their way among different factions without the security of knowing the origins of various ideological quarrels. And like all foreigners, they were always regarded by the indigenous artists as naïve, at the very least. Even such major figures as Vasily Kandinsky and Piet Mondrian were frequently seen as foreign to the French way of thinking, and lived, as did the Americans, at the margin of the French art world. The consequence was that the foreign contingent got to know each other quickly, and tended to help newcomers find their way around. Calder, during his first short sojourn that summer of 1926, immediately met the English-speaking Stanley William Hayter, who had arrived a few months before from London, and who was already acquainted with several significant artists of the international avant-garde. Hayter had a lot in common with Calder. He was a scientist, trained in geology and chemistry, and worked professionally as a chemist in England before he threw it all in for a career as an artist. This common professional background was important in Calder's evolution. When Calder returned for a longer stay in Paris the following fall, he also met the Spanish sculptor José de Creeft, whose studio he often visited, and where he first saw forged-iron works by Gargallo.

According to Calder, during his first years in Paris he thought of himself as a painter. Others saw him as an amusing humorist—good fun and an original. His experiments with toys with movable parts, which he began in 1926, and his single-

line wire sculptures, such as the caricature of cabaret singer Josephine Baker, were viewed as refreshing and entertaining, as was the early version of his circus begun in 1927. He was the beneficiary of a discernible fad in Paris, where Americans from Baker to Calder himself were regarded as exotic and exciting. But it must be added that the growing sense of malaise in the Parisian intellectual world also led to a serious interest in the fruits of an extremely different culture. "I wonder if America realizes what artistique France is expecting of her," wrote the important critic André Salmon, in an introduction to a Graham exhibition catalogue in 1929. Salmon, an intimate of Picasso and Apollinaire, pointed to the example of Walt Whitman "restoring Homeric lyricism to our worn-out naturalism," and said that Graham "has struck us as a double and simultaneous phenomenon of assimilation and transposition. . . . This painter, away from our midst, deriving so to speak from . . . cubism . . . already restores it to us, at the same time purified and enlarged." [38]

Assimilation and transposition: Calder was a master at assimilation, having exposed himself in many studios to experiences that often represented contrasting artistic values. Through Hayter, who opened his etching studio Atelier 17 in late 1927, he encountered a great many Surrealists, including Eluard, Arp, and Yves Tanguy, and probably also Kandinsky, whom Hayter (and Graham) deeply admired. Hayter's point of view was deeply influenced by his Surrealist friends as well as by the Russian master whose radical vision of space he would faithfully follow. It may be that Calder's initial experiments with mobile elements were informed by Hayter's assimilation of Kandinsky's principles. Hayter summarized his views throughout the prewar years in a lecture in which Kandinsky's ideas prevail:

> There is a certain development in art, generally known as non-objective, which can be seen in the early works of Kandinsky, where there is still a static frame of reference but things are sometimes set up which appear to be in motion, not in the sense of successive displacements as with the Futurists, but themselves moving and involved with elements of speed and time. . . . The dimension of time—the fourth dimension—was added to the dimension of space. [39]

Calder continued to travel back and forth between New York and Paris for several years. In the fall of 1928, he rented a studio in Paris, for a stay of a year and a half. It was in 1928 that he met Miró, visited his studio, and began his lifelong friendship with the older artist. Miró took pleasure in encouraging Calder to settle

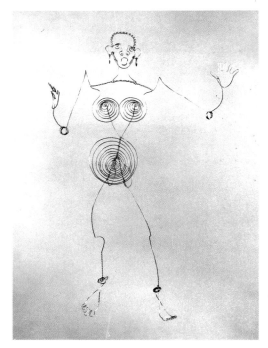

Alexander Calder, Josephine Baker, *1927-29. Iron-wire construction, 99 x 56.6 x 24.5 cm (39 x 22 3/8 x 9 3/4 inches). The Museum of Modern Art, New York, Gift of the artist.*

down to explore more ambitious avenues, and probably shared with Calder his enthusiasm for Paul Klee. Miró's interest in primitive art, his sense of whimsy, and his great appreciation for folk art, particularly hand-carved toys, provided the grounds for a real friendship. After a return visit to New York, from June 1929 to March 1930, Calder took another studio in Paris. Six months later he had a second important encounter, which he always maintained provided the shock that brought him to abstract art: his visit to Mondrian's apartment-studio in October 1930. He was smitten not so much by Mondrian's paintings—although he quickly adopted the older master's habit of limiting his palette to the primary colors and black and white—as by the radiant ambience of the carefully arranged studio, in which Mondrian had tacked rectangles of red, yellow, and blue to his white walls.

It would be hard to attribute Calder's sudden swerve away from literal depiction to any particular influence, but there were several curious cultural conjunctions and historical facts that might be cited. The Great Depression into which America was sliding had its impact in Europe as well, making for an unusually anxious state of mind that subsisted until the outbreak of World War II. From the chorus of laments over the general aesthetic confusion that had begun in the mid-1920s, several voices emerged forcefully from different camps. The Surrealists and the Constructivists were both vociferously declaring their belief in the value of science, but with very different tones of voice. When Breton, for instance, published his novel *Nadja* in 1928, he included a photograph of a strange object he had found in a flea market that had set him off on the quest for mathematical models at the Poincaré Institute. That object, so mysterious in its irregular shape and network of lines, was thought to be a three-dimensional model of a population graph. Breton and his friends saw these models of scientific thought as an affirmation of the fantastic depths of the human imagination. However, Calder's friends among the Parisian Constructivists saw scientific paradigms as the necessary accompaniment of a progressive, non-objective art that they regarded as parallel to modern science. Among the many Europeans who moved to Paris in the 1930s, there were artists who were descendants of both Dada and the initial De Stijl principles, such as van Doesburg and his close friend Arp; others who had witnessed the abstract, often machine-oriented constructions undertaken in the Bauhaus; and still others who knew the original Russian avant-garde that, like Vladimir Tatlin, had drawn quasi-scientific principles from Picasso's initial experiments with Cubist structures. Calder

Piet Mondrian's studio in Paris, 1933. Courtesy Haags Gemeentemuseum.

soon came into contact with most of these artists, as well as the French painters Robert Delaunay and Jean Hélion, when he joined Abstraction-Création in the winter of 1931. That same winter he embarked on his career as an innovative abstract sculptor in metal.

Exhibition of work by Alexander Calder at the Galerie Percier, Paris, 1931.

By the time an exhibition of Calder's abstract sculpture opened at the Galerie Percier in April 1931, Paris had seen the works of several artists who had begun to work with open-form metal construction. Calder's friend Isamu Noguchi, who had worked in Brancusi's atelier, was experimenting with sheet-brass, curving it and cutting it into irregular free-form shapes that recalled the biomorphic shapes used by both Arp and Miró during that period. Transparency as a sculptural value was increasingly discussed by critics, and works by well-known sculptors such as Jacques Lipchitz and Henri Laurens demonstrated the principle in the late 1920s. But Calder's exhibition struck a particular chord, especially the delicate wire constructions grouped under the title "Volumes - Vectors - Densities" (which Calder was showing together with "Drawings and Portraits" in wire). For the catalogue, his friend Fernand Léger—whom he had also met in 1930—wrote that Calder's whimsy had released him from Neo-Plasticism, permitting him to create works in which "the wire became taut, geometric, perfectly embodying the plastic in art, the present time, deliberate anti-romanticism dominated by a striving for equilibrium."[40]

Léger may have approved of the "objective" and antiromantic attitude he saw in Calder's new works, but Calder himself had ambitions that were quite in keeping with romanticism, especially the imaginative variety that his friend Miró incorporated into his paintings of stars and planets in the cosmos, which he rendered, as had Klee, as simple circles floating in space. Calder himself spoke of the group of works he called "Universes" as having some kind of universal or cosmic feeling, and in a talk many years later, in 1951, spoke seriously of the underlying motifs that he had established in 1930 and never abandoned: "The underlying sense of form in my work has been the system of the universe, or part thereof. For this is a rather large model to work from."[41] Earlier, he had given a statement for the Abstraction-Création almanac of 1932, in which he opened with the rhetorical question: how does art come into being? He answered:

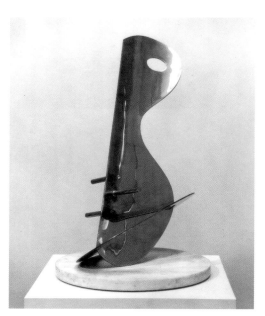

Isamu Noguchi, Leda, 1927. Brass and marble, 59.2 x 36.2 x 28 cm (23 ⁵⁄₈ x 14 ¹⁄₄ x 11 inches). The Isamu Noguchi Foundation, Inc.

> Out of the volumes, motion, spaces carved out within the surrounding space, the universe. . . . Out of directional line—vectors representing motion, velocity, acceleration, energy, etc. . . . Spaces and volumes created by the

slightest opposition to their mass, or penetrated by vectors, traversed by momentum. None of this is fixed. Each element can move, shift, or sway back and forth in a changing relation to each of the other elements in this universe.[42]

In the Galerie Percier exhibition, Calder showed experiments with delicate linear wire structures, so slender that they would vibrate to the footsteps of visitors. The empty circles of bent wire were punctuated with tiny wooden spheres, attached so as to almost suggest the sound of a small clapper. Marter notes that Calder had been fascinated as a child by what he called eighteenth-century toys demonstrating the planetary system, and suggests convincingly that these new abstract metaphors for the universe may have been suggested by mechanical orreries such as the Copernican armillary sphere.[43] In any case, the works of 1932 led directly to Calder's early experiments with kinetic pieces, at first achieved by attaching rudimentary machinery—a simple motor drive or hand crank—and later, using only gravity and wind to move the elements. In 1932, he created several works, dubbed by Duchamp "mobiles," in which the element of random movement is utilized to achieve a shifting equilibrium. Calder, who seemed to have been interested in Mondrian's discussions of dynamic equilibrium, described his own *Object with Red Discs* (also known as *Calderberry Bush*, cat. no. 67) in similar terms. He said that he suspended a two-meter rod with one heavy sphere from the apex of a wire, giving the cantilever effect, and that five thin aluminum disks, projecting at right angles, were held in position by a wooden sphere counterweight. The effect was that when one of the red-painted aluminum pieces was lightly touched, the entire sculpture became animated, quivering and slightly shifting in space. From such initial experiments it was a short step to the hanging mobile that Calder developed later in the 1930s, in which he achieved the lyrical expression of the universe that he had sought since 1930. Calder's achievement in introducing an aleatory principle in sculpture has been compared to the achievements of avant-garde composers, among them Edgar Varèse (who also created a composition he called *Density 21.5*). It is certainly the source of most kinetic sculpture ever since, ranging from Takis to Pol Bury.

Toward the late 1930s, Calder began to work with more fantastic shapes, probably encouraged by his closer relationships with various Surrealist artists. Here he revealed his affinities with González and Picasso, bending large sheets of iron or steel, cutting them into billowing, twisting shapes, and bolting them together, proto-

types of the huge public, bolted stabiles (aptly described by Gauguin's phrase "bolt-ed monsters") that he began making after World War II. These works were shown in New York in 1937, and called "stabiles." In Paris that spring, Calder visited Miró, who brought him to meet the architects of the 1937 World's Fair Spanish Pavilion, for which he, González, and Picasso were preparing works. Calder, who maintained friendships with several important members of Paris's Spanish colony, and whose politics were always to the left, volunteered his services, and when a Spanish artist who had been asked to create a mercury fountain defaulted, Josep Lluís Sert asked Calder to take his place. In many ways this extraordinary collaboration can be seen as the culmination of the American's long interaction with Spanish artists—a moment when the torch that passed from Picasso to González was handed to the New World. American ingenuity, ambivalently admired and despised by Europeans, became, in a mercurial flash, something essential. The drive to conquer new materi-als, going back to the earliest decade of the century, found its ultimate expression in Calder's harnessing the volatile and dense substance mercury to produce not only movement, but new relationships of color and tone. No doubt it was a great and symbolic satisfaction both for Calder and his American colleagues to see in all the photographs of the Spanish Pavilion, Picasso's epoch-making *Guernica* behind the *Mercury Fountain*.

David Smith "there where the others art not"

Calder had left the Art Students League in 1925, a year before Smith arrived in New York. By the fall of 1927, Smith was a full-time student at the League, where he too learned from Sloan ("I got anarchy and cubes from John Sloan"[44]). But within a year, the Czech-born painter Jan Matulka was teaching at the league, where he imbued a whole generation of painters with the principles of European Cubism, talked to them about Kandinsky, and urged upon his students an attitude of explo-ration that Smith always maintained had been crucial to his development as an artist. In 1929, Alfred H. Barr, Jr. inaugurated the Museum of Modern Art, giving New York its first coherent series of exhibitions documenting the Modern move-ment. That same year, Smith met Graham, who by that time had become a signifi-cant figure in the avant-garde art world of New York at least partly because, as the agent of Frank Crowninshield, a collector of primitive art, Graham was able to visit

Paris frequently and could bring back the news of the great world to his eager young acolytes. Through Graham, Smith met others of his own generation, such as Willem de Kooning and Arshile Gorky, as well as the older Stuart Davis, all of whom, like him, were avid for news from the French capital and open to all the shifting winds.

Smith often recalled Graham's essential contribution to his own development. One of the important aspects of Graham's influence lay in his broad intellectual interests and his insistence that his younger friends keep up with both the literary and art journals of the sophisticated international world. Naturally, these included *Cahiers d'art*, in which Smith saw Picasso's works regularly (he tore out the pages of a 1929 issue reproducing Picasso's *Projects for Monuments* and always kept them), and later *Minotaure*. But there was also *transition*, in which Smith first encountered the work of James Joyce, who would remain a primary source of inspiration. While it is true that the reproductions of works by Picasso and, especially, González, were the fundamental catalysts in Smith's formation as a sculptor, Joyce contributed to that which was unique to Smith: his surging emotional, almost diaristic attitude toward his work, and his stubborn insistence on the painterly foundation for his life's work. The Joycean stress on free association and wordplay—so adaptable to collage, for instance—suited his temperament. When, during his mature years, Smith wrote of his work, he often alluded to Joyce, and sometimes, in his diction, there are imitations of Joyce's approach:

> Rarely the Grand Conception, but a preoccupation with parts. I start with one, then a unit of parts, until a whole appears. Parts have unities and associations and separate afterimages—even when they are no longer parts but a whole. The afterimages of parts lie back on the horizon, very distant cousins to the image formed by the finished work.[45]

By 1932, when Smith probably made his first welded works, the rudiments of his approach to sculpture were already in place. But its full evolution followed an erratic course in which the fact that "Mondrian, cubism, constructivism and surrealism all came on me at one time, without my even knowing the difference between them"[46] sometimes undermined the clarity of his conceptions, and led him occasionally into rather banal experiments. Yet, like his friends, who were all painters, Smith benefited from the aesthetic diversity and general absence of partisanship enjoyed by New York artists. That liberal atmosphere lasted until the depths of the mid-1930s, when the Depression, with its unique by-product of federally sponsored

art projects, brought forth a strong social demand for realist (and nationalist) art. At that point, Smith, along with other progressive artists—including his friends de Kooning, Gorky, Jean Xceron, Davis, and Adolph Gottlieb, to mention just a few— became fervent standard-bearers of Modernism, which was under attack. Smith later wrote that "belligerent vitality and conviction"[47] were, along with affection, the attributes of the creative artist. His own belligerent vitality was immense, even during those confused years when so many artists felt torn between their vaguely socialist or anarchist political convictions and their fundamental belief in the formal, ahistorical values of Modern art.

During the mid-to-late 1930s, American artists who were otherwise deeply committed to the Modern tradition were, through circumstances, drawn into the problems of society at large. The new emphasis on the virtues of the working class, and on the need of some of the masses for art, deeply affected young artists. The myth of the machine was revived, and many artists, among them Smith, vaunted their earthy experiences in which they encountered the working man. Smith had spent a summer holiday as a welder and riveter in an automobile plant when he was nineteen years old, and later worked in a factory that produced tanks and locomotives during the war. His pride in being an equal with skilled workers never abated. When he found the Terminal Iron Works workshop in Brooklyn in 1932 and rented a corner of it near the forge, he rejoiced in his ability to get on with the workers; later, in 1950, he even made a sculpture in homage to one of the owners, an Irish blacksmith named Blackburn (cat. no. 111). (Smith was not alone in developing the manly image of the working American artist, consciously adopted as a contrast to the elegance of the European tradition: Jackson Pollock always insisted on his working-class origins and experiences, as did Franz Kline, Clyfford Still, and others.)

Many commentators have connected the Abstract Expressionists' radical departure from European sources with the generally pragmatic attitudes of Americans and their long habituation to advanced technology and skyscraper culture; but a more specific source of the sweeping, open gestures, the desire for large-scale or monumental images, and the adventurous bravura was the conflict spawned during the Depression. That was the first time that modern American artists felt acknowledged as legitimate members of society, at least insofar as government sponsorship legitimized them. But many of them, while maintaining their aggressive Modernism, also felt a wistful need to function with the muscled power, the swag-

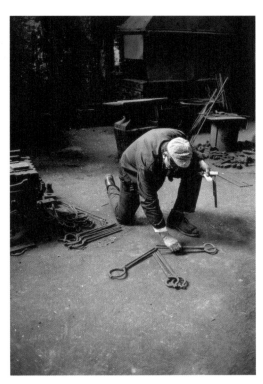

David Smith in Voltri, Italy, 1962.

gering gait of the worker as he was idealized during that brief flirtation with social-ism. Léger's visit to New York in the mid-1930s was a great success in large measure because his modern idiom was adapted to social ideals, couched in terms of "sci-ence-organized-by-society" socialism. As brief as this phase was, it left a lasting mark on Smith who, in his last years, produced some of his most extraordinary works in Italy in an abandoned factory at Voltri. There, side by side with skilled Italian iron-workers, he felt at home; it was, as he said, the nearest thing to a socialist experience in his life.[48]

The situation of Smith and his generation during the late 1930s was certainly as intellectually tumultuous as that of the artists in Paris, but there was one signifi-cant difference: New York had the Museum of Modern Art, in which Barr was com-piling the first overview of the century's diverse artistic heritage. In the signal year of 1936, Barr presented two epoch-making exhibitions organized on broad interna-tional lines: *Cubism and Abstract Art* followed by *Fantastic Art, Dada, Surrealism*. Both exhibitions had immediate effects on the work of the younger New York artists. But *Cubism and Abstract Art* was perhaps more influential, for in the show and in the catalogue—which made its way into virtually every studio—Barr managed not only to gather works from many countries, but to touch upon every single twen-tieth-century avant-garde tendency, and even to acknowledge the importance of the young by including works by Calder and Alberto Giacometti. Barr noted the new tendency toward nongeometric abstraction, talked about "abstract biomorphic" and "abstract expressionist" approaches, and in general tried to bring together diverse views under the rubric of abstraction. As a result, American artists found that they could work more freely, drawing upon whatever resources they felt an affinity for, without being mired in ideological campaigns.

When Smith began his initial experiments with welding around 1932-33, he still thought of himself as a painter. His work reflected the popularity of Picasso's Synthetic Cubist approach among artists he associated with, especially Davis, Gorky, and Graham, who de Kooning said were so close that they were called the Three Musketeers. These three ringleaders prided themselves on their free adaptations of European styles, and tended to include local allusions to real places and real things in their paintings. Picasso was very much with the American painters of the 1930s, not only through reproductions in magazines but also experienced directly through the inclusion of his work in various exhibitions. One truly catalytic painting, *The*

Studio (1927-28, cat. no. 19), had been seen in reproduction within months of its creation and, in 1935, entered the Museum of Modern Art's permanent collection. Smith kept a close watch on Picasso, and inspired by the issue of *Cahiers d'art* in which Picasso's wire sculptures had been reproduced, began his intermittent experiments with welded and forged sculpture.

Smith often traced his own evolution for interviewers, always stressing the presence first of Picasso and then of González in his imagination, and adding that he was a painter for whom the canvas eventually became the ground for sculpture. It stands to reason that Smith's method of composing works in direct metal grew out of the collage technique with which he experimented in the early 1930s. A direct-metal sculptor usually cuts his larger elements and spreads them out on the floor, all the while imagining their evolution. In effect, Smith was working horizontally with relief elements closely related to his drawings and paintings. The practice of contour-line drawing that had been drilled into him at the Art Students League stood him in good stead. All during the 1930s he assimilated and adapted whatever caught his eye, producing a sequence of works in which the initial impulse had been suggested by the works of other artists. In 1934 in New York, he saw an exhibition of sculpture by Gargallo and an exhibition of "Abstract Sculpture" by Giacometti at the Julien Levy Gallery. Gargallo's curved planes of sheet metal immediately made their appearance in Smith's work, while Giacometti's Surrealist freedom, his use of the horizontal plane as both base and sculpture, and the irrationality of his imagery began to appear in Smith's drawings. Also in 1934, Graham gave Smith a small work by González and showed him two others in his possession. In 1935, Smith began his great pilgrimage to Europe, stopping in Paris, where Graham educated him in the latest developments, visiting the Soviet Union, and then returning to Paris and spending several weeks in Hayter's Atelier 17, where he certainly encountered a great deal of Surrealist talk.

Smith returned to New York in July 1936—a New York that had been galvanized by Barr's exhibitions. Smith, an assiduous reader, talker, and searcher, would have had the glimmering of possible syntheses of all he had seen in Europe by perusing Barr's catalogue for *Cubism and Abstract Art*. There, Barr had reproduced one of the five Giacomettis in the show, *Head-landscape* (1932), which, he said, was "from the Surrealist point of view, a successful plastic pun, but it is also an interesting biomorphic abstraction and a solution of one of the problems which has recent-

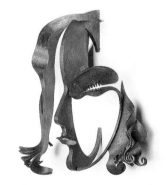

Pablo Gargallo, Greta Garbo, *1930. Iron, 20 x 10 x 20 cm (7 ⁷/₈ x 3 ¹⁵/₁₆ x 7 ⁷/₈ inches). Museo Nacional Centro de Arte Reina Sofía, Madrid.*

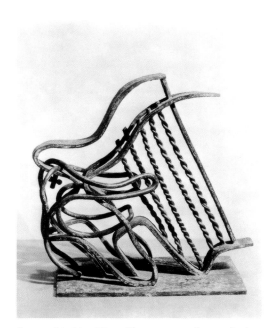

Jacques Lipchitz, Harp Player, *1931. Bronze (unique work), 26.6 cm (10 ¹/₂ inches) high. Courtesy of Marlborough Gallery, New York.*

ly held the attention of sculptors, namely the composition of isolated forms which Arp had suggested in his reliefs and which Giacometti carries further in his project for a City Square."[49] In the same catalogue, Barr reproduced Lipchitz's *Elle* and *Harp Player* of 1931, both of which utilize coiling wiry elements. Barr described them as abstract anthropomorphic figures achieving great formal interest by their transparent effect of intertwining lines.[50] Barr also showed Calder's 1936 mobile (a work strongly reminiscent of Miró) and said that Calder had recently abandoned geometric shapes in favor of irregular, quasi-organic forms.

Fortified by the arguments proposed in this important exhibition and book, Smith, and many other artists in New York, were inspired to seek their own tone of voice. The late 1930s and early 1940s, as troubling as they were, saw innumerable American artists strike out on their own—some out of despair over their long apprenticeship to the Europeans, others out of an exuberant, dawning confidence in their own artistic destiny. There was a strong feeling among artists of Smith's generation that the only answer to their various artistic dilemmas was a kind of reckless decision to experiment, take risks, and, as so many of them said, strike out into the unknown. Smith was among them. A new quixotic and whimsical note occurred in his iron construction *Suspended Figure* of 1935 (cat. no. 100), and found its full expression two years later in *Billiard Player Construction* (cat. no. 103), a work for which there are enough drawings to suggest Smith's process. Smith's audacity as a sculptor is marked in this adaptation of Picasso's painting vocabulary, for certainly his point of view was strongly influenced by Picasso's *The Studio* and, perhaps even more, by *Painter and Model*, both completed in 1928. *Billiard Player Construction*'s organic references within a geometric linear framework, and the humor in translating the rounded joint of the wire billiard cue, are Picassoesque. But there is something of Smith's own here too. He has, with considerable boldness, defied the usual sculptural canons by establishing what Edward F. Fry called a "space frame" as a means of establishing a pictorial plane for a frontal but nevertheless three-dimensional composition.[51] This pictorial element in which Smith also proposed anthropological references remained an essential part of Smith's vocabulary throughout his life. He never flinched from what many artists of his period would have called, scornfully, literary references. His Joycean impulse was to invent arresting forms that carried their story with them. Smith's sense of freedom toward the end of the 1930s was undoubtedly enhanced by the example of Giacometti, whose *The Palace at*

4 A.M. was a celebrated work, as was the horizontal *Woman with Her Throat Cut* (cat. no. 92). In 1937, Smith produced *Interior* (cat. no. 104), a freely adapted version of Giacometti's palace, decidedly frontal; and in 1939, *Interior for Exterior* (cat. no. 106), a complicated fusion of Surrealist fantasy and Constructivist geometric structuring in which the automatistic scribblelike use of wrought steel and bronze is juxtaposed with a rectilinear "space frame." He hadn't forgotten Picasso's lessons, however, and that same year composed *Reclining Figure* (cat. no. 107), using iron rods and spherical joints in a parody of Picasso's first linear pieces.

Alberto Giacometti, The Palace at 4. A.M., *1932-33. Construction in wood, glass, wire, and string, 63.5 x 71.8 x 40 cm (25 x 28 ¼ x 15 ¾ inches). The Museum of Modern Art, New York, Purchase.*

By the time the war came, Smith had joined others of his generation in a defiant mood, proclaiming the right to use any motif or means. Their iconoclasm extended to a kind of syncretism, allowing them to weave back and forth in time and space and to draw upon any impressions that they might recollect. Appearing in Smith's notebooks and sketches of the war period and for a few years after are Surrealist automatistic exercises, and ambiguous forms that such painters as Gorky, de Kooning, Mark Rothko, and Gottlieb were also using. Smith also responded to the dark mounting pressures of the world in 1939 with the anecdotal, quasi-Surrealist *Medals for Dishonor*, demonstrating his defiance toward stylistic rules by declaring his inspiration from ancient coins and, at the same time, his moralistic political indignation in classical caricature tinged by Surrealist derision. Sometime in the early 1950s, Smith wrote in his notebook:

> Do we dare do bad works
>
> often they are the best
>
> in such a sense bad is only the external opinion
>
> but inwardly the artist feels new depths
>
> and he is already there where
>
> the others are not
>
> or may not get for a generation.[52]

He had been gearing up for the "bad works" by his eclectic fusions such as *Home of the Welder* of 1945 (cat. no. 108), in which literary metaphors are rampant and the juxtaposition of disparate parts in a framed stage (or box, as in the Joseph Cornell works he had also seen) provide a stream-of-consciousness atmosphere quite foreign to prevailing sculptural modes.

By 1950, the "new depths" the artist inwardly felt (so much like Picasso's definition of freedom as "the act of freeing something in oneself") were plumbed with

increasing assurance. Smith's works of the 1950s show his complete coming of age, and in one work after another he was able to produce a commanding presence unlike anything that had preceded. Smith continued his exploration of the "space frame" in a group of welded-steel compositions on an increasingly monumental scale. At first there were the candid drawings in space, such as *The Letter* of 1950 (cat. no. 113), an abacuslike compendium of framed signs reminiscent of both Torres-García and Gottlieb. Then there were the airborne drawings in space, such as the *Hudson River Landscape* of 1951 (cat. no. 115), of which Smith spoke in several statements, always stressing the psychological source in the fluid movement of travel through a landscape and the free associations that the various elements can inspire. That same year, Smith welded the large, triumphant *Australia*, bringing the lessons of González into a new monumental realm, and a year later he began the *Agricola* sculptures (sometimes referred to as a series, but in Smith's view, grouped together only because they comprised "many found objects, like hand-forged parts of agricultural implements that have functioned in the past era,"[53] cat. nos. 116-17). Also in 1952, Smith worked on diverse standing figures, such as *The Hero* (cat. no. 118), in which he harked back both to Brancusi, whose organic incorporation of pedestal and work had impressed Smith, and to Miró, leading him into the powerful works grouped under the title *Tank Totem*, beginning in 1953 and continuing into the 1960s. The element of the base of an industrial tank became, in these works, the magic touchstone, allowing Smith to give free play to his increasing desire to make great signs, resembling semaphores, against the sky.

By this time, Smith was cutting large, curved members and welding them into new configurations with great assurance. His mastery of his means enabled him to try many different techniques, some fondly recalling González, as in the clusters of short elements found in González's *Head Called "The Snail"* of 1935 (cat. no. 51) and translated by Smith in the *Timeless Clock* of 1957 (cat. no. 123) into a more robust conformation (which is also related to Calder's cosmic imagery analogous to the orrery). González and Picasso are also recalled in a group of a dozen forged-steel works of 1955, in which Smith drew out the lines of his steel bars into tall, suggestive, slender figures, a motif later elaborated in the composed works of 1956-57 that he called *Sentinels* (cat. no. 120). Many of these vertical works emerged from Smith's careful evaluation of González, particularly works such as *The Dream* of 1931. Like González, Smith returned again and again to the translation of the erect human fig-

David Smith, Australia, *1951. Painted steel, 202 x 274 x 41 cm (79 ½ x 107 ⅞ x 16 ⅞ inches); at base 35.6 x 35.6 cm (14 x 14 inches). The Museum of Modern Art, New York, Gift of William Rubin.*

ure into a resounding composite of allusions. In many works, he continued to use color to emphasize implied volumes. But in the 1950s, he rarely used color illusionistically, as he had, for instance, in the works of the 1930s. At times, as in the late works grouped under the title *Cubi*, Smith burnished the surfaces of his steel volumes in order to suggest the painter's scumble, insisting always that the painter's prerogatives could be joined with the sculptor's. In this he was faithful to Picasso, who, painter that he was, used paint on his metal constructions to unify them.

The immense vitality that Smith displayed in this developing history of the iron age was extraordinarily evident during his last years, when he produced the *Voltri* series, the apogee of the whole tradition. He had written as early as 1952:

> My aim in material function is the same as in locomotive building: to arrive at a given functional form in the most efficient manner. The locomotive method bows to no accepted theory of fabrication. It utilizes the respective merits of casting, forging, riveting, arc and gas welding, brazing, silver soldering. It combines bolts, screws, shrink fits—all because of their respective efficiency in arriving at an object or form in function.[54]

Although Smith's grand vision of locomotive building certainly moved him outside the pale of European sculpture, he carried on—much to his credit—the fundamental principles laid down by Picasso and González, but without being trameled by them. He furthered a technique and a vocabulary of forms. He did not change sculptural syntax any more than a poet does when he plays on the sonnet form. What Smith did was to express passionate intuitions through his choices among forms and the ways of construing them, as does a poet with words. In *Voltri* he not only called upon old memories of the work of Picasso and González, but he recalled Giacometti, too, such as in the marvelous wheeled *Voltri VII* (cat. no. 124) and the sculptor's table reminiscent of Giacometti's 1933 bronze. The delights he had experienced working uninterrupted in Italy carried into the last year of his life, when he produced the large wheeled fantasies he called *Wagon*, one of which returns in very large scale as straightforward forged iron, rounding the circle of the iron age.

David Smith, Wagon II, *1964. Steel, 273.1 x 282.6 x 111.8 cm (107 ¹/₂ x 111 ¹/₄ x 44 inches). Collection of Candida and Rebecca Smith.*

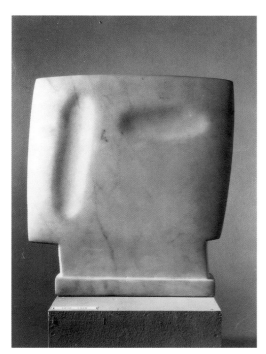

Alberto Giacometti, Gazing Head, *1929. Marble, 41 x 37 x 8 cm (16 ¹/₈ x 14 ⁹/₁₆ x 3 ¹/₄ inches). Kunsthaus Zürich, Property of the Alberto Giacometti Foundation.*

The new psychological realm of Giacometti

In 1928, the year that Picasso began his collaboration with González, the twenty-seven-year-old Giacometti, still an occasional art student at the Académie de la Grande Chaumière, had the good luck to have two sculptures exhibited at the Jeanne Bucher Gallery. There he was spotted by André Masson, who immediately introduced him to the group of renegade Surrealists at the rue Blomet, among them Bataille, Miró, and, most important, the young poet Leiris. Giacometti, who until then had been a lonely foreigner, often desperately depressed, was suddenly part of a largely French group that not only encouraged his volatile impulses but quickly placed him at the center of their own campaign against received ideas in Western culture. Breton summarized the situation of sculpture at that moment:

> From its original exteriority, the object in sculpture became increasingly self-denying in appearance as it traversed the two great crises of cubism and futurism. . . . Emerging from these movements, it found itself putting its resources, in *constructivism*, against the *mathematical object* that had just appeared on the scene radiating a faultless, overwhelming elegance. From that moment it had no alternative but to arise, phoenix-like, from its own ashes, achieving this renascence by calling on the growing power of automation (Arp), the pure joys of equilibrium (Calder), the inescapable, dialectical play between the solid and the hollow (Moore), or, safeguarded by constant reference to first principle—Egyptian art, the evolving art of Persia, Assyria and Babylon, the art of the Cyclades group of the Aegean Islands—all the resources of the modern poetic magic (Giacometti).[55]

The work that had first captured Masson's attention was *Gazing Head*, one of what Giacometti called his "plaque" sculptures, completed during the winter of 1927-28. This was the first of his works that the young sculptor felt had brought him to a new road after much searching. And yet, when he talked about it, Giacometti's characteristic doubt, which so endeared him to his increasingly troubled and doubting friends among the writers, is primary: "Did I actually want to make something I saw in things, or express the way I felt about them? Or a certain feeling for form that is inside you and you want to bring it outside?"[56] How he felt about things, and a certain feeling for form, would be held in a remarkable tension in his important works of the next few years. Through his art, Giacometti was a

most eloquent spokesman for the prevailing sense in the 1930s of the total instability of things. The son of an intelligent and accomplished painter, Giacometti came well equipped to his task. Aside from his studies in Paris, first with Archipenko and then with Antoine Bourdelle, he had had a thorough training in drawing and painting from his father. In his various memoirs of his early years in Stampa, Switzerland, he always stressed his training in draftsmanship. It was then, according to Giacometti, that at the age of around eighteen, he had his first intimation of a conflict that would later be of crucial significance. He described how his father had set up a still life of pears, and how he had drawn them increasingly smaller, defying centuries of tradition by ignoring foreshortening in favor of the way things at a distance are really seen: small and bereft of the third dimension. In Paris, Giacometti doggedly pursued through drawing a burgeoning insight about the psychology of perception. A fellow student described Giacometti in his cramped hotel room in the mid-1920s as a passionate draftsman: "To get to the basics of a face he would indicate the significant points with dots and connect them with fine lines, like a complex system of coordinates."[57] This method—much like that González had spoken of, with "points in space" that had to be linked up—was developed with full knowledge of Cubist precedents. When he began to explore the modern idioms of sculpture, Giacometti had in mind the works he had recently seen by three sculptors who had taken their cues from Picasso: Archipenko, Lipchitz, and above all Laurens, to whom he made a special pilgrimage in the mid-1920s. Giacometti also knew Picasso's own experiments with phenomenological perception, such as making pinhead figures to create the illusion of distance, and playing with perceptual ambiguities and anamorphic perspectives in works such as *Painter and Model* of 1928.

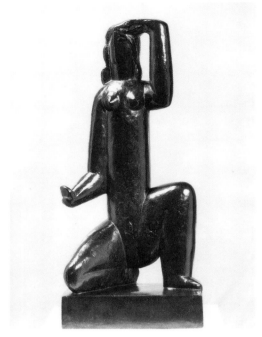

Henri Laurens, Large Woman with a Mirror, *1929. Bronze, 71 cm (28 inches) high. Musée des Beaux-Arts, Nancy.*

Like other sculptors in the age of iron, Giacometti had also considered the work of Brancusi. In his *Spoon Woman* of 1926 (cat. no. 86), with its gently hollowed oval torso, there are shades of Brancusi, as well as of Cycladic, New Guinean, and African sources. The slender plaster slabs that Giacometti turned into planar heads the following year—his "plaque" sculptures—show him moving toward the reductions that he would later make the essence of his style. They constituted, as Cocteau remarked, "such powerful light sculpture . . . that one is led to speak of snow that preserves the footprint of a bird."[58] The works of 1928-29, although modeled rather than welded and still carrying the imagery derived from the folk-art spoon, metamorphosed into a sign for woman. However, they are already opening

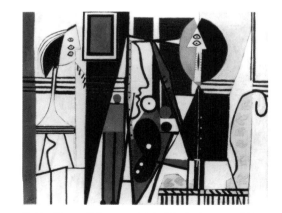

Pablo Picasso, Painter and Model, *Paris, 1928. Oil on canvas, 129.8 x 163 cm (51 ¹/₈ x 64 ¹/₄ inches). The Museum of Modern Art, New York, The Sidney and Harriet Janis Collection.*

out, incorporating levels of space and pure undulating, linear movement, as in *Reclining Woman Who Dreams* (cat. no. 89). By that time, Giacometti was imbibing the fierce lessons of Bataille, whose "metaphysics of cruelty and self-derision,"[59] as Yves Bonnefoy has called Bataille's preoccupation with violent imagery, for a time deeply affected Giacometti. The stabbing gesture in *Man and Woman* (cat. no. 88) is explicitly sexual and moves into space with the linear force that Picasso had unleashed in 1928-30.

Leiris, who published an article in the newly founded review *Documents* on Giacometti's most recent works in 1929, spoke of the young sculptor passionately. He pointed out that "everything he makes is like a fixation of one of those moments we experience as crises, which live from the intensity of a quickly perceived and immediately internalized adventure."[60] Later, Giacometti himself, in a letter to Pierre Matisse, spoke of his work at that time as giving him some part of his vision of reality, but lacking "a sense of the whole, a structure, also a sharpness that I saw, a kind of skeleton in space."[61] Leiris's allusion to moments of crises refers to the personal experience of an exceptionally sensitive artist, but the widespread feeling of general crisis in Europe at that time certainly contributed to the heightened emotional tone of Leiris and of scores of other writers. This was not a vague or sentimental feeling. There were real events from 1930 until the war that amounted to more than intellectual crises. To cite just one instance: in November 1930, to accompany the showing of their film *L'Age d'or* at Studio 28, Luis Buñuel and Salvador Dalí arranged for an exhibition of works by Max Ernst, Man Ray, Miró, Arp, and other Surrealists. A few days after the riotous first night, members of the League of Patriots and the League Against Jews (Ligue antijuive) stormed the theater and sacked the gallery, destroying several works.

This event was one of many that alarmed and disheartened Paris, and Giacometti, always attentive to political events and at times a militant activist, was not untouched. In 1930, Dalí saw Giacometti's sculpture *Suspended Ball* of 1930 in a prestigious exhibition of works by Arp, Miró, and Giacometti at Pierre Loeb's gallery, and fetched Breton immediately. Both Surrealists saw the aggressive distinction of a work in which metal bars, introduced as sculptural material by Picasso, were transformed into a cubic prison for a potentially sinister encounter. The Surrealists, after all their proselytizing for the shock value of gratuitous encounters, as expressed in the Comte de Lautréamont's series of images beginning with the

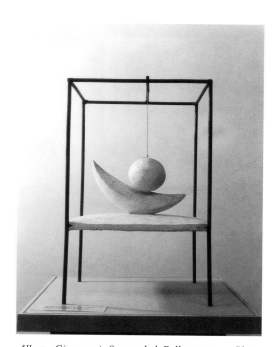

Alberto Giacometti, Suspended Ball, *1930-31. Plaster and metal, 61 x 36 x 33.5 cm (24 x 14 ¹/₈ x 13 ³/₁₆ inches). Kunstmuseum Basel, Property of the Alberto Giacometti Foundation.*

words "beautiful as . . ." (and, in one celebrated passage, continuing: "the chance encounter of a sewing machine and an umbrella on a dissecting table"), felt that they had found their man. And Giacometti felt an instant affinity with Breton and quickly became a very active member of the Surrealist cenacle. While Breton had seen magical poetry in *Suspended Ball*, and Dalí had rightly called attention to what he termed the symbolically active objects, Giacometti knew that he was coming closer to the fusion of how he *felt* about things and how a feeling for form could be harnessed to a kind of psychological anecdote.

Breton lost no time broadcasting the importance of the new recruit and shortly after their first meeting published Giacometti's drawings and text entitled "Objets mobiles et muets" in the December 1931 issue of *Surréalisme au service de la révolution*. These explicit drawings of the sculptures in which Giacometti suspended suggestive objects (for instance, the bisected ball that resembled buttocks, in *Suspended Ball*) fulfilled the need for movement, what Giacometti called in the letter to Pierre Matisse "a third element." He wanted his works to contain a suggestion of movement as a sensation that could be induced. Such a suggestion of movement occurred in the game-board works of 1931, such as *Man, Woman, and Child* of 1931, with its obvious anecdotal intention, but became more highly developed beginning in 1932. Giacometti's own description of his next phase, in which intense feelings and often violent imagery took precedence over formal considerations, makes clear the nature of his revolt against his entire background and training:

> It was no longer a question of reproducing a lifelike figure but of living. . . . There was also a need to find a solution between things that were rounded and calm, and sharp and violent. It is this which led during those years ('32-'34 approximately) to objects going in directions that were quite different from each other, a kind of landscape—a head lying down; a woman strangled, her jugular vein cut; construction of a palace with a skeleton bird and a spiral column in a cage and a woman at the other end.[62]

Despite the Surrealist emphasis on oneiric signification, anecdote, and arcane imagery, Giacometti during those years addressed himself also to problems endemic to the sculptor's vision: how to work both with and against gravity; how to suggest different apprehensions of space within a single work; how to make parts become subordinate to a whole. In *Model for a Square* of 1932 (a version of which is seen in the 1932 drawing of his atelier, Giacometti was faithful to his new idea of making

Alberto Giacometti, Mobile and Mute Objects, *first published in* Le Surréalisme au service de la révolution, *no. 3 (December 1931), p. 18.*

Alberto Giacometti, Drawing of My Studio, *1932. Pencil on paper, 32.7 / 31.9 x 49.3 cm (12 ⁷/₈ / 12 ¹/₂ x 16 ⁵/₈ inches). Öffentliche Kunstsammlung Basel, Kupferstichkabinett, Kunstmuseum Basel.*

things discrete and going in different directions, but the desire for unity is evident in his aligning on a diagonal a scooped-out half-sphere rising from the ground, and a sphere hollowed in the ground, beckoning to its sister form. In *Woman with Her Throat Cut* of the same year, Giacometti literally finds the skeletal reduction he had sought for some time, and suggests with great force the idea that the floor as ground and the sight line from above are suitable means for a sculptor to suggest the tensions between disparate forms and compositional unity.

In 1933, he worked out the scenario for his markedly theatrical *The Palace at 4 A.M.* in several drawings, which appears to confirm Reinhold Hohl's suggestion that one of the primary sources Giacometti drew upon were set designs from prewar Russia. Certainly the several levels of space articulated by the cagelike enclosure of the dangling spine, the suspended trapeze, and the upper tower suggest the new conception of theatrical space put forward in Vsevolod Meyerhold's theater, with its determination to move vertically as well as horizontally. Kazimir Malevich had set it out clearly, and to the degree that Giacometti worked out the basic structure of this three-dimensional drama, he was partaking of the Constructivist tradition. However, the strongest element was certainly that of the mythmaking demanded by Surrealism.

With *Invisible Object* of 1934, Giacometti began his exodus from Surrealism, although Breton regarded the work as worthy of praise in several of his important writings. This large, static, frontal, clearly Egyptian-inspired sculpture had an enormous impact upon viewers, thanks to its fusion of seemingly ancient modes of seeing with strange spatial restrictions established in the additive way Picasso had worked on his assembled pieces. The figure itself carries memories of hieratic gestures of a venerable tradition. But the framelike chair and the plaque imprisoning the woman's shins establish spaces more akin to the modern vision of construed, planar space. Although there are shades of the dark imagery favored by the Surrealists (the head is uncannily like that of a praying mantis, that carnivorous insect that so fascinated the Surrealists because they believed that the female consumed her mate after the act of coitus), the essential impact lies in its basically sculptural, as opposed to anecdotal, conception.

Giacometti's experiences in the 1930s undoubtedly shaped the artistic development that led to his postwar works, with their unique resolutions of sculptural problems. His search for fresh approaches to the articulation of three-dimensional

space led him beyond the conventions of sculpture established during the first half of the century and into the spatial realm of phenomenology. He had moved a long way from vanishing-point perspective in his drawings and paintings, in which vectors and geometric frames within frames always establish the ambiguity of the space in which figures loom. And, in his sculpture, he had reduced volumes and stripped away surfaces to the point that dynamic space—that essential reference for a sculptor—becomes the real delineator of a visual experience. He carried the cage enclosure—a sort of theater of the mind—into a new psychological realm in which, as in *The Cage (Woman and Head)* of 1950 (cat. no. 95), the perceived whole requires an instant of adjustment to the existence of several measures of space established by vertical forms of different scale, contained and yet not contained by the towerlike linear structure. The paradoxes initiated in the 1930s continued to appear, as in the sense of motion emphatically braked in his splendid *Chariot* of 1950 (cat. no. 97), with its clearly nonfunctional wheels, and in various versions of *Walking Man* (cat. no. 98), all of which stress the weight and immobility of the huge feet.

Giacometti's departure from the iron-age vocabulary begins a new chapter in sculpture history, in which the articulation of parts is no longer achieved only by assembling positive and negative spaces in largely linear terms. Yet, without the examples of the 1920s, the final sequence of busts and figures in his oeuvre is inconceivable, as he himself often indicated. The harsh decisions he had taken in the early 1930s sprang from his personal crisis, but they also reflected the *pourquoi pas* (why not?) of his dejected comrades in Paris and the what-the-hell of their equally disheartened American confreres. After the mid-1930s, each had to find his way out of the cul-de-sac that Jean-Paul Sartre had begun defining in his widely discussed novel *La Nausée* in the late 1930s. Giacometti, more than most artists, experienced the shock of discovering the force of contingency, as did Sartre's anti-hero Roquentin, and it would lead him to the works of his maturity, so ridden with doubt and epitomizing a tragic vision. The worries of the 1930s, induced by the universally acknowledged bad times, followed artists into their studios and hung like shrouds on traditional sculptures, forcing many of them to turn away and begin at degree zero, as had the early Russian artistic revolutionaries. What happened in sculpture as a result of all these turbulent forces was a transformation of the idea of space through a combination of doubt and daring, by treating space—that intangible but experienced something—as a coequal with matter. Giacometti presided over

the near dissolution of the sculptural object that had begun with the early twentieth-century visions of transparency. He ushered in a period in which ambiguity, or what was called "the informal"—a vision of form that Arthur Rimbaud had long before prophesied would become the mark of Modern art—became the *lingua franca* of postwar artistic developments, a period that is still evolving today.

All translations are the author's own unless otherwise specified.

1. "Manifesto for a Sacred Sociology," manifesto for the Collège de Sociologie (Paris, 1936).
2. Antonin Artaud, "The Trip to Mexico" (1936), in *Artaud: Selected Writings*, ed. by Susan Sontag (Berkeley, 1988), p. 360.
3. Antonin Artaud, "First Contact with the Mexican Revolution," in *ibid.*, p. 366.
4. E. Tériade, "Jacques Lipchitz," *Cahiers d'art*, no. 5 (1930).
5. George L. K. Morris, "The American Abstract Artists," in *The World of Abstract Art* (New York, 1957), p. 133.
6. Octavio Paz, "André Breton or the Quest of the Beginning," in *Alternating Current* (New York, 1972), p. 48.
7. *Ibid.*, p. 43.
8. Georges Bataille, "Le Jeu Lugubre," *Documents*, no. 7 (December 1929), p. 297. "Intellectual despair results in neither impotence nor dreaming but in violence."
9. André Breton, *Nadja* (Paris, 1928). "Beauty will be *convulsive* or will not be."
10. Vicente Huidobro, *Altazor*, trans. by Eliot Weinberger (New York, 1988).
11. William Tucker, *Early Modern Sculpture* (New York, 1974), p. 107.
12. André Breton, "Picasso dans son élément," *Minotaure*, no. 1 (June 1933), p. 4.
13. André Breton, "The Crisis of the Object," in *Surrealism and Painting*, trans. by Simon Watson Taylor (New York, 1972), p. 275.
14. Gertrude Stein, *Paris France* (New York, 1970), p. 54.
15. Breton et al., quoted in Patrick O'Brian, *Picasso, A Biography* (New York, 1975), p. 265.
16. Julio González, "Desde Paris," *Cahiers d'art* 10, no. 7 (1935); quoted by Marilyn McCully in *Picasso Anthology* (London, 1981), p. 193.

17. Maurice Raynal, *Picasso* (Paris, n.d.).

18. Rusiñol, quoted in Robert Hughes, *Barcelona* (New York, 1992), p. 436.

19. Salvador de Madariaga, "Introduction" to Unamuno, *Selected Works*, vol. 4, trans. by Anthony Kerrigan (Princeton, 1972), p. xxxvi. Unamuno's title, *Nada menos que todo un hombre*, translates as "Nothing less than the total man."

20. *Ibid.*, p. xxxi.

21. Hughes, *Barcelona*, p. 437.

22. Roland Penrose, *The Sculpture of Picasso* (New York, 1967), p. 19.

23. Hélène Parmelin, *Picasso dit . . .* (Paris, 1966), p. 26.

24. Baltasar Gracián, *Agudeza y arte de ingenio* (Madrid, 1974), p. 15.

25. Picasso, quoted in Dore Ashton, *Picasso on Art* (New York, 1972), p. 66.

26. *Ibid.*, p. 67.

27. Boccioni, reprinted in Herschel B. Chipp, *Theories of Modern Art* (Berkeley, 1968), p. 298.

28. Paul Gauguin, *The Writings of a Savage*, ed. by Daniel Guerin (New York, 1978), p. 28.

29. David Smith, "González: First Master of the Torch," *Art News* 54, no. 10 (February 1956), p. 37.

30. González, in Andrew C. Ritchie, *Sculpture of the Twentieth Century* (New York, 1952), reprinted in Ashton, *Twentieth-Century Artists on Art* (New York, 1985), p. 58.

31. Margit Rowell, *Julio Gonzalez* (New York, 1982).

32. Thanks to Professor Roald Hoffmann for his insight concerning Old Testament references to artistic ironworking.

33. Tucker, *Early Modern Sculpture*, p. 76.

34. Rowell, *Julio González*, p. 29.

35. Ashton, *Twentieth-Century Artists on Art*, p. 58.

36. Joan Marter, *Alexander Calder* (New York, 1991), p. 25.

37. John Sloan, *The Gist of Art* (New York, 1939), quoted in Barbara Rose, *Readings in American Art* (New York, 1968), p. 42.

38. André Salmon, "Introduction" to John Graham exhibition catalogue, 1929, at the Dudensing Gallery, in Marcia Epstein Allentuck, *John Graham's System and Dialectics of Art* (Baltimore, 1971), p. 32.

39. Stanley William Hayter, Lecture VI, July 29, 1948, San Francisco Art Institute Archives, 53-54, quoted in Susan M. Anderson, *Pursuit of the Marvelous* (Laguna Beach, Calif., 1950), p. 14.

40. Léger, quoted in Marter, *Calder*, p. 105.

41. Calder, quoted in Ashton, *Sculpture*, p. 96.

42. Calder, quoted in Marter, *Calder*, p. 112.

43. Marter, *Calder*, p. 107.

44. David Smith, "Notes on My Work," *Arts Magazine* 34, no. 5 (February 1960), p. 5.

45. *Ibid.*

46. Smith, interview in Katherine Kuh, *The Artist's Voice* (New York, 1962), p. 219.

47. Smith, "Thoughts on Sculpture," *College Art Journal* 13, no. 3 (1954), p. 203.

48. Smith, undated letter written to the author from Italy.

49. Alfred H. Barr, Jr., *Cubism and Abstract Art* (New York, 1936), p. 197.

50. *Ibid.*, p. 191.

51. Edward F. Fry, "Introduction" to catalogue of the exhibition *David Smith*, held at the Solomon R. Guggenheim Museum in 1969, p. 11.

52. Smith, quoted in *ibid.*, p. 14.

53. Smith, quoted in Kuh, *Artist's Voice*, p. 224.

54. "Who Is the Artist? How Does He Act?" *Everyday Art Quarterly*, no. 23 (Minneapolis, winter 1952), p. 16.

55. André Breton, *Surrealism and Painting* (New York, 1972), p. 72.

56. Giacometti, quoted in Reinhold Hohl, *Alberto Giacometti* (New York, 1970), p. 248.

57. Quoted in *ibid.*, p. 247.

58. Jean Cocteau, diary entry, winter 1928-29, in *Opium* (Paris, 1930). Reprinted in Jean Cocteau, *Oeuvres complètes*, vol. 10 (Lausanne, 1940), p. 140.

59. Yves Bonnefoy, *Giacometti* (Paris, 1991), p. 163.

60. Michel Leiris, "Alberto Giacometti," *Documents*, no. 6 (1929), p. 209.

61. Giacometti to Pierre Matisse, late 1947, quoted in *Alberto Giacometti*, catalogue of the exhibition held at the Pierre Matisse Gallery, New York, Jan. 19-Feb. 14, 1948, p. 29.

62. *Ibid.*

Pablo Picasso, drawing from a sketchbook, Juan-les-Pins, 1924. Musée Picasso, Paris.

Francisco Calvo Serraller
Vulcan's Constellation

The age of iron began many centuries ago by producing very beautiful objects, unfortunately for a large part, arms. Today, it provides as well bridges and railroads. It is time this metal ceased to be a murderer and the simple instrument of a super-mechanical science. Today the door is wide open for this material to be, at last, forged and hammered by the peaceful hands of an artist.

Only a cathedral spire can show us a point in the sky where our soul is suspended!

In the disquietude of the night the stars seem to show to us points of hope in the sky; this immobile spire also indicates to us an endless number of them. It is these points in the infinite which are precursors of the new art: *"To draw in space."* [1]

So wrote Julio González about the new "age of iron" in sculpture that he and Pablo Picasso had initiated in the 1930s. This also may be considered as a statement about the period itself: the name "age of iron" is particularly appropriate in describing the 1930s, both for the role that iron played that decade in the work of Picasso and González—and many artists who followed, such as Alexander Calder, Alberto Giacometti, and David Smith—and for the political climate of the time. [2] Coming as it did between the Wall Street crash of 1929 and the beginning of World War II, just after the Spanish Civil War ended, the 1930s was a decade of iron hardness, and, again like iron, was forged under the blows of force and in the heat of fire. The ter-

minology of the period is replete with terms such as "discipline," "responsibility," "commitment," "front," and so on. During the civil war that devastated their country, when the Spanish Republicans defended the Basque city of Bilbao against the siege by Franco's Nationalist troops, that city was nicknamed, for propaganda purposes, "the belt of iron." The name is doubly meaningful, referring not only to Bilbao's fierce resistance but also to the source of the wealth, and therefore the power, of what was then the capital of Basque country: its highly developed iron-working industry.[3] Equally significant is that Bilbao is only a few miles from the town of Guernica, which was so cruelly bombed by the German Condor Legion in April 1937. The three-day slaughter of unarmed civilians and refugees not only helped to solidify resistance psychologically in that defensive "belt of iron," but was also the inspiration for the mural that Picasso had been commissioned to create for the Spanish Pavilion at the Paris World's Fair of 1937.

Pablo Picasso, Guernica, *May 1-June 4, 1937. Oil on canvas, 349.3 x 776.6 cm (137 ¹/₂ x 305 ³/₄ inches). Museo Nacional Centro de Arte Reina Sofía, Madrid.*

Between the moment at the beginning of 1937 when Picasso, who by then had officially accepted the honorific title of director of the Prado Museum, received the commission to create a great work for the Spanish Pavilion at the Paris World's Fair and his decision to draw inspiration from the Guernica massacre, other tragic events had taken place in the Civil War. Even Picasso's hometown, Málaga, located at the opposite end of Spain from the Basque country, had fallen. Its resistance and final surrender, and the ensuing repression carried out by Franco's victorious forces, were recorded by Arthur Koestler, a war correspondent at the time who was almost executed by the Fascists.[4] But it was Guernica—the deliberate bombing of a defenseless civilian population trapped in a small city that had no strategic or military value but symbolized the historical identity of the Basque people—that aroused Picasso's "fury"[5] and his inspiration. The result was a quickly completed work that stood as a universal condemnation of war, one that transcended the tragic event that inspired it. Clearly, Picasso had adopted the revolutionary point of view with which Goya, in *The Third of May, 1808* or *The Moncloa Executions*, had inverted the conventional moral of history painting, which traditionally celebrated the victory of the conquered over their conquerors. *The Moncloa Executions* evoked the cruel repression carried out by French occupation troops in 1808 after the spontaneous uprising of Madrid's populace on the preceding day.[6]

Francisco de Goya, The Third of May, 1808 *or* The Moncloa Executions, *1814. Oil on canvas, 266 x 345 cm (104 ³/₄ x 135 ³/₄ inches). Museo del Prado, Madrid.*

González also produced emblematic works that sought to reflect the tragedy of the Spanish Civil War, especially his celebrated *Montserrat*. This sculpture simulta-

Julio González's Montserrat *(1936-37) in the Spanish Pavilion at the Paris World's Fair, 1937.*

Josep Lluís Sert and Luis Lacasa, Spanish Pavilion at the Paris World's Fair, 1937.

neously embodied the ideals of freedom and social revolution, defended by the now-threatened Republic, and local Catalan identity. (González was born in Barcelona.) Having been invited to show a work at the Spanish Pavilion, González had difficulty in deciding between bringing *Montserrat*—and there is some disagreement as to whether it was finished a year before González received the commission from the Republic—or *Woman with a Mirror* (ca. 1936-37, cat. no. 57). *Woman with a Mirror* is one of the greatest sculptures he would produce, but its composition, which was daringly avant-garde, kept it from fulfilling the propagandistic requirements called for at the time. Apparently, Picasso tried to persuade González to show *Woman with a Mirror*, but he ultimately chose *Montserrat*.[7] Picasso, to complement González's work, brought sculptures that he had made during the first half of the decade: the impressive *Woman with Vase* (1933), two female heads, one female bust, and a nude swimmer, all dated 1931 and all bearing the characteristics of pieces done in the studio of his country home, the château de Boisgeloup, near Paris, which he bought in 1930.[8]

Joan Miró presented *Head of a Catalan Peasant*, also known as *The Reaper*, a figure inspired by the folk image of the Catalan peasant, which, in turn, evoked traditional nationalist mythology; the painting, however, exhibited the intense, expressionistic and violent style that Miró had been using since approximately 1934. Calder, strongly linked to Miró and Spain, and the only foreign-born artist invited to show a work at the Spanish Pavilion, contributed his *Mercury Fountain*. Finally, within what we can call genuinely avant-garde art, the promising Castilian sculptor Alberto Sánchez exhibited *The Spanish People Have a Road that Leads to a Star*.[9]

Joan Miró's Head of a Catalan Peasant *in the Spanish Pavilion at the Paris World's Fair, 1937.*

The rest of the Spanish artistic presence in the Pavilion was radically different: ninety-four figurative artists, most of whom exhibited illustrations of conventional propagandistic scenes. Of the more traditional artists in the Pavilion, one of the best-represented in terms of the number and importance of works was José Gutiérrez Solana (1886-1945), who exhibited fifteen paintings. Solana managed to invert the folkloric image of so-called "black Spain," practiced at the end of the previous century by Ignacio Zuloaga, and dug deep into that blackness, beyond the traditions of conventional representation (*costumbrismo*). As a result, unexpectedly, a painter who until then had been viewed with misgiving in and outside of Spain, began to attract international interest.[10] There were other, lesser-known Spanish painters and sculptors of the same period who, agreeing with or adopting international tendencies

then in force, revolved around a more or less expressionist realism.[11] Clearly, among the many figurative artists not all were mediocre illustrators of military feats. Almost all of those who had artistic talent chose realism precisely because the avant-garde model had entered a period of crisis during the 1930s.[12]

The prevailing artistic style among the works shown in that Pavilion, created against the tragic and hallucinatory background of the Civil War, was not different from the dominant international currents, which caused the decade to be nicknamed the "era of the realisms."[13] With the exception of the Abstraction-Création group and the isolated activity of some members of the avant-garde, many of whom had by then become teachers, most artists in the 1930s had returned to figuration and realism. This included the dominant faction among the Surrealists, who at the time were strongly influenced by the ideas and works of Salvador Dalí and René Magritte, enemies of automatic painting and any form of abstraction. Mexican muralism, which reached the height of its prestige during the 1930s, was also a clear manifestation of what was then understood as a social art of political propaganda.

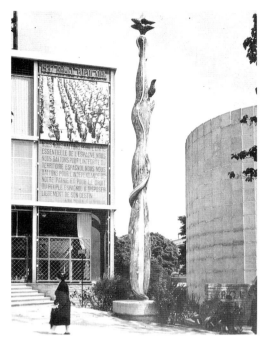

Alberto Sánchez's The Spanish People Have a Road that Leads to a Star *in front of the Spanish Pavilion at the Paris World's Fair, 1937.*

During that decade, these polarized attitudes brought into opposition abstractionists and realists, a confrontation that not infrequently became a revision of the old conflict between avant-garde and tradition, a struggle between a formalist art and one of content, of elite versus popular. Picasso was one of only five avant-garde artists invited to participate in the Spanish Pavilion, the others being Calder, González, Miró, and Sánchez. What these artists were to make concrete, through their individual works, was this "crisis of the avant-garde." They sought to transcend the conventional dichotomy between avant-garde and realism by means of what we could call an attempt to "semantify" the avant-garde idiom.[14]

I think that Picasso's evolution during these years—approximately between 1925 and 1940—was in this regard a paradigm. It became a driving force that stimulated what other artists of similar tendencies, such as González, were beginning to produce. The issue of who deserves preeminence with regard to the new style of making sculpture in iron is banal and inappropriate. Nor does it seem relevant to repeat the commonplace about Picasso the "artist" seeking help from González the "artisan," and how, because of their brief collaboration, the artist learned how to use the acetylene torch and the artisan found his way toward creative art. In the same context—although more interesting—the difference that critics have seen between how González and Picasso conceived iron sculpture does not seem fundamental to

me. Picasso saw it in synthetic and objectified form, the culmination of his Cubist experience with collage, while González viewed it in basically naturalist style, as art historian Rosalind Krauss has so cogently described it.[15] What I think most important is their fundamental agreement about the need to respond to the crisis of the avant-garde without having to reject its idiom or doing it violence.

In a certain sense, this attitude goes back to what Breton, when he was still a Dadaist, postulated in the years immediately following World War I, when he indignantly rebelled not only against the "return to order," but also against the academic stabilization of Cubism. I am not referring only to Breton's simple declaration that "Cubism was a school of painting, Futurism a political movement," and Dada "a state of being."[16] He also spoke about the need to "perhaps restore content to form."[17] As is well known, Breton was better at defining problems than solving them: his suggestion about how to articulate this restitution of content to form went no further initially than holding up the metaphysical Giorgio de Chirico as a model; even though he resisted condemning the relevance of "plastic automatism" to the plastic arts from the revolutionary perspective of first-stage Surrealism, he also resisted elaborating upon the practice, a notion even more improbable than automatic writing.[18] In any case, no one can deny he had a premonition regarding the crisis of the avant-garde and its eventual "semantification," or that he strongly believed that the person best suited to provide the solution was Picasso, that quintessential Modernist who had repeatedly refused to leap entirely into abstraction.[19]

Picasso's situation in the period between the two wars was rather complicated and at times dramatic. After World War I, not only was Picasso's financial situation secure but he became a "star," much sought-after by high society. His marriage to the Russian ballerina Olga Koklova distanced him from the bohemian circles of his earlier period and gave him an air of respectable bourgeois stability that dangerously rounded out his social success. However, the most serious problem for art at that time was the apparent "return to order" of many avant-garde artists and the development of a Cubist "school," which reached its apotheosis in 1925 with the *Exposition internationale des arts décoratifs* in Paris. The Surrealists, then in their first, organizational phase, justly and violently attacked the exhibition. Picasso was not immune to these "reactionary" temptations, which in his work took the form of Mediterranean neoclassicism and of using Ingres as a model, thus accentuating the "pleasing" side of his work. But Picasso is Picasso, and even when such elements of

José Gutiérrez Solana, Christ of the Blood, *ca. 1920. Oil on canvas, 201 x 128 cm (79 ¹/₁₆ x 50 ³/₈ inches). Musée national d'art moderne, Centre Georges Pompidou, Paris.*

regressive weakness appeared in his art between 1915 and 1925 he could produce works of astonishing intensity and strangeness: for example, *The Three Bathers*, which he painted in the summer of 1920 in Juan-les-Pins, whose background figure is deformed in a style of prolongation that prefigured what was to come; or that other pair of mysterious, sarcastic, rather infernal trios, *The Three Musicians* (1921) and the very disturbing *Three Ballerinas* (1925). We also have to take cognizance of the sets he created for Sergei Diaghilev's ballets, particularly for *Parade* and *Mercure*, whose revolutionary force, from the plastic point of view, was appreciated almost exclusively by the Dadaists and Surrealists, even though they found ballet itself revolting.[20]

Pablo Picasso, The Three Musicians, *1921. Oil on canvas, 203.2 x 188 cm (80 x 74 inches). Philadelphia Museum of Art, The A. E. Gallatin Collection.*

Some of the statements Picasso made during the 1920s allow us to see clearly how he was already distancing himself from those who, artistically speaking, were allowing themselves to be carried along by events, rejecting the ever more academic avant-garde, especially Cubism. So, with deliberate ambiguity, he asserted that "the artist should know the means by which to convince others of the truth of his lies. If in his work he only shows he has investigated and explored the means by which his lies will be believed, he will never achieve anything." And also: "Cubism is no different from the other pictorial schools. The same principles and elements are common to all of them."[21]

Toward the end of 1924, the first issue of *La Révolution surréaliste* appeared. As an organ of the iconoclastic Surrealist movement, it sought to settle accounts with Modernism along the lines announced by Breton in his Dadaist writings. The first issue included reproductions of works by Giorgio de Chirico, Raymond Desnos, Max Ernst, Man Ray, André Masson, Max Morise, Pierre Naville, and—surprisingly—Picasso. In the following years, the Surrealists repeatedly treated Picasso differently from other avant-garde artists, despite the fact that he always shunned any formal relationship with Breton's group.

As early as the second issue of *La Révolution surréaliste*, published on January 15, 1925—during Surrealism's initial, most arbitrary and combative phase—the respect that Picasso inspired was obvious. The cover of that issue featured a photograph of a scarecrow with the title "French Art at the Beginning of the Twentieth Century." The issue's numerous illustrations included a two-page spread devoted entirely to Picasso: eight of the drawings completed during 1924 that would later be engraved for Ambroise Vollard's edition of Honoré de Balzac's short story "The Unknown Masterpiece."

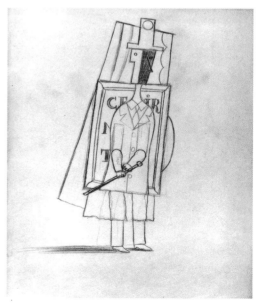

Pablo Picasso, Study for a Manager (*study for the ballet* Parade)*, 1917. Graphite on paper, 27.6 x 22.5 cm (10 ⁷/₈ x 8 ⁷/₈ inches). Musée Picasso, Paris.*

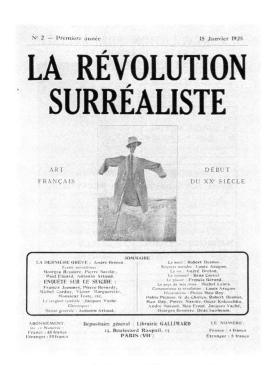

N° 2 — Première année 15 Janvier 1925

LA RÉVOLUTION
SURRÉALISTE

ART DÉBUT
FRANÇAIS DU XX SIÈCLE

SOMMAIRE

Cover of La Révolution surréaliste, no. 2 (January 15, 1925).

Pablo Picasso, drawings published in La Révolution surréaliste, no. 2 (January 15, 1925), p. 16, later engraved for Ambroise Vollard's edition of Honoré de Balzac's "The Unknown Masterpiece," published in 1931.

In 1926, Picasso, commenting ironically on the abuse of certain interpretations made by the Surrealists about his drawings, told Jaime Sabartés:

Some followers of the Surrealist school discovered that my ink sketches and drawings are composed of dots and lines. It's that I admire celestial maps. I think they're beautiful, even if I don't know what they mean. So, one day, I started to trace out a huge number of dots connected by lines and blots that looked suspended in the sky. I had the idea of using them in my compositions, introducing them as purely graphic elements. But just see how astute these Surrealists are. They discovered that these drawings corresponded to their own abstract ideas.[22]

Irrespective of the natural repugnance all artists feel for literary or incomplete interpretations made at the expense of their work, and irrespective of the reluctance Picasso always felt about allowing himself to be summed up in Surrealist rhetoric, this statement is especially valuable vis-à-vis the text by Julio González quoted at the beginning of this essay. It is not a matter of verifying the source of González's ideas about "drawing in space" starting from the contemplation of the stars. If one examines the larger art-historical context of the period, it becomes clear just how important the theme of the celestial constellations was at that moment in the history of the avant-garde and, more generally, in Modern art.

This idea is supported by Albert Boime's recent effort to discover the sources and the meaning of Vincent van Gogh's famous painting *The Starry Night* (1889). Boime not only explains convincingly the realistic elements in a picture that until now has been romantically interpreted as the fantastic product of a hallucinatory mind, but also shows the impact that increased astronomical knowledge had on contemporary art. Through his revisionist interpretation of this work, we can see the fascination of many artists with the new physical image of the stars and, obviously, their high metaphorical value.[23]

The influence of van Gogh, Paul Gauguin, and Paul Cézanne on avant-garde groups of the early twentieth century is well known. However, van Gogh's particular effect on fin-de-siècle Barcelona—in whose shadow González and Picasso developed—has been less examined. That is not to say that their interest in celestial maps as a source of artistic inspiration derives from van Gogh.[24] But there can be no doubt that Picasso and González (and many other Modern artists) were influenced by the prevailing cultural climate. And, as Boime has pointed out, Camille

Flammarion's scientific essays about astronomy and its mystical-philosophical implications were extraordinarily popular in France and were almost simultaneously translated into several other languages, including Spanish (published in Barcelona by the important Catalan company Montaner y Simón).[25]

Vincent van Gogh, The Starry Night, *1889. Oil on canvas, 73.2 x 92 cm (29 x 36 ¼ inches). The Museum of Modern Art, New York, Acquired through the Lillie P. Bliss Bequest.*

In part augmented by his reputation as a martyr of art, van Gogh had a huge influence in fin-de-siècle bohemian circles and the avant-garde of the new century, and posthumously cast his somber aura on the personal world of Picasso. Picasso had been traumatized by the suicide of his Catalan friend and colleague Carlos Casagemas in 1901, an incident that colored both the form and content of his work during his first years in Paris. His pessimistic mood was sustained by the prevailing aesthetic climate, in which art was frequently linked with love and death and dominated by the ideas of Schopenhauer and Nietzsche (especially the latter). Those ideas had shaped the culture and, in part, the revolutionary politics (primarily that of the anarchists) of the Barcelona of Picasso's youth. It left such a deep impression on him that it permanently influenced his personality.[26] As Nietzsche declared in *Thus Spoke Zarathustra*: "To engender a dancing star, one must have within oneself . . . a certain chaos."[27] The Romantic exaltation of the night and the contemplation of the stars is a recurring theme in *Zarathustra* and in the art of certain of its readers, among them undoubtedly van Gogh and also the young Picasso and his friends.

Crossing the starry night of Picasso's production, and directly related to the theme of the constellation drawings, is the theme of the alienated artist, the artist dominated by chaos and madness, emblematically represented by van Gogh. This theme obsessed Picasso, and he crystallized it in the series of drawings he made to illustrate "The Unknown Masterpiece," in which the brilliant painter Frenhofer goes mad thinking he can see the invisible: the most perfect representation of a female figure, transformed in one of his paintings into an inextricable tangle of lines, a kind of prototypical abstract painting.[28]

When Picasso, on the occasion of the tenth anniversary of Guillaume Apollinaire's death, was commissioned to create a monument to his friend's memory, he wanted to evoke in his sculpture the fictional monument described in Apollinaire's prose novelette *The Poet Assassinated*. In this fantasy, a sculptor, named *l'oiseau du Bénin* (the Bénin bird), erects a monument to the memory of the story's hero, the poet Croniamantal. The passage in which the Bénin bird speaks to the dead poet's mistress, Tristouse, about the kind of statue he's going to create is cited

by Werner Spies—correctly, I believe—as the determining factor in Picasso's idea for the monument:

"A statue, made of what?" asked Tristouse. "Marble? Bronze?"

"No, that's too old-fashioned," answered the Bénin bird. "I want to erect to him a statue made of nothing, like poetry and fame."

"Bravo! Bravo!" replied Tristouse, applauding, "a statue made of nothing, of the void, that's the very thing. When do we start?" [29]

But the idea of this nothing, the void, was for Picasso like falling into the total absence of content, the loss of the figure, pure irrationality, the abstract. If such chaos is creatively essential for Picasso, the work of art arises out of its conjuring.

In 1923, the year that he began to make his first "drawings in space"—both those for "The Unknown Masterpiece" and the sketches he did for the ballet *Mercure*—he made the following statement to Mario de Zayas: "Frequently, a concern with [formalist] investigation has caused painting to lose its way and caused the artist to get lost in intellectual analysis. Perhaps that's the principal defect of Modern art. The spirit of [formalist] investigation has poisoned those who did not completely understand all the positive and decisive elements of Modern art, which made them try to paint the invisible and, therefore, to try to paint what cannot be painted." [30]

The publication in 1923 of this and other statements by Picasso invites the legitimate speculation that he was trying to distance himself from those who had tried to establish a scientific basis for Cubism, which by then had become something of a formal "school" based on a rigorous intellectual system of composition. Among those who championed this form of Cubism was the Spaniard Juan Gris, with whom Picasso had an ambivalent relationship (although perhaps Picasso's disaffection with Gris was exaggerated by Gertrude Stein [31]). In fact, nearly all Spanish avant-garde artists felt an antipathy toward Gris, objecting to his overly "abstract" approach to painting, his immersion in intellectual analysis and formalist investigation. It was enough to drive anyone mad, and its fatal result was the insane desire to try to "paint the invisible," as in Balzac's prophetic short story.

Vollard published "The Unknown Masterpiece," with thirteen etchings by Picasso, in 1931. The volume also included, as a kind of introduction, reproductions of some sixteen pages from a sketchbook Picasso had used in 1926 in Juan-les-Pins and sixty drawings scattered throughout the text of the novel. In his celebrated

Pablo Picasso, Painter with Model Knitting, *Paris, 1927. Etching on paper, 19.2 x 27.7 cm (7 9/16 x 10 7/8 inches). The image was included in "The Unknown Masterpiece."*

Recollections of a Picture Dealer, Vollard recalled the publication as follows: "But of all the works I have published, the one that most puzzled the bibliophiles when it was announced was Balzac's *Chef d'Œuvre Inconnu*, with original etchings and woodcuts by Picasso, in which cubist realisations rub shoulders with drawings that remind one of Ingres. But each new work of Picasso's shocks the public, till the day when astonishment gives way to admiration."[32]

This strange combination of what Vollard calls "Cubist works" and "drawings that recall Ingres" also applies to the engravings Picasso did for his *Suite Vollard* (1930-37) and an edition of Ovid's *Metamorphoses* (1931). The theme of the relationship between the painter and his model in the seclusion of the studio was developed in both. This theme in turn conjures up others: the confrontation between the reality of the model and the reality of the work; the erotic relationship between the artist and his real or imagined model; the self-absorption of the artist; and melancholy.[33]

Contradiction was an inherent part of Picasso's characteristic creative dynamic. He never simply moved from one approach or style to another but juggled several simultaneously over an extended period, and only gradually did one emerge as predominant. Such was the process that took Picasso from the "drawings in space"—which influenced his paintings during the late 1920s as much as those sculptural essays in iron that required the participation of González as artisan—to the more classic organic forms with rounded shapes that became more and more frequent in the paintings and sculptures he made in the early 1930s in his studio at Boisgeloup. The photographer Brassaï visited Boisgeloup in 1933, and commented on the classical and undulating character of the majority of the works he found there:

> He opened the door to one of those immense naves, and we could see, radiant in white, a city of sculptures. . . . I was astonished by the roundness of all those forms. A new woman had entered Picasso's life: Marie-Thérèse Walter. He'd found her quite by accident on rue de la Boëtie and painted her for the first time exactly one year before, on December 16, 1931, in the *Red Chair*. . . . After that day, all his painting began to undulate. Since the planar and the corporeal, straight lines, angular lines, frequently clash in his work with curved lines, sweetness following on harshness, tenderness following on violence. In no moment of his life was his painting so undulating, so full of sinuous curves, arm twisted with arm, hair in spirals. . . . Most of the statues that stood before me revealed the stamp of that *new look*, beginning with the

Picasso's studio at rue de la Boëtie, 1932. Photo by Brassaï.

grand bust of Marie-Thérèse bent forward, with its almost classical head, the straight line of the forehead joined without interruption with the nose, a line that invaded his entire work. In the series *The Sculptor's Studio*, which Picasso had engraved for Vollard . . . there were also, in the future plans, monumental, almost spherical heads. They weren't imaginary! My surprise was immense when I found them here in flesh and blood—I mean in all their relief, all curved, the noses more and more prominent, the eyes in the form of balls, similar to a savage goddess.[34]

The simultaneity of angles and curves in those sculptures, which so impressed Brassaï, creates an unexpected sense of drama and violence, even in the most apparently sweet moments.

The abstract, the invisible, the merely speculative were, for Picasso, like diabolical temptations he had to exorcise like so many ghosts. One might imagine that such conflicts and choices were also faced by González, but in his work there is more doubt than dialectic and, in crucial moments, ethics split with aesthetics, something that never happened to Picasso. Nevertheless, both of them came to have serious doubts about the formalism that increasingly dominated the avant-garde during the 1930s. In reaction against this perceived weakness, both of them developed what we might call an eccentric attitude in their work—so characteristic of traditional Spanish art. That eccentricity of Spanish art revealed itself centuries earlier in reaction against the predominant classicism and then returned again in the work of Goya. It became rampant in the twentieth century when the very idea of the modern became in Spain a tragic matter of identity. In the paradoxical work of Goya, it was that tragic aspect which astonished the nineteenth-century French writer Théophile Gautier, who related it to the Enlightenment background of Goya's images: "Thinking to serve new ideas and beliefs, he traced out the portrait and the history of old Spain."[35]

Spanish artistic identity had always been full of paradoxes and contradictions. Before Romanticism, hardly anything was known about Spanish artists in Europe, and the fundamental reason for this ignorance and disdain by Europeans for traditional Spanish art was the same reason that has brought about its vindication in our time: its anti-classicism.[36] That predominant anti-classical orientation transformed the Spanish School into something at first eccentric and then, more recently, something "timeless."

Picasso's studio in Boisgeloup, 1933. Photo by Brassaï.

The timelessness of modern Spanish art manifested itself in just the way Gautier perceived it in Goya, but that timelessness has also been a characteristic of almost all the best Spanish artists of the twentieth century, including Picasso and González. Those two made Spanish themes the basis of many of their works, not only in the most direct, simple, and, therefore, recognizable manner, through the use of orthodox icons, but also through what in another context I have called "a moralizing aesthetic fixed in content." [37]

Abstraction has been repudiated at one time or another by most Spanish avant-garde artists, beginning with Picasso himself. Even Gris, who was disdained by almost all his Spanish contemporaries for being too "abstract," "intellectualized," "cold," and—the ultimate criticism—"not very Spanish," declared that he was trying to "humanize" Cézanne—that is, to reverse the process of abstraction to which the technique of the French master led. [38] However, it is probable that this stance of being "outside of history" was also the reason for the surprising facility with which the Spanish artists of the twentieth century could assume an avant-garde attitude, which implied a break with the past. [39]

One model of anti-classicism as a break with the past was the Gothic revival, which began in the second half of the eighteenth century and reached its fullest expression in the middle of the nineteenth, opening the way to Modernism. During the first third of the twentieth century, when González and Picasso were creating their mature works, there was a new return to the Gothic, this one more psychological than stylistic. González's reference to a cathedral spire pointing to the stars as a map pointing the way to the new art of "drawing in space" is an important example of the Gothic influence.

In 1911, three years after he published his *Abstraction and Empathy*, which established his principles of psychological aesthetics, Wilhelm Worringer published another book, *Form in Gothic*. There he describes the prototype of the Gothic personality and what he calls "the principle of Gothic architecture": "All expression to which Greek architecture attained was attained *through* the stone, *by means of* the stone; all expression to which Gothic architecture attained, was attained . . . *in spite of* the stone. Its expression was not derived from the material but from the negation of it, by means only of its dematerialization." Worringer elaborates his contrast between the classical and the Gothic with the sensuality of classical architecture opposed to the pure expressive will of the Gothic, the utility of the classical

Burgos Cathedral, Spain.

opposed to the absence of practical objectives in the Gothic, how the Gothic allows itself to be carried away: "There are no walls, no mass . . . only a thousand separate energies speak to us, whose substantiality we are hardly conscious of, for they act only as vehicles of an immaterial expression . . . we see only free and uncontrolled energies striving heavenward with an enormous *élan*." Finally, Worringer juxtaposes the beauty of the finite of classical man with the tension suffered by "Gothic man, dualistically riven and therefore transcendentally disposed, [who] could only feel the thrill of eternity in the infinite."[40]

Some of Worringer's concepts appear to coincide with González's ideas and works (although there is no indication of any direct influence). Worringer even establishes a relationship between the Gothic and the use of iron in Modern art, the only essential difference between them being that uniformity in Gothic architecture was established by the mode of construction, and in modern iron architecture by the material. This difference was eliminated in González's iron sculpture, to which it is possible to apply what Worringer wrote:

> The modern art of steel construction has first given to us again a certain inward understanding of Gothic. Here again people have been confronted with an architectural form in which the artistic expression is taken over by the medium of construction.

He adds a short time later, however:

> For in modern architecture it is the material itself which directly invites this exclusively structural significance, while in Gothic the structural ideas were attained, not by means of the material, but in spite of the material, in spite of the stone. In other words: underlying the artistic appearance of the modern building constructed of steel there is no will to form which, for particular reasons, emphasizes structure, but only a new material. The utmost that might be said for it is that it is an atavistic echo of the old Gothic will to form which urges the modern Northern man to an artistic emphasis of this material and which even allows us to hope for a new style in architecture dependent on its relevant use.[41]

Thus, Worringer in 1911 nurtured the hope that in an undetermined but not too distant future an appropriate use of iron would define a new style of construction.

Picasso and González, who took the greatest advantage of iron in the sense of that constructive will desired by Worringer, spent their formative years in fin-de-siè-

cle Barcelona. There, the gothicizing style locally known as *modernismo*—the term usually used in Spain to designate Art Nouveau—was being produced in an overwrought cultural climate that favored what were then referred to as "Nordic values."[42] That Picasso was attacked early on in Paris with the contemptuous epithet *boche* (German), the worst insult in France after the Franco-Prussian War, is telling, as is the fact that González and the equally avant-garde Catalan Miró, among others, used the title "Gothic men" for some of their works. But much of González's sculpture arises out of his relationship to iron working and the special flowering of that old local tradition during Catalonia's fin-de-siècle *modernismo*.

We are confronted once again by the anticlassical heritage of the Spanish School, which can be viewed as the result of a gothicizing sensibility, renewed during the Baroque period and then revealed again and again, even during the development of the contemporary period. How can we explain Picasso and González reviving a discredited and extremely humble material like iron and wanting to work it with artisan techniques? Was it that eccentric Spanish "Gothic" which so anachronistically shaped the aesthetic leap taken by them together to use iron as the material for constructing a new sculptural space? Not to mention that González did not find his creative spark until he was over fifty, precisely when he was offered the possibility of taking his old trade of smithery to new heights.

By the same token, pursuing the anthropological factors that might have contributed to this unexpected expressive movement toward iron by some Spanish avant-garde artists, we cannot overlook what Mircea Eliade has written about the extremely rich mythological background of iron cultures[43] or the wide and complex iconographic use in Baroque Spain of the Greco-Roman god Vulcan, the blacksmith. The Spanish painters of the seventeenth century loved to paint Vulcan, not only in the way he was usually represented in European culture but in a rather strange style, as a "worker."[44]

Nearly all other Spanish avant-garde artists during the 1930s, those years particularly laden with anxiety and tragedy, repeatedly turned to painting still lifes and mystical landscapes. Some of the best twentieth-century Spanish still lifes were painted between 1936 and 1946. Such is the case not only with Picasso, but also with Dalí, Oscar Domínguez, Luis Fernández, and others. However, the most interesting and significant example is that of Miró, whose *Still Life with Old Shoe* (1937) is a work that, according to James Thrall Soby, may be compared with Picasso's *Guernica*.

Antoni Gaudí, modernista *iron gate, Güell Pavilion, Barcelona.*

Diego de Velázquez, The Forge of Vulcan, *1630. Oil on canvas, 223 x 290 cm (87 ³/₄ x 117 ³/₄ inches). Museo del Prado, Madrid.*

After giving a precise description of Miró's tragic still life, Soby concludes that "as in all the paintings in this series . . . this calamitous situation occurs on the ground." However, while continuing in that tragic mode, Miró raised his point of view toward the stars, renewing or insisting on that flight of mystical celestial contemplation.[45] Between 1939 and 1944, Miró completed one of his most celebrated series, *The Constellations*. According to his own account, he began the series in Normandy, in Varengeville-sur-Mer, the idea having come to him accidentally when he noted the effect produced by some paint that had dried on some pages of an album. Miró says, referring to some canvases he'd just painted in oil:

> Having finished my work, I washed out my brushes in solvent and, to dry them, I wiped them against the white pages of the album, without guiding myself with any preconceived notion. The stained surface put me in a good mood and provoked the birth of forms, human figures, animals, stars, the sky, the moon, and the sun. I drew all of it with charcoal, very vigorously. Once I'd achieved plastic balance and put all those elements in order, I began to paint with gouache, with the minute care of the artisan or the primitive; this kind of work requires quite a bit of time. . . . We had to get out of Varangeville right away because the region, which had been calm, was being mercilessly bombarded by the Germans. With allied armies completely routed and in the thick of continuous bombardments, we took a train for Paris. Pilar led Dolors, who was then very small, by the hand, and I held the portfolio with *The Constellations* that were finished and the rest of the album that I would use to complete the series under my arm. We left Paris for Barcelona one week before the Germans entered Normandy. No sooner had we arrived than we left there too as a precaution. We went to Palma, where I could live in peace, not known by anyone and without seeing anyone. . . . I was very depressed at the time. I thought a Nazi victory was inevitable, and that everything we loved, everything that gave us a reason to go on living had sunk forever in an abyss. I thought that in this defeat there was no more hope for us, and started expressing that feeling of anguish by tracing on the sandy beach the signs and forms from which I had to free myself so that the waves would immediately take them away. Or I would model figures or arabesques projected in the air like the smoke from a cigarette that rises to caress the stars, fleeing the stench and decay of a world built by Hitler and his cronies.[46]

Joan Miró, Still Life with Old Shoe, *1937. Oil on canvas, 81.3 x 116.8 cm (32 x 46 inches). The Museum of Modern Art, New York, Gift of James Thrall Soby.*

Miró's *Constellations* thus took form as another surprising spatial fugue, whose plastic image seems to have been produced in the most unpremeditated manner but which progressively becomes charged with depth, with dramatic anxiety.

The theme of the constellations suddenly seems to have proliferated during this period. Besides affecting Picasso, González, and Miró, it appears in the work of Sánchez, who showed his sculpture *The Spanish People Have a Road that Leads to a Star* in the Spanish Pavilion at the 1937 World's Fair. It is a decidedly avant-garde work, strongly influenced by Picasso's sketches for sculptures with biomorphic deformations from around the spring and summer of 1928. In any case, it was clearly a sculpture of ascent.[47] (Later, the theme would appear in the Spanish Surrealist Luis Buñuel's film *The Milky Way*.)

Are all these things coincidences more or less pushed along by the anthropological background of a gothicizing, exaltedly spiritual country on the margin of the process of modernizing secularization? Coincidental or not, the resultant works of art cannot be interpreted only in terms of a national modality. If González can be regarded as one of the fundamental points of reference, I would agree with those who have observed that the style of his late works is related not only to Picasso but also to Torres-García or Magnelli. There is even a certain relationship, as William Tucker has pointed out,[48] with Paul Klee, an artist who, curiously enough, was always highly respected by the historical Spanish avant-garde, beginning with Picasso and continuing with Miró.

The theme of the constellations was of prime importance to Klee, as early as his visit to Tunisia in 1914, and it grew in importance during the final period of his career, which coincides with the moment we are dealing with here.[49] Later, this same theme also dominated a period in the career of Calder, who even adopted the name *Constellations* for an important series of sculptures in the early 1940s. The relationship between Calder and Miró is clear, as is the sympathy Calder expressed for Spain; the feeling was mutual, as demonstrated by the exceptional inclusion of the American artist's work in the Spanish Pavilion in 1937.

Klee, in a revealing passage written in 1902, made the following observation:

I am not Pan in the reeds, I am merely a human being and want to climb a few steps, but really climb them.

Affect the world, but not as part of a multiplicity like bacteria, but as an entity, down here, with connections to what is up there.[50]

Joan Miró, The Beautiful Bird Revealing the Unknown to a Pair of Lovers, *1941. Gouache and oil wash on paper, 45.7 x 38.1 cm (18 x 15 inches). The Museum of Modern Art, New York, Acquired through the Lillie P. Bliss Bequest.*

Paul Klee, Night Feast, *1921. Oil on paper, mounted on cardboard painted with oil, mounted on board; paper 36.9 x 49.8 cm (14 1/2 x 19 5/8 inches); board 50 x 60 cm (19 3/4 x 23 5/8 inches). Solomon R. Guggenheim Museum, New York.*

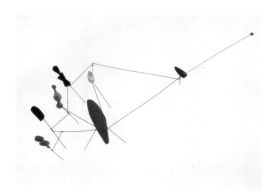

Alexander Calder, Constellation, *1943. Wood and metal rods, 55.9 x 113 cm (22 x 44 ¹/₂ inches). Solomon R. Guggenheim Museum, New York, Collection Mary Reynolds, Gift of her brother, 1954.*

After the outbreak of World War I, Klee developed certain ideas based on the concepts of Worringer, who had considerable influence on the painters of the German Blaue Reiter group, with whom Klee exhibited in 1912 and 1913.[51] In 1915, for example, Klee wrote in his diary:

> The heart that beat for this world seems mortally wounded in me. As if only memories still tied me to "these" things. . . . Am I turning into the crystalline type?
>
> Mozart took refuge (without neglecting his inferno!) on the joyous side, for the most part. Whoever does not understand this might confuse him with the crystalline type. [. . .]
>
> One deserts the realm of the here and now to transfer one's activity into a realm of the yonder where affirmation is possible.
>
> Abstraction.
>
> The cool Romanticism of this style without pathos is unheard of.
>
> The more horrible this world (as today, for instance), the more abstract our art, whereas a happy world brings forth an art of the here and now.
>
> Today is a transition from yesterday. In the great pit of forms lie broken fragments to some of which we still cling. They provide abstraction with its material. A junkyard of unauthentic elements for the creation of impure crystals.
>
> That is how it is today.
>
> But then: the whole crystal cluster once bled. I thought I was dying, war and death. But how can I die, I who am crystal?
>
> I, crystal. [. . .]
>
> I have long had this war inside me. This is why, interiorly, it means nothing to me.
>
> And to work my way out of my ruins, I had to fly. And I flew. I remain in this ruined world only in memory, as one occasionally does in retrospect.
>
> Thus, I am "abstract with memories." [. . .]
>
> Certain crystalline formations, against which a pathetic lava is ultimately powerless.[52]

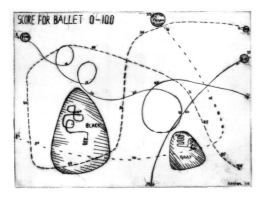

Alexander Calder, Score for Ballet 0-100, *1942. Engraving, printed in black; plate 28.9 x 37.8 cm (11 ³/₈ x 14 ⁷/₈ inches). The Museum of Modern Art, New York, Gift of the artist.*

I have quoted this passage at length not only because, as Geelhaar observes,[53] it underlines the use of those terms so typical of Worringer, such as "crystalline,"

"abstraction," and "immanence" (i.e., "the here and now"), but also because it shows Klee in the process of overcoming the avant-garde orthodoxy of abstract formalism and moving toward what in the 1930s became his characteristic improvisatory poetic style, combining nature and abstraction, life and the laws of pictorial structure.

Klee, in utopian fashion, declares himself to be a "bleeding crystal,"[54] echoing the German philosopher Ernst Bloch, who was also devoted to the Expressionists and influenced by Worringer. For Bloch, all historical construction may be reduced to the paradigms of the geometrical-Egyptian and the vitalist-Gothic, which are the true desirable alternatives. But, ideally, the crystal of death and the tree of life would be reunited in a single vision:

> All great constructions have been *sui generis*, built in utopia, as the forerunner to a space adequate to mankind. And the human thing erected like that, transposed into rigorously significant spatial forms, is also, as committed, a displacement from the organic and the human to the crystal. It is also, especially, a penetration of the crystalline by the impulse, the human, and the plenitude constructed there. When the conditions for the order of freedom cease to be partial, the road will finally open again toward the unity of physical construction and organic ornament, for the joy of ornament. *Realiter* will open for the first time, without Egypt here and Gothic there, that is, without what is that way being called crystal or tree of life having to continue alternating, mixing with each other, or envying each other mutually. The crystal is the frame, more, the horizon of serenity, but the ornament of the tree of human life is the only real content of this serenity and surrounding clarity. The best world that expresses and reproduces in advance the grand architectonic style exists thus, totally a-mythic, as a real thing committed *vivis ex lapidibus*, from the stones of life.[55]

Without in any way disdaining the formal correspondences through which we can relate the work of González with that of Klee, as Tucker has done, I think the concurrence of their ideals and attitudes is particularly important, especially when analyzed in the context of the crisis of the avant-garde of the 1930s, in the same way it obviously exists among the other artists in the present exhibition.

In addition, the nocturnal landscape is a recurring theme throughout almost all of Klee's artistic career. Klee found himself as an artist during his trip to Tunis in 1914. On Easter Sunday (April 12) in St. Germain, on the eve of his voyage, he

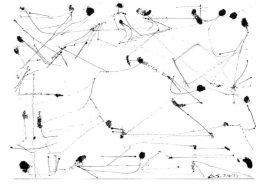

David Smith, Untitled (Delta Sigma, 3/5/53), *1953. Brush and ink on paper, 45.7 x 61 cm (18 x 24 inches). Collection of Candida and Rebecca Smith.*

Paul Klee, Winter, *n.d. Lithograph on paper, published in* Verve, *no. 3 (summer 1938).*

experienced the following revelation when he was looking at the sky at sunset, as he noted in his *Diary*:

> The evening is indescribable. And on top of everything else a full moon came up. Louis urged me to paint it. I said: it will be an exercise at best. Naturally I am not up to this kind of nature. Still, I know a bit more than I did before. I know the disparity between my inadequate resources and nature. This is an internal affair to keep me busy for the next few years. It doesn't trouble me one bit. No use hurrying when you want so much.
>
> The evening is deep inside me forever. Many a blond, northern moon rise, like a muted reflection, will softly remind me, and remind me again and again. It will be my bride, my alter ego. An incentive to find myself. I myself am the moonrise of the South.[56]

The summer 1938 issue of the magazine *Verve* (no. 3) included a double-page spread with reproductions of works by Klee; the first is a drawing of a stellar constellation in whose reduced center there is a circle bearing the words *Sommeil d'hiver*. A few pages earlier, there is a constellation in a lithograph by Miró, but with a title dedicated to summer. In the preceding issue (spring 1938), the corresponding double-page spread features works by Kandinsky—constellations with the title *Etoiles*. In the same issue, opposite an extract from an essay by Georges Bataille called *Corps célestes*,[57] is an allusive lithograph by André Masson.

Klee's late works tend toward a figurative expressionism dominated by the images of angels or demons populating the heavens and hell, the high altitudes and below ground.[58] The relationship between form and content, action as an event that temporalizes and thus dramatizes the picture, and the importance of line bring these works closer to those critical problems in which the avant-garde of the 1930s developed.

The pivotal figure at the center of the crisis of the avant-garde and its "semantification" is Picasso. In 1935, *Cahiers d'art* (no. 10) published notes on art in which Picasso declared that, in his case, "painting is a cluster of destructions," and went on to generalize about abstract art:

> Abstract art is nothing more than painting. Where is the drama? Abstract art does not exist. We must always begin with something; then we can remove all trace of reality. Then there is no danger, because the idea of the object will have left an indelible mark. It is what incited the artist, stimulated his ideas,

Vasily Kandinsky, Etoiles, *n.d. Lithograph on paper, published in* Verve, *no. 2 (spring 1938).*

and aroused his emotions. After all, ideas and emotions will remain caught in his work. No matter what they do, they cannot escape from the picture, of which they form an integral part, even though their presence cannot be detected. Man, whether he likes it or not, is the instrument of nature, which imposes on him his aspect and characteristics. In my Dinard and Pourville pictures, I was expressing a vision very similar to this one. . . . You can't go against nature: it is more powerful than the strongest man! We can allow ourselves certain liberties, but only in the matter of details. Nor does there exist a *figurative* or a *non-figurative* art: everything appears to us in the form of *figures*. Even metaphysical ideas are expressed through symbolic *figures*; their effect on us can be more or less intense.[59]

Picasso's declarations agree with a Picasso quotation González loved: no one can draw a perfect circle. In any case, what Picasso says about the ineluctable link between the artist and some aspect of reality, which the artist can then reduce or disfigure, is also in perfect harmony with González's usual method of creation, as Rosalind Krauss has pointed out:

> Thus, if the gathering forces for abstract art had advertised the conditions of twentieth-century aesthetics as a struggle between abstraction and naturalism, spirit and matter, conception and representation, culture and nature, González was forced to acknowledge that he was unwilling to take sides against nature. Trained as he was in the arts of decoration, and trained to think of the decorative as a modality of the frivolous, González's term of highest praise for that which was truly art was that it was "serious." And for him, an art that completely abandoned nature could not be serious.[60]

Krauss goes on to compare González's method, which committed him to draw from nature, with that of Picasso, and illustrates this comparison by analyzing the creative process in González's *Woman Combing Her Hair I* (ca. 1931). Comparing the sketch and the finished sculpture reveals that the differences between them are insignificant. According to Krauss, such a process of "abstraction," beginning with a first realistic image, was antithetical to "Picasso's improvised assemblage."[61]

Early in her essay, Krauss quotes González's statements against abstraction "not directly inspired in nature,"[62] particularly geometrical abstraction. These statements are from a 1931 manuscript entitled "Picasso sculpteur et les cathédrales"; some of it is strikingly similar to Picasso's own critique of abstraction, published in

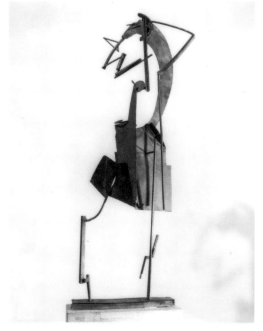

Julio González, Woman Combing Her Hair I, *ca. 1931. Iron, 165.8 x 54 x 27 cm (65 ¼ x 21 ¼ x 10 ⅝ inches). Musée national d'art moderne, Centre Georges Pompidou, Paris.*

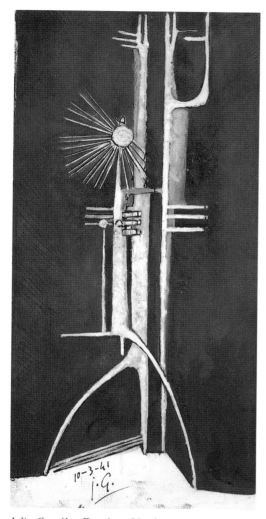

Julio González, Drawing, *March 10, 1941. India ink on paper, 32.1 x 15.3 cm (12 ⁵/₁₆ x 6 inches). Estate of Hans Hartung, France.*

1935. Here, González once again shows himself to have been the faithful and respectful transcriber of Picasso's opinions. Of course, that does not mean that their working and creative methods were identical. Moreover, what for González was the essential factor in his definitive artistic conception was only an episode for Picasso.

Another example of the correspondence of their ideas may be found by comparing Picasso's statement about celestial maps, related to Sabartés, to González's notion of the stars as an inspiration for a new art of "drawing in space" (both are quoted above). Christa Lichtenstern, in her brief but rigorous monograph on Picasso's *Monument to Apollinaire,* not only emphasizes this textual concurrence but analyzes in detail, beginning with the 1924 book of drawings, the entire series of related patterns that Picasso completed between then and 1928, which unifies and gives coherence to the exploration of this new art of "drawing in space." Lichtenstern also examines Picasso's oeuvre in terms of the antecedents and historical consequences of this idea in other artists' drawings, sculptures, and paintings.[63] But I think it possible to go further into the idea from a "poetic" and not merely formal perspective. The disquiet revealed by Picasso through his drawings and sculptures of the late 1920s is closely related to what he revealed through his illustrations for "The Unknown Masterpiece," as well as its echoes in some of the other series of etchings that came to form the so-called *Suite Vollard,* especially that part of it related to the theme of the "Sculptor's Studio" (see note 33).

The self-absorption of the artist in the studio and the pure formal analysis that dangerously distances the creator from reality, ultimately driving him mad, are certainly the elements in Balzac's novel that most interested Picasso and other important avant-garde artists of the Modern era. This is at the heart of Picasso's statement from the year 1923, where he confesses the danger that stalks the Modern artist who tries to "paint the invisible."

One must consider all this against the background of the historical context in which Picasso and González lived and thought, just as Krauss does in the following passage about González:

> The aesthetic battle lines of the 1920s and 1930s were drawn through the mimetic/abstract axis. But further, these terms were understood as fronts for another set of terms, namely *matter* and *spirit.* Any avant-garde text from this time—Constructivist, Neo-Plasticist, Abstraction-Creationist, Surrealist—will describe the actual aesthetic struggle as a war between the physical and the

conceptual, a duality that we have no trouble translating further into mind/body. González was, intellectually, a creature of his time, and therefore when setting out to verbalize his aesthetic invention he used the current terms of the debate. . . . This combination, this marriage of body and spirit, González goes on to call "ennobling," a term that is entirely appropriate for the marriage in question. For like the yolk and white of the Platonic image, the noble offspring of this marriage is Man.

Thus the aesthetic field, as it was structured by the thinking of the twenties and thirties, was the collective semantic marker not for Art but for Man. The field was both thoroughly humanized and psychologized, its obsessive subjects either biological or psychic creation. Although a field agonized by the warring rights of abstraction and representation might *seem* to be defining the domain of the aesthetic, those terms functioned in fact to define the combined terrain of *psyche* and *soma*, the structural unity of Man. Furthermore, this was man in his essential or natural state, man as a function of nature rather than a product of culture.[64]

Here, Krauss presents a magnificent synthesis of what constituted and gave meaning to the aesthetic domain of the period between the wars. Her description of "man as a function of nature" recalls the monologue of Antoine Roquentin, the protagonist of Jean-Paul Sartre's *Nausea* (1937) as he contemplates the small city of Bouville from a hilltop. Roquentin feels nauseated by the regularity of bourgeois life. First he parodies the ridiculous customs that govern the predictable actions of each one of the citizens of Bouville and then finishes his reflection as follows:

And all this time, great, vague nature has slipped into their city, it has infiltrated everywhere, in their house, in their office, in themselves. It doesn't move, it stays quietly and they are full of it inside, they breathe it, and they don't see it, they imagine it to be outside, twenty miles from the city. I *see* it, I *see* this nature . . . I know that its obedience is idleness, I know it has no laws: what they take for constancy is only habit and it can change tomorrow.[65]

The only escape the desolate Roquentin finds, although it is equivocal, is that of the aesthetic domain, which leads him to think of writing a book:

Couldn't I try [. . .] in another medium? . . . It would have to be a book: I don't know how to do anything else. But not a history book: history talks about what has existed—one existence can never justify the existence of anoth-

Joaquín Torres-García, Constructivist Painting, *ca. 1931. Oil on canvas, 75.2 x 55.4 cm (29 ⁵/₈ x 21 ⁷/₈ inches). The Museum of Modern Art, New York, The Sidney and Harriet Janis Collection.*

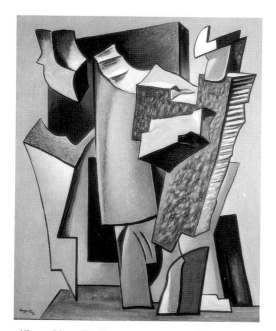

Alberto Magnelli, Pierre no. 2, *1932. Oil on canvas, 163 x 131 cm (64 ¹/₁₆ x 51 ⁹/₁₆ inches). Musée Cantini, Marseilles.*

er. [. . .] Another type of book. I don't quite know which kind—but you would have to sense, behind the printed words, behind the pages, something that doesn't exist, that would be above existence. A story, for example, something that could never happen, an adventure. *It would have to be beautiful and hard as steel and make people ashamed of their existence.*[66] [Italics added.]

In 1930, Sigmund Freud published *Civilization and Its Discontents*, in whose final paragraph he asserts: "And now it is to be expected that the other of the two 'Heavenly Powers,' eternal Eros, will make an effort to assert himself in the struggle with his equally immortal adversary. But who can foresee with what success and with what result?"[67] In 1932, Louis-Ferdinand Céline published, to great success, his *Voyage au bout de la nuit*. And, in 1939, the young and *engagé* English poet Stephen Spender published a book of his poems from that decade, including "The Uncreating Chaos," in which the following lines appear:

> Beyond the blacked-out windows of our nightmare
>
> Facts race their hundred miles an hour
>
> In iron circles on an iron plain. . . .[68]

Besides Picasso, with his funerary monument dedicated to the memory of Apollinaire, which served as a definitive stimulus for González's artistic realizations, there are two other contemporary artists who exercised a positive influence on him: the Uruguayan Joaquín Torres-García and the Italian Alberto Magnelli. Both, in principle, were totally committed to the Abstraction-Création group. Torres-García and González had been friends since youth and comrades in the artistic bohemia of fin-de-siècle Barcelona. They also shared an artisanal background and an obsession for giving meaning to decorative elements.

Torres-García was strongly influenced by pre-Columbian art, which he discovered in 1928. This discovery marked his work in the early 1930s, through which he developed his concept of "constructive universalism."[69] A combination of a kind of Cubist composition and a chromatic range similar to the principles of Neo-Plasticism, Torres-García's painting focused for a time on schematic motifs related to urban life and, later, on little figures and signs inspired by pre-Columbian art. The tones became more and more muted and opaque, while the monochromatic, archaic character of the figures give to his work an air that recalls folk art in clay: a compact and tactile background subtly "spiritualized" with the superimposed mesh-work of figures. This idiom corresponded to more than one aspect of what

González was doing, especially in the tension between the physical presence of the "real" elements and the more "abstract," geometrical elements.[70]

González's relationship with Magnelli, beginning in 1934, was also close. The two had friends in common, such as Christian Zervos and the Spaniard Luis Fernández, and, as the art historian Margit Rowell has pointed out, González was particularly fascinated by a series of paintings Magnelli was creating under the general title *Shattered Stones*. According to a statement made by Magnelli's widow and recorded by Rowell, it seems that González was a frequent visitor to Magnelli's studio in Villa Seurat and that he once declared while standing in front of Magnelli's paintings that he would like to make a sculpture like the paintings in the *Shattered Stones* series.[71]

With Fernández (whose personal discretion, as with González, has unnecessarily held back the later recognition of his true artistic value), González felt a great moral and aesthetic identification. An account of this affinity may be found in an article by Fernández in a 1932 issue of the important Spanish avant-garde magazine *A. C. Documentos de Actividad Contemporánea*, of which twenty-five issues appeared between 1931 and 1937. These are the most politically significant dates of that period in Spain: in 1931 the Second Republic was proclaimed, and 1937—the year of the Paris World's Fair—was the bloody midpoint of the Civil War, when the balance between the two sides was clearly shifting in favor of Franco's Nationalist troops. Fernández's article is one of the few at that time that warmly proclaimed the importance of González, and the only one to speak in his defense in Spain. It was illustrated with three photographs of sculptures by González: *Composition* (probably 1931); *The Kiss I* (1930); and *Couple/The Embrace* (probably 1927-29).

Of particular interest is how Fernández interpreted the transformation of González's work after the sculpture of the late 1920s, attributing the change to the Catalan artist's return to his Hispanic roots after having lived for decades under the spell of French art:

> The change brought about in him was of such intensity that it seemed for a moment that this Spanish-born sculptor was going to create works of the purest French spirit. But when he gave himself over completely to his work, the racial traits of his ancestors were reborn in him, and through his iron hammer Arabs, Phoenicians, Greeks, Jews, and Catalonians worked once again.[72]

Pages 30-31 of Luis Fernández's article "El Escultor Julio González" in A. C. Documentos de Actividad Contemporánea *5 (first quarter, 1932).*

Fernández not only affirmed the importance of González's art but prophetically suggested that his work might be subject to the same incomprehension suffered by the by-then-deceased Gris:

> The work of González is one of the most solid and most beautiful elements in the future edifice the younger generation is building, though generally unrecognized in Spain, where only his imitators are known. The same thing happened with the paintings of Juan Gris, whose importance has barely been understood by anyone in Spain, before or after his death.[73]

Fernández and González were not only friends but were linked by other artistic affinities. Fernández came to Paris in 1924, and his first avant-garde phase there was marked by the influence of the Purism of Amédée Ozenfant and Le Corbusier. Later he evolved, logically, toward Neo-Plasticism and the ideals defended by the Abstraction-Création group, an artistic trajectory that explains his admiration for Gris and his intimate understanding of the work of Torres-García and González. At the same time, his relationship with Picasso was also close, and they even collaborated. Fernández's work during the 1930s is the best reflection of these ideals and is marked by an insistence on the compact, on geometric volumes of tubular, cylindrical, or prismatic shape, as well as monochromism and rough texture. The phrase *satisfaction hallucinatoire*, which Fernández used to describe his work in an article published in 1935,[74] expresses the notion of some kind of geometric spirit paradoxically nurtured by a strange fire, and reinforces what we could call a kind of curious amalgam of abstraction and Surrealism. This strange hybrid was practiced by other Spanish artists too, who were also members of the School of Paris, such as Bores, Caneja, and Cossío; all of whom, like Gris and Torres-García, recall Zurbarán.

This mixture of geometry and Surrealism has been studied by Valeriano Bozal, who emphasizes Fernández's affirmation that the images respond, with that *satisfaction hallucinatoire*, to the desires that form in the human subconscious.[75] Beginning in the 1940s, Fernández not only abandoned abstraction but poured forth the ardent silence that had been incubating in his earlier work, manifesting even more the subterranean links of aesthetic complicity with González.

This tension between the abstract and the figurative, the organic and the crystalline, as well as the underlying, disturbing spirit of hallucination that marks certain episodes in the work of Torres-García, Fernández, and González himself are not so far from those manifested by Picasso. In his case, however, the tension is pro-

Luis Fernández and Julio González in Monthyon, France, ca. 1936-39.

duced in a more dramatically violent and disconcerting fashion, and should be interpreted as a dialectic between what Worringer calls *Abstraction and Empathy*, which fit Picasso's contradictory nature so well.[76]

On January 4, 1936, *Cahiers d'art* published an extraordinary monographic issue dedicated to Picasso. The issue contains photographs of a great number of his works produced between 1930 and 1935, along with articles by such French luminaries as Breton, Eluard, Hugnet, Man Ray, Péret, and Zervos, and such Spanish artists as Dalí, Fernández, González, and Sabartés, with the articles of the last two being closest to what we could call the spirit of Picasso.[77] In the article by Fernández, "Art sur-descriptif et art non-figuratif," the tense boundaries between abstraction and figuration are clearly defined. After rejecting banal abstraction as a simple non-figurative form of art, and after definitively rejecting the idea that Picasso's work could in any way be called abstract, he writes:

> But in all these cases, without exception, the choice and coordination of the plastic elements arise from their similarities with the latent subjects of the painting, hence from their power of representation, their power to form images, which makes them clearly contrary to any abstract intentions. For the same reason, abstract intentions cannot, in their ultimate consequences, be realized, and the desire to follow them leads to the gradual suppression of the vital elements of the work. . . . Here we see, according to the given facts, wherein lies the fundamental difference between the two tendencies that we call *abstract*: on the one hand, we have a *suppression* of the evocation of the external world; on the other hand, we have instead a broadening of this evocation, by bringing in psychic images whose connections to external objects can vary from the most remote allusion to the most exact, complete description. . . . Rarely is a label, when applied to art works, not a source of confusion. Ever since the beginning of Cubism, pedants disguised as theoreticians have thrown themselves upon it and smothered whatever joy, whatever liberation of the instincts, it once contained, to the benefit of whatever restrictive qualities it had—though not in Picasso, of course. And only by means of maneuvers that one might call *abortive* can one infer the nothingness of so-called *pure plastics* to be a consequence of Cubism.[78]

Approximately a year and a half before the publication of the Picasso issue of *Cahiers d'art*, the magazine *Minotaure* (in the same issue in which Breton published

Luis Fernández, Abstraction: Michelangelo's Hand, *ca. 1934. Drawing on canvas, 30 x 18 cm (11 ³/₄ x 7 ¹/₈ inches). Collection of the Compañía Telefónica de España, Madrid.*

his celebrated text "La beauté sera convulsive") included an article by E. Tériade stating that one of the common traits of the art of the moment is "the impassioned search for movement in plastic expression":

> From pathetic expression to Dionysiac expression, all is movement, undulation, gyration, a delirium of intricate rhythms in space to evoke time; even the sculpture that, twisted and nervous, opens up, explodes, shatters its primitive mass and breaks up into transparent gestures . . . has nothing comparable to the immutable fixity of an irrevocable, and static, art.[79]

Among the illustrations accompanying the article, there is a two-page spread, one half of which is filled with photographs of four metal sculptures by Jacques Lipchitz, the other with four figurative pieces by Pablo Gargallo. Another page is given over to Giacometti's *Head of a Man* and *Pavillon Nocturne* and Picasso's *Figure* (cat. no. 32). *Figure*, one of three sculptures that Picasso made of iron, string, and wood in 1931, evokes a strange plant with a metal trunk and frayed leaves. If we take the spool used as a base to be a pedestal, what it supports is a statue of a pathetic figure whose body is made of twisted barbed wire.

These works by Lipchitz and Gargallo and Picasso's strange, violent sculpture are the best proof that the direction created approximately half a dozen years before by Picasso and González had managed to catch on in "perceptive" terms. That is, not only had it managed to inspire or interest other artists—and in this sense I share Werner Spies's opinion that Picasso's drawings of 1927 and 1928 had a direct influence on Giacometti's sculpture between 1929 and 1932—but, as may be seen in the visual composition of *Minotaure*, it had managed to prepare the eye of the viewer.

The significance of this proliferation of iron as a prominent material in the sculpture of the 1930s has been analyzed by Josephine Withers,[80] who calls particular attention, quite properly, to the work of Calder, Giacometti, Léger, Lipchitz, and Miró. She also mentions Brancusi, pointing out how his polished bronzes sought a luminosity and transparency in sculpture by a system completely opposed to the drawings in space of González. In this sense, I also agree with Tomás Llorens, in whose view Brancusi represents the culmination of the Western classical tradition, while González—together with Picasso—creates the basis for what will be the new sculpture of the postwar era.

A decisive event marked Giacometti's artistic development. According to the artist himself, he had abandoned using real models after 1925, but ten years later, in

Cover of Cahiers d'art, *January 4, 1936, special issue devoted to Picasso's work of 1930-35.*

1935, decided to return to a more realistic mode, causing confusion and incomprehension among his Surrealist friends. Some of the most important members of the group condemned this new orientation, which was later termed "retour à la figuration,"[81] and which covers the period 1933 to 1945. If we examine Giacometti's writings and statements of the 1930s we see, beyond any Surrealist rhetoric, an obsession with the hallucinatory dimension of reality, conceived in terms of a tension somewhat similar to that evinced in the sculptures of González and Picasso.[82]

Calder had been working with wire as the material for his comic little circus figures since the end of the 1920s. From 1943 to 1945 he created his series of *Constellations*, whose title he took, as he said, from the series of gouaches Miró created between 1940 and 1941. Calder's *Constellations* were conceived as assemblages of abstract forms created from colored wood and connected by wires, which were also colored. The pieces could be set on the ground or suspended in the air. They echo Mondrian and Miró, but most of all the series reveals a breath of poetic mysticism, of "evasion" in the Surrealist sense—an element that was smiling, playful, and even rather sarcastic—which was not the most frequent characteristic of Calder's work. What might have influenced him to take this direction was the tragic course of events at that moment, something beyond the merely plastic influences previously mentioned. In this sense, we must recall that Calder's relationship with the Spanish avant-garde was very close, especially with Miró, and he was the only foreigner whose work was included in the Spanish Pavilion at the 1937 World's Fair.

And yet, Calder, like his compatriot David Smith (and both of them in contradistinction to Giacometti), did not have a "religious" or tragic attitude toward sculpture. Each one, in his own way, expressed a "secularized," humorous, or, at least, ironic, point of view. Smith was one of the first artists to understand the importance and potential aesthetic implications of González's iron sculpture, as he did that of Giacometti. But he knew how to reinterpret both in an original, secular key, draining their work of their passionate tensions. This entailed an ability to bring into practice a brilliant syntactic analysis, while hallucination opened the way to a modern sense of irony that was more critical and worldly, less scatological. This convergence of the religious and the secular, the metaphysical and the worldly, the tragic and the comic, all of it worked out through a non-constructive use of iron— during a period aptly described by the phrase "tempest of steel" (the title of Ernest Junger's account of his experiences in the apocalypse of World War I)—constitutes

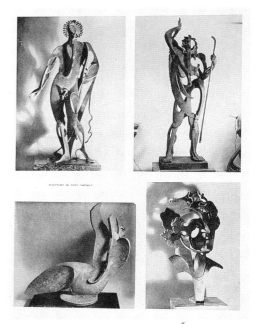
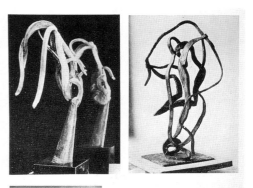
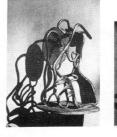
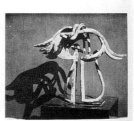

Illustrations of sculptures by Jacques Lipchitz and Pablo Gargallo for "Aspects actuels de l'expression plastique" by E. Tériade in Minotaure, *no. 5 (May 12, 1924).*

one of the greatest attractions of the present exhibition. In it, under the tutelary shadow of Picasso, who was the Modern hero par excellence, the tragic-religious González is the counterbalance to the secularizing Smith. González and Smith are like two faces staring at each other in Modernity, directing their sight successively toward the past and the future.

The realm of iron exists in the shadow of the mythological blacksmith Hephaestus (who the Romans called Vulcan), that unfortunate son of the goddess Hera. He was conceived through parthenogenesis and violently thrown from the heights of Olympus by his father Zeus, whether out of the shame his father felt for the lamentable appearance of the newborn baby or because of the secret moral insult he received for not participating in his conception. Whether he was deformed at birth or because of his fall from heaven—the classical sources do not agree on this point—the fact is that the lame and tragicomic Hephaestus was a great blacksmith and a most dexterous creator of invisible knots that not even the gods could escape.

Coinciding with this mythological vision from the Greek pantheon of the celestial blacksmith, other, non-Western religions also agree on the idea of interpreting the discovery of iron with a gift fallen from heaven, a meteor, and in the tragic-sacrificial sense of that fall. All of which must recall to us the text by González that appears at the outset of this essay. There, the Spanish sculptor, after evoking that stellar dimension of metallic drawing in space, also announced the need to transfigure its bloody use into an artistic purpose, by nature alien to death.

> The important problem to solve here is not only to wish to make a work which is harmonious and perfectly balanced—No! But to get this result by the marriage of *material* and *space*. By the union of real forms with imaginary forms, obtained and suggested by established points, or by perforation—and, according to the natural law of love, to mingle them and make them inseparable, one from another, as are the body and the spirit.[83]

In this way, under the constellation of the blacksmith, we reach the end of this central story of contemporary sculpture, which begins and ends in fire, a fire that semantically puts new life into the dying embers of an avant-garde in crisis during the 1930s. Like a phoenix, it will rise from those ashes after World War II.

(Translated, from the Spanish, by Alfred Mac Adam.)

Antonio Tempesta, The Forge of Vulcan, *etching from Ovid's* Metamorphoses, *published in Amsterdam in 1606. The Metropolitan Museum of Art, New York, Gift of S. P. Jones, 1935.*

1. From "Statements by González," *The Museum of Modern Art Bulletin* 23, nos. 1-2 (1955-56), pp. 42-44. First published in Andrew Carnduff Ritchie, *Sculpture of the Twentieth Century*, catalogue for the exhibition at the Museum of Modern Art, New York, 1952, p. 30. Quoted later in Josephine Withers, *Julio González: Sculpture in Iron* (New York, 1978), p. 141.

2. See, amid the vast bibliography that deals globally with the avant-garde of the 1930s: Louis Roux, ed., *L'Art face à la crise: L'Art en Occident 1929-1939* (Université de Saint-Etienne, C.I.E.R.E.C., Travaux XXVI, Saint-Etienne, 1980); Pontus Hulten, ed., *Les réalismes 1919-1939*, catalogue for the exhibition at the Centre Georges Pompidou in Paris, Dec. 17, 1980-April 20, 1981; Pontus Hulten, ed., *Paris-Paris: Créations en France 1937-1957*, catalogue for the exhibition at the Centre Georges Pompidou in Paris, May 28-Nov. 2, 1981; Marie-Aline Prat, *Peinture et avant-garde au seuil des années 30* (Lausanne, 1984); Edward Lucie-Smith, *Art of the 1930s: The Age of Anxiety* (Longon, 1985); Giles Néret, *L'art des années 30* (Fribourg, 1987); Anne Bony, *Les années 30* (Paris, 1987); Kenneth E. Silver, *Esprit de Corps: The Art of the Parisian Avant-Garde and the First World War, 1914-1925* (Princeton University Press, 1989); and Luciano Caramel, *L'Europa dei razionalisti: Pittura, scultura, architettura negli anni trenta* (Milan, 1989).

3. See Juan Pablo Fusi Aizpurúa, *El problema vasco en la II república* (Madrid, 1979).

4. Koestler describes his traumatic experience in *The Spanish Testament* (1937).

5. See José Bergamín, "Picasso furioso," in *Cahiers d'art*, nos. 4-5 (Paris, 1937). In this extraordinary issue of Christian Zervos's celebrated magazine, devoted entirely to Picasso's *Guernica*, there are also articles by Jean Cassou, Georges Dutuit, Pierre Mabille, Paul Eluard, and Michel Leiris. Bergamín's point was not merely to emphasize Picasso's rage about a local massacre, but what it meant in symbolic terms. Bergamín states that he would prefer to think that Picasso, having been moved by the bombing of the Basque village, was creating an homage in his picture to the resistance of those defending Madrid at the time. This of course has led to countless debates in Spain, where national identities have been and continue to be polemical. In that context, see writings by Juan Larrea, *Guernica* (Madrid, 1977), and Josep Palau i Fabre, *El Guernica de Picasso* (Barcelona, 1979).

6. Much has been written about the relationship between Picasso's *Guernica* and Goya's *Moncloa Executions*. Among the more notable studies are those by Juan Larrea and, especially, André Malraux, who wrote essays on Goya and Picasso (*Saturne: Essai sur Goya* and *La Tête d'Obsidienne*). The organic unity of Malraux's critical treatment of both is surprising, even when he doesn't make the relationship between them explicit by means of comparisons. He could dare to think about a future democratic Spain when he published *La Tête d'Obsidienne*, even though Franco was still in power—a Spain where the two pictures could be hung opposite each other in the Prado. See Francisco Calvo Serraller, "André Malraux: Encuentro imprevisto," in *La senda extraviada del arte* (Madrid, 1992), pp. 194-201.

7. Catherine B. Freedberg, *The Spanish Pavilion at the Paris World Fair of 1937* (New York, 1986), pp. 295-316.

8. The most complete documentation available today about the works that Picasso assembled for the Spanish pavilion is in the catalogues for the following exhibitions: *Guernica: Legado Picasso*, Prado Museum (Madrid, 1981), and *Pabellón Español. Exposición Internacional de París 1937*, Centro de Arte Reina Sofía (Madrid, June-September, 1987), pp. 99-127.

9. See C. B. Freedberg, *the Spanish Pavilion*, p. 475; and *Pabellón Español*, pp. 96-99.

10. On J. Gutiérrez Solana, see M. Sánchez-Camargo, *Solana, vida y pintura* (Madrid, 1962); L. Alonso Fernández, *J. Solana: estudio y catalogación de su obra* (Madrid, 1985); and Francisco Calvo Serraller, "Ensayo deambulatorio en torno a José Gutiérrez Solana," in *José Gutiérrez Solana (1886-1945)* (Madrid, 1992), pp. 31-37.

11. This was the case of, among others, Manuel Angeles Ortiz, Aurelio Arteta, Juan Bonafé, Feliú Elías, Horacio Ferrer, Pedro Flores, Francisco Mateos, Pedro Mozos, Santiago Pelegrín, Jesús Perceval,

Gregorio Prieto, Antonio Rodríguez Luna, Arturo Souto, and Eduardo Vicente.

12. See Jaime Brihuega, *La vanguardia y la República* (Madrid, 1982); Miguel A. Gamonal Torres, *Arte y política en la guerra civil española: el caso republicano* (Granada, 1987); Christopher H. Cobb, *La cultura y el pueblo: España 1930-1937* (Barcelona, 1981); Hipólito Escolar, *La cultura durante la guerra civil* (Madrid, 1987). For documentary and doctrinal testimonials about the Thirties, see José Díaz Fernández, *El nuevo romanticismo: polémica de arte, política y literatura*, ed. by J. M. López de Abiada (Madrid, 1985); and Josep Renau, *Arte en peligro: 1936-39* (Valencia, 1980). On realism in Spain, see Valeriano Bozal, *El realismo entre desarrollo y el subdesarrollo* (Madrid, 1966); *El realismo plástico en España de 1900 a 1936* (Madrid, 1967); and *Pintura y escultura españolas del siglo xx (1900-1939)* (Madrid, 1992).

13. See the catalogue of the exhibition *Les réalismes 1919-1939,* held at the Centre Georges Pompidou in Paris in 1981.

14. See Tomás Llorens and Francisco Calvo Serraller, *Le siècle de Picasso* (Paris, 1987), pp. 82-88.

15. Rosalind Krauss, "This New Art: To Draw in Space," in *Julio González: Sculpture and Drawings* (New York: The Pace Gallery, 1981).

16. André Breton, *Les pas perdus* (Paris, 1969), p. 64.

17. *Ibid.*, p. 15.

18. Breton did not publicly show support for Surrealism in the visual arts until he was provoked by an article in *La Révolution surréaliste* (no. 3, April 15, 1925, p. 27), laconically entitled "Beaux-Arts," which attacked the validity of Surrealist art. It was written by Pierre Naville, co-editor with Benjamin Peret of the Surrealist journal. Breton's reaction was instantaneous: he took the editorship of the magazine away from Naville, and in the next issue began a series of articles that he called "Surrealism and Painting" (1925-28). See Francisco Calvo Serraller, "La teoría artística del surrealismo," in *Imágenes de lo insignificante: el destino histórico de las vanguardias en el arte contemporáneo* (Madrid, 1987), p. 172 and passim.

19. See Francisco Calvo Serraller, "Picasso y el surrealismo," in *VVAA, Picasso 1881-1981* (Madrid, 1981), pp. 43-74.

20. Despite the repugnance that Breton felt for music in general and for ballet in particular, when Picasso's *Mercure* opened on June 18, 1924, and some of Breton's friends dared to ridicule it, he immediately organized an homage to the painter by way of apology. This is all the more astounding when we note Breton's violent reaction to Max Ernst and Miró when they decided to collaborate with Diaghilev two years later.

21. These statements were made to Mario de Zayas and published in *The Arts* in 1923. The quotations are taken from *Picasso: poemas y declaraciones* (Mexico, 1944), pp. 27, 28.

22. Pablo Picasso, "Letter on Art," originally published in the magazine *Ogonek* 20 (Moscow, May 16, 1926). It was also published in *Deutsche Kunst und Dekoration*, vol. 58 (Darmstadt, 1926). The passage I have quoted is taken from *Picasso: pintura y realidad; textos, declaraciones, entrevistas*, ed. by Juan Fló (Montevideo, 1973), pp. 57-58.

23. Albert Boime, *Van Gogh: La Nuit etoilée, L'histoire de la matière et la matière de l'histoire* (Paris, 1990).

24. Retrospectives of van Gogh's work were held in Paris in 1901 and 1905. González moved to Paris in 1900, and Picasso went there for extended visits in 1900, 1901, and several times more before settling there in 1904. However, it is unlikely that they knew of van Gogh's correspondence with his brother Théo and with Emile Bernard, which appeared in *Mercure de France* beginning in 1893 and which contains numerous references to the subject of the stars.

25. Among the most widely known works by Flammarion are *Histoire du ciel* (Paris, 1881); *Monde avant la création de l'homme* (Paris, 1886); and *L'Astronomie* (Paris, 1889).

26. See Patricia Leighten, *Re-Ordering the Universe: Picasso and Anarchism 1897-1914* (Princeton, 1989).

27. Boime ends his essay (see note 23) with the quotation. In fact, sky and star-related metaphors abound in Nietzsche's *Zarathustra*.

28. See Olivier Bonard, *La peinture dans la création balzacienne* (Geneva, 1969); Dore Ashton, *A Fable of Modern Art* (London, 1980); and Francisco Calvo Serraller, *La novela del artista: imágenes de ficción y realidad social en la formación de la identidad artística contemporánea, 1830-1850* (Madrid, 1990).

29. Werner Spies, *La escultura de Picasso* (Barcelona, 1989), p. 93.

30. Picasso, *Picasso: poemas y declaraciones*, pp. 27-28.

31. Gertrude Stein, *Autobiography of Alice B. Toklas* (New York, 1933), p. 260. Here, Stein writes, "Juan Gris was the only person whom Picasso wished away. The relation with them was just that."

32. Ambroise Vollard, *Recollections of a Picture Dealer* (Boston, 1936). Trans. from the French by Violet M. MacDonald. (New York, 1978), pp. 261-62.

33. See Francisco Calvo Serraller, "La parábola del escultor: la *Suite Vollard* de Picasso," in *La senda extraviada del arte*, pp. 208-26; and Birgitte Baer, "Creatividad, mitos y metamorfosis en los años treinta," in *Picasso clásico*, catalogue for the exhibition held in Málaga, October 1992-January 1993, pp. 111-53.

34. Brassaï, *Conversaciones con Picasso* (Madrid, 1966), p. 30.

35. Théophile Gautier, *Voyage en Espagne* (Paris, 1964), p. 156.

36. Which is exactly what Gautier himself said, in *Tableaux à la plume* (1850) (Paris, 1880), pp. 97-98:

 "Silence was the only thing there was about this beautiful country until the Romantic school made it fashionable through Victor Hugo's *Orientaux*, Alfred de Musset's *Contes*, the *Théâtre de Clara Gazul*, and Merimée's *Nouvelles*. Studies were carried out on the *Romancero*, the works of Calderón, and since poetry rapidly stimulated interest in the other arts, Spanish painting began to be looked into. . . . In a logical reaction against the pseudo-classical taste that still held sway as much in painting as in poetry, people turned toward the Middle Ages, cathedrals, knights in shining armor . . . and no country expressed that knightly, Catholic ideal better than Spain . . . Spain is the Romantic country par excellence; no other nation has taken less from Antiquity."

 See also Ilse Hempel Lipschutz, *Spanish Painting and French Romantics* (Cambridge, Mass., 1972).

37. See Francisco Calvo Serraller, "Naturaleza y naturalismo en el arte español," in *Del futuro al pasado. Vanguardia y tradición en el arte español contemporáneo* (Madrid, 1988), p. 39.

38. Juan Gris, *De las posibilidades de la pintura y otros ensayos* (Barcelona, 1971), p. 21.

39. See Francisco Calvo Serraller, "Del futuro al pasado: la conciencia histórica del arte español," in *Del futuro al pasado* (Madrid, 1988), pp. 17-37.

40. Wilhelm Worringer, *Form in Gothic*, ed. and intro. by Sir Herbert Read (London, 1927), pp. 104-07.

41. *Ibid.*, p. 107.

42. An example of this can be found in José María Roviralta's article "La regeneración estética de España," published in the Modernist magazine *Luz* (Barcelona) in the third week of November 1898:

 Our race is degenerate; we are losing energy and the proof of this is the very indifference with which we view everything and let everything happen . . . Change is imposed on us, our rachitic race is worn out, civilization, progress, the world needs energy to burn, lungs to weaken, and new life to consume in its work. Let these energies come, let these lungs come and this new life that the world needs to fly through the air and run and lose itself in the depth of a road it doesn't know; let an impulse come so that the world will not stop; stay behind you effeminate spirits, and let him who can follow his rapid pace. Indifference: get back! Open the way! Open the way for the spirit of the north!

 By the same token, if we examine what was then being praised in the avant-garde magazines of that

fin-de-siècle Barcelona, which shaped the young Picasso and Julio González as well, we find the following names: Beardsley, Björson, Crane, Dostoyevsky, Grieg, Ibsen, Kierkegaard, Maeterlink, Nordau, Ruskin, Strindberg, Tolstoy, Wagner, Whistler, and Wilde, along with those of the French Symbolists. And as an ideological foundation, we see the thought of Schopenhauer and Nietzsche together with all the theoreticians of anarchism. See Francisco Calvo Serraller, "Edvard Munch y España, una afinidad excéntrica," in *Pintores españoles entre dos fines de siglo* (Madrid, 1990), pp. 85-90.

43. See Eliade's *Forgerons et alchimistes* (Spanish trans.: *Herreros y alquimistas*, Madrid, 1974). Especially interesting, because of their resonance in what has been said here about González's ideas about "drawing in space" and the theme of the constellations, are Eliade's ideas about the celestial origin of iron, a theme he develops in the first chapter, "Meteorites and Metallurgy."

44. See Rosa López Torrijos, *La mitología en la pintura española del siglo de oro* (Madrid, 1985), pp. 334-37.

45. I treat this theme at length in my essay "Naturaleza y naturalismo en el arte español," pp. 55-59.

46. Miró, quoted by R. Penrose in *Miró* (Barcelona, 1976), pp. 101-02.

47. There are two interesting aspects of this sculpture by Alberto Sánchez (Toledo, 1885; Moscow, 1962): the fact that it was the concrete realization of the series of drawings he conceived as monumental projects while he waited for funding, such as those entitled *Monument to Birds*, *Sculpture of the Horizon*, *Monument to Children*, etc., and the fact of its being telluric, a horizontal that becomes vertical. See Josep Renau, *Arte en peligro, 1936-1939* (Valencia, 1980), p. 22; J. Alix Trueba, *Escultura española 1900-1936* (Madrid, 1985), pp. 165-76; and *Pabellón Español. Exposición Internacional de París 1937*, pp. 88-90. Aside from being obsessed throughout his career with themes related to the flight of birds, starry nights, and ascent, Sánchez also used such phrases as "drilling space" or "volumes that fly" to describe his work. See Alberto Sánchez, *Palabras de un escultor* (Valencia, 1975).

48. William Tucker, "La escultura de Julio González," in *Studio International* (December 1970), Journal of Modern Art Print supplement 17/6.

49. See Max Huggler, *Paul Klee: die Malerei als Blick in den Kosmos* (1969); Constance Naubert-Riser, *La création chez Paul Klee: Etude de la relation théorie-praxis de 1900 à 1924* (Paris, 1978); and Christian Geelhaar, *Paul Klee et le Bauhaus* (Neuchâtel, 1972), p. 129 and passim.

50. Paul Klee, *The Diaries of Paul Klee, 1898-1918*, ed. by Felix Klee (Berkeley and Los Angeles, 1964), diary entry no. 421, pp. 122-23.

51. See Peter Selz, *La pintura expresionista alemana* (Madrid, 1989), pp. 21-29; and Klaus Lankheit, "La historia del *Almanaque*" in Vasily Kandinsky and Franz Marc, *El Jinete Azul (Der Blaue Reiter)*, Spanish trans. by R. Burgaleta (Barcelona, 1989), pp. 249-53.

52. Klee, *Diaries*, nos. 950-53, pp. 313-15.

53. Christian Geelhaar, *Paul Klee*, p. 25.

54. Klee, *Diaries*, no. 951, p. 313.

55. Ernst Bloch, *El principio esperanza*, Spanish trans. by F. González Vicén (Madrid, 1977), vol. 2, p. 322.

56. Klee, *Diaries*, no. 926k, pp. 290-91.

57. Bataille studies the ideology underlying attempts to make the skies anthropomorphic as an attempt to personify in it the Good. See C. McDannell and B. Lang, *Historia del cielo* (Madrid, 1990).

58. See Margaret Plant, *Paul Klee: Figures and Faces* (London, 1978).

59. Picasso, *Poemas y declaraciones*, pp. 35-36 (see note 21).

60. Rosalind Krauss, "This New Art: To Draw in Space," in *Julio González: Sculpture and Drawings* (New York: The Pace Gallery, 1981), p. 6.

61. *Ibid.*

62. *Ibid.*, p. 10.

63. Christa Lichtenstern, *Picasso: Monument à Apollinaire. Projet pour une humanisation de l'espace* (Paris,

1990), pp. 30-44.

64. Krauss, "This New Art," p. 10.

65. Jean-Paul Sartre, *Nausea*, English trans. by Lloyd Alexander (New York, 1959, 1964), p. 212.

66. *Ibid.*, p. 237. [Ed.'s note: Some phrases have been retranslated. Also, the ellipses in brackets indicate elision of a sentence or a phrase; all other ellipses are in the original text.]

67. Sigmund Freud, *Civilization and Its Discontents*, trans. by James Strachey (New York, 1961), p. 104.

68. Stephen Spender, *Collected Poems: 1928-1985* (London, 1985), p. 58.

69. See Joaquín Torres-García, *Historia de mi vida* (Barcelona, 1990), pp. 190-234. There he relates his activities in Paris between 1928 and 1932. Of special interest is what he says about his old friend Julio González (p. 217 and passim):

> What was González doing in Paris? There seemed to hang over him an incurable discontent, a skepticism about everything, almost a depression, completely stifling him. Knowing all Paris, he seemed to hide himself, willfully withdrawing from everything, abandoning every intention to act in a determined way. That's how he was. And Torres tried to bring him out, to stimulate him, by pulling him out of that swamp. He had good pieces in his studio (it was he who taught Gargallo and others, and he who forged, perhaps improving them, Picasso's iron sculptures). And having all that, could he remain stuck in his corner?

What Torres-García says in the next passage is a venomous attack on Picasso's moral character, one that fails to recognize not only that González did not share his negative opinion but that he was not convinced by Torres-García. For Torres-García's writings on art, see *Universalismo constructivo*, 2 vols. (Madrid, 1984).

70. See Margit Rowell, "Joaquín Torres-García: en busca de una memoria perdida," in *Torres-García*, catalogue for the exhibition at the Museo Nacional Centro de Arte Reina Sofía (Madrid, 1991), pp. 12-14.

71. Margit Rowell, "Julio González: Technique, Syntax, Context," in *Julio González: A Retrospective*, catalogue for the exhibition at the Solomon R. Guggenheim Museum (New York, 1983), pp. 27-28.

72. Luis Fernández, "El escultor González," in *A. C. Documentos de Actividad Contemporánea. Publicación del G.A.T.E.P.A.C.*, vol. 2, no. 5 (Barcelona, 1932), p. 30.

73. *Ibid.*, pp. 30-31.

74. Luis Fernández, "La division du travail," in *Cahiers d'art*, no. 14 (Paris, 1935).

75. Valeriano Bozal, *Pintura y escultura españolas del siglo xx (1900-1939)* (Madrid, 1992), p. 529.

76. See Francisco Calvo Serraller, "Revueltas modernas del clasicismo," in *Picasso clásico* (Málaga, 1992), pp. 47-48.

77. González's article, "Desde Paris," written in Catalán, is simply an announcement calling attention to Picasso because of the exhibition of his work organized by the A.D.L.A.N. in Barcelona.

78. Luis Fernández, "Art sur-descriptif et art non-figuratif," in *Cahiers d'art*, no. extraord. (Paris, January 4, 1936), p. 104. This passage trans. by Stephen Sartarelli.

79. E. Tériade, "Aspects actuels de l'expression plastique," in *Minotaure*, no. 5 (Paris, May 12, 1924), p. 44. This passage trans. by Stephen Sartarelli.

80. Withers, "González and the Art of the Thirties," a chapter in her *Julio González: Sculpture in Iron*, pp. 100-18.

81. The exhibition shown at the end of 1986 and the beginning of 1987 at the Rath Museum in Geneva and at the Centre Pompidou in Paris was titled *Alberto Giacometti: retour à la figuration, 1933-1947.*

82. See Alberto Giacometti, *Ecrits*, ed. by M. Leiris and J. Dupin (Paris, 1990).

83. From "Statements by González."

Catalogue

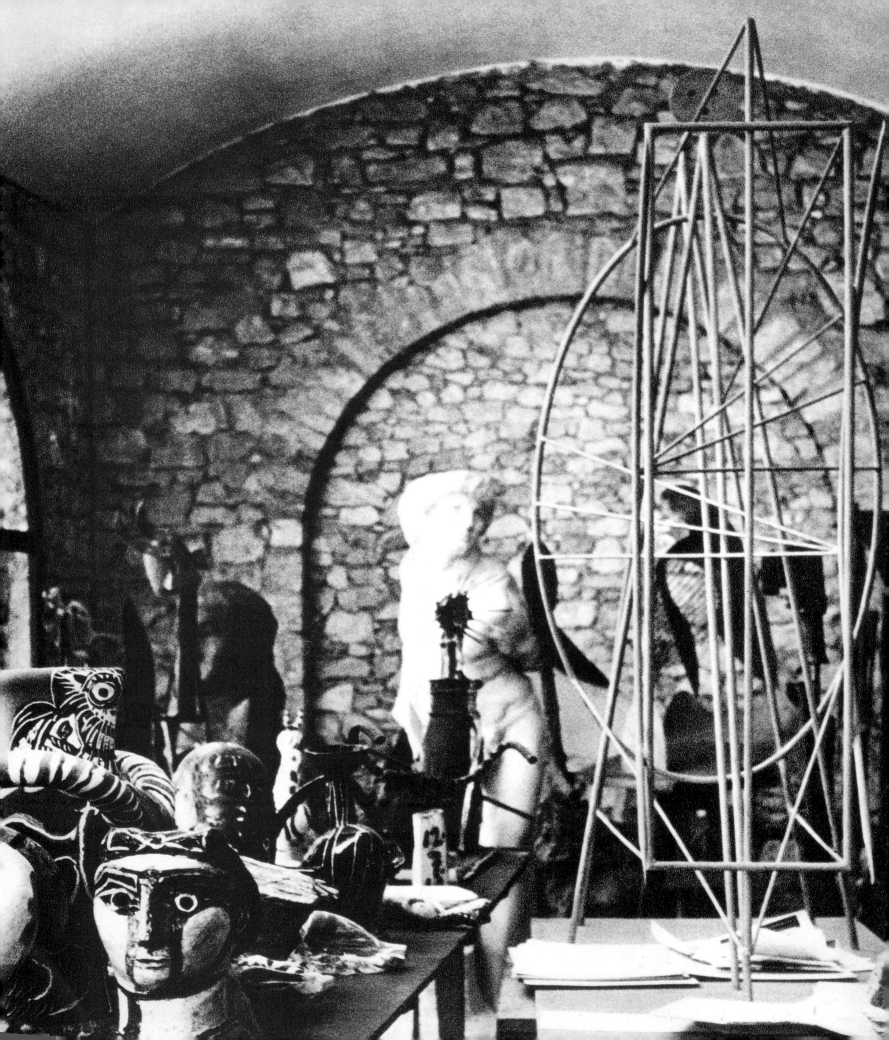

Pablo Picasso

Pablo Picasso's studio in Mougins, France, 1970.

1. *The Painter and His Model (Le Peintre et son modèle)*
 February 11, 1928
 Pen and india ink on paper
 21.1 x 27.1 cm (8 ⁵⁄₁₆ x 10 ⅝ inches)
 Not in Z
 Musée Picasso, Paris MP 1026

2. *The Painter and His Model (Le Peintre et son modèle)*
 February 12, 1928
 India ink on paper
 23.6 x 34 cm (9 ¼ x 13 ⅜ inches)
 Not in Z
 Musée Picasso, Paris MP 1027

3. *The Painter and His Model (Le Peintre et son modèle)*
 February 1928
 India ink on paper
 23.5 x 34 cm (9 ¼ x 13 ⅜ inches)
 Not in Z
 Musée Picasso, Paris MP 1029

4. *Studies for "Head" (Etudes pour "Tête")*
 1928
 Pen and india ink on paper (recto)
 37 x 27 cm (14 ⁹⁄₁₆ x 10 ⅝ inches)
 Verso: *Cavalier*
 Not in Z
 Musée Picasso, Paris MP 1024, r

5. **Page 14 of *Sketchbook 1044, Surrealist Figures***
 (*Carnet 1044, Figures surréalistes*)
 July 27-December 17, 1928
 Album with fifty-nine drawings, india ink and pencil
 on paper
 38 x 31 cm (14 ¹⁵⁄₁₆ x 12 ³⁄₁₆ inches) each page
 Not in Z
 Collection Marina Picasso, Galerie Jan Krugier, Geneva
 09214-09272

6. **Page 15 of *Sketchbook 1044, Surrealist Figures***
 (*Carnet 1044, Figures surréalistes*)
 July 27-December 17, 1928
 Album with fifty-nine drawings, india ink and pencil
 on paper
 38 x 31 cm (14 ¹⁵⁄₁₆ x 12 ³⁄₁₆ inches) each page
 Not in Z
 Collection Marina Picasso, Galerie Jan Krugier, Geneva
 09214-09272

7. **Page 20 of *Sketchbook 1044, Surrealist Figures***
 (*Carnet 1044, Figures surréalistes*)
 July 27-December 17, 1928
 Album with fifty-nine drawings, india ink and pencil
 on paper
 38 x 31 cm (14 ¹⁵⁄₁₆ x 12 ³⁄₁₆ inches) each page
 Z VII, 206
 Collection Marina Picasso, Galerie Jan Krugier, Geneva
 09214-09272

8. **Page 58 of *Sketchbook 1044, Surrealist Figures***
 (*Carnet 1044, Figures surréalistes*)
 July 27-December 17, 1928
 Album with fifty-nine drawings, india ink and pencil
 on paper
 38 x 31 cm (14 ¹⁵⁄₁₆ x 12 ³⁄₁₆ inches) each page
 Not in Z
 Collection Marina Picasso, Galerie Jan Krugier, Geneva
 09214-09272

9. **Page 5 of *Sketchbook 021, Kisses, Nudes, Faces, Personages***
 (*Carnet 021, Baisers, nus, visages, personnages*)
 June 18-July 8, 1928
 Album of fifty-four drawings, india ink on paper
 31 x 23.5 cm (12 ¹⁄₁₆ x 9 ¼ inches) each page
 Not in Z
 Collection Marina Picasso, Galerie Jan Krugier, Geneva
 09273-09325

10. **Page 29 of *Sketchbook 021, Kisses, Nudes, Faces, Personages***
 (*Carnet 021, Baisers, nus, visages, personnages*)
 June 18-July 8, 1928
 Album of fifty-four drawings, india ink on paper
 31 x 23.5 cm (12 ¹⁄₁₆ x 9 ¼ inches) each page
 Not in Z
 Collection Marina Picasso, Galerie Jan Krugier, Geneva
 09273-09325

WS: Werner Spies, *Picasso: Das Plastische Werk*, catalogue for the exhibition
Picasso Plastiken held at the Nationalgalerie Berlin in 1983 and the
Kunsthalle Düsseldorf in 1983-84.

Z: Christian Zervos, *Pablo Picasso: Oeuvres*, vols. I-XXXII (Paris, 1932-77).

11. Page 27 of *Sketchbook 021, Kisses, Nudes, Faces, Personages*
(*Carnet 021, Baisers, nus, visages, personnages*)
June 18-July 8, 1928
Album of fifty-four drawings, india ink on paper
31 x 23.5 cm (12 1/16 x 9 1/4 inches) each page
Not in Z
Collection Marina Picasso, Galerie Jan Krugier, Geneva
09273-09325

12. Page 7 of *Sketchbook 021, Kisses, Nudes, Faces, Personages*
(*Carnet 021, Baisers, nus, visages, personnages*)
June 18-July 8, 1928
Album of fifty-four drawings, india ink on paper
31 x 23.5 cm (12 1/16 x 9 1/4 inches) each page
Not in Z
Collection Marina Picasso, Galerie Jan Krugier, Geneva
09273-09325

13. *Musical Instruments (Instruments de musique)*
1927
Oil and charcoal on canvas
73 x 92 cm (28 3/4 x 36 3/16 inches)
Z VII, 110
Collection of Paloma Picasso-López and
Rafael López-Cambil

14. *Standing Woman (Femme en pied)*
1927
Oil on canvas
133 x 105 cm (52 3/8 x 41 3/8 inches)
Not in Z
Collection Marina Picasso, Galerie Jan Krugier, Geneva
12471

15. *Figure (Figure)*
1927
Oil on plywood
129 x 96 cm (50 3/4 x 37 3/4 inches)
Z VII, 137
Musée Picasso, Paris MP 101

16. *Figure and Profile (Figure et profil)*
1928
Oil on canvas
72 x 60 cm (28 3/8 x 23 5/8 inches)
Z VII, 129
Musée Picasso, Paris MP 103

17. *Painter with the Palette and the Easel*
(*Peintre à la palette et au chevalet*)
1928
Oil on canvas
130 x 97 cm (51 3/16 x 38 3/8 inches)
Not in Z
Musée Picasso, Paris MP 104

18. *The Painter in His Studio (Le Peintre dans son atelier)*
1928
Oil on canvas
46 x 55 cm (18 1/8 x 21 5/8 inches)
Not in Z
Private collection

19. *The Studio (L'Atelier)*
winter 1927-28 (dated 1928)
Oil on canvas
149.9 x 231.2 cm (59 x 91 inches)
Z VII, 142
The Museum of Modern Art, New York,
Gift of Walter P. Chrysler, Jr., 1935

20. *The Studio (L'Atelier)*
1928
Oil and black crayon on canvas
161 x 129.9 cm (63 5/8 x 51 1/8 inches)
Z VII, 136
Peggy Guggenheim Collection, Venice 76.2553 PG3

21. *White Head on Burgundy Background*
(*Tête blanche sur fond bordeaux*)
1928
Oil on canvas
55 x 46 cm (21 5/8 x 18 1/8 inches)
Z VII, 133
Private collection, Paris

22. *Personage on Yellow Background (Personnage sur fond jaune)*
1928
Oil on canvas
65 x 54 cm (25 5/8 x 21 1/4 inches)
Not in Z
Private collection, Paris

23. *Yellow and Gray Geometric Figures*
(*Figures géometriques jaunes et grises*)
ca. 1928
Oil on canvas
100 x 81 cm (39 3/8 x 31 7/8 inches)
Not in Z
Collection of Bernard Ruiz Picasso, Paris

24. *Head of a Woman (Tête de femme)*
April 27, 1944
Oil on canvas
92 x 73 cm (36 ¼ x 28 ¾ inches)
Z XIII, 243
Marx Collection, Berlin

25. *The Kitchen (La Cuisine)*
November 9, 1948
Oil on canvas
175.3 x 250 cm (69 x 98 ½ inches)
Z XV, 106
The Museum of Modern Art, New York,
Acquired through the Nelson A. Rockefeller
Bequest, 1980

26. *Head (Tête)*
October 1928
Painted iron and brass
18 x 11 7.5 cm (7 ¹/₁₆ x 4 ⁵/₁₆ x 2 ¹⁵/₁₆ inches)
WS 66A
Musée Picasso, Paris MP 263

27. *Figure (Figure)*
October 1928
Metal wire and sheet metal
37.7 x 10 x 19.6 cm (14 ³/₁₆ x 3 ¹⁵/₁₆ x 7 ¹¹/₁₆ inches)
WS 71
Musée Picasso, Paris MP 266

28. *Woman in a Garden (La Femme au jardin)*
1929-30
Bronze (after painted wrought iron)
210 x 117 x 82 cm (82 ¾ x 46 x 32 ¼ inches)
WS 72, II
Private collection, United States

29. *Head of a Woman (Tête de femme)*
1929-30
Painted iron, sheet metal, springs, and
found objects (colanders)
100 x 37 x 59 cm (39 ⅜ x 14 ⁹/₁₆ x 23 ¼ inches)
WS 81
Musée Picasso, Paris MP 270

30. *Head of a Man (Tête d'homme)*
1930
Iron, brass, and bronze
83.5 x 40.5 x 36 cm (32 ⅞ x 15 ¹⁵/₁₆ x 14 ³/₁₆ inches)
WS 80
Musée Picasso, Paris MP 269

31. *Female Personage (Personnage féminin)*
1930
Welded iron
80.5 x 32 x 25 cm (31 ⅝ x 12 ⅝ x 9 ⅞ inches)
WS 73
Private collection, Paris

32. *Figure (Figure)*
1931
Metal wire and wooden spool
32 x 9.5 x 6 cm (12 ⅝ x 3 ¾ x 2 ⅜ inches)
WS 83
Collection Marina Picasso, Galerie Jan Krugier, Geneva
55199

33. *Figure (Figure)*
1931
Iron and metal wire
26 x 12.5 x 11.1 cm (10 ¼ x 4 ¹⁵/₁₆ x 4 ⅜ inches)
WS 84
Musée Picasso, Paris MP 271

34. *Figure (Figure)*
ca. 1960
Wire
93 cm (36 ⅝ inches) high
WS 68A
Private collection, Paris

35. *Head (Tête)*
1962-64
Cut sheet metal
105 x 70 x 48 cm (41 ⅜ x 27 ⁹/₁₆ x 18 ⅞ inches)
Maquette of sculpture for the Chicago Civic Center
WS 643 2A
Collection Marina Picasso, Galerie Jan Krugier, Geneva
56386

36. *Figure, Monument (Figure)*
1972
Cor-Ten steel
395.3 x 149.2 x 319.3 cm (155 ⅝ x 58 ¾ x 125 ¾ inches),
including base
Approved by the artist; constructed by Maurice Brouha after
enlargement of 1928 original maquette
WS 68C
The Museum of Modern Art, New York,
Gift of the artist, 1973

1

2

3

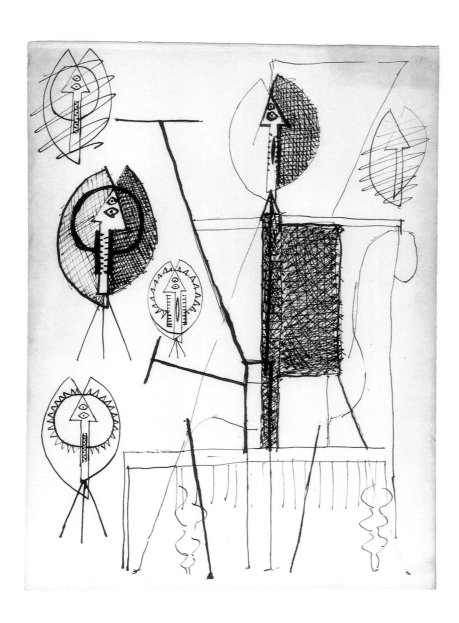

4

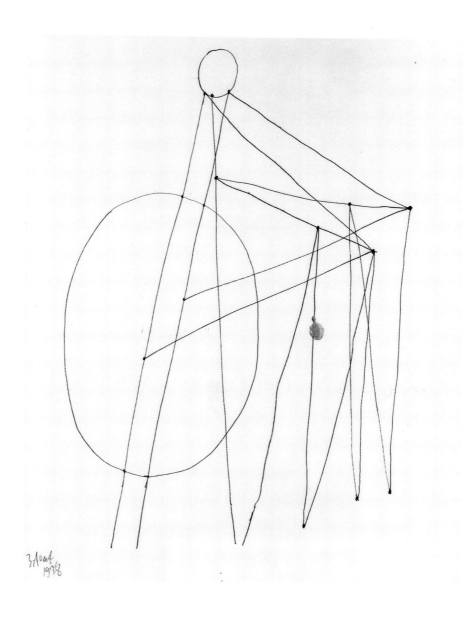

5

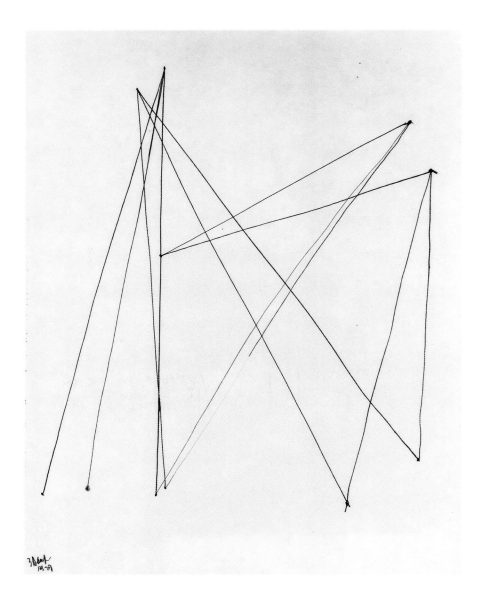

6

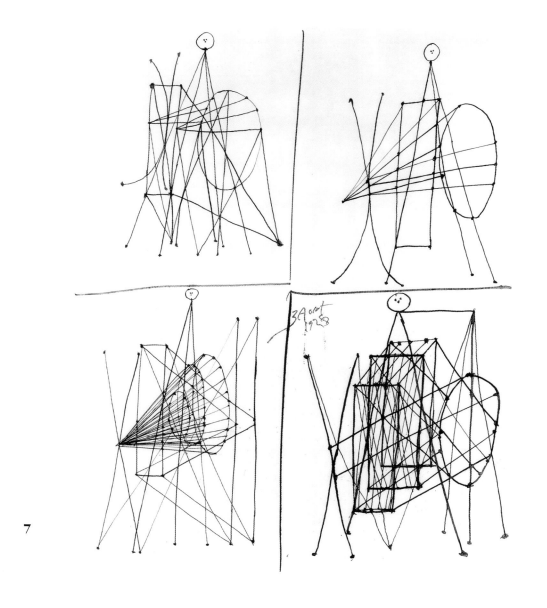

7

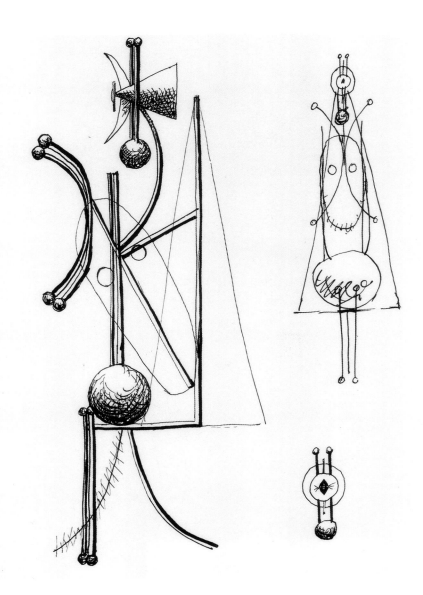

8

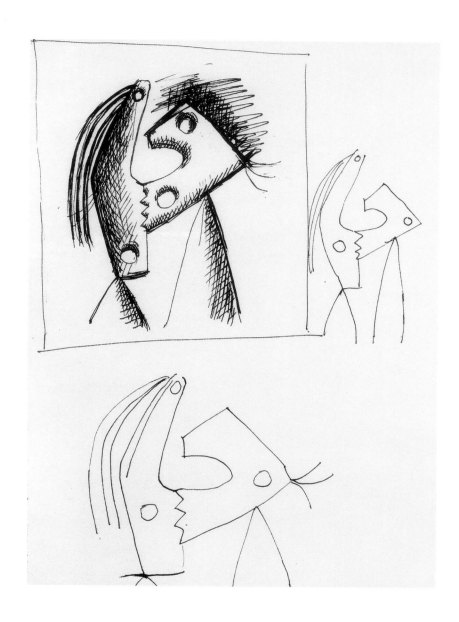

9

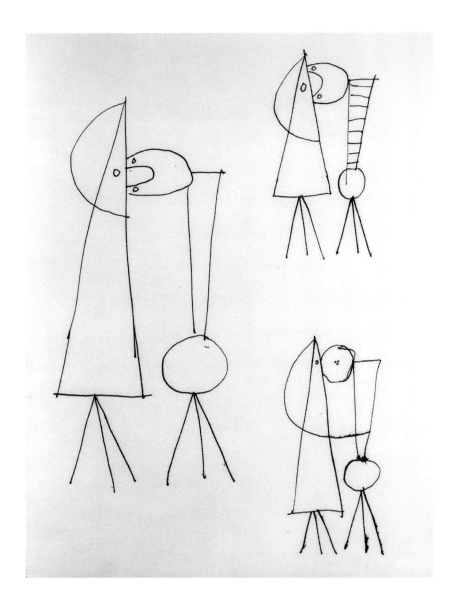

10

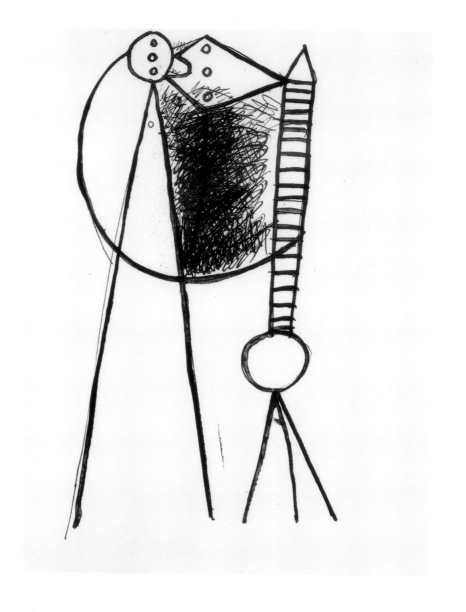

11

12

13

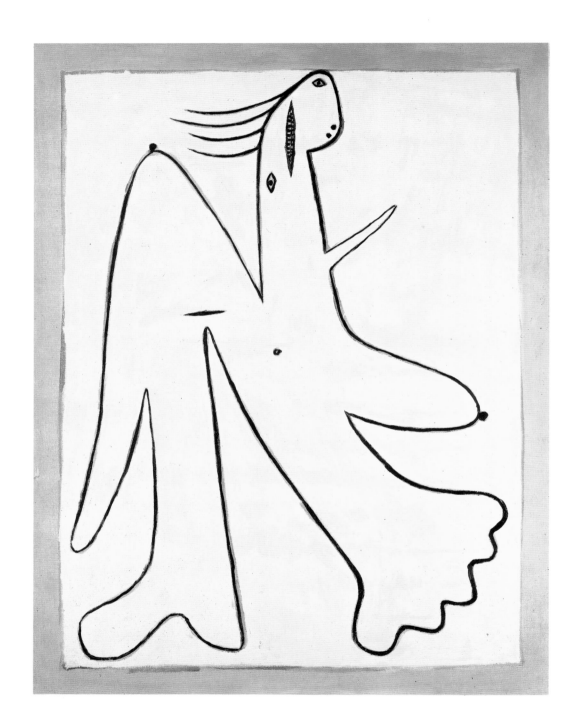

14

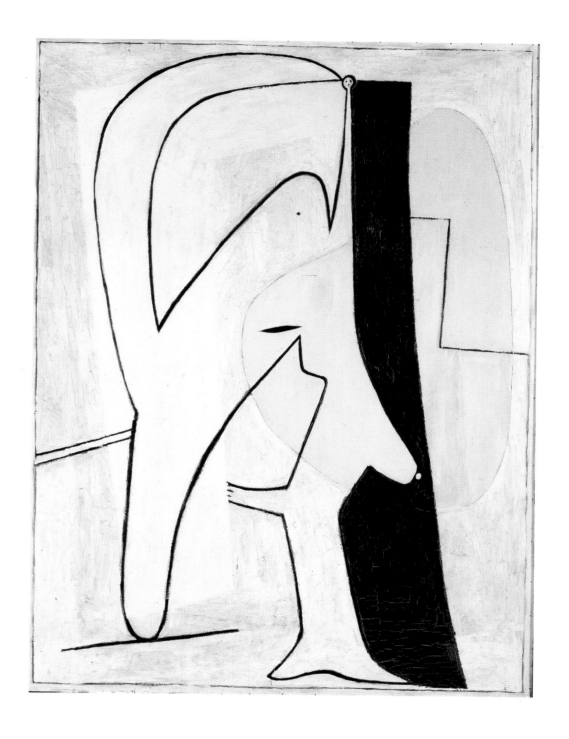

15

16

17

18

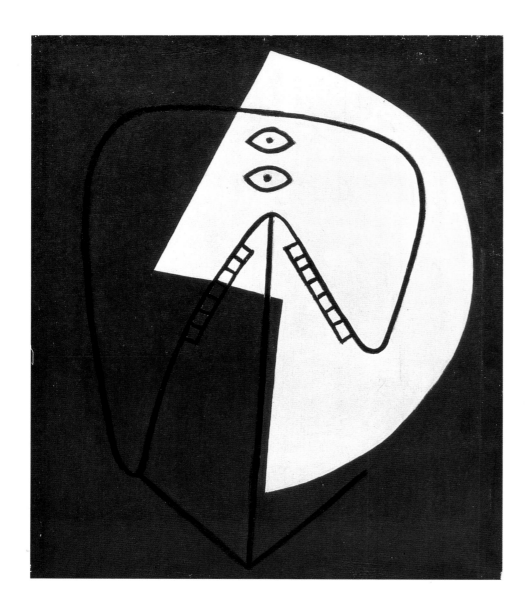

21

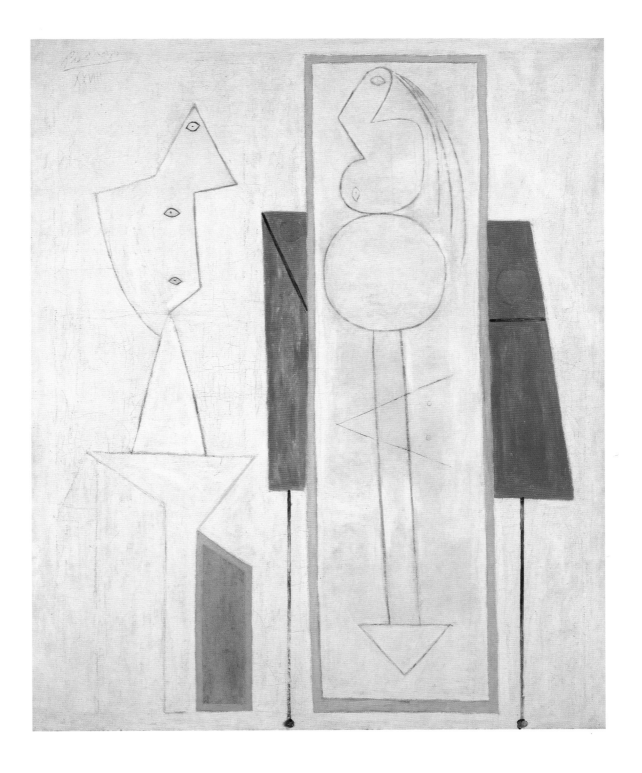

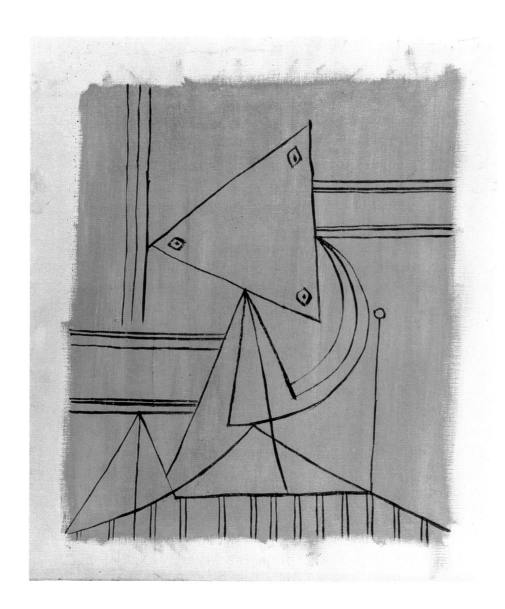

22

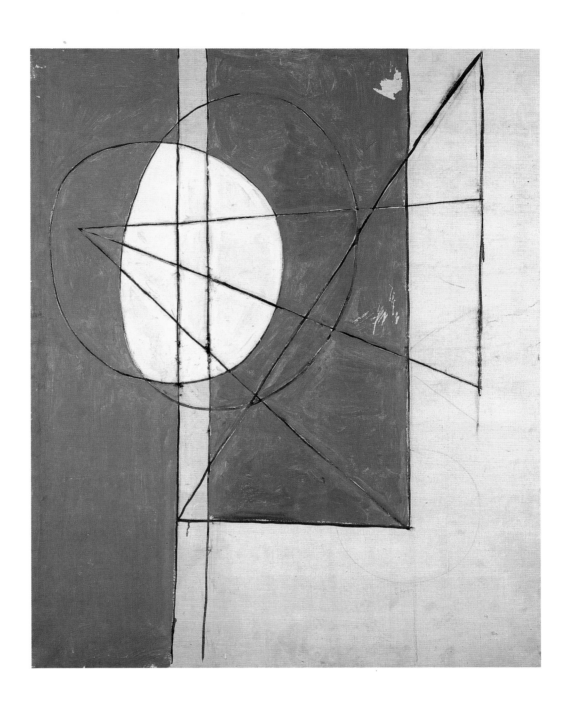

23

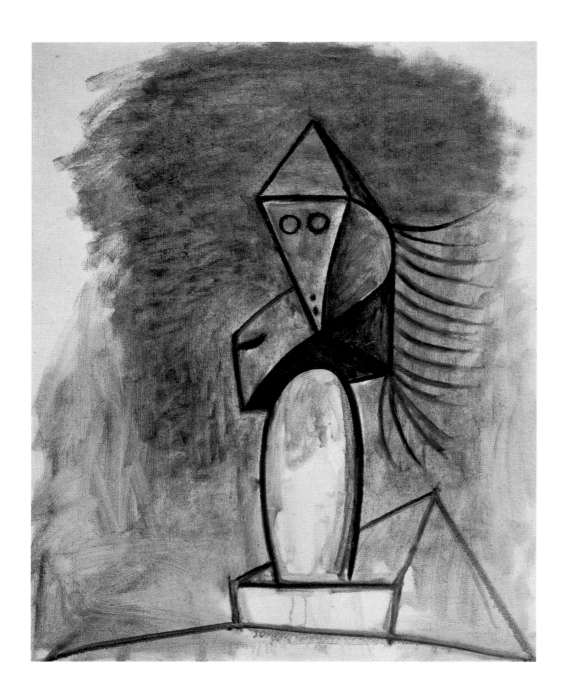

24

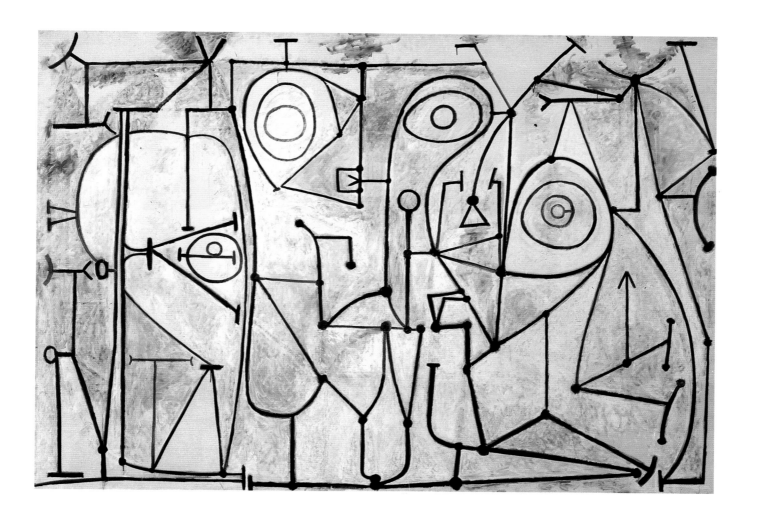

25

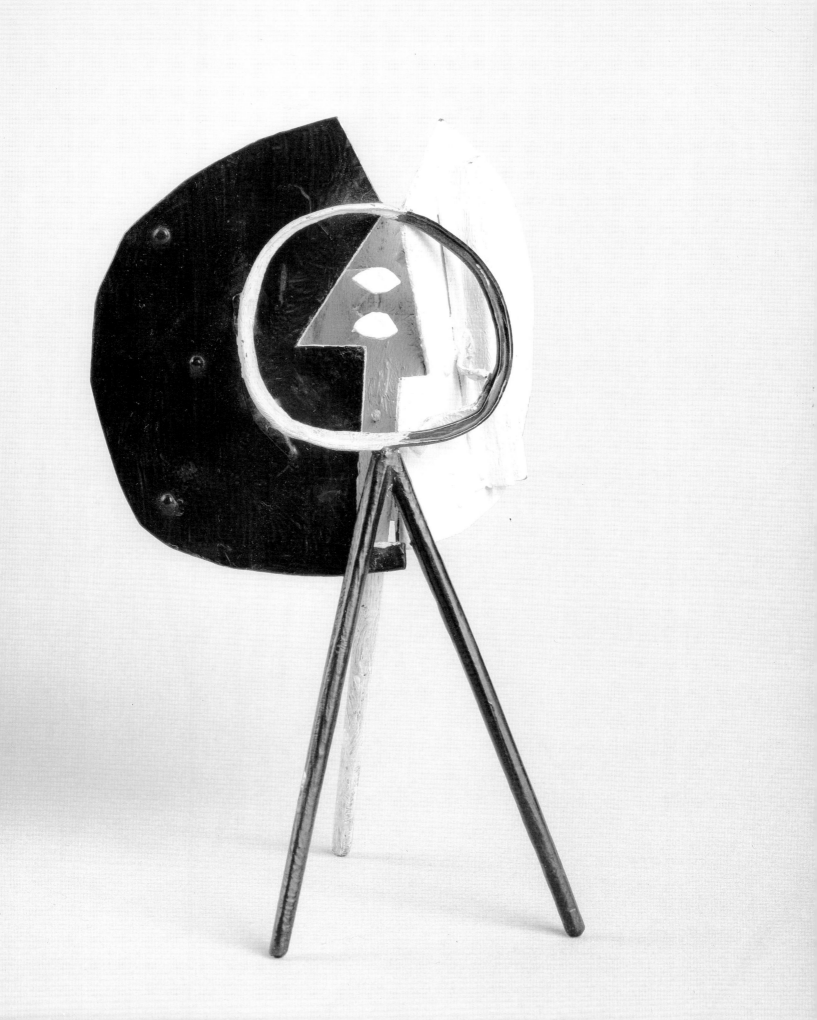

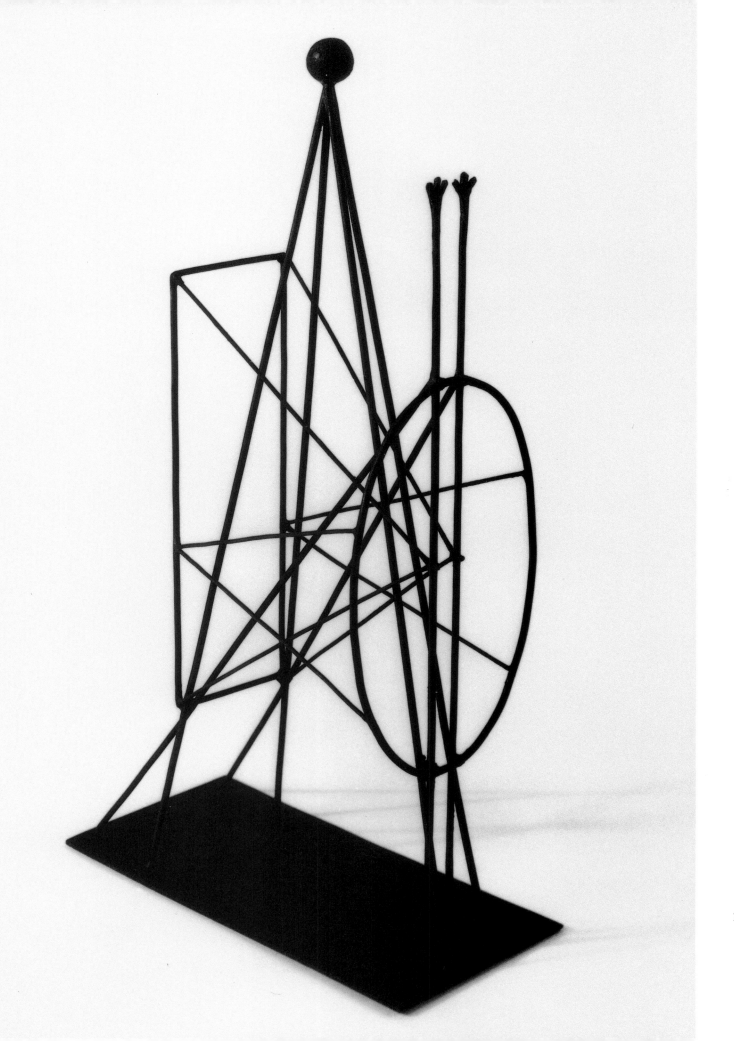

27

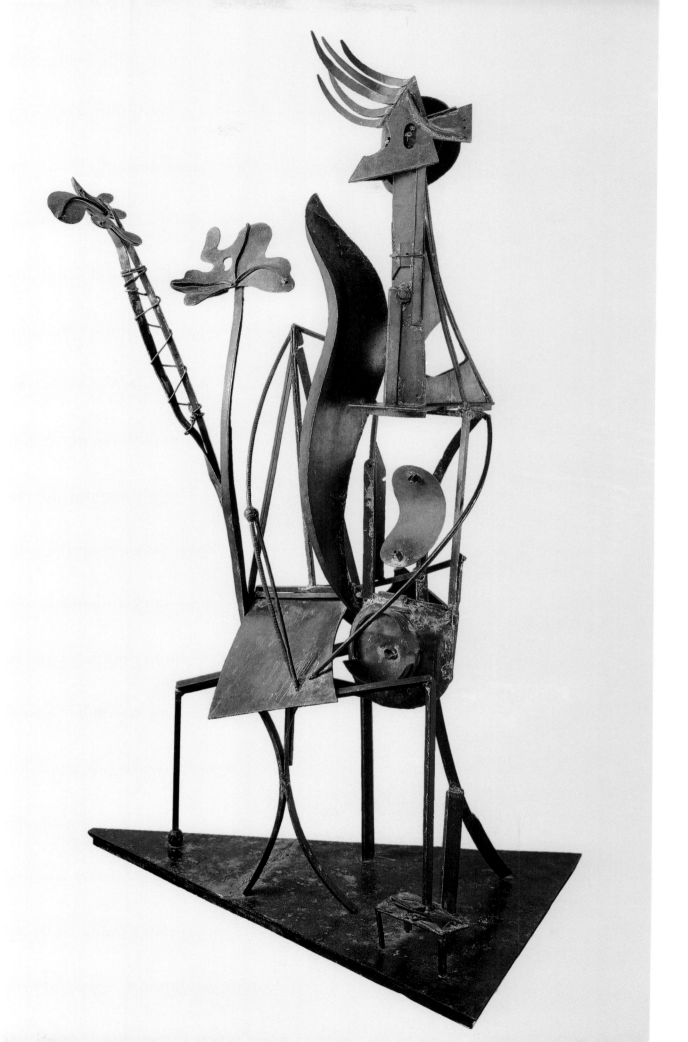

28

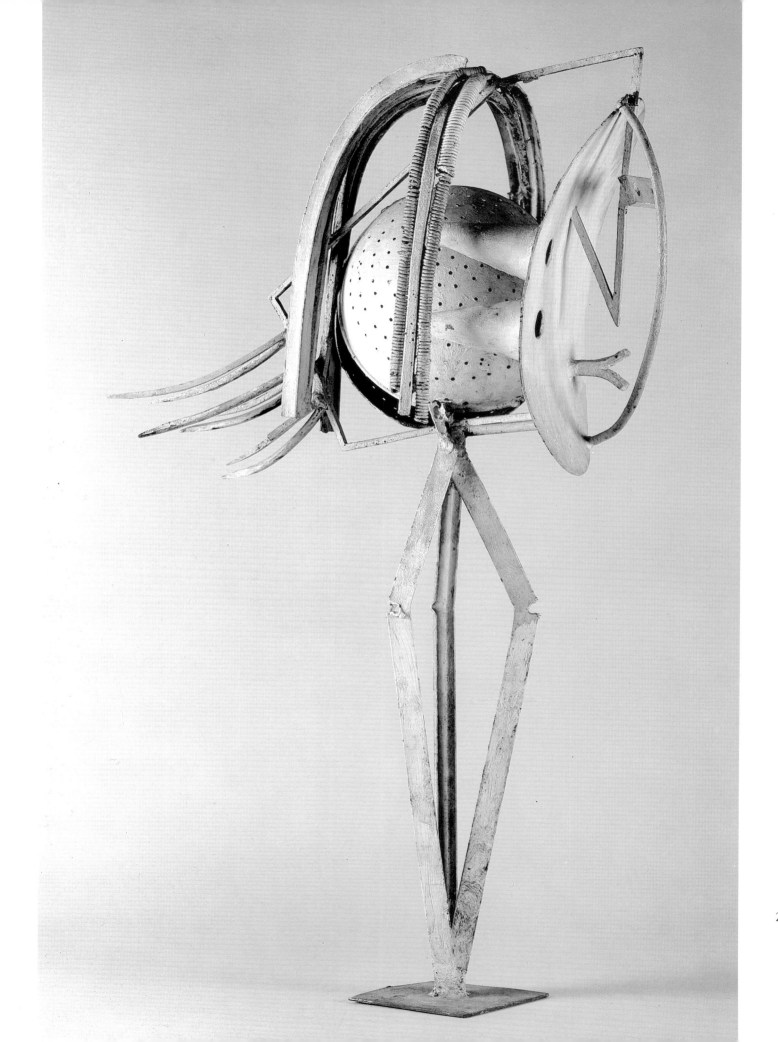

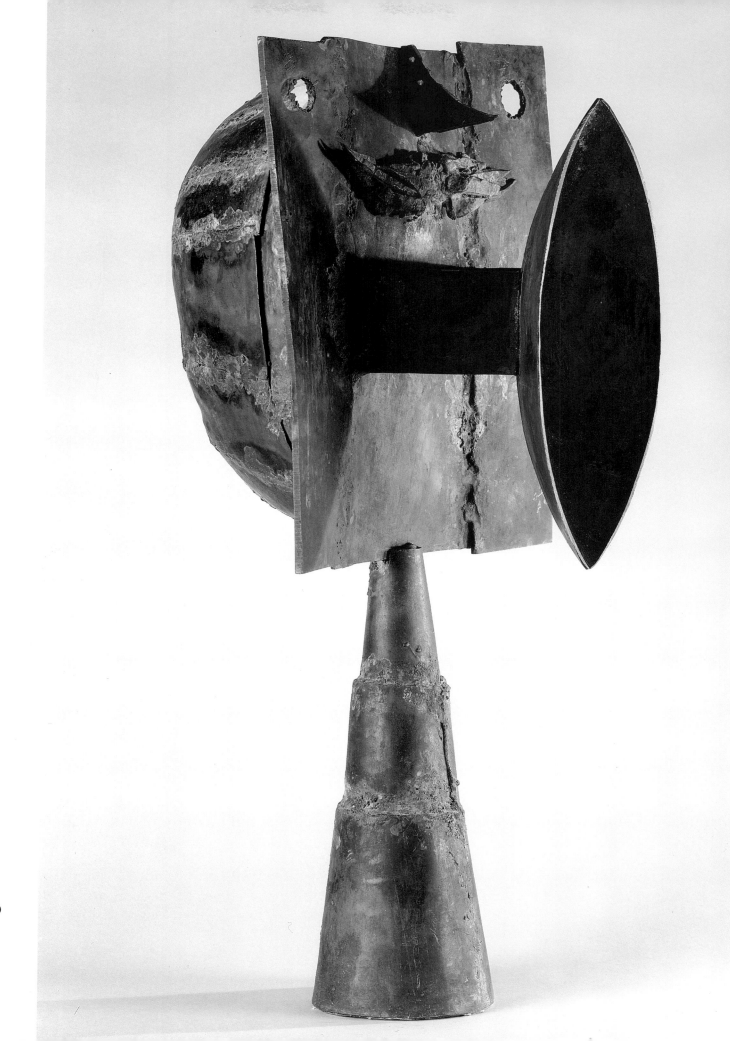

30

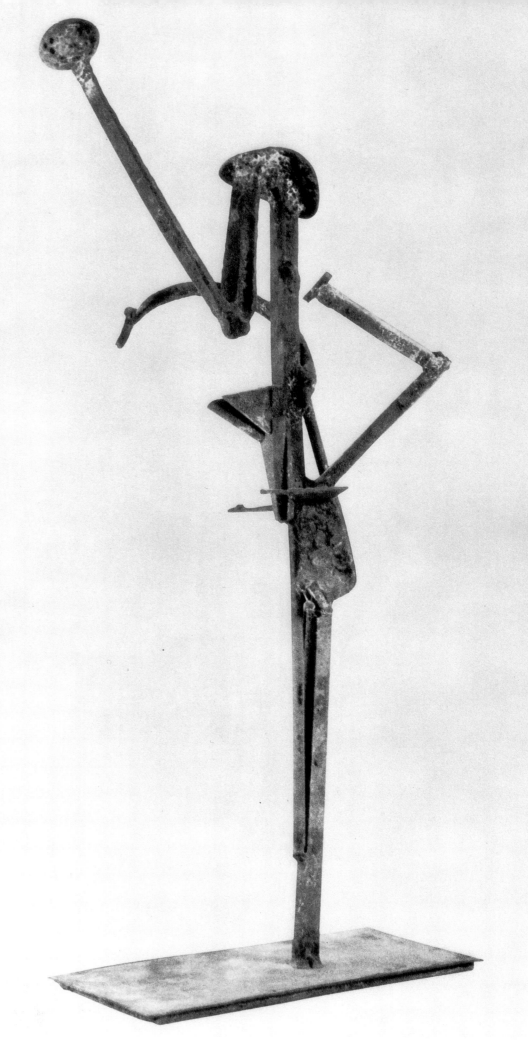

31

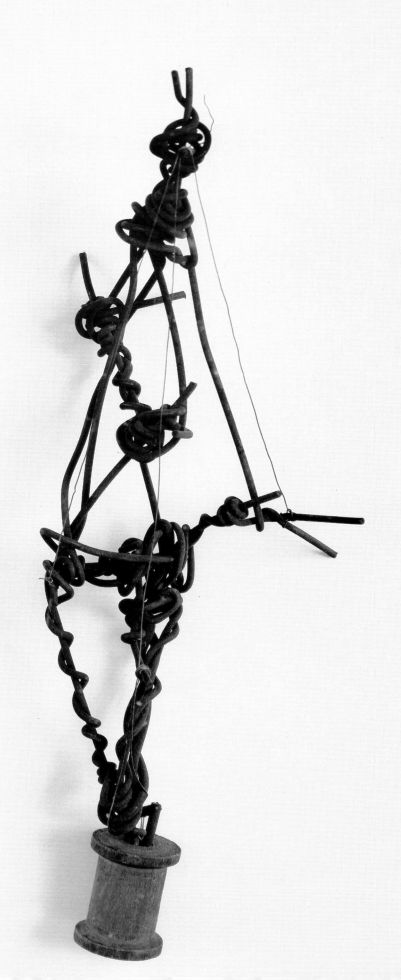

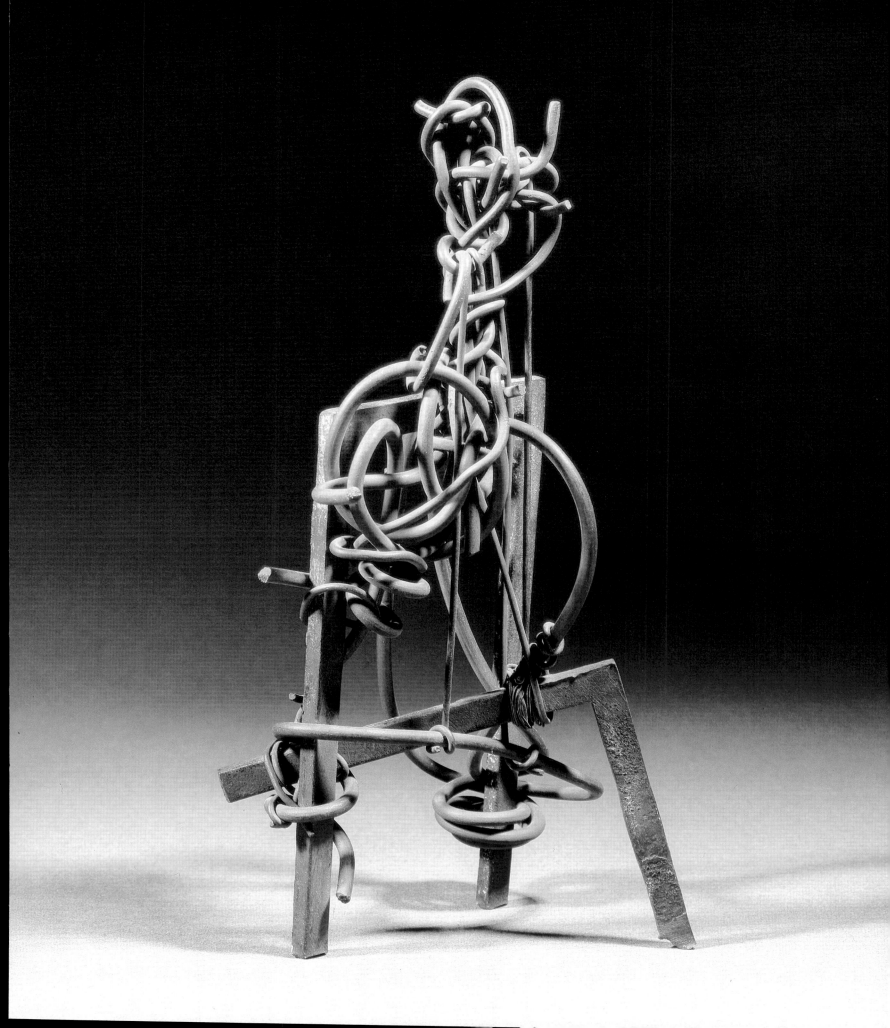

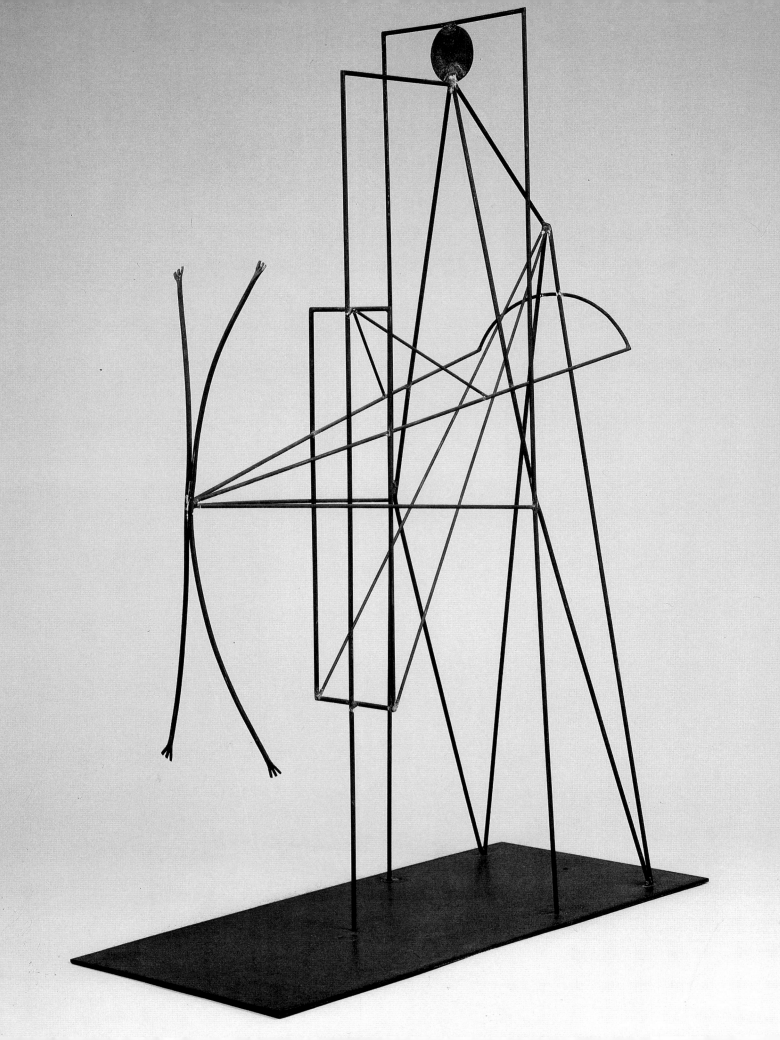

34

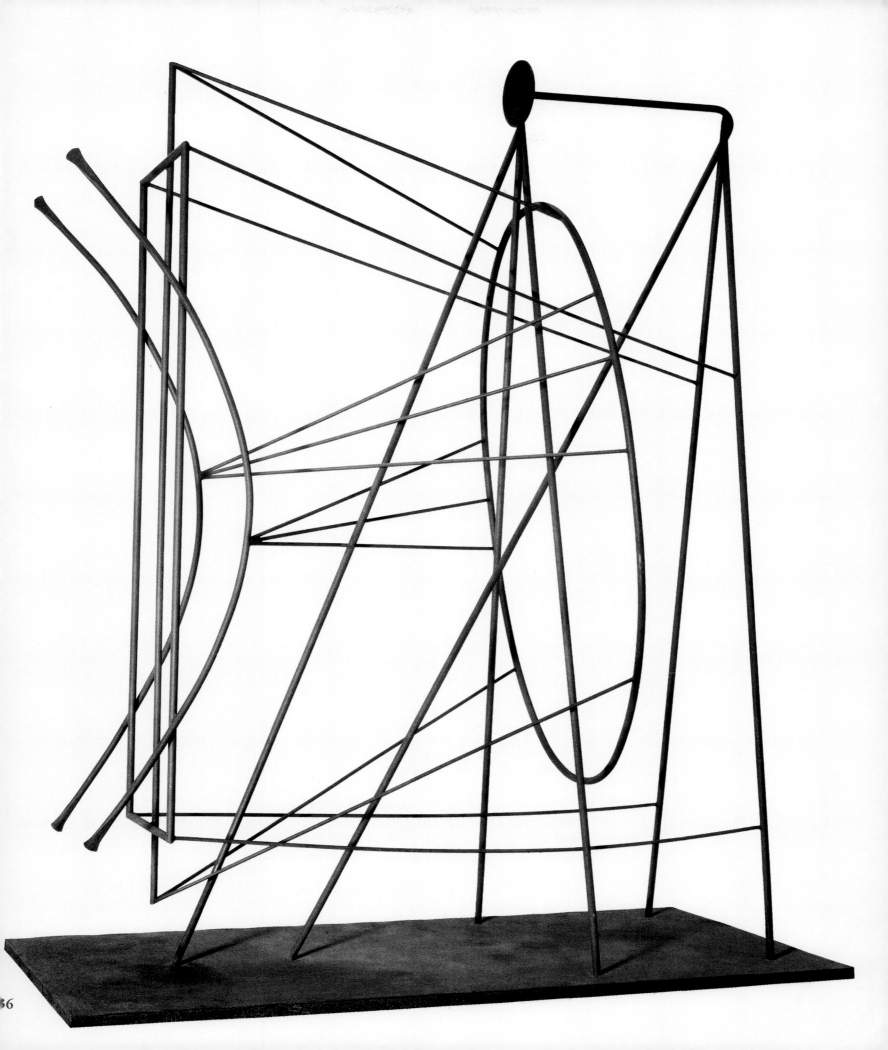

35 >

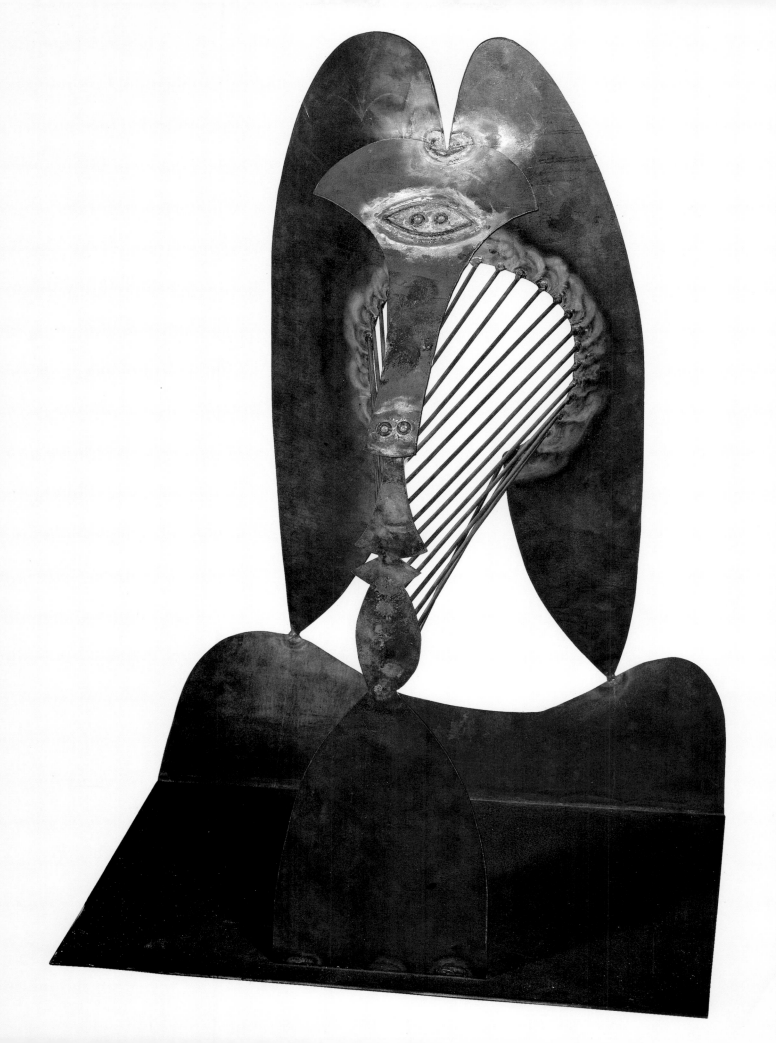

Julio González

Julio González's studio in Arcueil, France, late 1937.

37. *Harlequin/Pierrot or Colombine (Arlequin/Pierrot ou Colombine)*
ca. 1930
Iron
43 x 30 x 30 cm (16 ¹⁵/₁₆ x 11 ¹³/₁₆ x 11 ¹³/₁₆ inches)
GCRS 126
Kunsthaus Zürich,
Vereinigung Zürcher Kunstfreunde

38. *Resplendence (Standing Figure) (L'Eblouissement [Personnage debout])*
1932
Silver
21 x 8.9 x 5.1 cm (8 ¼ x 3 ½ x 2 inches)
GCRS 132
Philadelphia Museum of Art,
A. E. Gallatin Collection

39. *Head Called "The Swiss Woman" (Tête dite "La Suissesse")*
ca. 1932
Iron
38 x 21 x 19 cm (14 ¹⁵/₁₆ x 8 ¼ x 7 ½ inches)
GCRS 133
Kunsthalle Bielefeld, Germany

40. *The Lovers II (Les Amoureux II)*
ca. 1932-33
Iron
44.5 x 19.5 x 19 cm (17 ½ x 7 ¾ x 7 ½ inches)
GCRS 142
Instituto Valenciano de Arte Moderno,
IVAM Centre Julio González, Generalitat Valenciana

41. *Head Called "The Tunnel" (Tête dite "Le Tunnel")*
ca. 1932-33
Iron
46.7 x 21.6 x 30.8 cm (18 ⅜ x 8 ½ x 12 ⅛ inches)
GCRS 143
Tate Gallery, London,
Purchased 1992

42. *Head on a Long Stalk (Tête longue tige)*
ca. 1932-33
Iron
59.5 x 22 x 13 cm (23 ⅜ x 8 ⅝ x 5 ⅛ inches)
GCRS 146
Galerie Artcurial, Paris

GCRS: *Julio González: Catalogue raisonné des sculptures*, ed. by Jörn Merkert (Milan, 1987).

43. *The Large Trumpet (La Grande Trompette)*
ca. 1932-33
Iron
93 x 62 x 45 cm (36 ⅝ x 24 ⁷/₁₆ x 17 ¹¹/₁₆ inches)
GCRS 145
Collection of Dr. Walter A. Bechtler, Zollikon

44. *Head Called "The Fireman" (Tête dite "Le Pompier")*
ca. 1933
Silver
13.7 x 5.4 x 9.6 cm (5 ⅜ x 2 ⅛ x 3 ¾ inches)
GCRS 148
Private collection, Zurich

45. *Small Head with Triangle (Petite Tête au triangle)*
ca. 1933
Silver
23.1 x 7.3 x 9.6 cm (9 ⅛ x 2 ⅞ x 3 ¾ inches)
GCRS 149
Estate of Hans Hartung, France

46. *The Dream, The Kiss (Le Rêve, Le Baiser)*
ca. 1934
Iron
65.5 x 20 x 30 cm (25 ¹³/₁₆ x 7 ⅞ x 11 ¹³/₁₆ inches)
GCRS 154
Musée national d'art moderne,
Centre Georges Pompidou, Paris,
Bequest of Mme Roberta González, 1979

47. *Woman Combing Her Hair II (Femme se coiffant II)*
1934
Iron
121 x 60 x 29 cm (47 ⅝ x 23 ¾ x 11 ⅜ inches)
GCRS 156
Moderna Museet, Stockholm

48. *Large Maternity (Grande Maternité)*
ca. 1934
Iron
130.5 x 40.6 x 23.5 cm (51 ⅜ x 16 x 9 ¼ inches)
GCRS 157
Tate Gallery, London,
Purchased 1970

49. *Mane of Hair (La Chevelure)*
ca. 1934
Iron
29 x 22 x 17.5 cm (11 ⅜ x 8 ¾ x 6 ⅞ inches)
GCRS 167 (cited as forged bronze)
Estate of Julio González, Paris

50. *Large Standing Figure (Grand Personnage debout)*
ca. 1935
Iron
128 x 69 x 40 cm (50 ³/₈ x 27 ³/₁₆ x 15 ³/₄ inches)
GCRS 173
Fondation Marguerite et Aimé Maeght,
Saint-Paul-de-Vence, France

51. *Head Called "The Snail" (Tête dite "L'Escargot")*
ca. 1935
Iron
45.1 x 19.5 x 38.7 cm (17 ³/₄ x 7 ¹¹/₁₆ x 15 ¹/₄ inches)
GCRS 175
The Museum of Modern Art, New York,
Purchase 1937

52. *Personage Called by Picasso "The Angel," also "The Insect" and "Dancer"*
(Personnage appelé par Picasso "L'Ange," également dit "L'Insecte" et "La Danseuse")
ca. 1935
Iron
163 x 46 x 32 cm (64 ¹/₈ x 18 ¹/₈ x 12 ⁵/₈ inches);
stone base 16 x 29 x 29 cm (6 ⁵/₁₆ x 11 ³/₈ x 11 ³/₈ inches)
GCRS 202
Musée national d'art moderne,
Centre Georges Pompidou, Paris

53. *Seated Woman I (Femme assise I)*
ca. 1935
Iron
118 x 54 x 36 cm (46 ⁷/₁₆ x 21 ¹/₄ x 14 ³/₁₆ inches)
GCRS 203
Museo Nacional Centro de Arte Reina Sofía, Madrid

54. *Seated Woman II (Femme assise II)*
ca. 1935-36
Iron
90.3 x 25 x 37 cm (35 ⁹/₁₆ x 9 ¹³/₁₆ x 14 ⁹/₁₆ inches)
GCRS 204
Musée national d'art moderne,
Centre Georges Pompidou, Paris,
Bequest of Mme Roberta González, 1979

55. *Seated Woman III (Femme assise III)*
1934
Iron
60.5 x 19.3 x 22.8 cm (23 ³/₄ x 7 ⁵/₈ x 9 inches)
GCRS 205
Instituto Valenciano de Arte Moderno,
IVAM Centre Julio González, Generalitat Valenciana

56. *Reclining Figure (Grand Personnage allongé)*
ca. 1935-36
Welded wrought iron
45.6 x 94 x 42.5 cm (18 x 37 x 16 ³/₄ inches)
GCRS 206
The Museum of Modern Art, New York,
Nelson A. Rockefeller Bequest, 1979

57. *Woman with a Mirror (Femme au miroir)*
ca. 1936-37
Iron
204 x 67 x 36 cm (80 ⁵/₁₆ x 26 ³/₈ x 14 ³/₁₆ inches)
GCRS 219
Instituto Valenciano de Arte Moderno,
IVAM Centre Julio González, Generalitat Valenciana

58. *Dancer Holding a Daisy (Danseuse à la marguerite)*
ca. 1937
Iron
46 x 28.8 x 9.5 cm (18 ¹/₈ x 11 ⁵/₁₆ x 3 ¹/₄ inches)
GCRS 224
Instituto Valenciano de Arte Moderno,
IVAM Centre Julio González, Generalitat Valenciana

59. *Slender Form (Forme très fine)*
1937
Iron
87.5 x 7.7 x 12.8 cm (34 ⁷/₁₆ x 3 x 5 ¹/₁₆ inches)
GCRS 227 (cited as *Forme rigide*)
Estate of Hans Hartung, France, On long-term loan
to the Instituto Valenciano de Arte Moderno,
IVAM Centre Julio González, Generalitat Valenciana

60. *Gothic Man (Homme gothique)*
1937
Iron
50 x 13 x 26.5 cm (19 ¹¹/₁₆ x 5 ¹/₈ x 10 ⁷/₁₆ inches);
stone base 5.5 x 13 x 10.5 cm (14 x 5 ¹/₈ x 4 ¹/₈ inches)
GCRS 228
Estate of Hans Hartung, France, On long-term loan
to the Instituto Valenciano de Arte Moderno,
IVAM Centre Julio González, Generalitat Valenciana

61. *Monsieur Cactus I (Cactus Man I)*
(Monsieur Cactus I [Homme Cactus I])
August 23-24, 1939
Iron
65.5 x 27.5 x 15.5 cm (25 ³/₄ x 10 ³/₄ x 6 ¹/₈ inches)
GCRS 236
Estate of Julio González, Paris

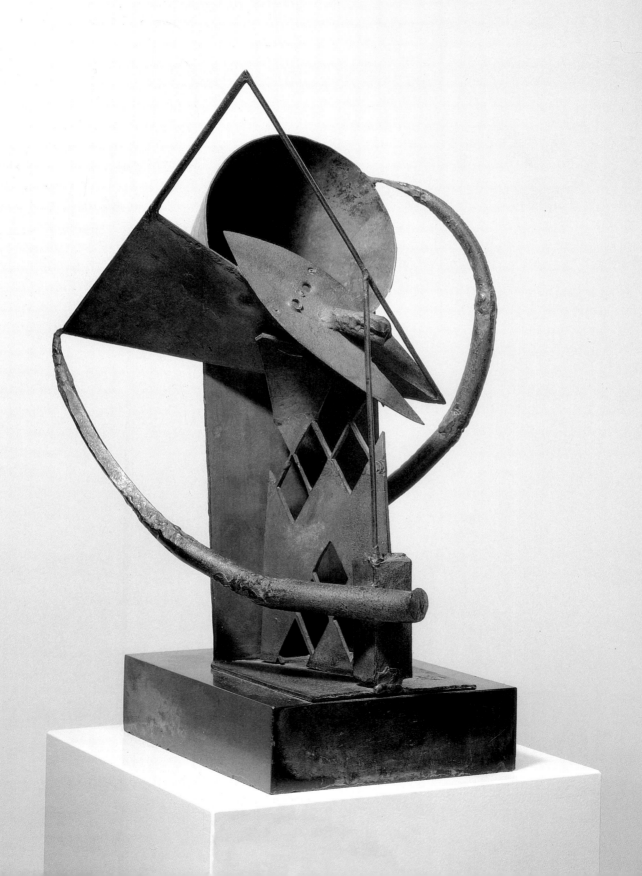

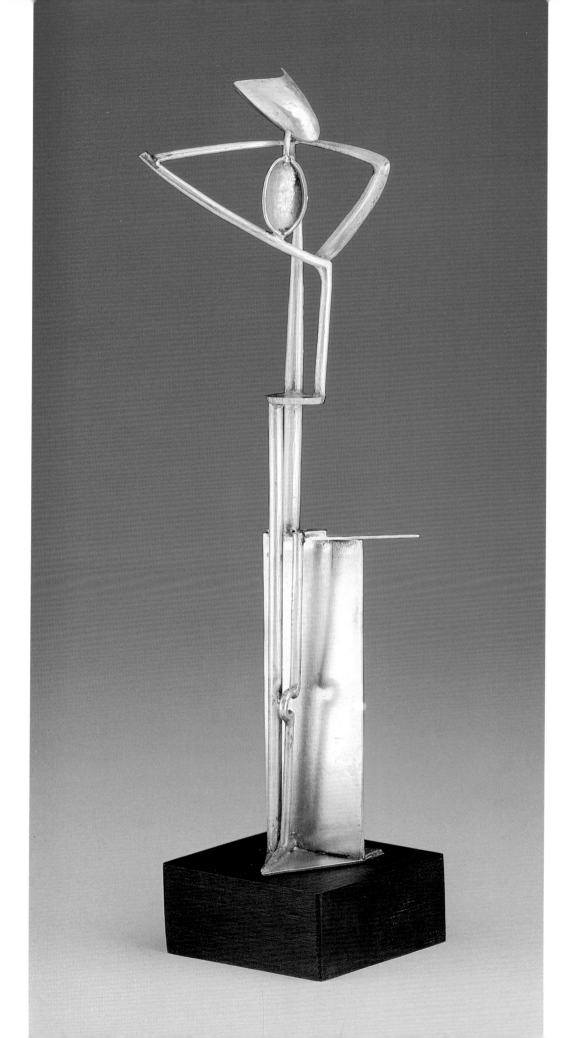

38

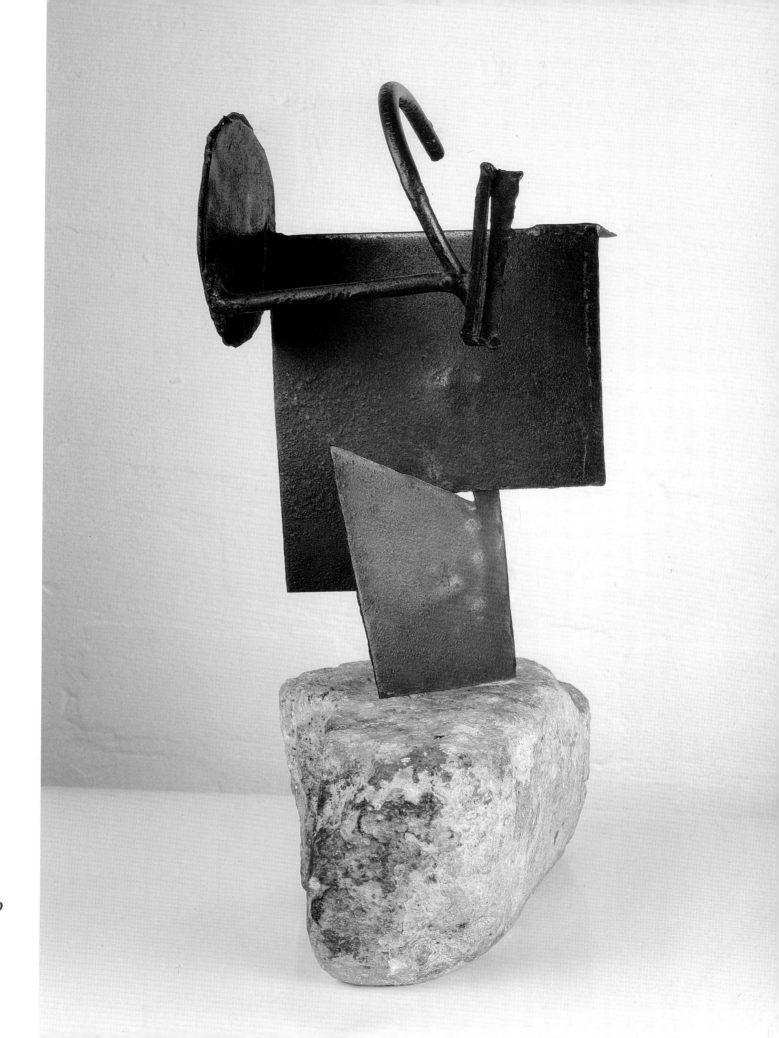

39

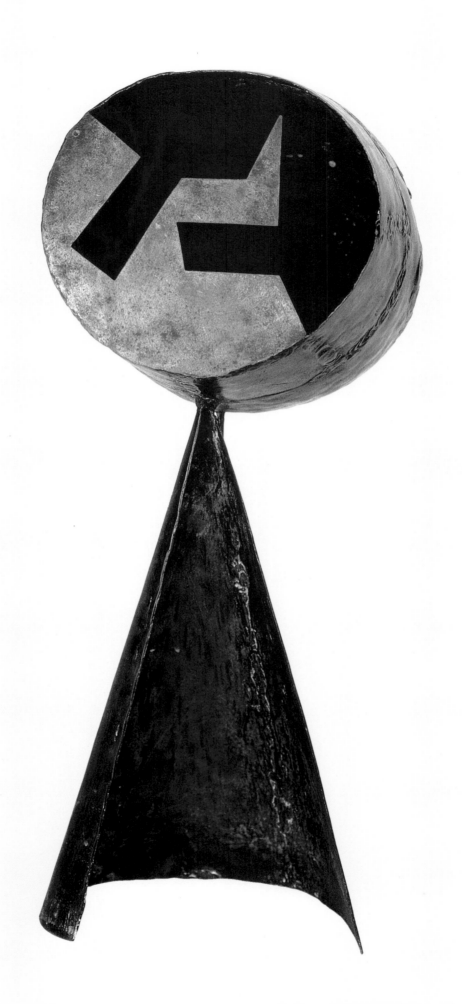

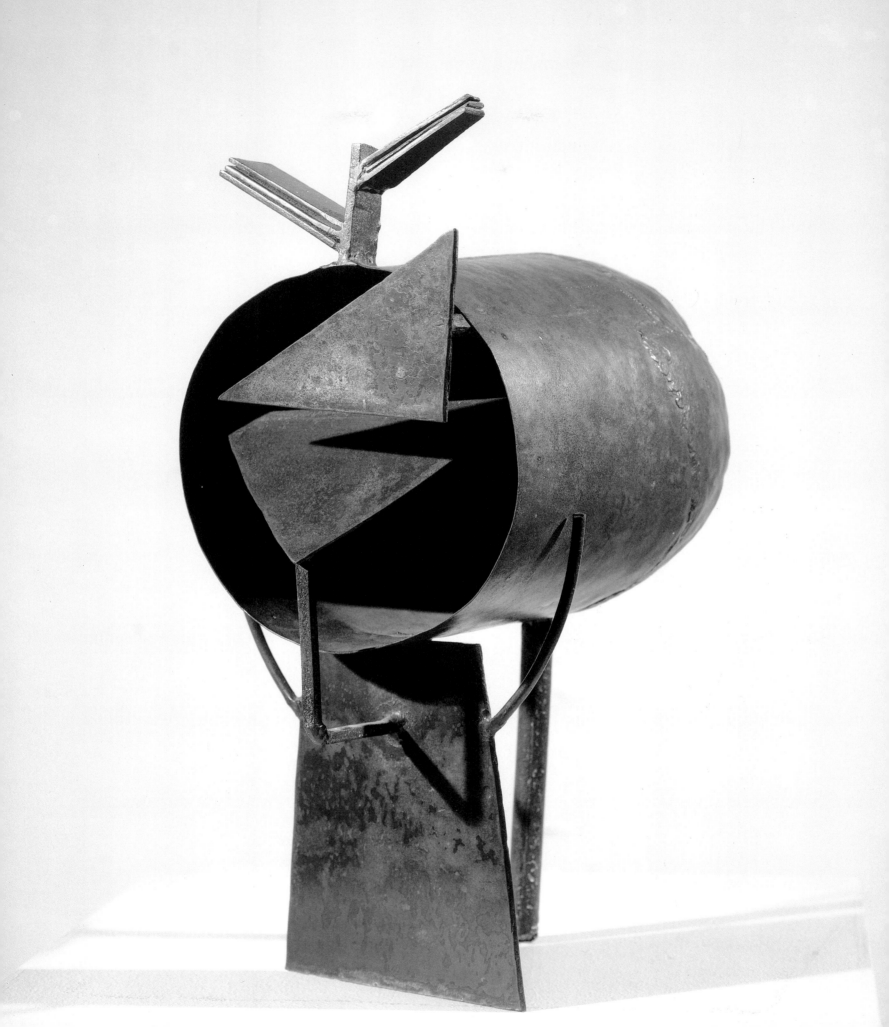

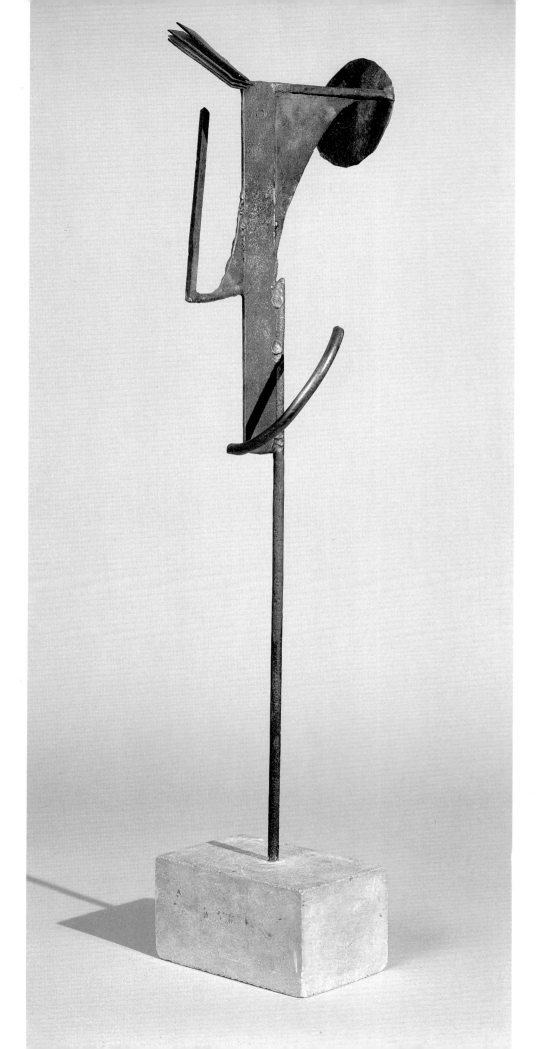

42
43 >

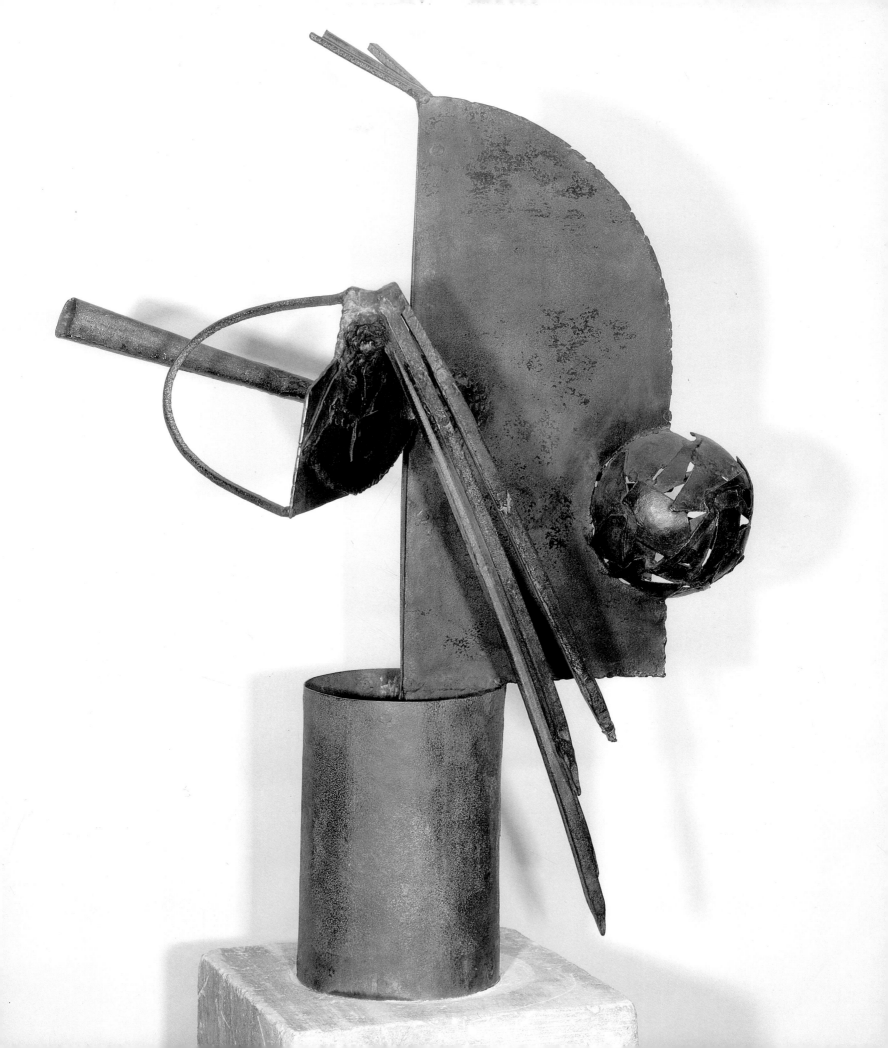

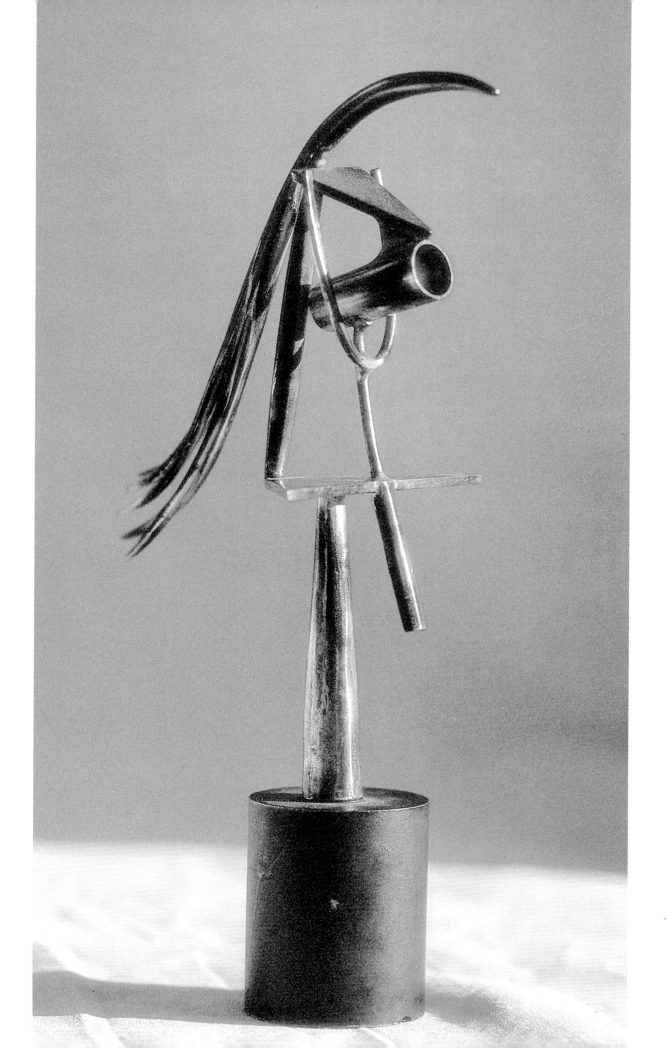

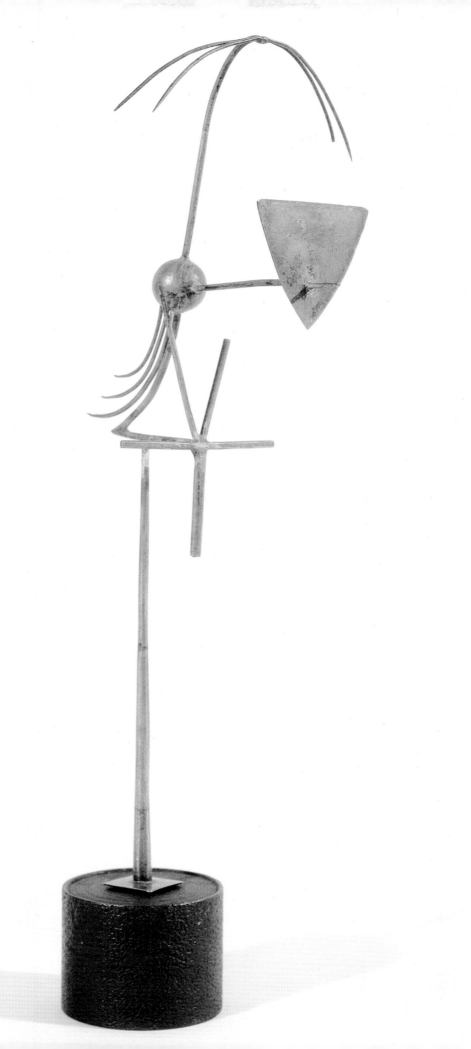

45

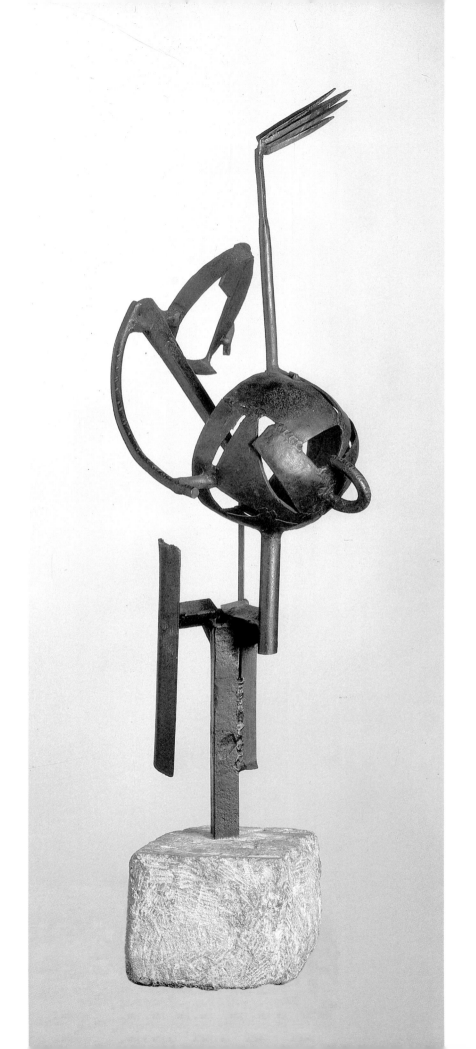

46

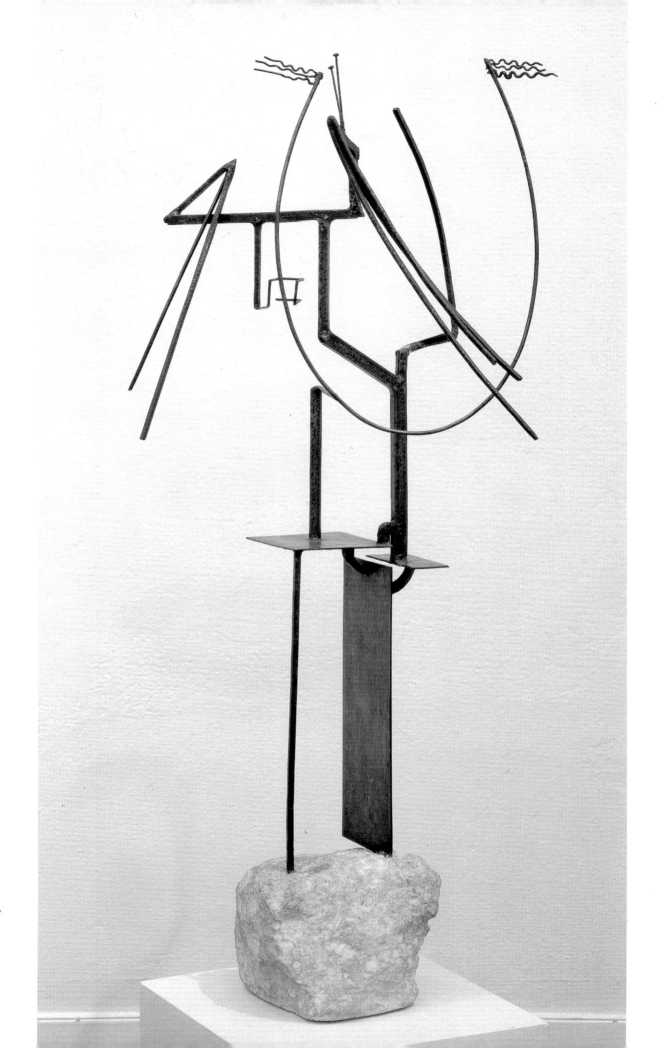

47

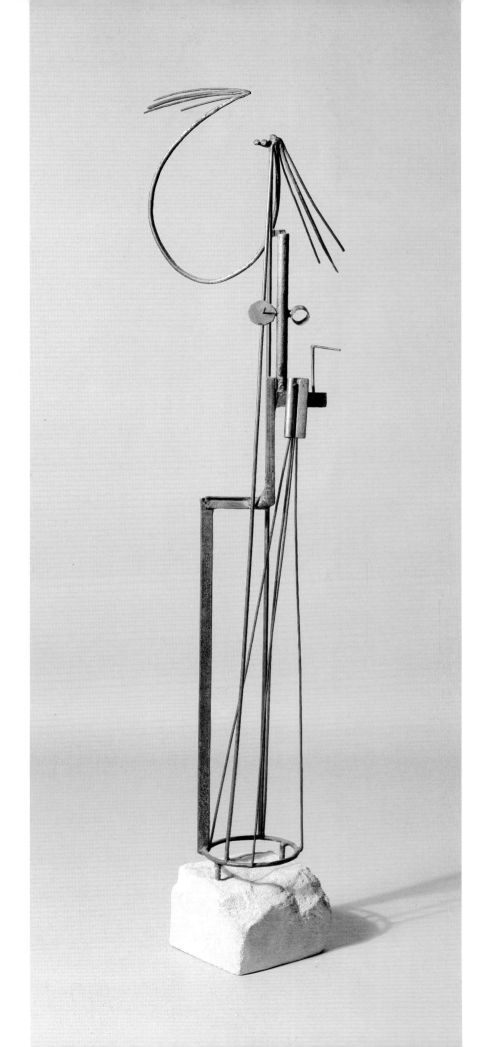

48

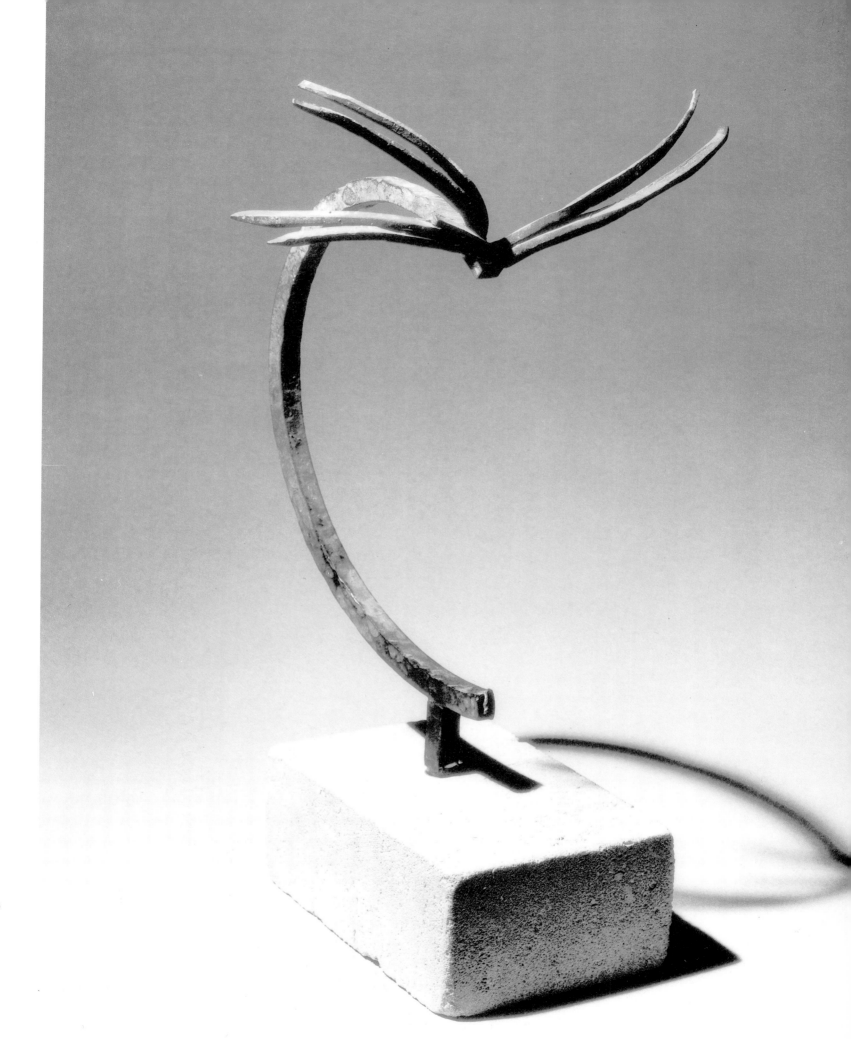

49

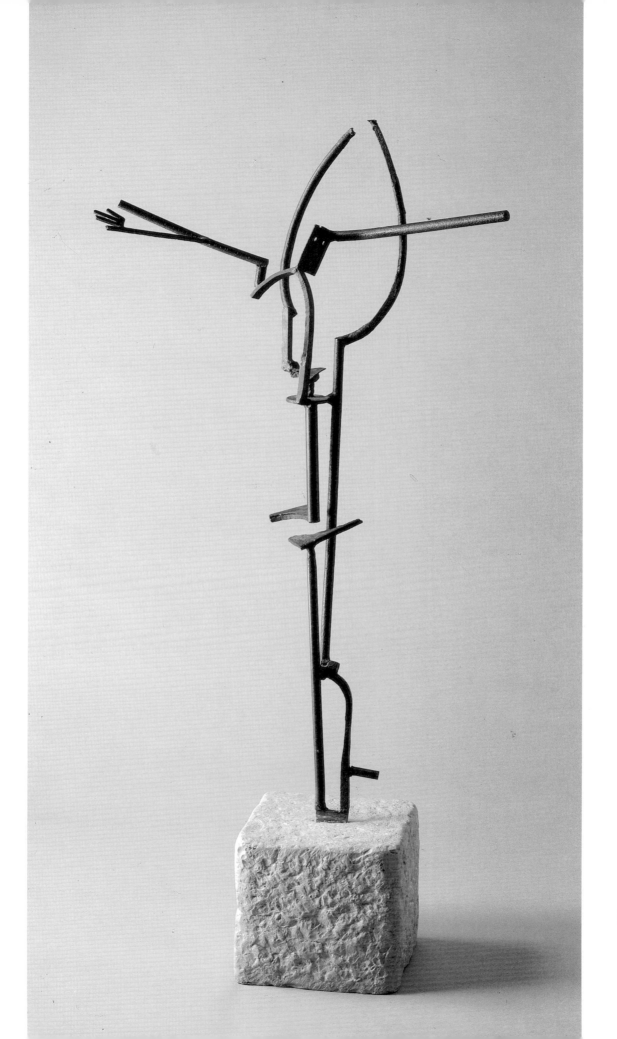

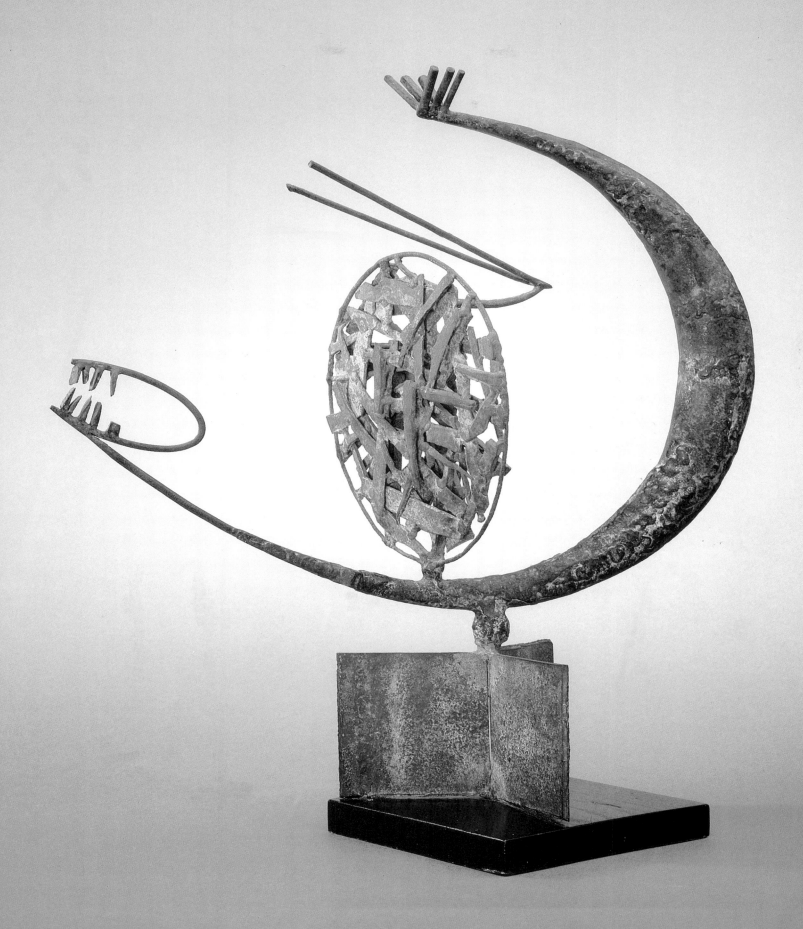

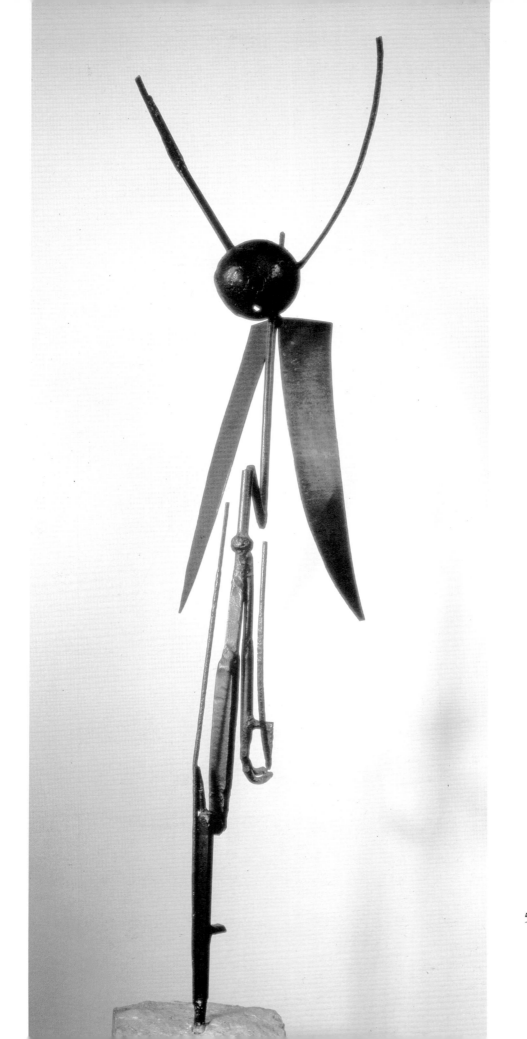

52

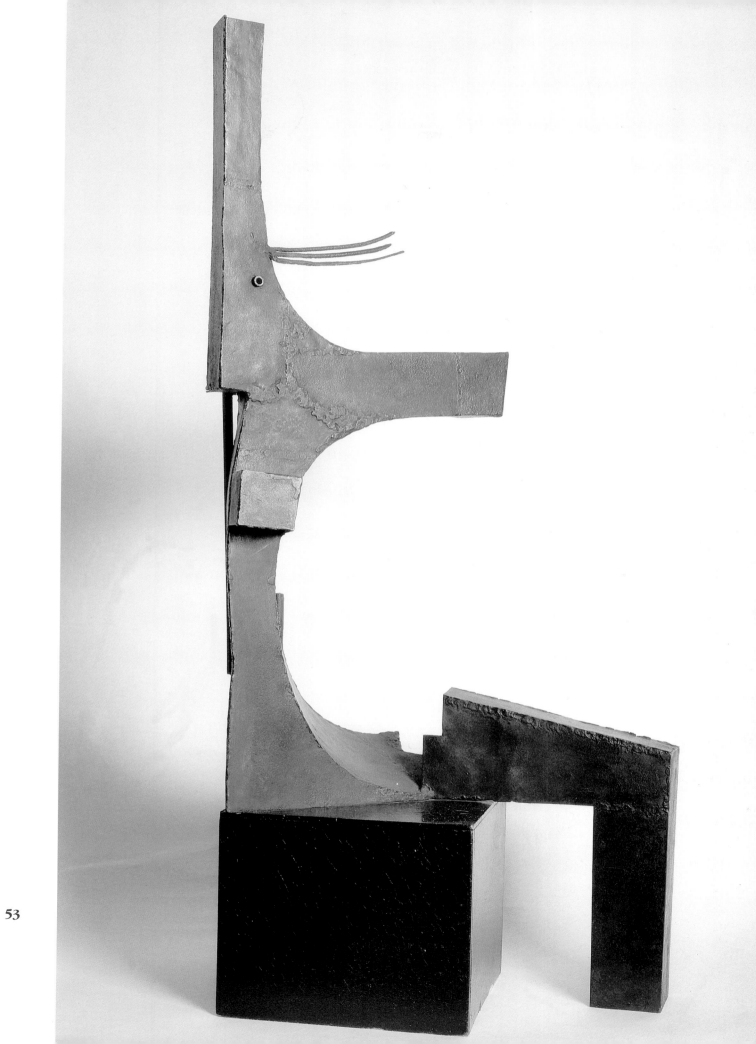

53

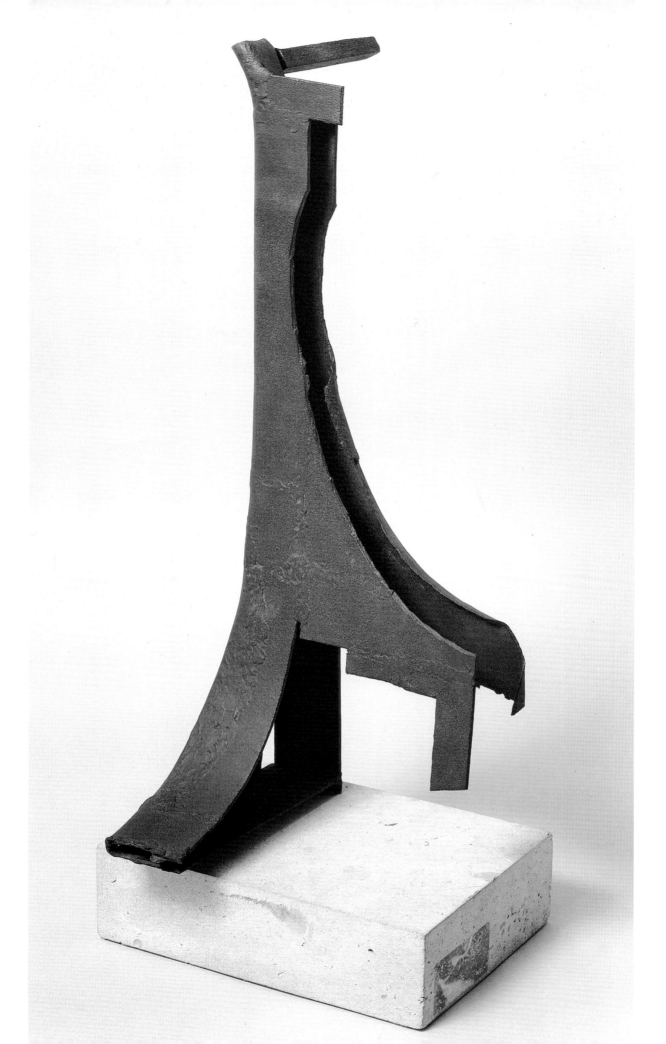

55
54 >

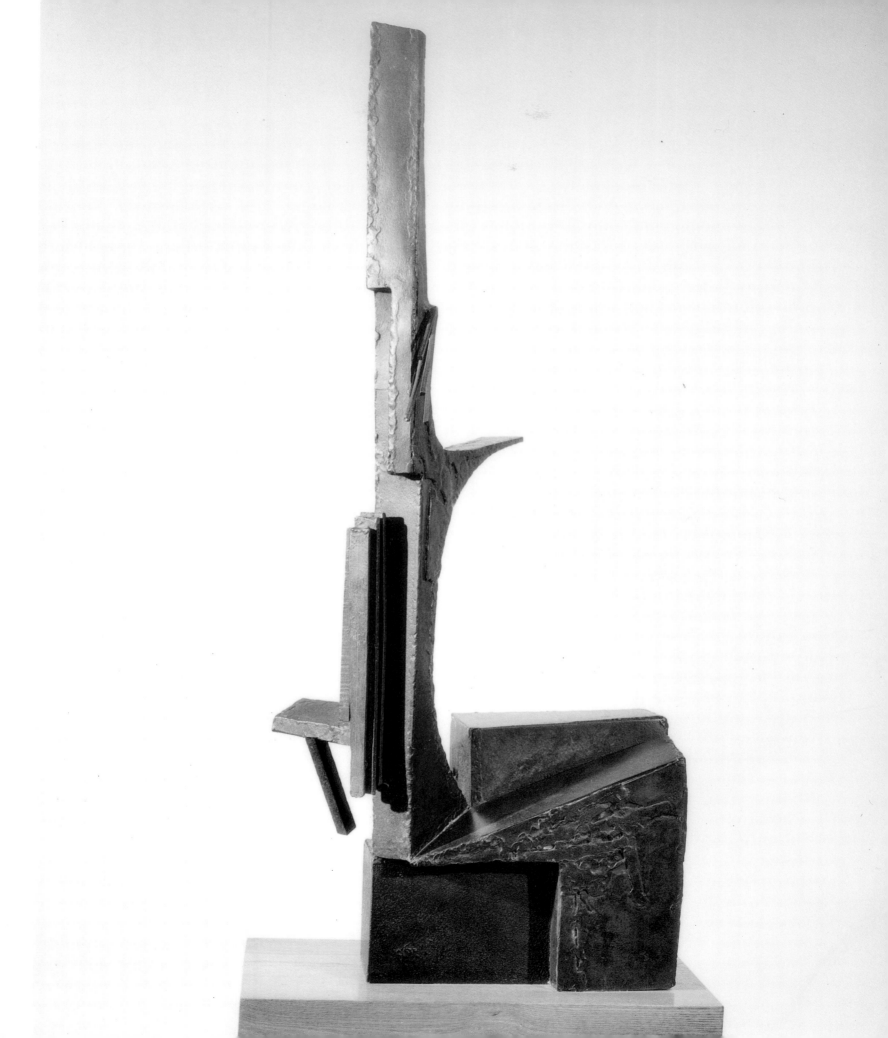

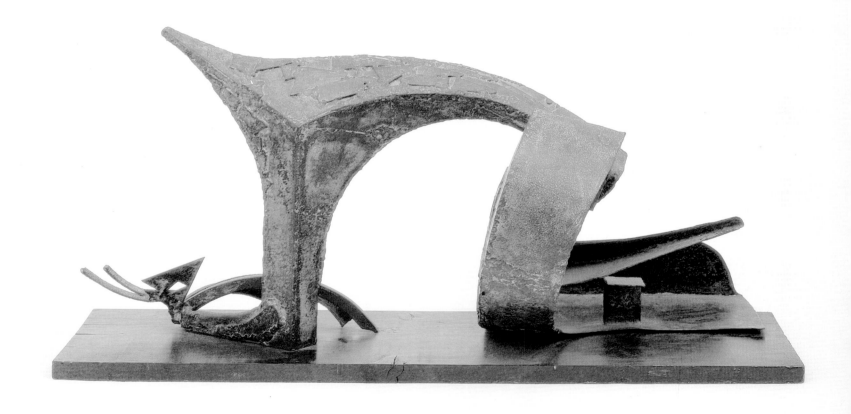

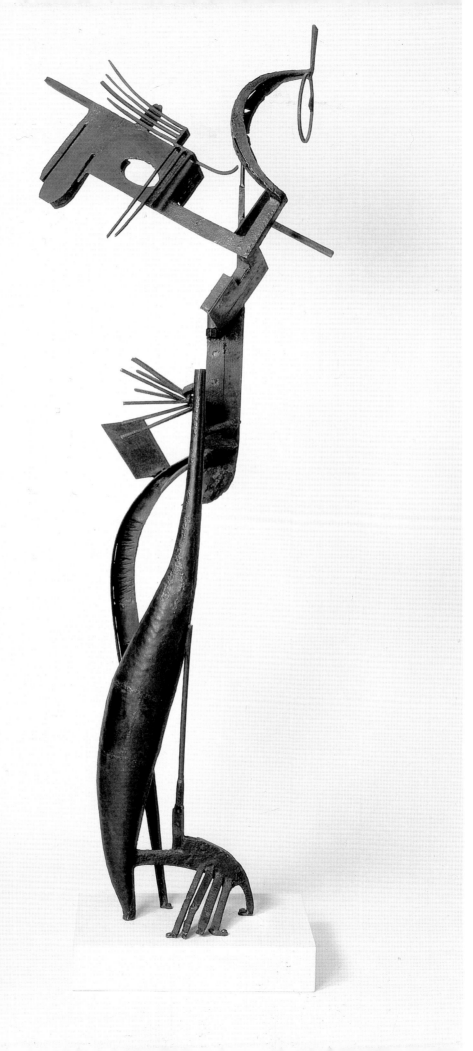

57

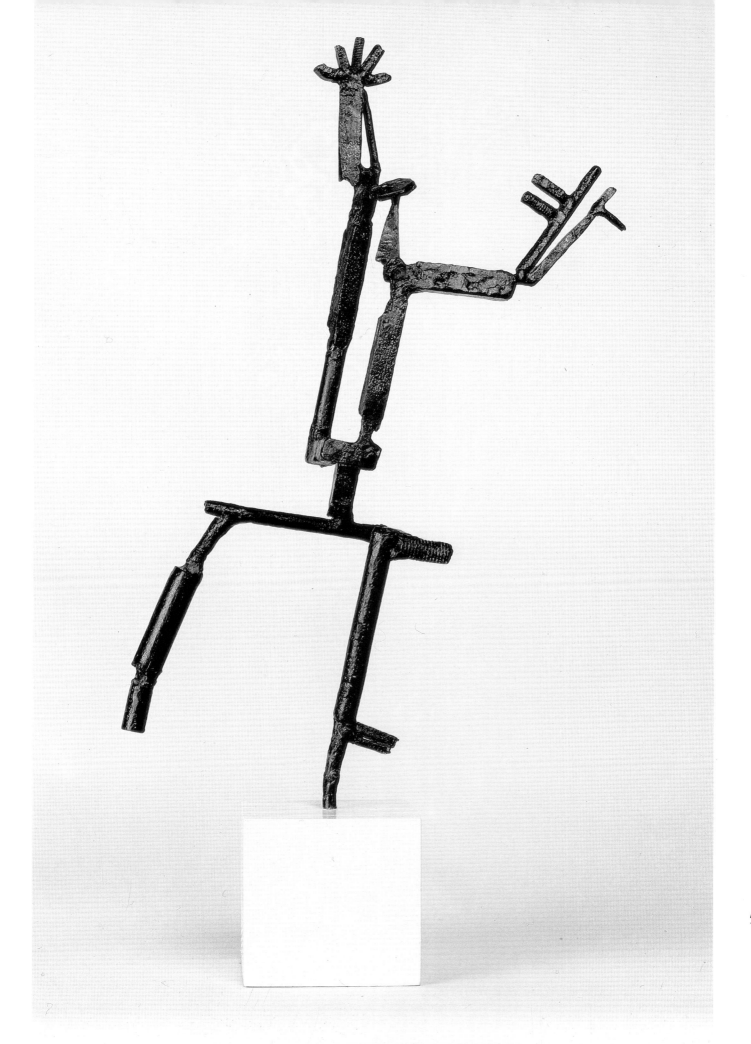

58

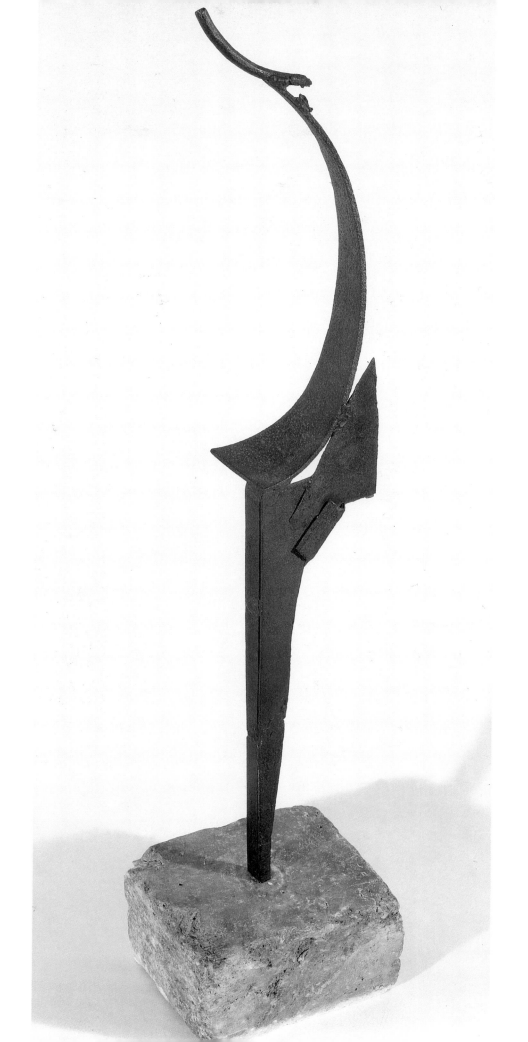

59

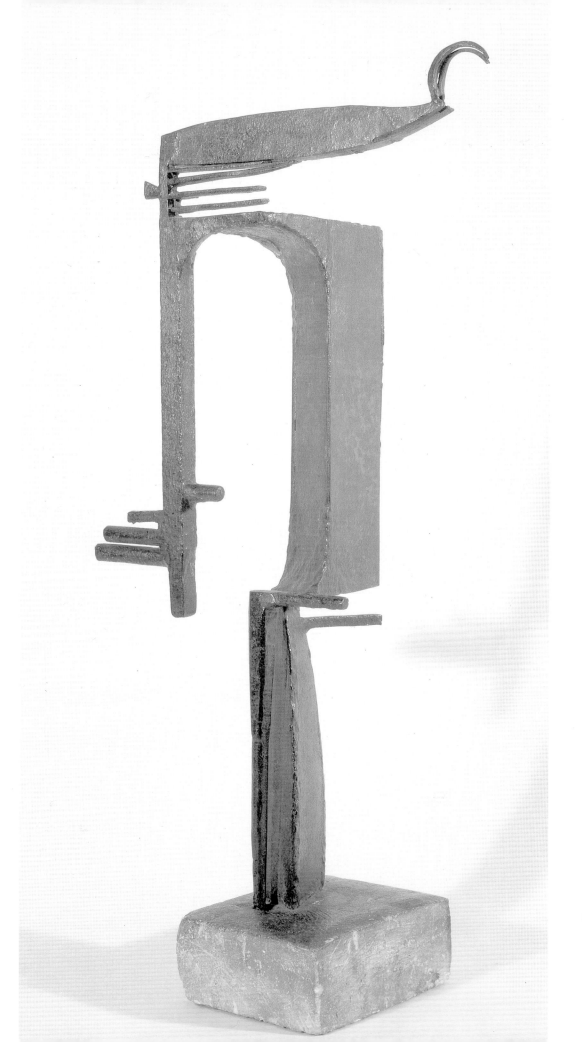

60

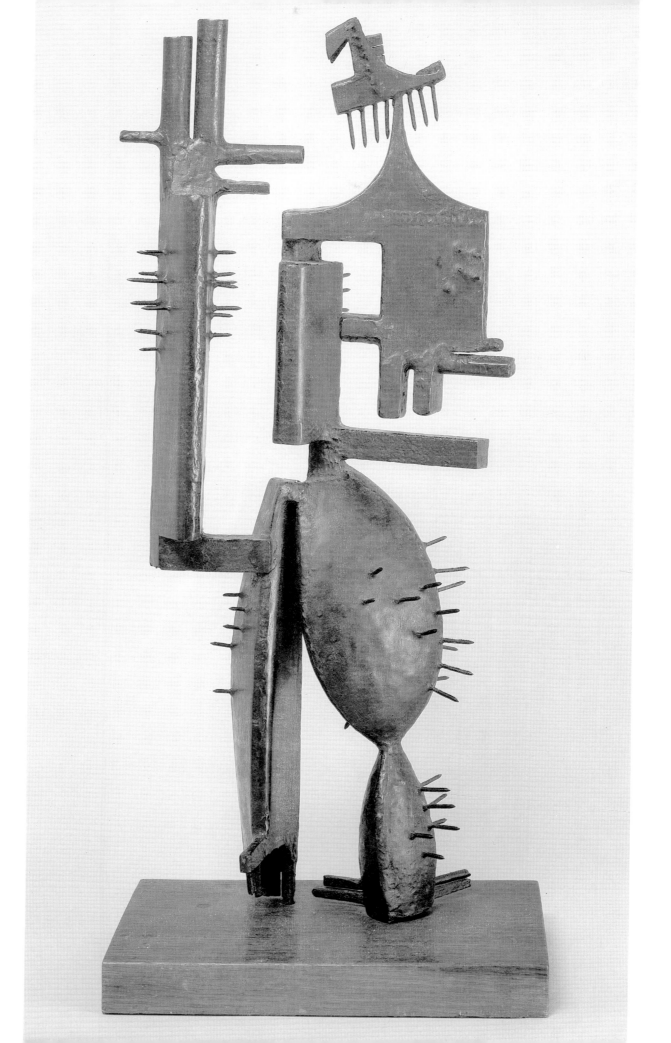

61

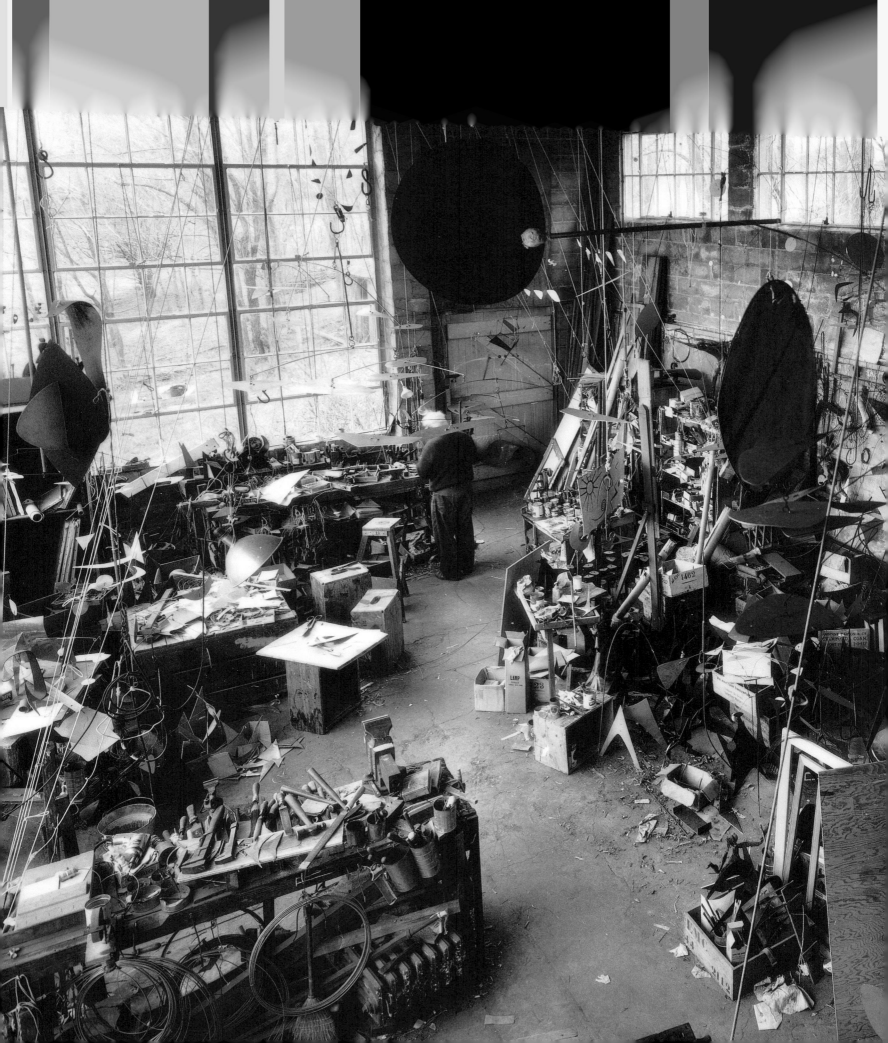

Alexander Calder

Alexander Calder's studio in Saché, France, ca. 1960.

62. *The Pistil*
1931
Wire, brass, and painted wood
99.4 x 34.3 x 29.8 cm (39 ⅛ x 13 ½ x 11 ¾ inches)
Whitney Museum of American Art, New York,
Purchase, with funds from the Howard and Jean Lipman
Foundation, Inc.

63. *Universe*
1931
Painted steel rod, wire, and wood
94 x 58.5 x 58.5 cm (37 x 23 x 23 inches)
Private collection

64. *Two Spheres within a Sphere*
ca. 1931
Wire and painted wood
95.3 x 81.3 x 35.5 cm (37 ½ x 32 x 14 inches)
Private collection

65. *Little Ball with Counterweight*
ca. 1931
Painted sheet metal, wire, and wood
162 x 31.7 x 31.7 cm (63 ¾ x 12 ½ x 12 ½ inches)
Collection of Mrs. Ruth Horwich, Chicago

66. *Feathers*
1931
Painted wire, wood, and lead weights
97.8 x 81.3 x 40.6 cm (38 ½ x 32 x 16 inches)
Private collection

67. *Calderberry Bush*
1932
Painted steel rod, wire, wood, and sheet aluminum
224.8 x 83.8 x 120.7 cm (88 ½ x 33 x 47 ½ inches) overall
Whitney Museum of American Art, New York,
Purchase, with funds from the Mrs. Percy Uris
Purchase Fund

68. *Steel Fish*
1934
Metal
284 x 350.5 x 61 cm (112 x 138 x 24 inches)
Private collection

69. *Tightrope*
1937
Wood, wire, and lead
283.2 cm (111 ½ inches) wide
Private collection

70. *Cage within a Cage*
ca. 1939
Painted rod, wire, wood, and string
92.7 x 148 x 67.9 cm (36 ½ x 58 ¼ x 26 ¾ inches)
Whitney Museum of American Art, New York,
Gift of the Howard and Jean Lipman Foundation, Inc.

71. *Four Leaves and Three Petals*
1939
Painted metal
205 x 174 x 135 cm (80 ¹¹⁄₁₆ x 68 ½ x 53 ⅛ inches)
Musée national d'art moderne,
Centre Georges Pompidou, Paris,
Bequest, 1983

72. *Sphere Pierced by Cylinders*
ca. 1939
Painted metal
210 x 69 cm (82 ¹¹⁄₁₆ x 27 ½ inches)
Private collection

73. *Hanging Spider*
ca. 1940
Painted sheet metal and wire
129.5 cm (51 inches) high
Whitney Museum of American Art, New York,
Mrs. John B. Putnam Bequest

74. *Thirteen Spines*
1940
Painted sheet metal, rod, and wire
210 cm (84 inches) high
Museum Ludwig, Cologne

75. *Three Black Pancakes*
ca. 1940
Painted metal
77.5 x 30.7 x 25.5 cm (30 ½ x 20 x 10 inches)
Private collection

76. *Mobile*
1941
Painted and unpainted sheet aluminum, iron wire,
and copper rivets
approximately 214 cm (84 ¼ inches) high
Peggy Guggenheim Collection, Venice 76.2553 PG137

77. *Black Spot on Gimbals*
1942
Wire and wood
40.7 cm (16 inches) high
Private collection

78. *Effet du Japonais*
ca. **1945**
Painted metal
213.3 x 182.8 x 68.5 cm (83 ⅞ x 71 ¼ x 27 inches)
Private collection

79. *Floating Wood Objects and Wire Spines*
1947
Painted sheet metal, wood, and wire
111 x 127 cm (43 ¹¹⁄₁₆ x 50 inches)
Collection of Mr. John Githens and
Ms. Ingeborg ten Haeff, New York

80. *Roxbury Flurry*
ca. **1948**
Painted sheet metal and wire
254 x 243.8 cm (100 x 95 ⅝ inches)
Whitney Museum of American Art, New York,
Gift of Louisa Calder

81. *Bifurcated Tower*
1950
Painted metal, wire, and wood
147.3 x 182.9 x 134.6 cm (58 x 72 x 53 inches)
Whitney Museum of American Art, New York,
Purchase, with funds from the Howard and Jean Lipman
Foundation, Inc. and exchange

82. *The Aeroplane-Tower with Six Leaves and a Dot*
1951
Painted rod, sheet metal, wood, and wire
134.2 cm (53 inches) high
Collection of Dr. and Mrs. Arthur E. Kahn

83. *Yellow Disk*
1953
Painted metal and copper
107 x 132.1 x 66 cm (42 ⅛ x 52 x 26 inches)
Private collection

84. *Funghi Neri*
1960
Plate steel
282 cm (111 inches) high
Private collection

85. *Untitled*
n.d.
Plate steel
330 cm (130 inches) high
Private collection

62 ›

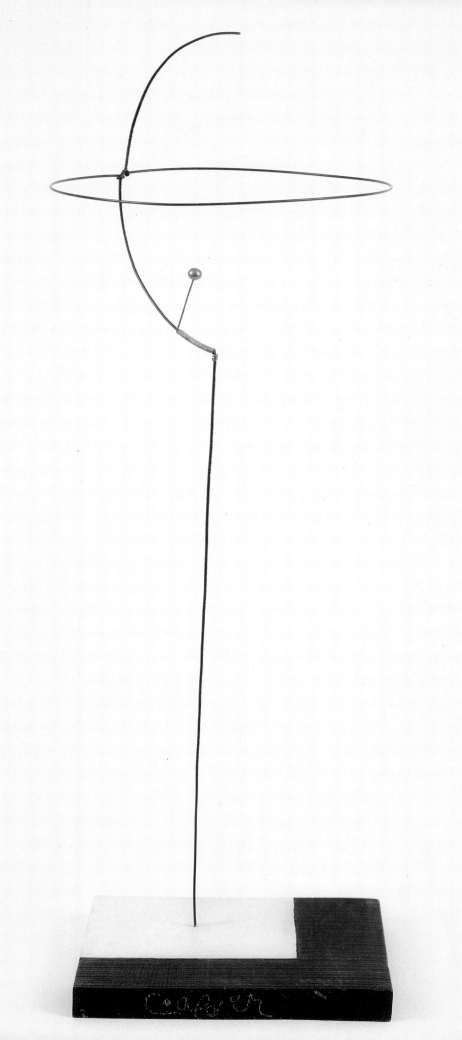

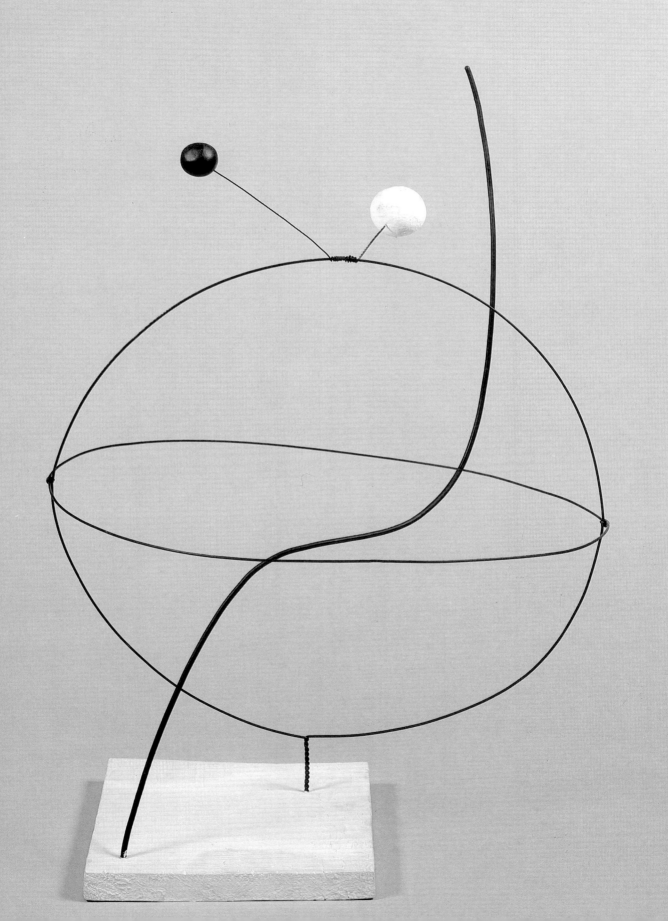

63

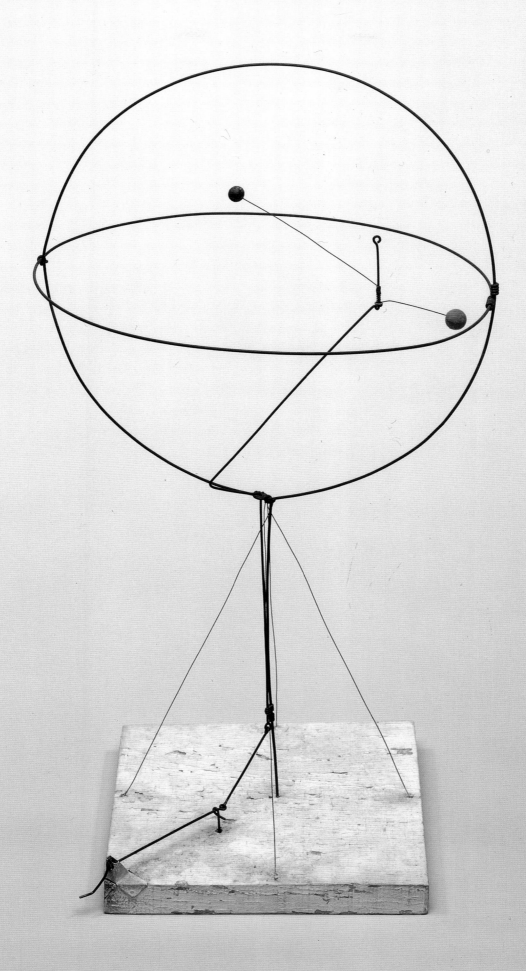

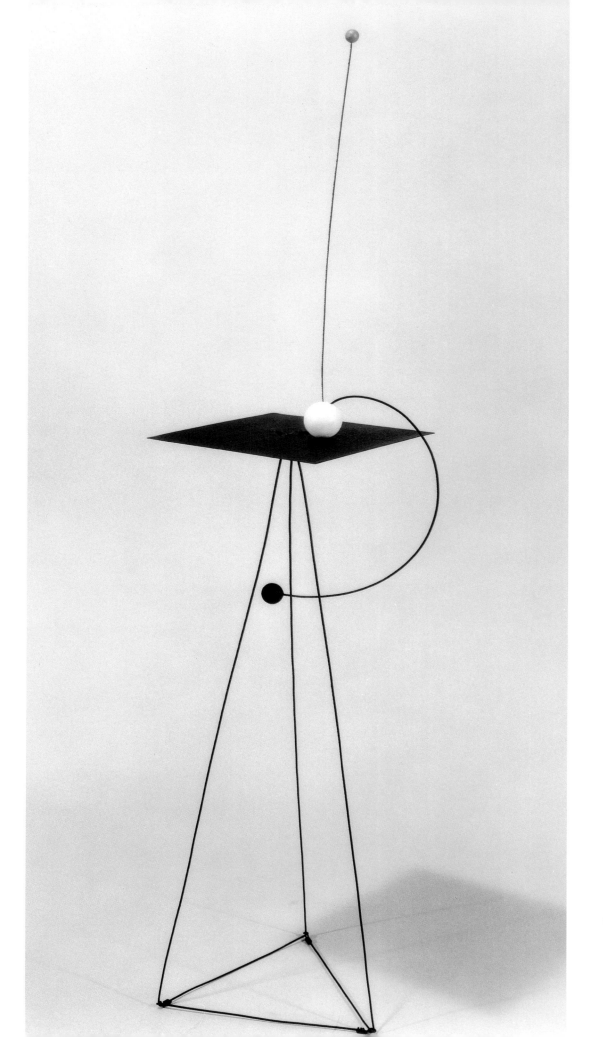

65

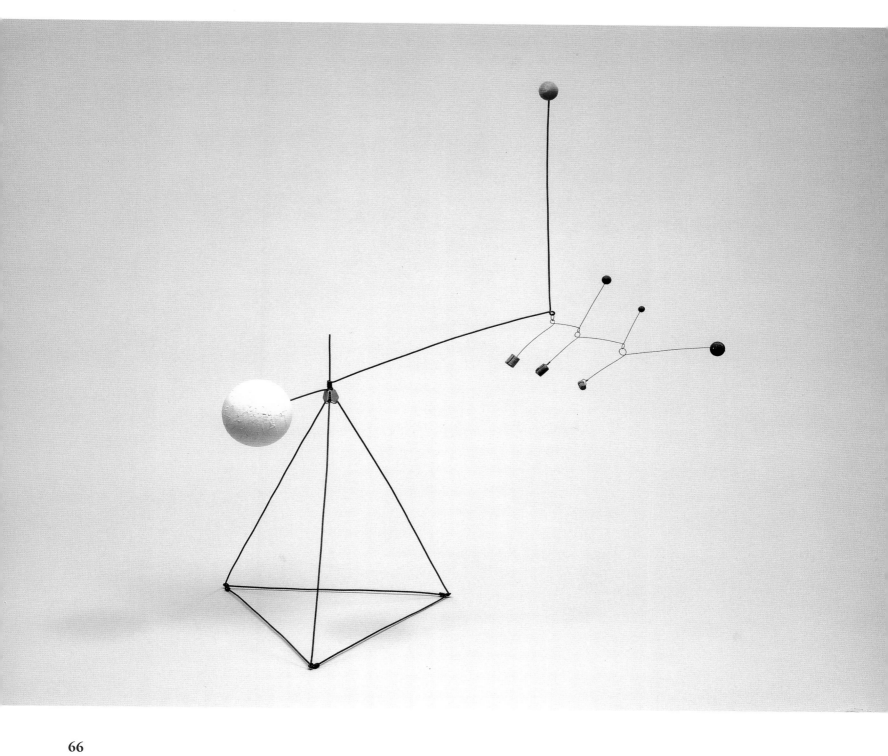

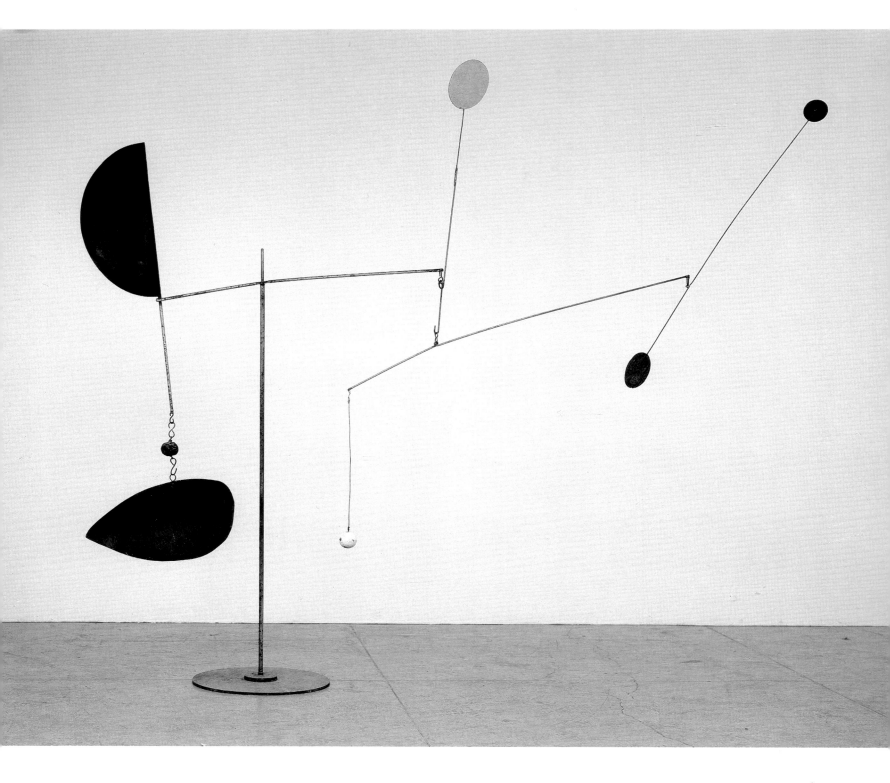

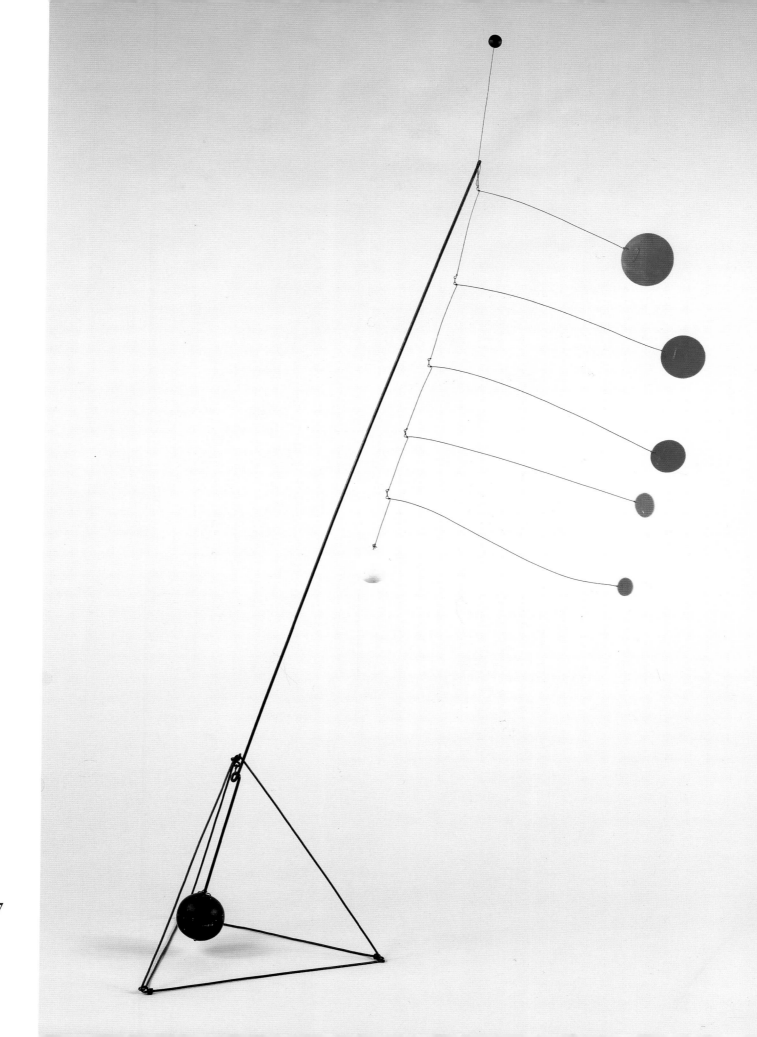

67

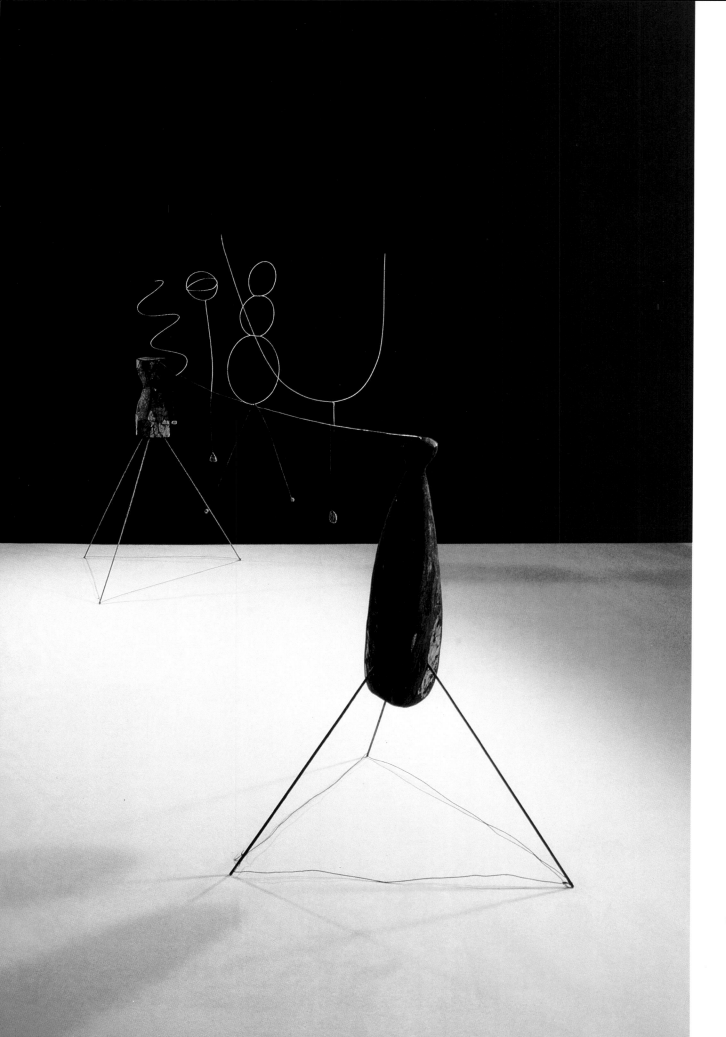

69

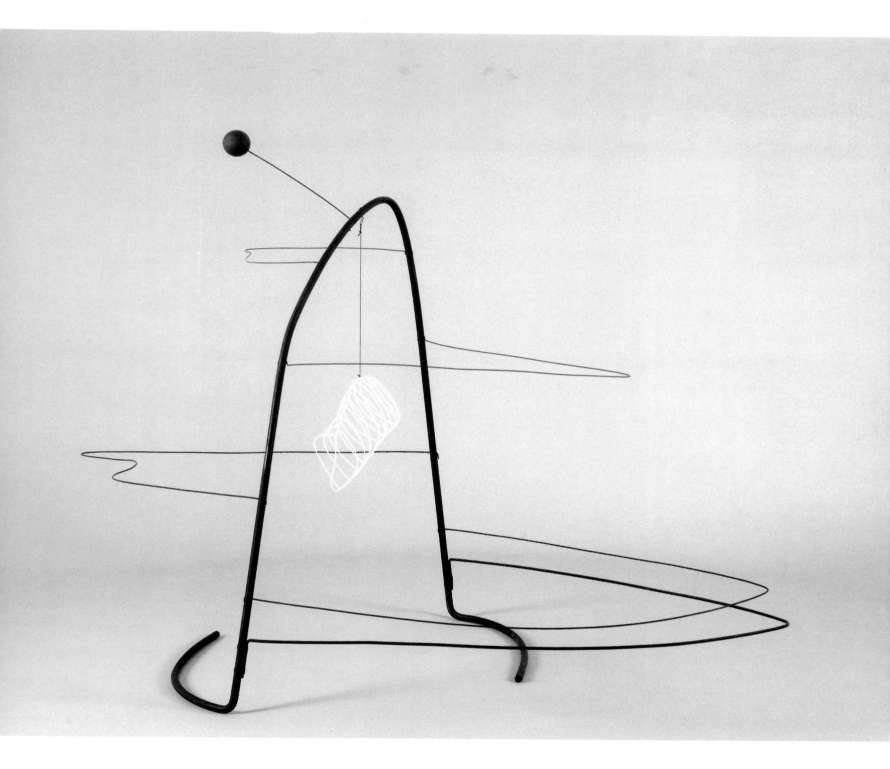

70

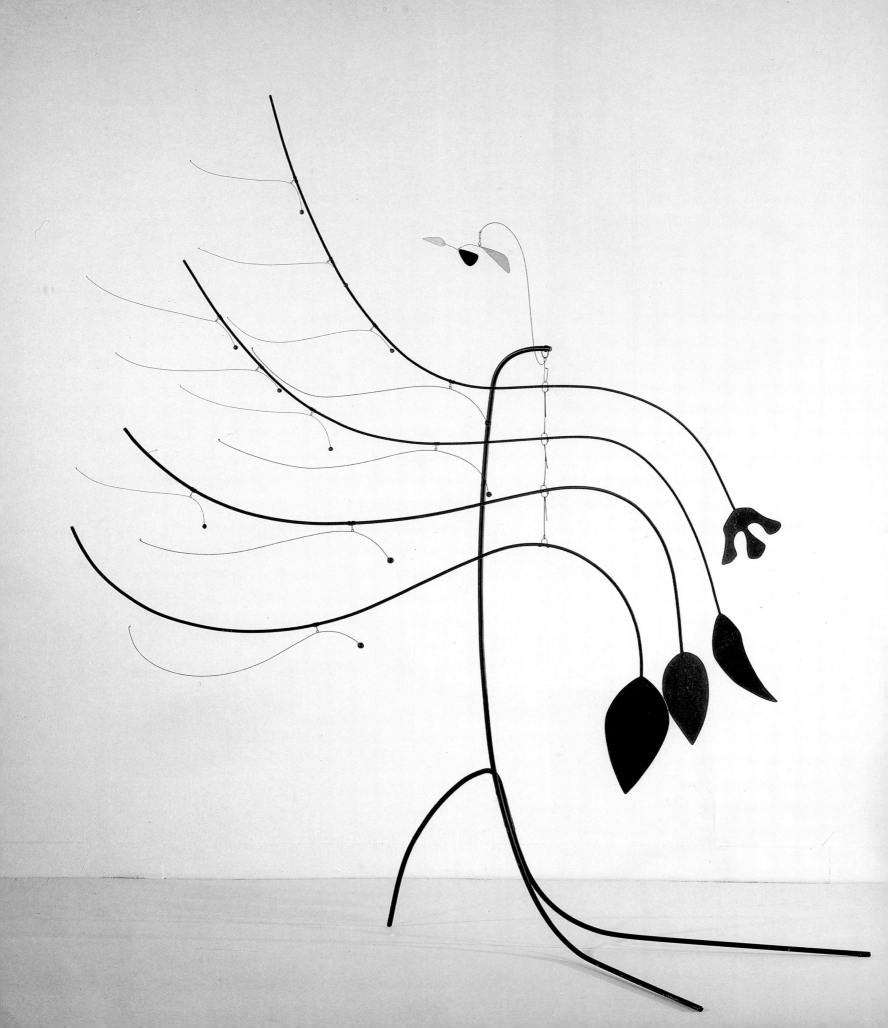

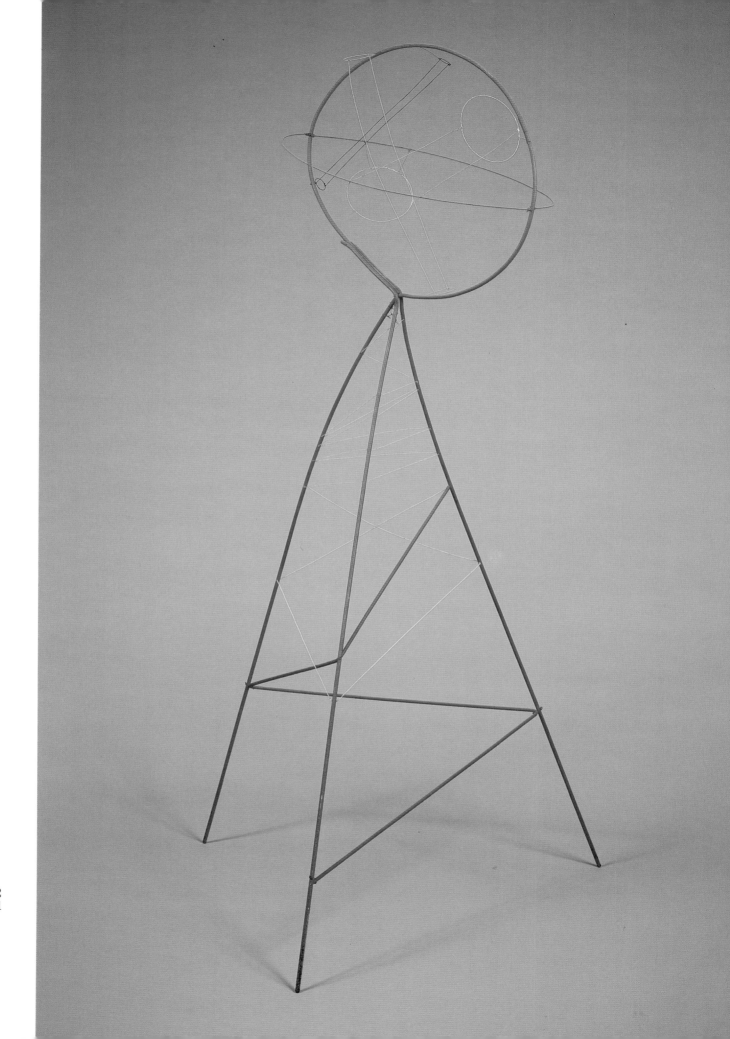

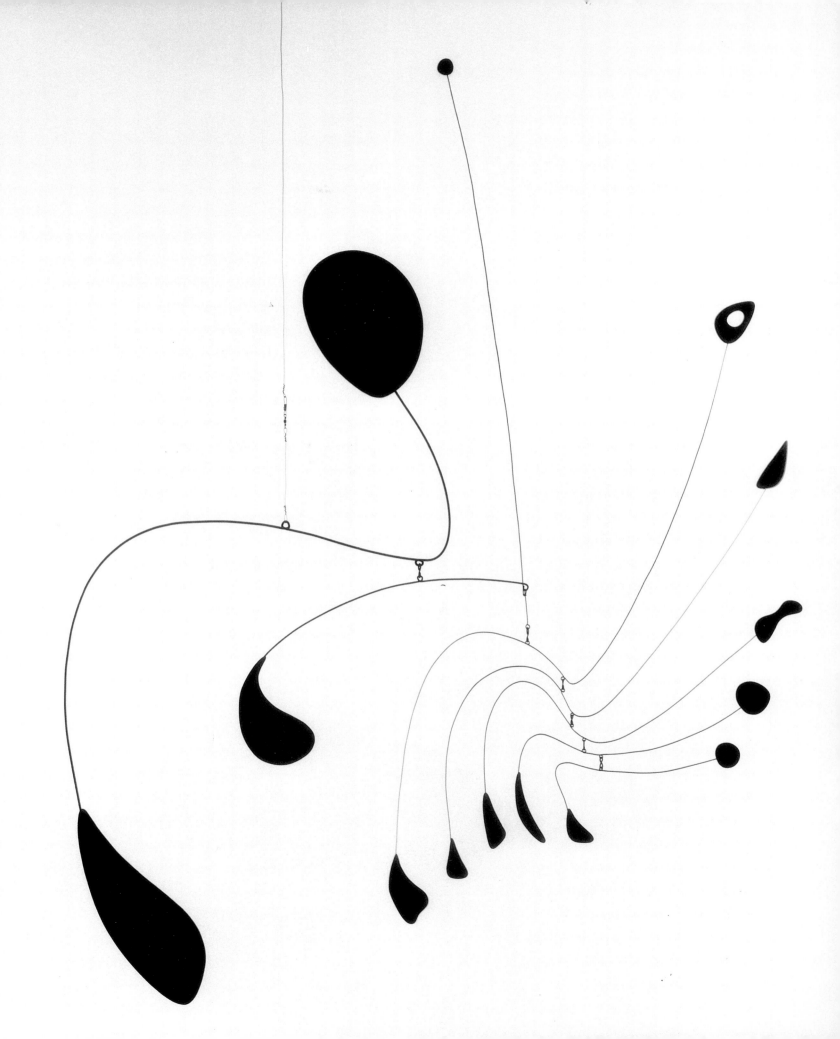

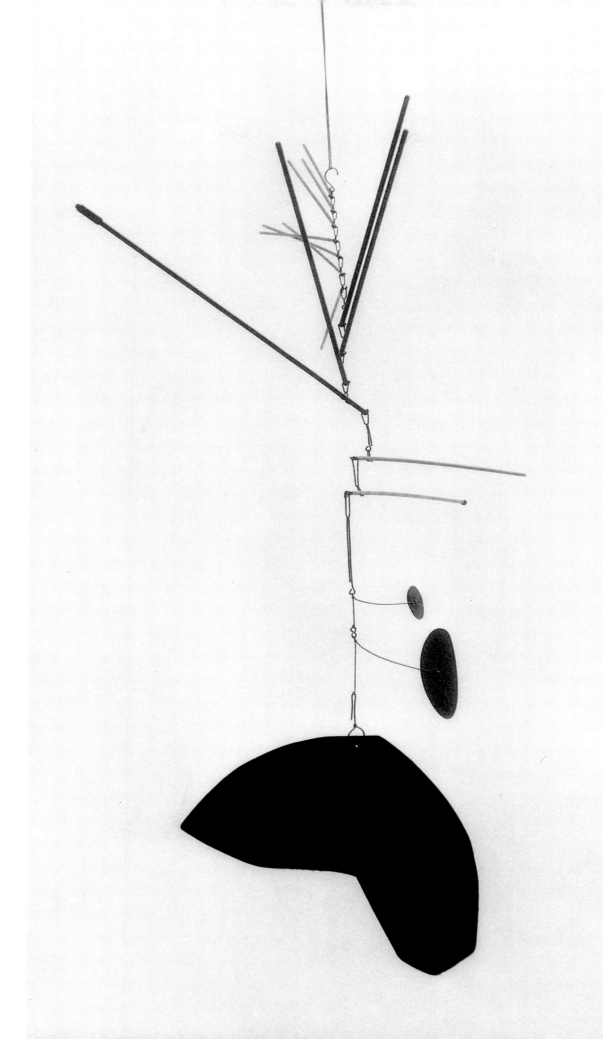

74
< 73

75 >

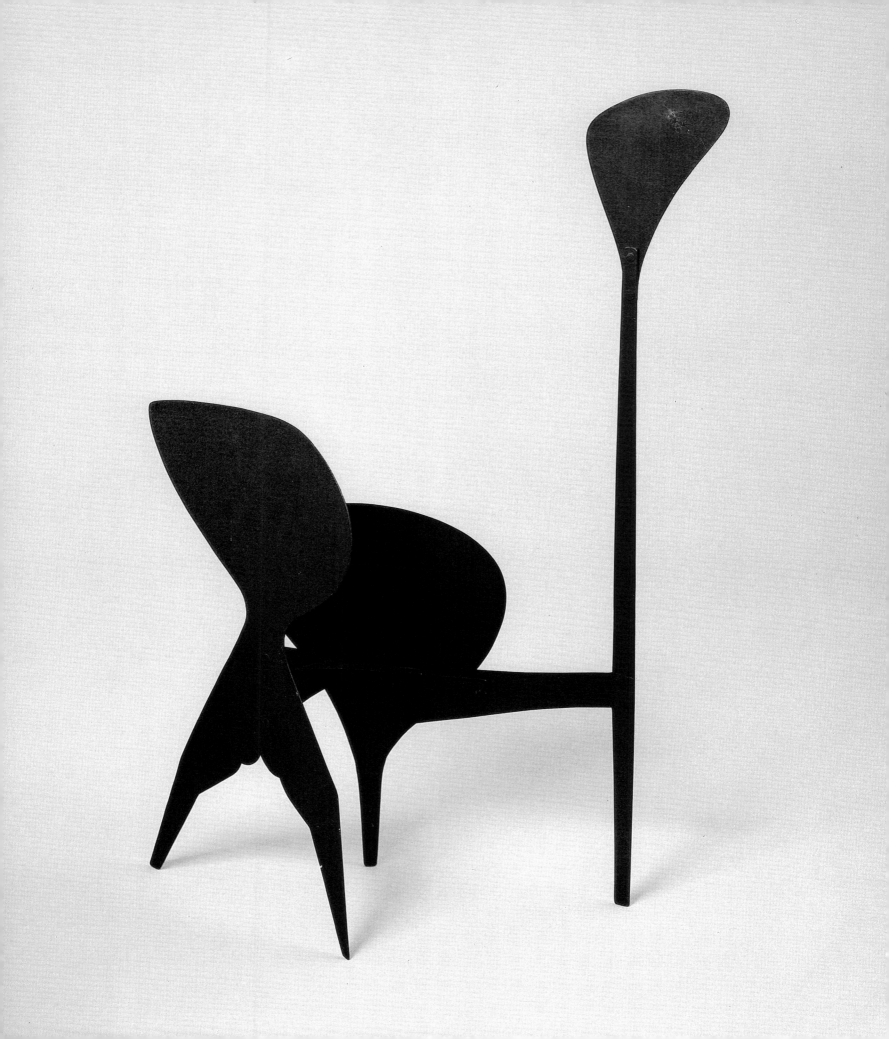

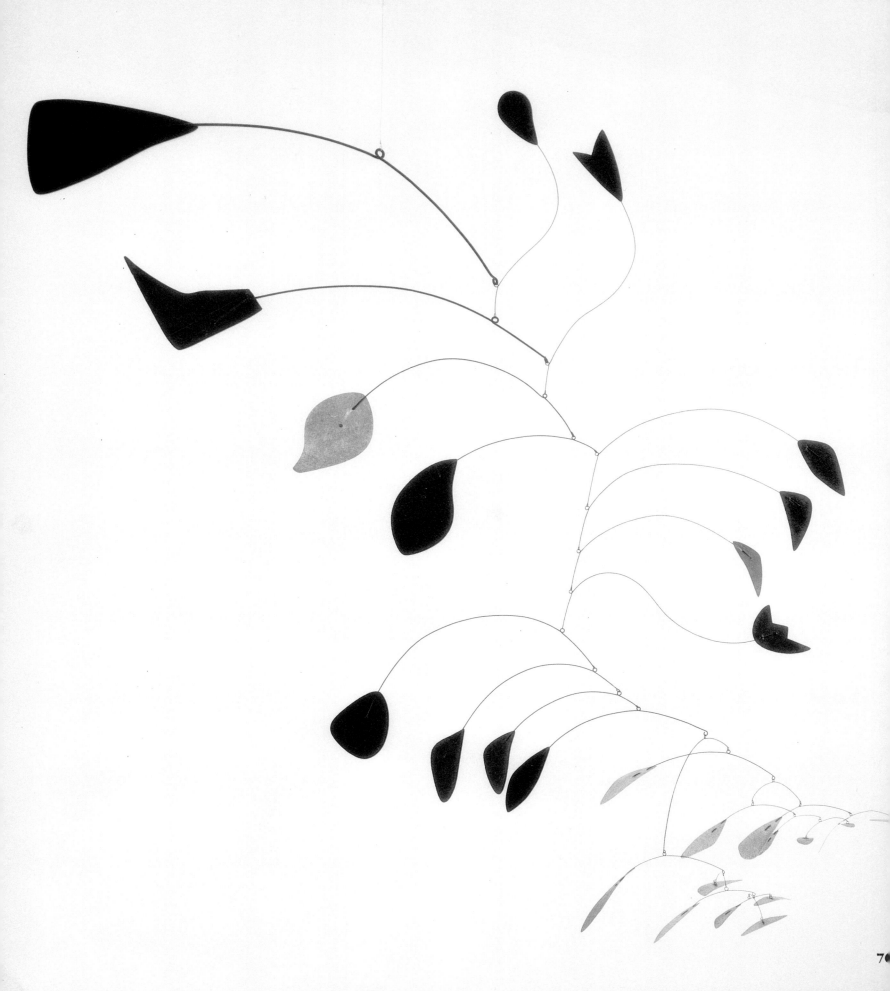

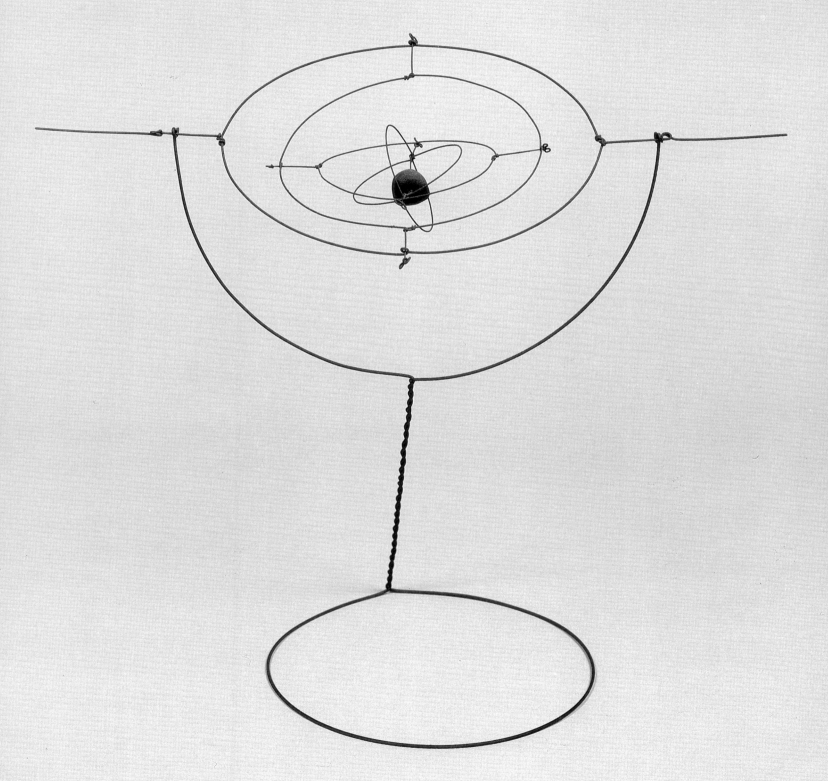

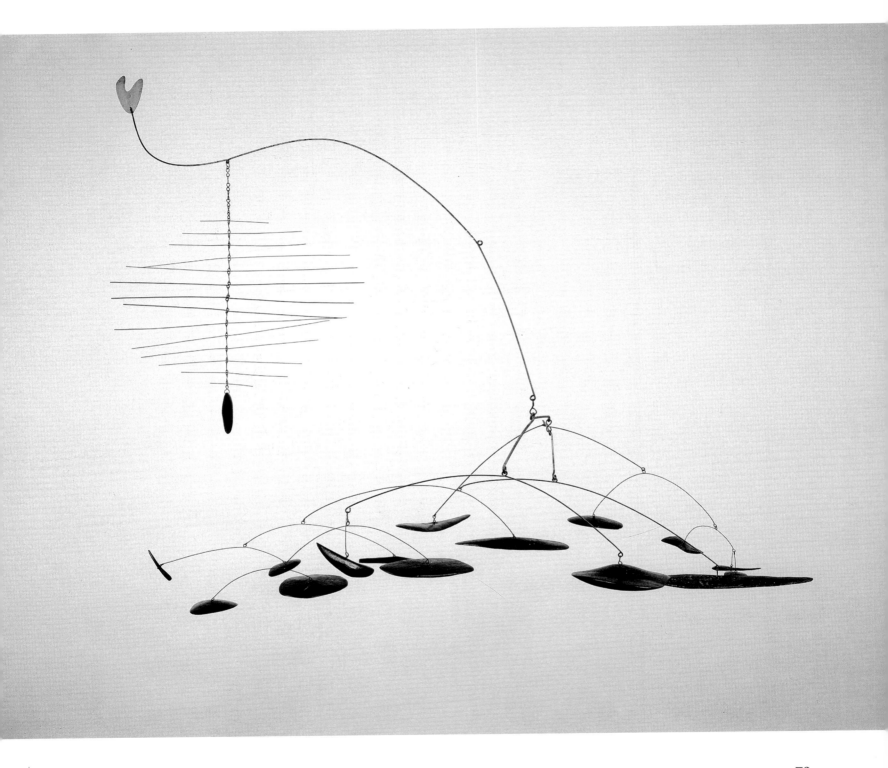

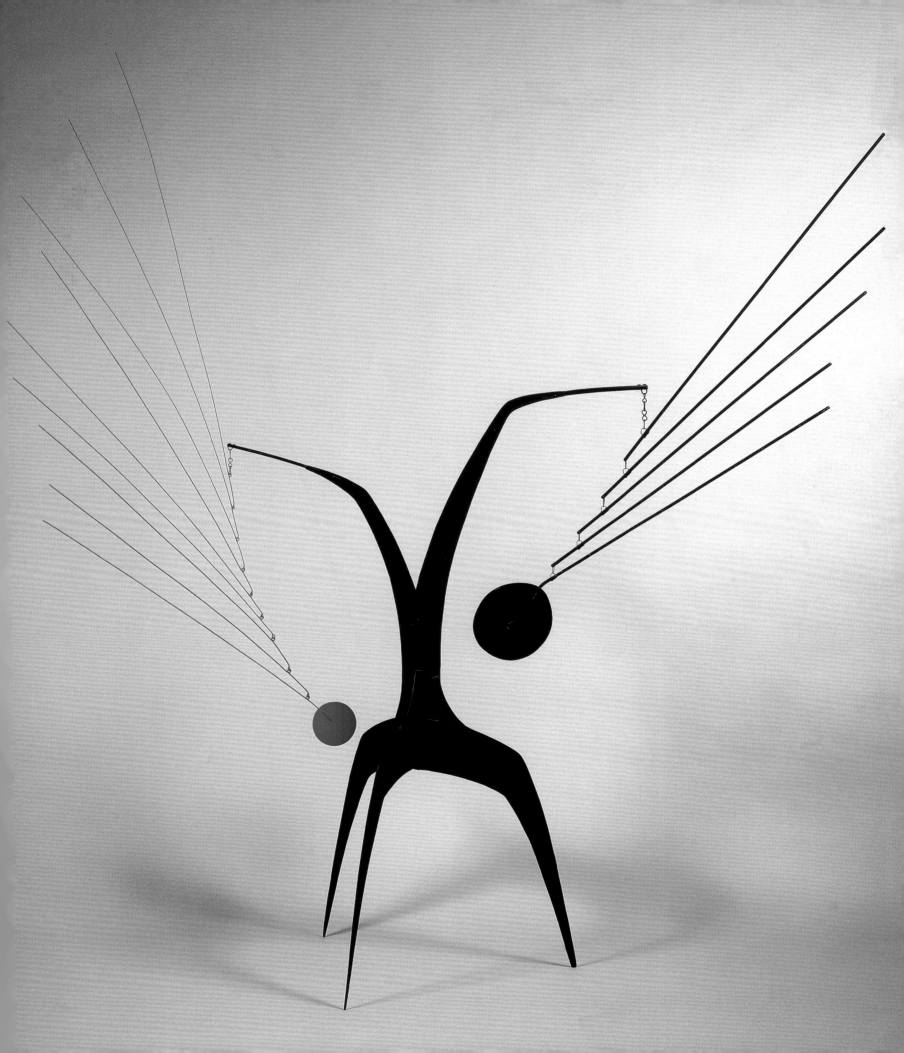

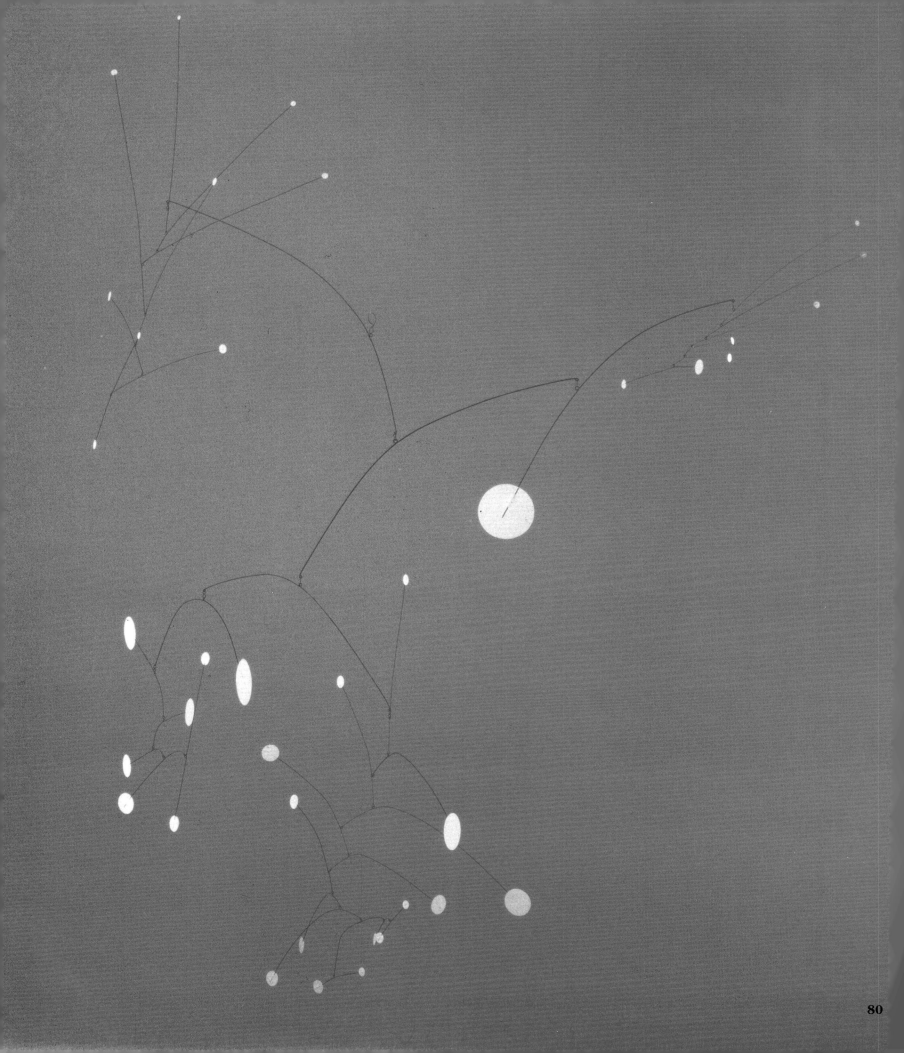

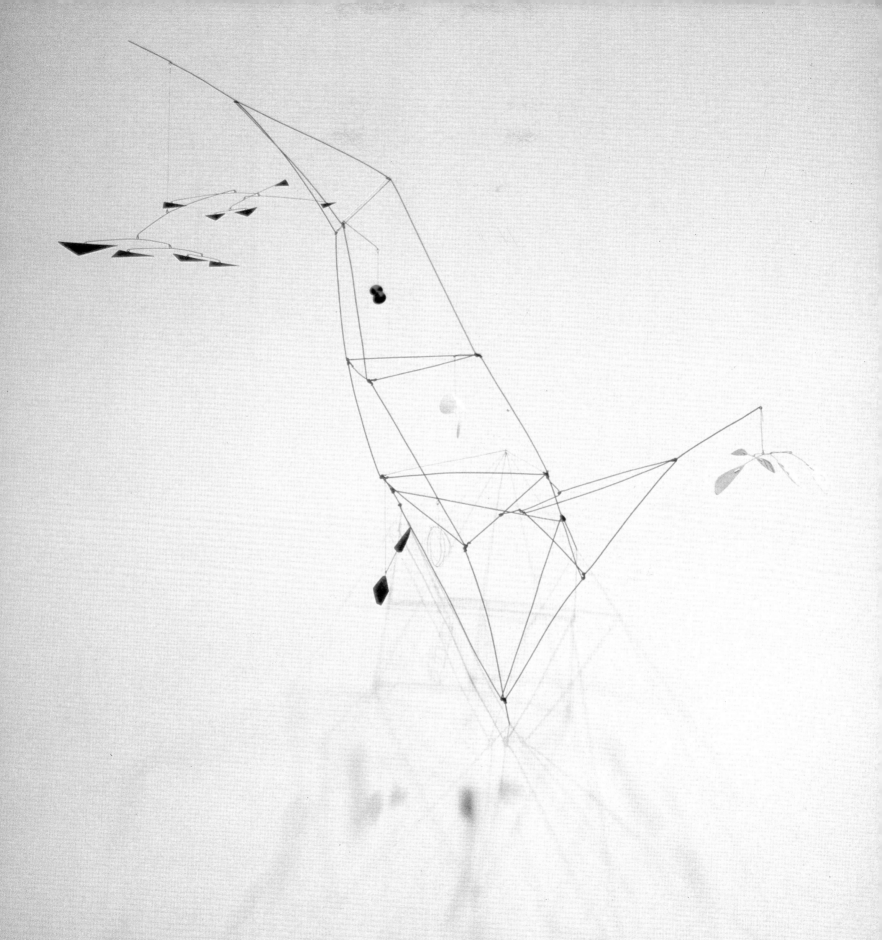

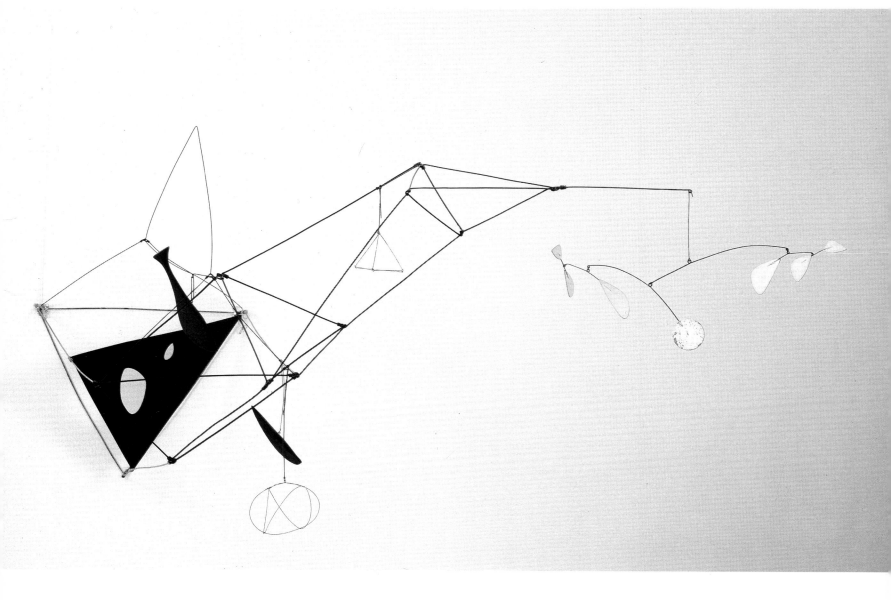

82

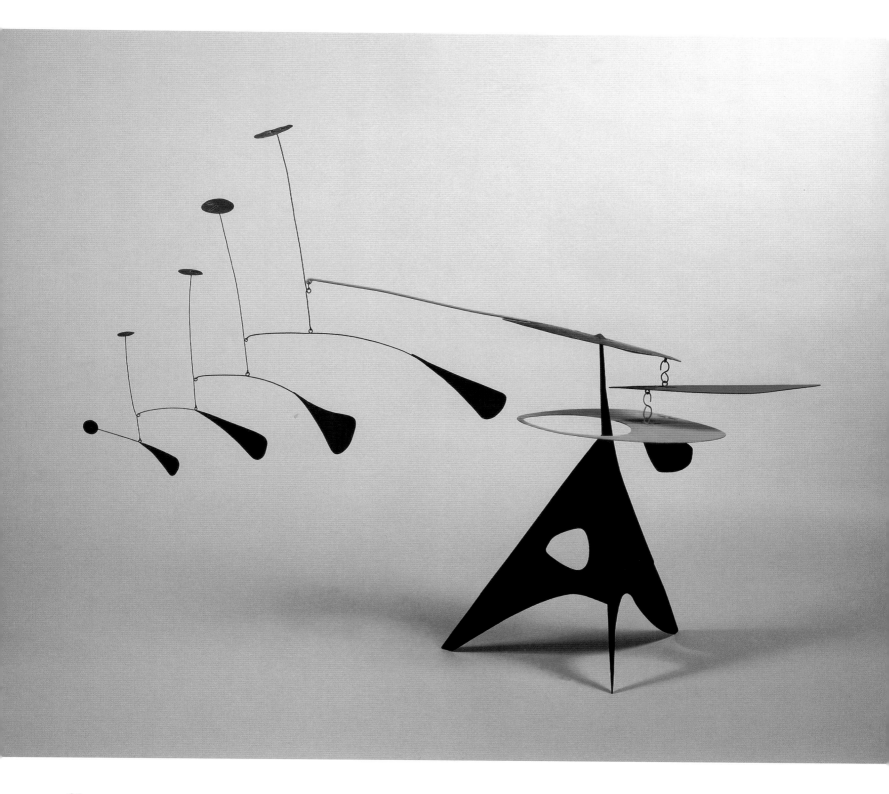

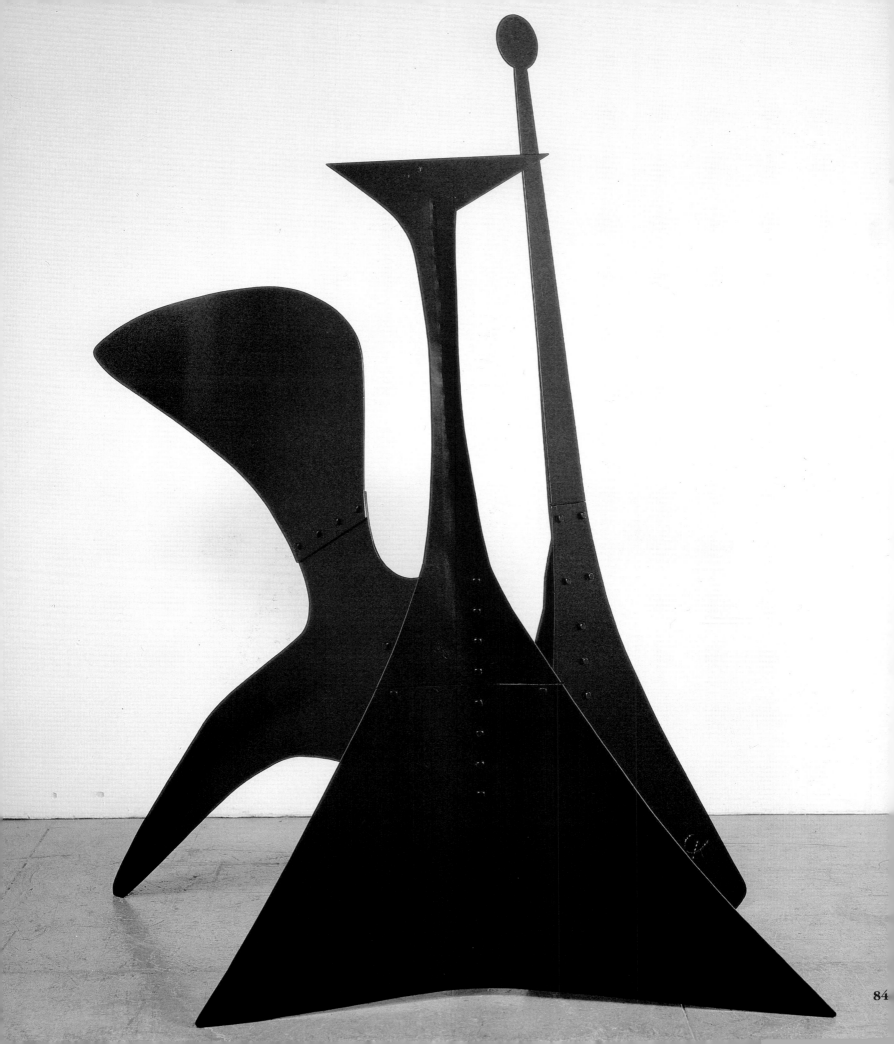

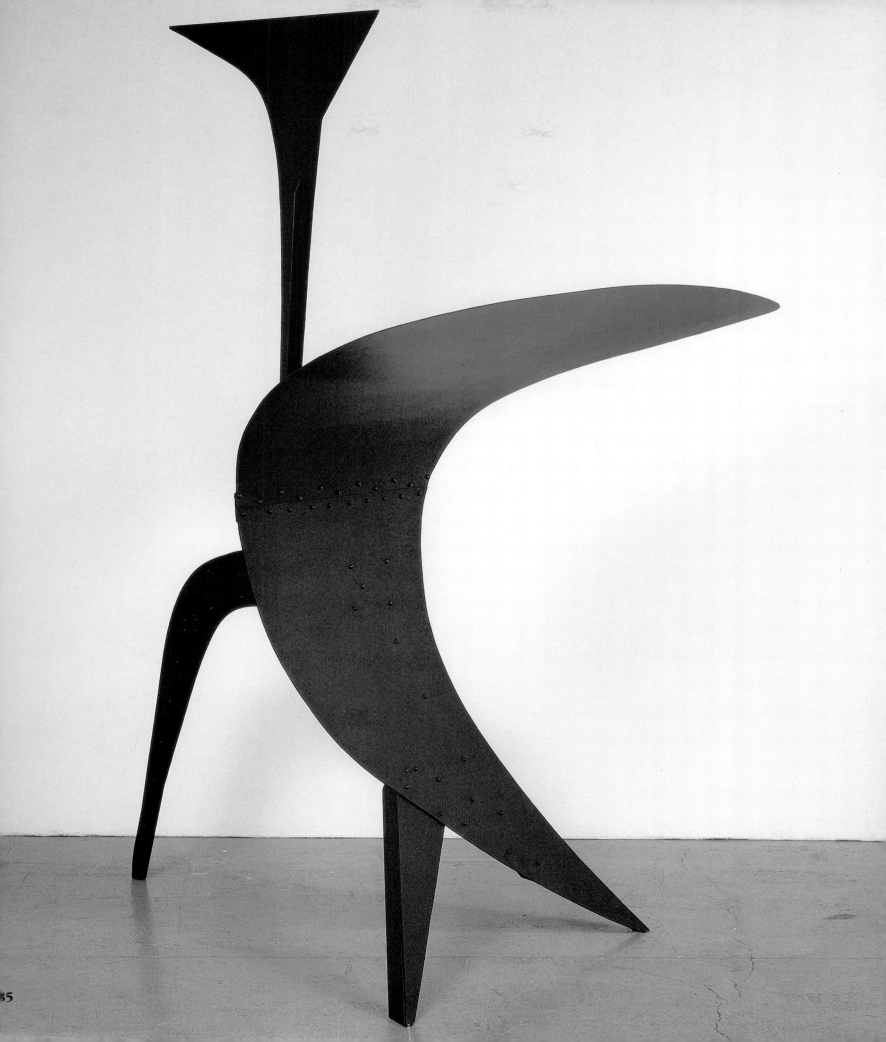

Alberto Giacometti

Alberto Giacometti's studio in Paris, ca. 1960.

86. *Spoon Woman (Femme-cuiller)*
1926
Bronze
143.8 x 51.4 x 21.6 cm (56 ⅝ x 20 ¼ x 8 ½ inches)
Number three of an edition of six; signed on reverse: *A. Giacometti*;
on reverse of base: *Alberto Giacometti 3/6*; not dated
Solomon R. Guggenheim Museum, New York 55.1414

87. *Composition (Man and Woman)*
(Composition [Homme et femme])
1927-28
Bronze
39.5 x 45.5 x 15 cm (15 ⁹⁄₁₆ x 17 ¹⁵⁄₁₆ x 5 ⅞ inches)
Signed on reverse of base: *Alberto Giacometti E/₁*; engraved on reverse
of base: *Cire/Pastori/Perdue*
Collection of E. W. Kornfeld, Bern

88. *Man and Woman (Homme et femme)*
1928-29
Bronze
40 x 40 x 16.5 cm (15 ¾ x 15 ¾ x 6 ½ inches)
Unique work
Musée national d'art moderne,
Centre Georges Pompidou, Paris,
Bequest, 1984

89. *Reclining Woman Who Dreams (Femme couchée qui rêve)*
1929
Painted bronze
24 x 43 x 13.5 cm (9 ⁷⁄₁₆ x 16 ¹⁵⁄₁₆ x 5 ⁵⁄₁₆ inches)
Number zero of an edition of six; signed on reverse of base,
right: *Alberto Giacometti ⁰⁄₆*
Kunsthaus Zürich,
Property of the Alberto Giacometti Foundation GS 17

90. *Man (Apollo) (Homme [Apollon])*
1929
Bronze
40 x 30.5 x 8.5 cm (15 ¼ x 12 x 3 ⅜ inches)
Number two of an edition of six; signed and dated in lower bar,
reverse: *²⁄₆ Alberto Giacometti 1929*
Kunstmuseum Basel,
Property of the Alberto Giacometti Foundation GS 18

91. *Reclining Woman (Femme couchée)*
1929
Bronze
27 x 44 x 16 cm (10 ⅝ x 17 ⁵⁄₁₆ x 6 ⁵⁄₁₆ inches)
Number one of an edition of six; signed and dated on reverse of base,
right: *Alberto Giacometti 1929 ¹⁄₆*
Kunstmuseum Winterthur,
Alberto Giacometti Foundation GS 16

92. *Woman with Her Throat Cut (Femme égorgée)*
1932 (cast 1940)
Bronze
23.2 x 89 cm (9 ⅛ x 35 ¹⁄₁₆ inches)
Solid cast; number one of an edition of six; foundry: Alexis Rudier,
Paris, no foundry mark; not signed, dated, or numbered
Peggy Guggenheim Collection, Venice 76.2553 PG131

93. *Nose (Le Nez)*
1947
Bronze, wire, rope, and steel
81 x 39.1 x 48.3 cm (31 ⅞ x 15 ⅜ x 19 inches) overall;
head 43.2 x 8.1 x 69.2 cm (17 x 3 ³⁄₁₆ x 27 ¼ inches)
Signed on bottom: *Alberto Giacometti/⁵⁄₆/Susse Fondeur/Paris*; not dated
Solomon R. Guggenheim Museum, New York 66.1807

94. *The Cage (First Version) (La Cage [Première Version])*
1950
Bronze
91.1 x 36.5 x 34 cm (35 ⅞ x 14 ⅜ x 13 ⅜ inches)
Number two of an edition of eight; engraved: *Susse Fondeur Paris*
Galerie Beyeler, Basel

95. *The Cage (Woman and Head) (La Cage [Femme et tête])*
1950
Bronze, with painted figures
170 x 34 x 32 cm (66 ¹⁵⁄₁₆ x 13 ⅜ x 12 ⅝ inches)
Number five of an edition of six; signed upper right:
Alberto Giacometti ⁵⁄₆, engraved: *Alexis Rudier Fondeur, Paris*
Musée de Grenoble

96. *The Capsizing Man (L'Homme qui chavire)*
1950
Bronze
60 x 14 x 32.5 cm (23 ⅝ x 5 ½ x 12 ⅝ inches)
Number three of an edition of six; signed and numbered;
engraved: *Alexis Rudier Fondeur, Paris*
Private collection, Courtesy Galerie Beyeler, Basel

97. *Chariot (Chariot)*
1950
Bronze
167 x 61.9 x 70 cm (65 ¼ x 24 ⅜ x 27 ½ inches)
Number six of an edition of six; signed: *A. Giacometti ⁶⁄₆*
Collection of Denise and Andrew Saul

98. *Walking Man (L'Homme qui marche)*
1960
Bronze
192 x 28 x 111 cm (75 ⅝ x 11 x 43 ¼ inches)
Stamped and signed on base
Louisiana Museum, Humlebaek, Denmark,
Gift of Ny Carlsbergfondet

86 >

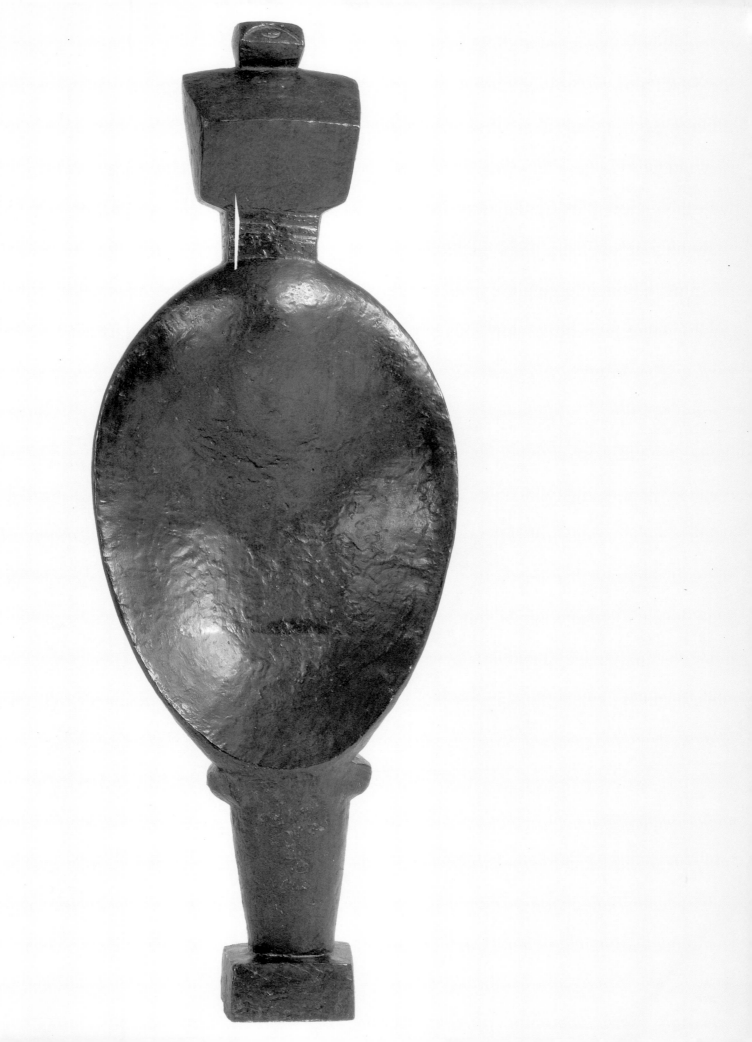

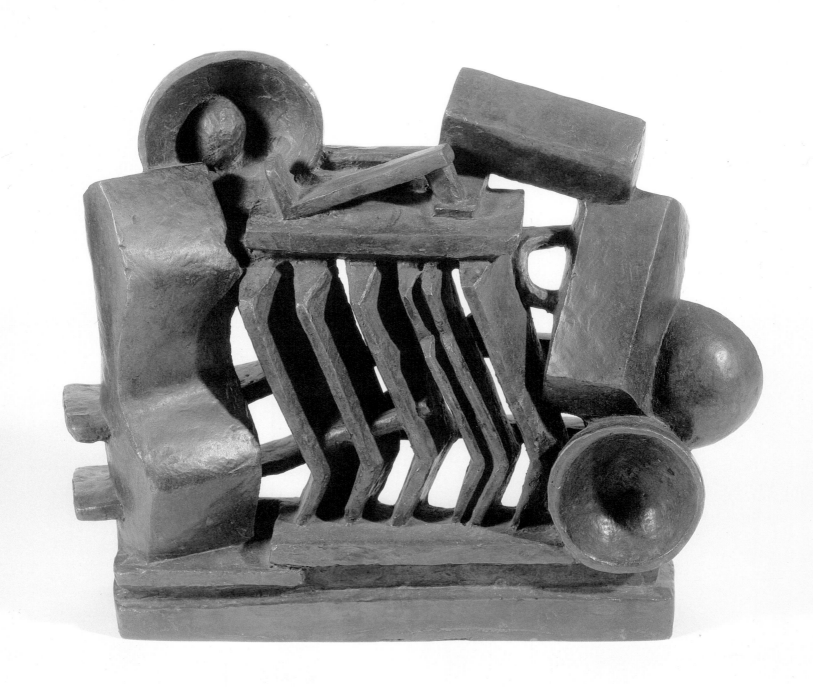

87
88 >

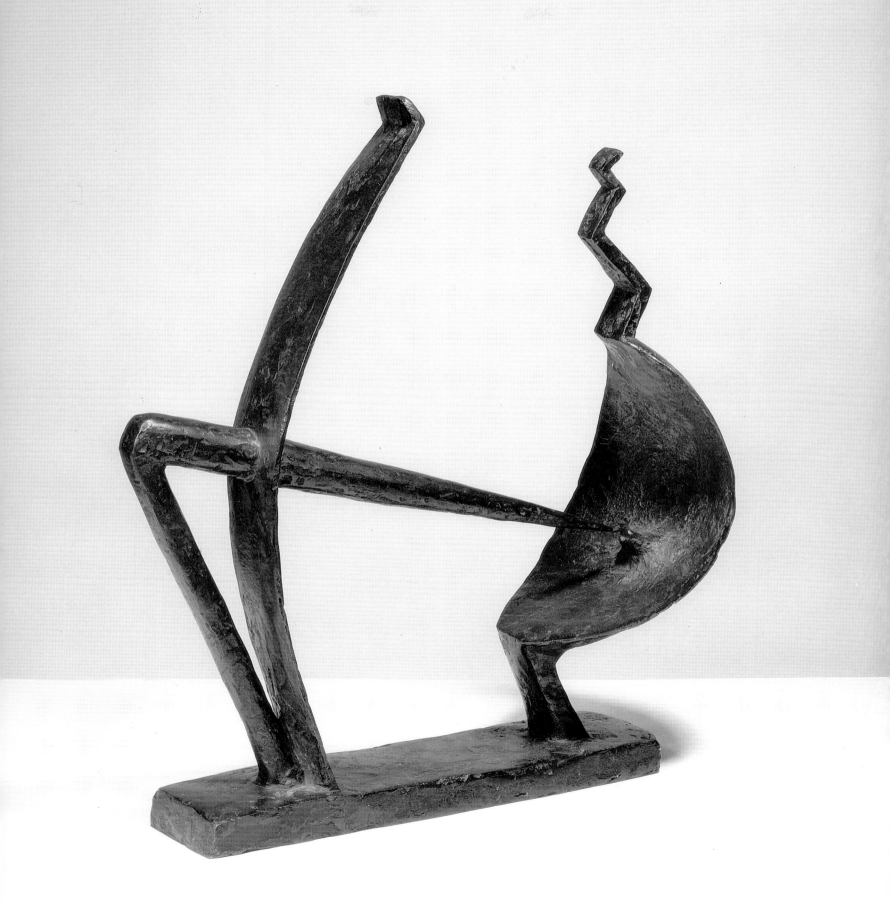

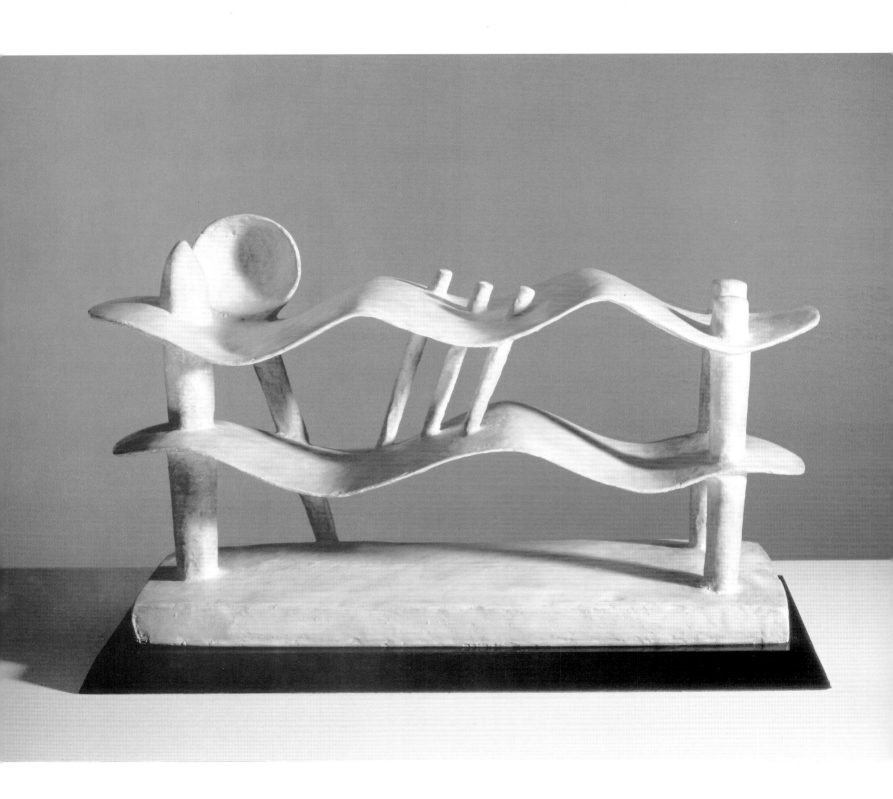

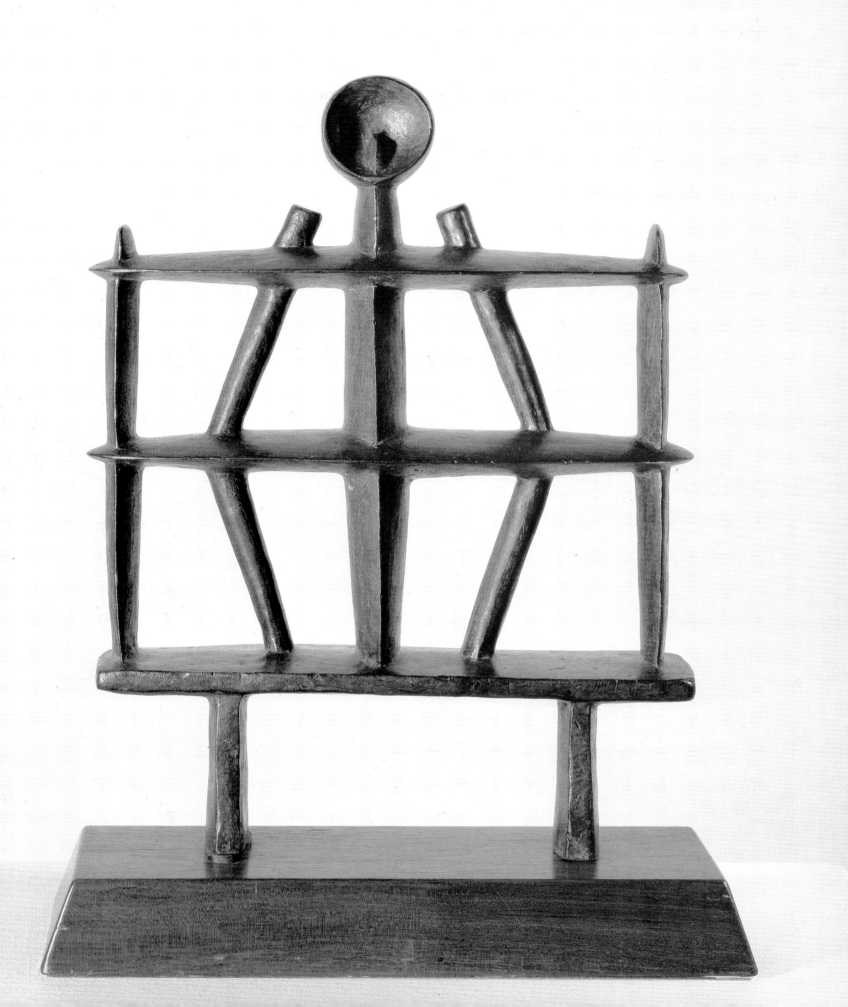

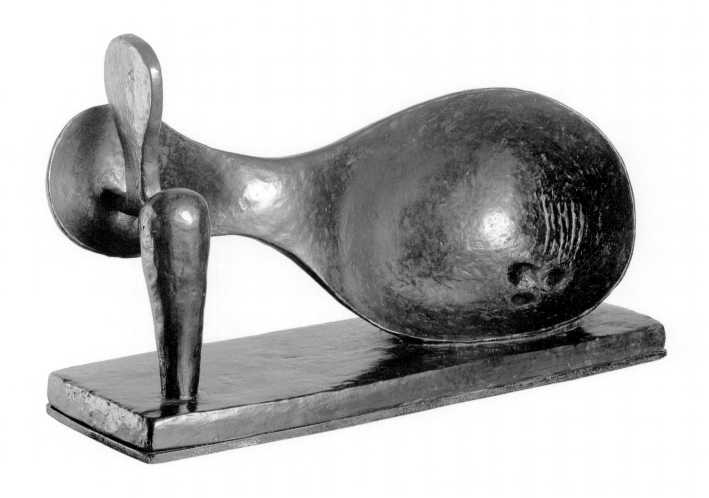

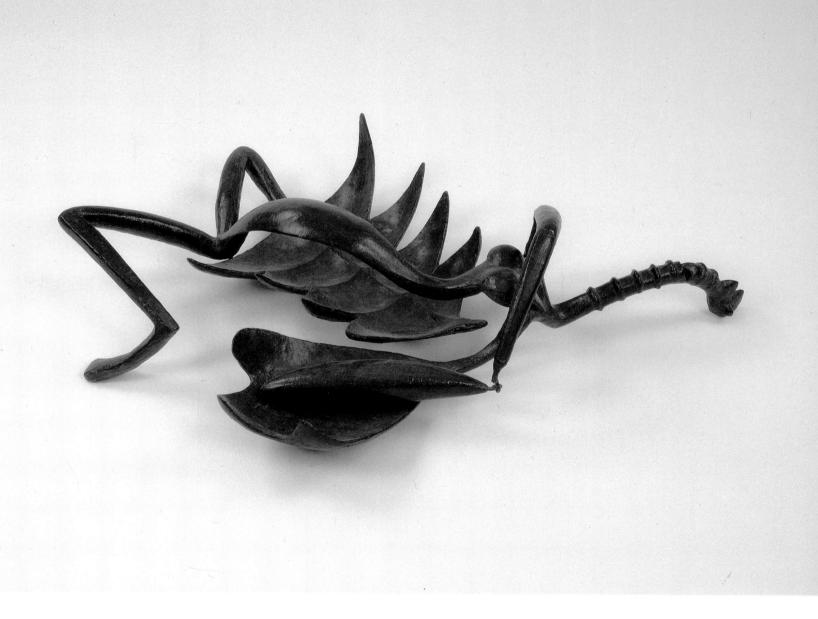

94
93 >

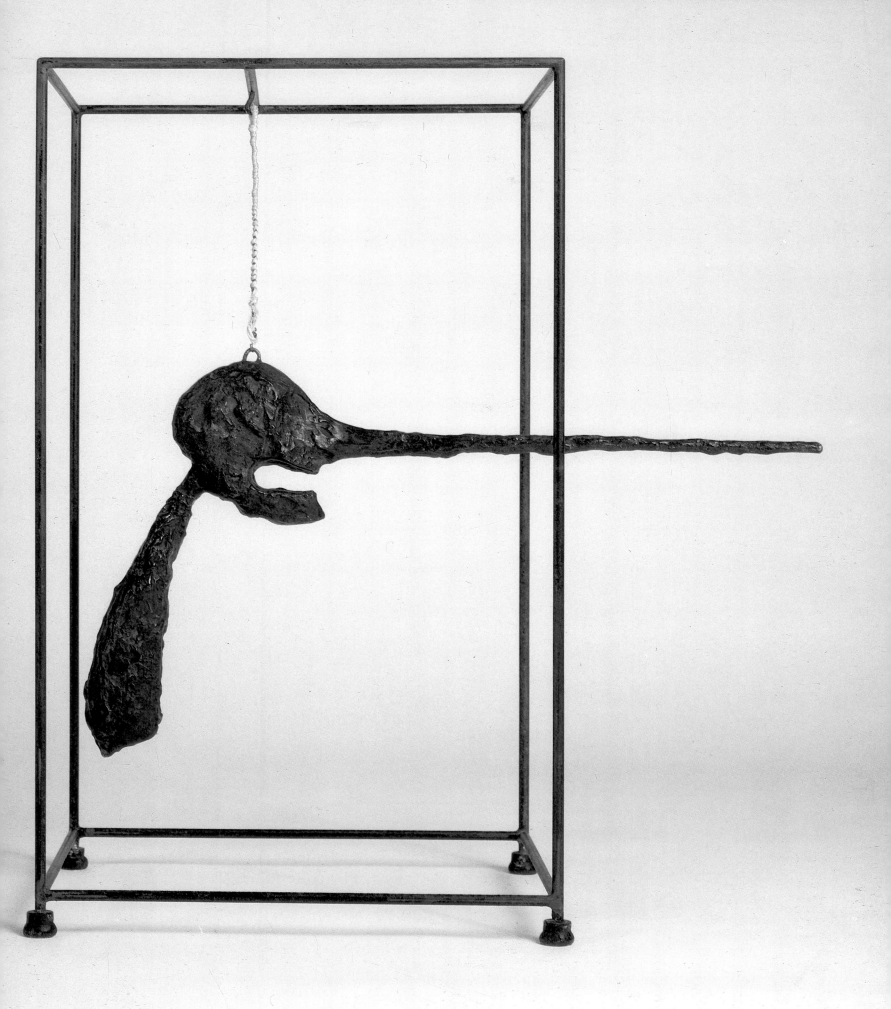

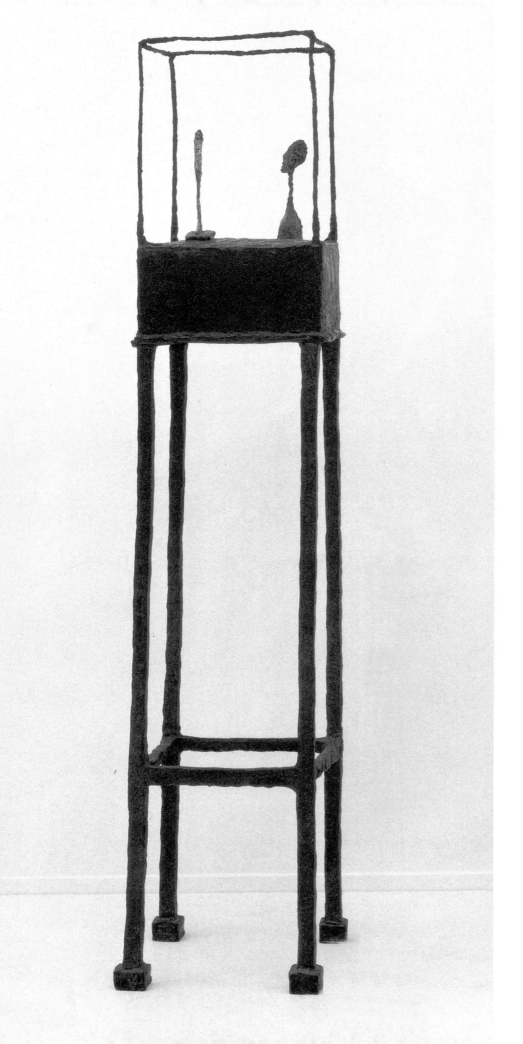

95

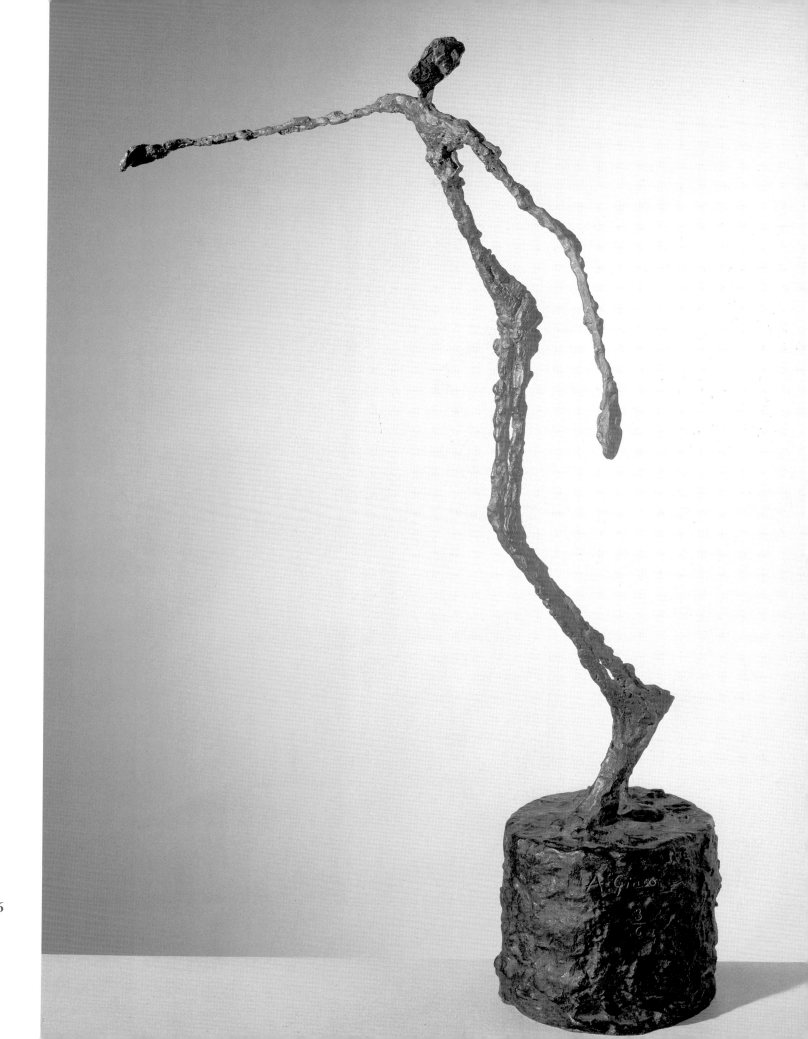

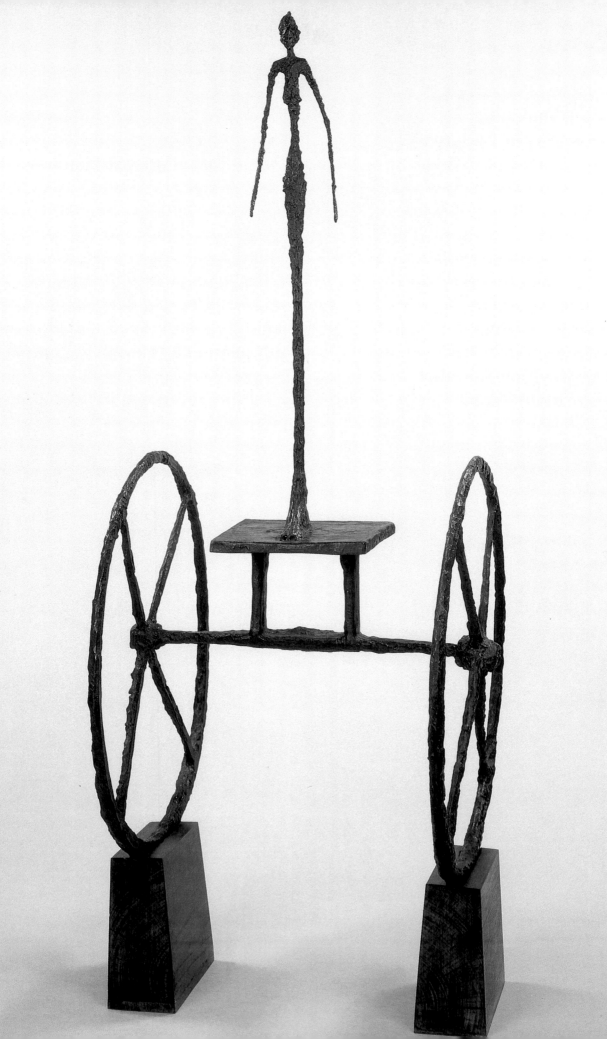

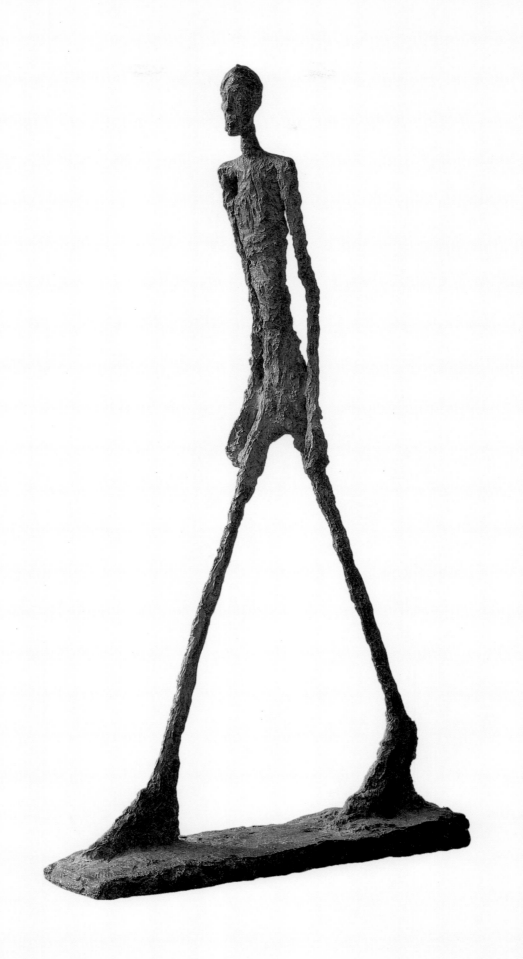

98
< 97

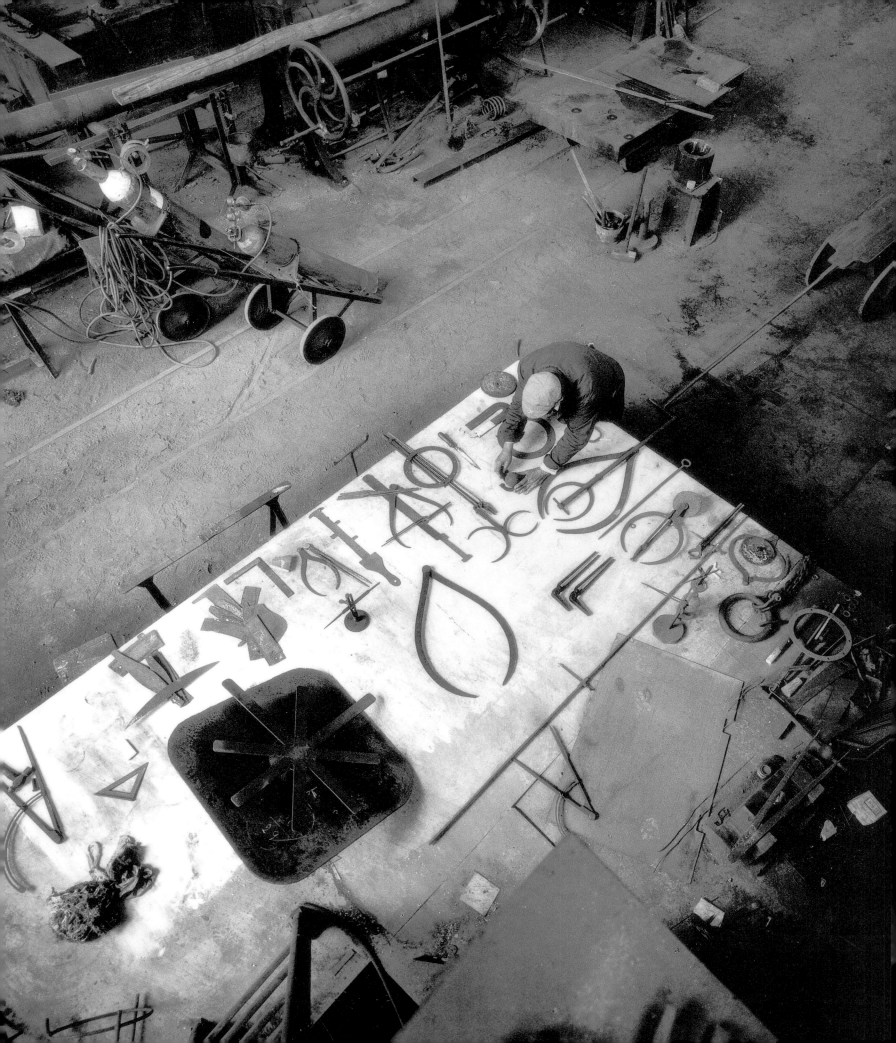

David Smith

David Smith's studio in Voltri, Italy, 1962.

99. *Construction*
1932
Wood, wire, nails, and coral, painted red, blue,
and yellow
94.3 x 41.3 x 18.4 cm (37 ⅛ x 16 ¼ x 7 ¼ inches);
wood base 4.5 x 24.2 x 30.5 cm (1 ¾ x 9 ½ x 12 inches)
RK 8
Collection of Candida and Rebecca Smith

100. *Suspended Figure (Reclining Figure)*
1935
Iron
55.3 x 69.9 x 26 cm (21 ¾ x 27 ½ x 10 ¼ inches)
RK 41
Courtesy of André Emmerich Gallery, New York

101. *Aerial Construction*
1936
Iron and painted terra-cotta
25.1 x 78.4 x 29 cm (9 ⅞ x 30 ⅞ x 11 ⁷⁄₁₆ inches)
RK 43
Hirshhorn Museum and Sculpture Garden,
Smithsonian Institution, Washington, D.C.,
Gift of Joseph H. Hirshhorn, 1972

102. *Construction in Bent Planes*
1936
Iron
34.9 x 15.2 x 76.2 cm (13 ¾ x 6 x 30 inches)
RK 45
Collection of Mr. and Mrs. Samuel H. Lindenbaum

103. *Billiard Player Construction*
1937
Iron and encaustic
43.8 x 52.1 x 16.2 cm (17 ¼ x 20 ½ x 6 ⅜ inches);
wood base 5.1 x 40.6 x 15.2 cm (2 x 16 x 6 inches)
RK 53
Collection of Dr. and Mrs. Arthur E. Kahn

104. *Interior*
1937
Steel and bronze, painted with red oxide
39.3 x 66 x 15 cm (15 ½ x 26 x 5 ¹⁵⁄₁₆ inches);
wood base 8.6 x 67.3 x 13.3 cm (3 ⅜ x 26 ½ x 5 ¼ inches)
RK 58
The Weatherspoon Art Gallery,
University of North Carolina at Greensboro,
Anonymous Gift, 1979

RK: Rosalind Krauss, *The Sculpture of David Smith: A Catalogue Raisonné*
(New York, 1977).

105. *Amusement Park*
1938
Steel
57.5 x 55.5 x 15.3 cm (22 ⅝ x 21 ⅞ x 6 inches);
wood base 7.7 x 53.3 x 9.2 cm (3 x 21 x 3 ⅝ inches)
RK 77
New Orleans Museum of Art,
Gift of Mr. and Mrs. Walter Davis, Jr.,
in honor of the Museum's 75th Anniversary

106. *Interior for Exterior*
1939
Steel and bronze
45.7 x 55.9 x 59.1 cm (18 x 22 x 23 ¼ inches);
steel base 3.3 x 29.8 x 28.2 cm (1 ⁵⁄₁₆ x 11 ¾ x 11 ⅛ inches)
RK 122
Collection of Mr. and Mrs. Orin Raphael, Oakmont,
Pennsylvania

107. *Reclining Figure*
1939-40
Iron rods and steel
24.1 x 43.2 x 20.3 cm (9 ½ x 17 x 8 inches)
RK 123
Collection of Dr. and Mrs. Arthur E. Kahn

108. *Home of the Welder*
October 1945
Steel
53.3 x 43.8 x 35.6 cm (21 x 17 ⅛ x 14 inches)
RK 108
Tate Gallery, London,
Lent from the collection of Candida and Rebecca Smith,
1984

109. *Steel Drawing I*
1945
Steel
66.1 x 56.5 x 15.3 cm (26 x 22 ¼ x 6 inches)
RK 190
Hirshhorn Museum and Sculpture Garden,
Smithsonian Institution, Washington, D.C.,
Gift of Joseph H. Hirshhorn, 1966

110. *Aggressive Character*
1947
Stainless steel and wrought iron
82.5 x 10 x 19 cm (32 ½ x 4 x 7 ½ inches);
wood base 4.45 x 17.78 x 20.96 cm (1 ¾ x 7 x 8 ¼ inches)
RK 212
National Gallery of Art, Washington, D.C.,
Lent from the collection of Candida and Rebecca Smith

111. *Blackburn, Song of an Irish Blacksmith*
1949-50
Steel and bronze
117 x 103.5 x 59 cm (46 ¹/₁₆ x 40 ³/₄ x 24 ¹/₄ inches);
stone base 20.3 cm (8 inches) high, 18.4 cm (7 ¹/₄ inches) in diameter
RK 228
Wilhelm Lehmbruck Museum, Duisburg, Germany

112. *Cathedral*
1950
Steel, with brown paint
86.5 x 62 x 43.5 cm (34 ¹/₈ x 24 ¹/₂ x 17 ¹/₈ inches)
RK 229
Private collection, New York

113. *The Letter*
1950
Welded steel
95.6 x 58.1 x 23.5 cm (37 ⁵/₈ x 22 ⁷/₈ x 9 ¹/₄ inches)
RK 232
Munson-Williams-Proctor Institute Museum of Art,
Utica, New York

114. *Star Cage*
1950
Various metals, welded, painted dark blue
114 x 130.2 x 65.4 cm (44 ⁷/₈ x 51 ¹/₄ x 23 ³/₄ inches)
RK 238
The Frederick R. Weisman Art Museum, University of
Minnesota, Minneapolis,
Purchase, John Rood Sculpture Collection Fund

115. *Hudson River Landscape*
May 8, 1951
Welded steel
125.7 x 190.5 x 42.5 cm (49 ¹/₂ x 75 x 16 ¹/₄ inches)
RK 257
Whitney Museum of American Art, Purchase

116. *Agricola V*
July 1952
Steel
90.2 x 71.1 cm (35 ¹/₂ x 28 inches)
RK 269
Collection of Barbara and Eugene Schwartz, New York

117. *Agricola IX*
August 1952
Steel
93 x 145 x 50 cm (36 ⁵/₈ x 57 ¹/₁₆ x 19 ³/₄ inches)
RK 273
Tate Gallery, London, Lent from the collection of
Candida and Rebecca Smith, 1984

118. *The Hero (Eyehead of a Hero)*
1951-52
Painted steel
187.3 x 64.8 x 29.8 cm (73 ³/₄ x 25 ¹/₂ x 11 ³/₄ inches)
RK 256
The Brooklyn Museum, New York,
Dick S. Ramsay Fund

119. *Parallel 42*
1953
Steel
136 x 66 x 48.3 cm (53 ¹/₂ x 26 x 19 inches)
RK 300
Collection of Candida and Rebecca Smith

120. *Sentinel I*
October 30, 1956
Steel
227.6 x 42.9 x 57.5 cm (89 ⁵/₈ x 16 ⁷/₈ x 22 ⁵/₈ inches)
RK 382
National Gallery of Art, Washington, D.C.,
Gift of the Collectors Committee 1979.51.1

121. *The Five Spring*
1956
Steel, stainless steel, and nickel
197 x 91.5 x 37.5 cm (36 x 14 ³/₄ x 77 ¹/₈ inches)
RK 366
Tate Gallery, London, Lent from the collection of
Candida and Rebecca Smith, 1984

122. *History of LeRoy Borton*
1956
Forged steel
224.5 x 67.9 x 62.2 cm (88 ¹/₄ x 26 ³/₄ x 24 ¹/₂ inches)
RK 371
The Museum of Modern Art, New York,
Mrs. Simon Guggenheim Fund, 1957

123. *Timeless Clock*
1957
Silver
53.3 x 68.6 x 30.5 cm (21 x 27 x 12 inches)
RK 436
Collection of Harry W. and Mary Margaret Anderson

124. *Voltri VII*
1962
Iron
215.8 x 311.6 x 110.5 cm (85 x 122 x 43 ¹/₂ inches)
RK 564
National Gallery of Art, Washington, D.C.,
Ailsa Mellon Bruce Fund

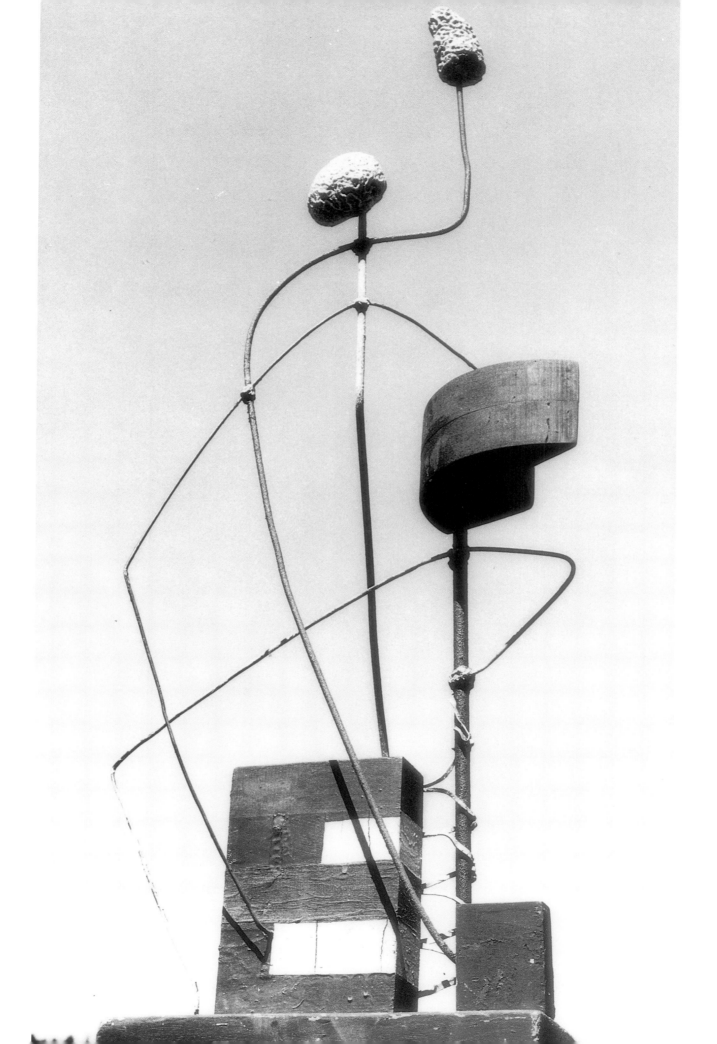

99

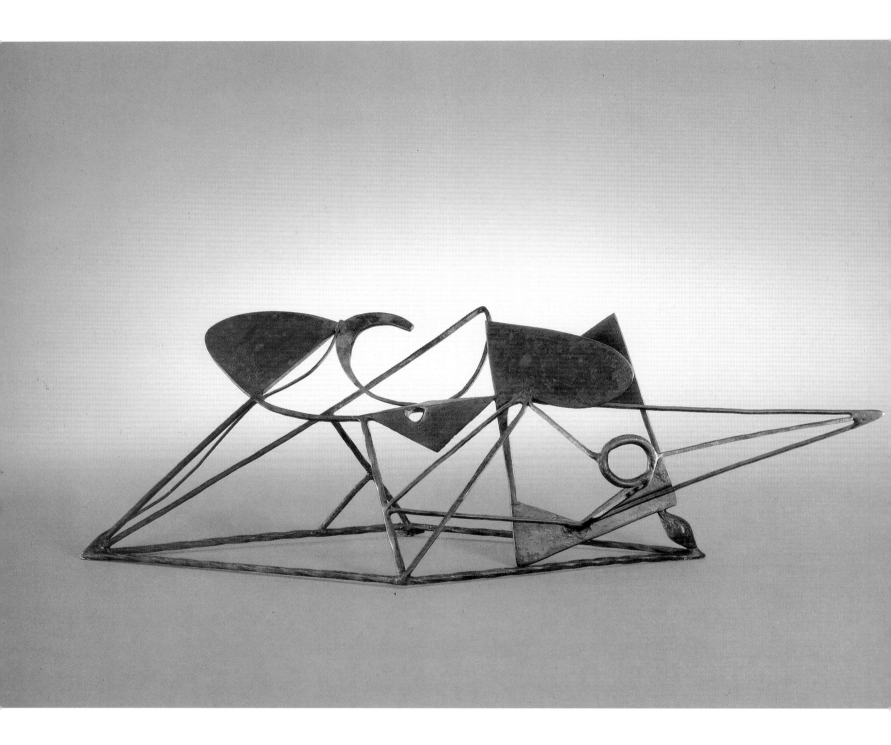

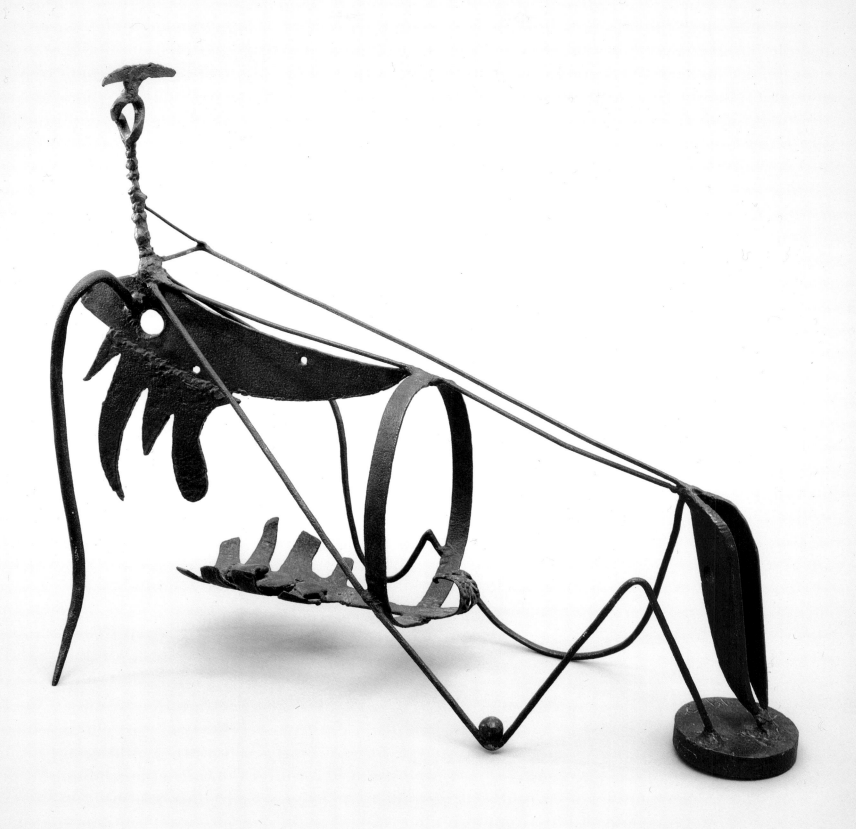

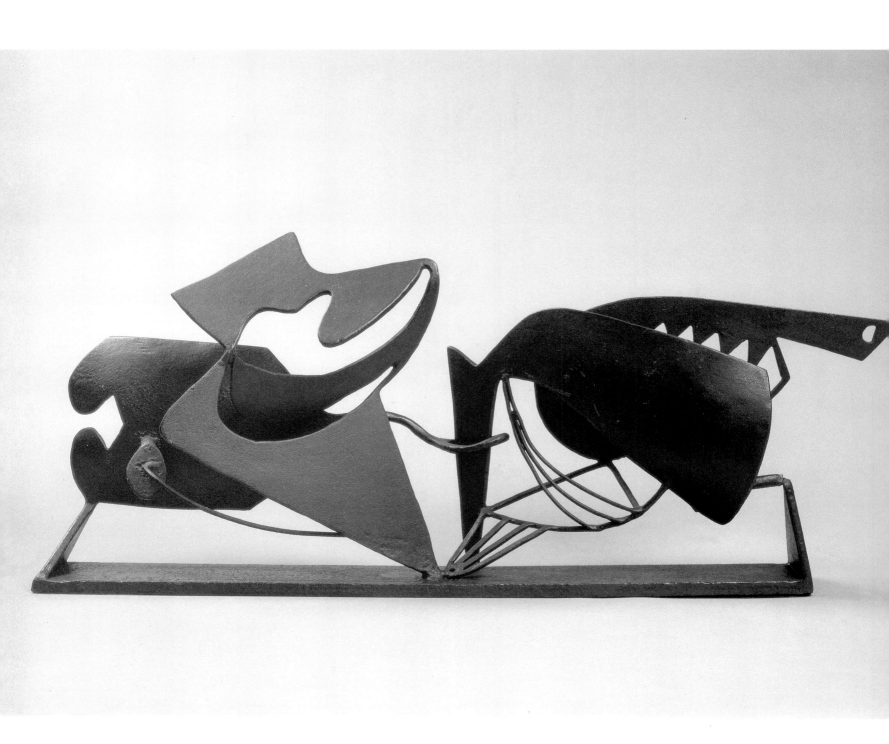

102

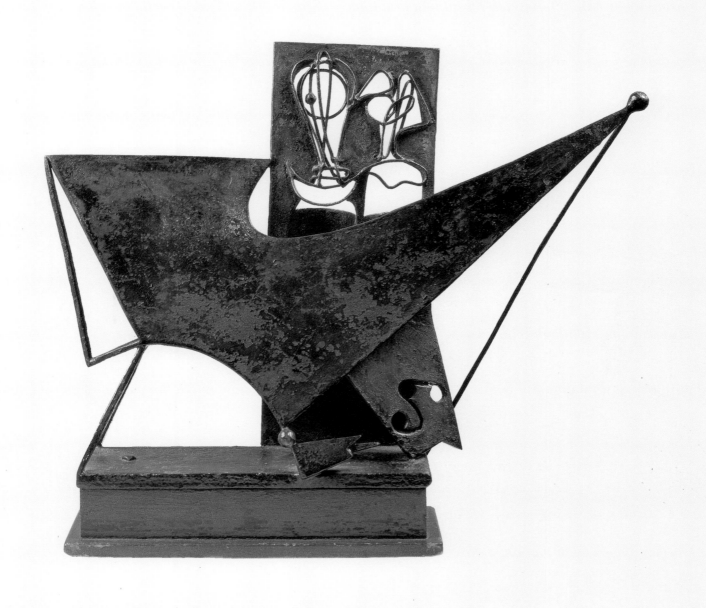

103

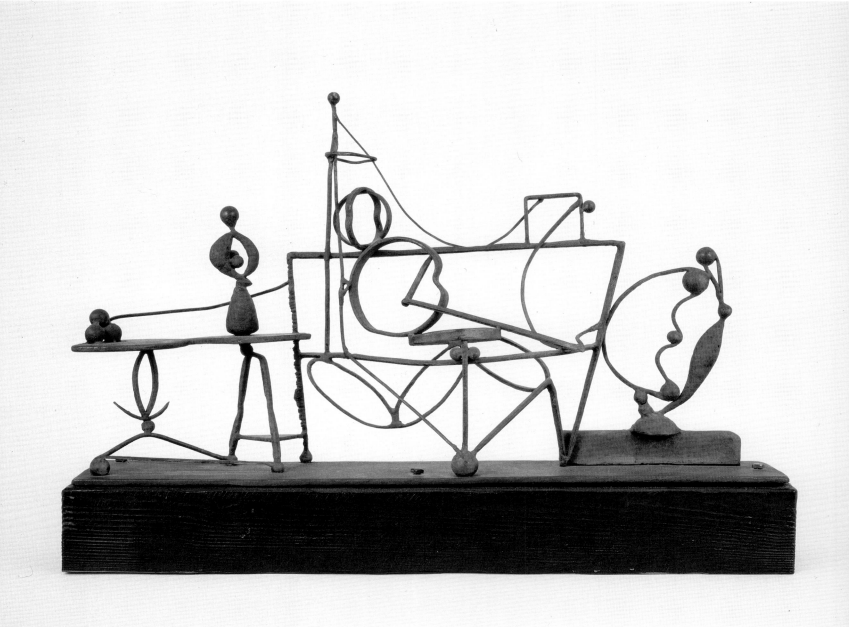

104

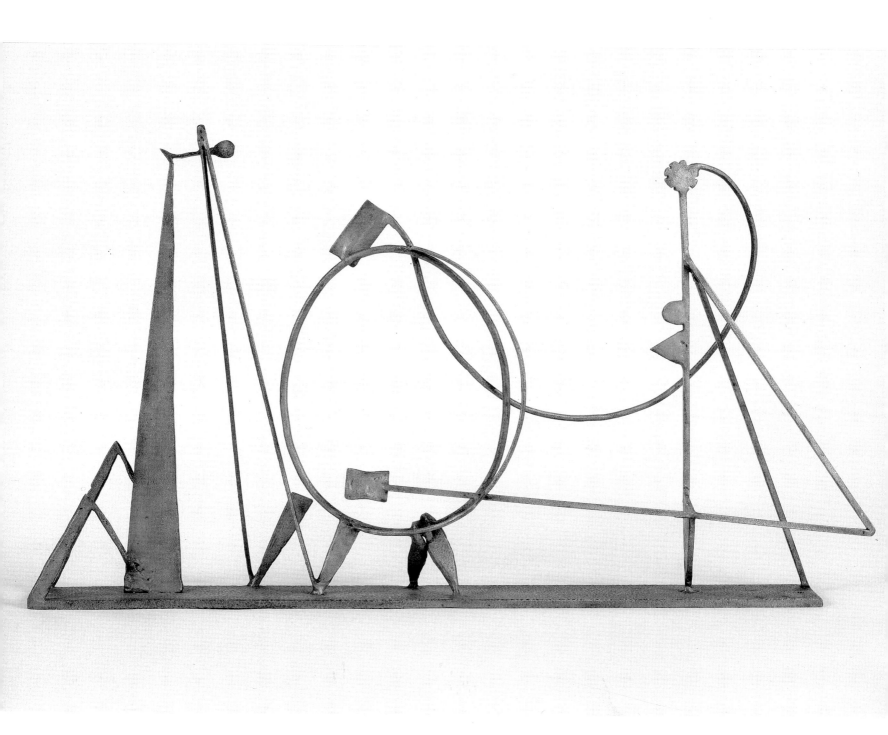

105

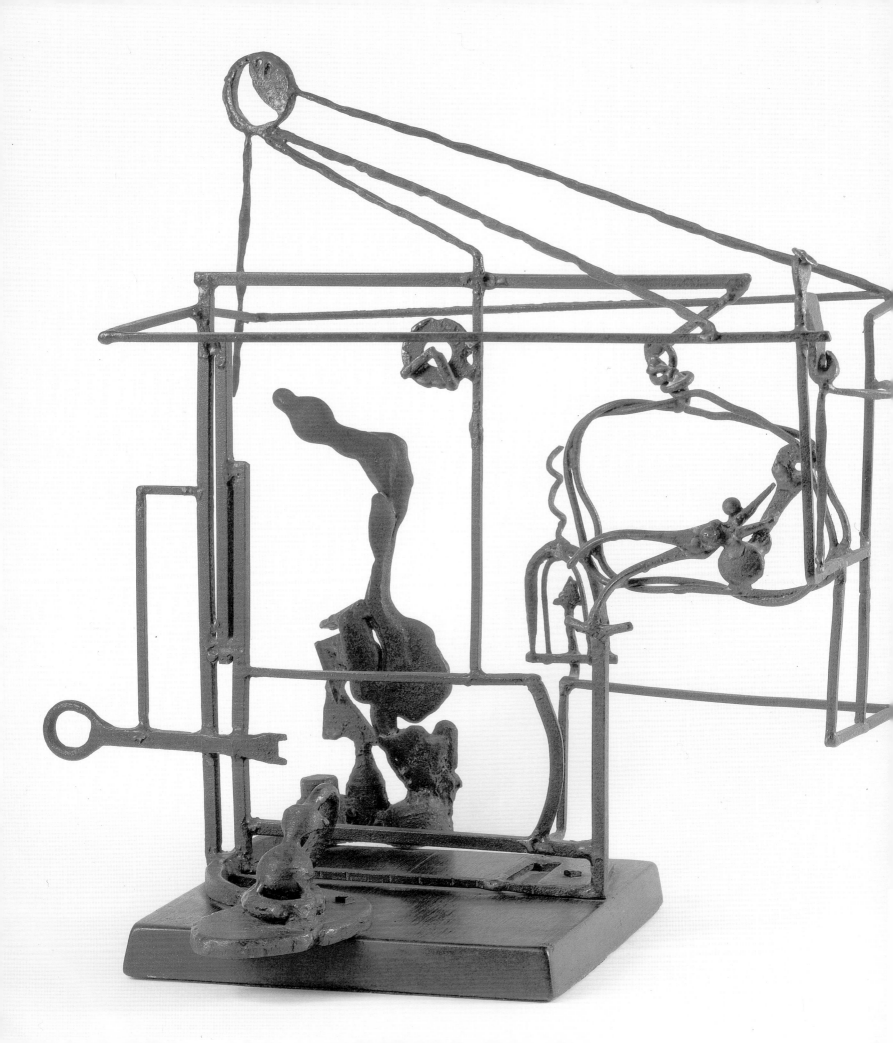

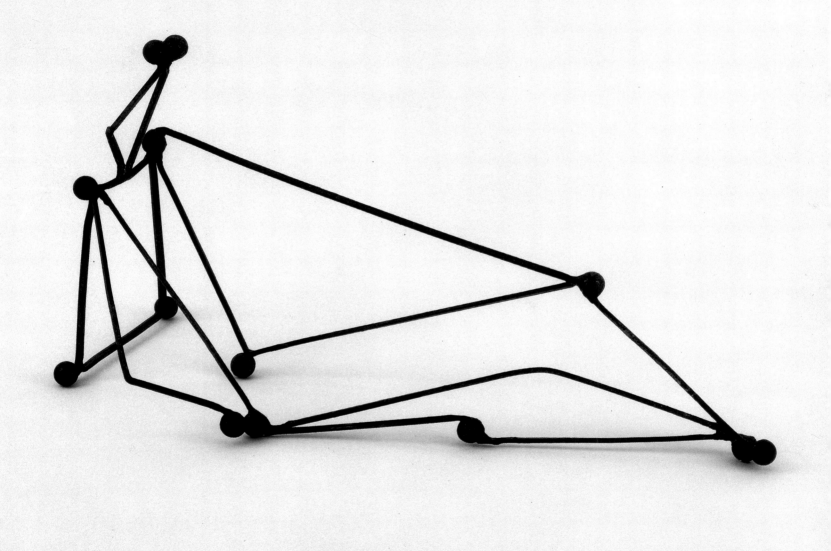

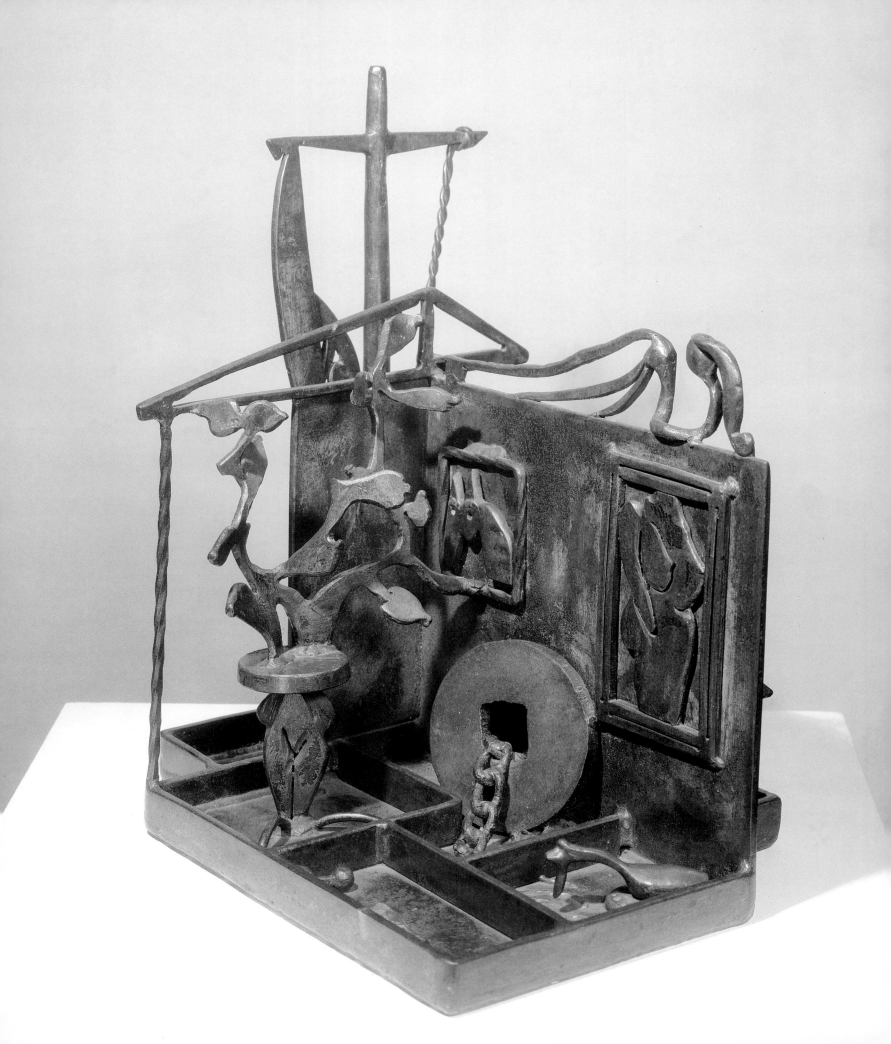

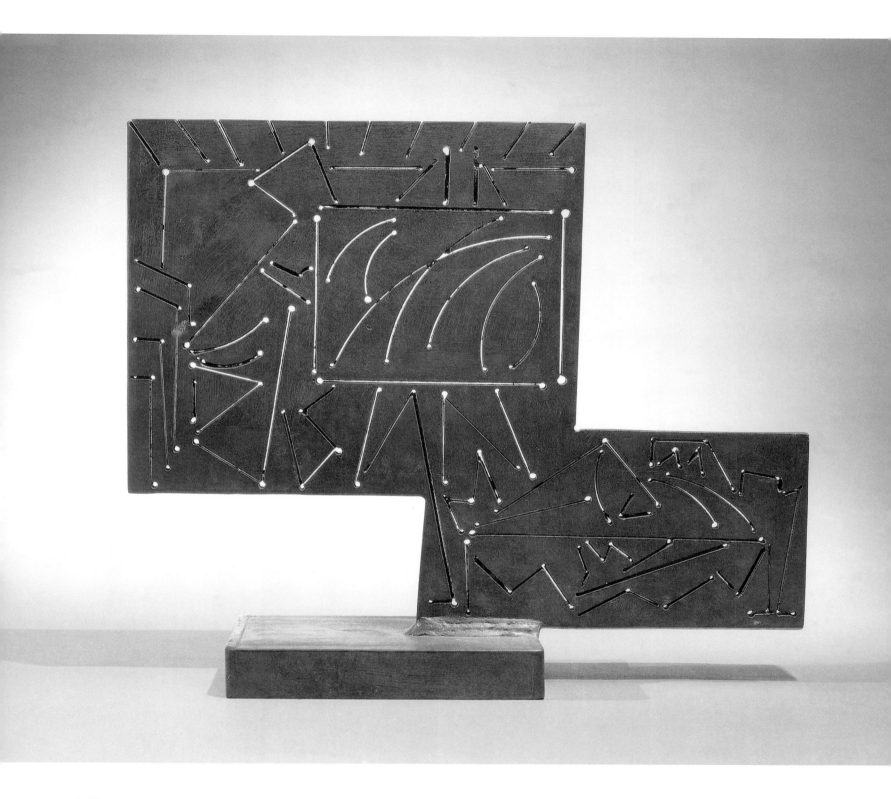

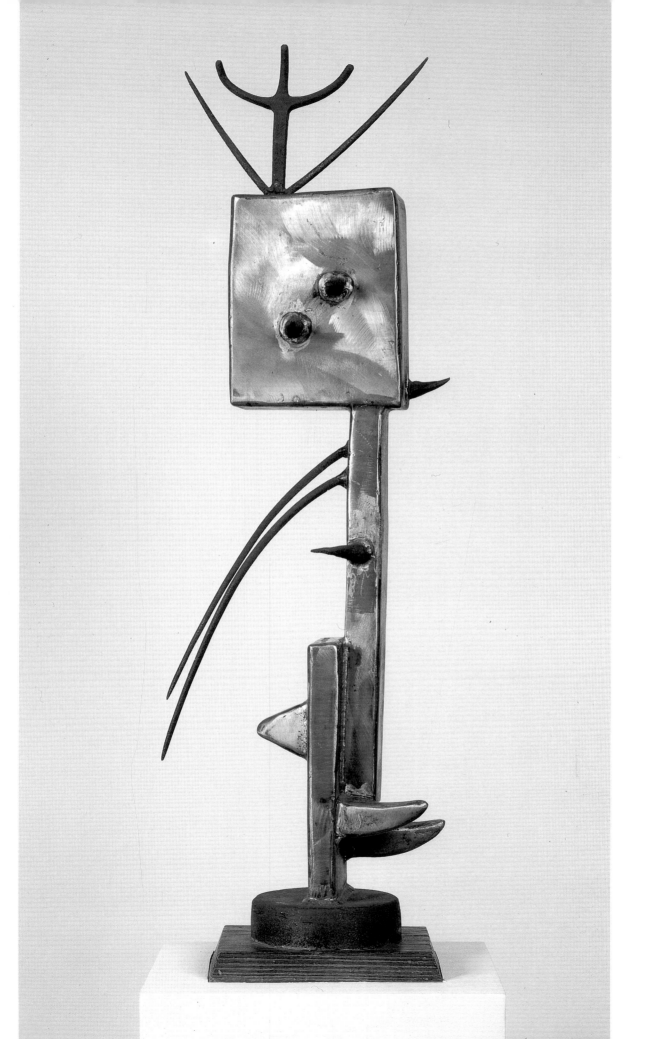

110
111 >

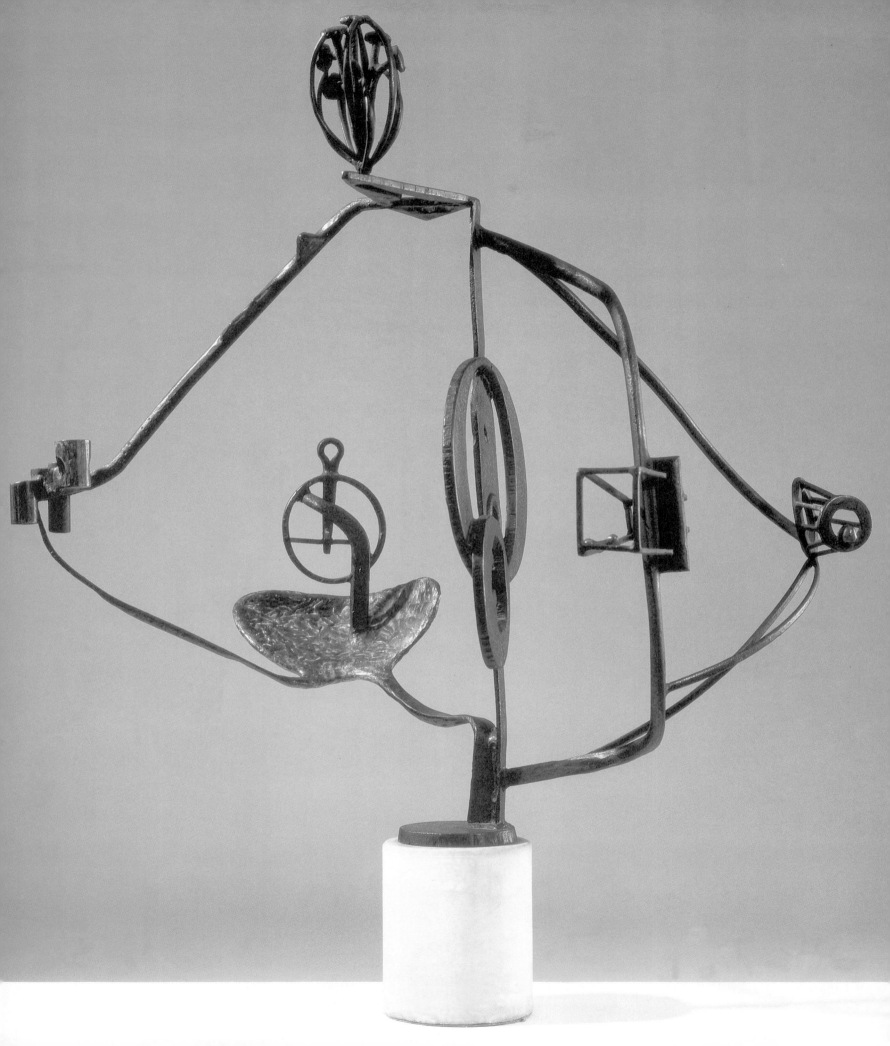

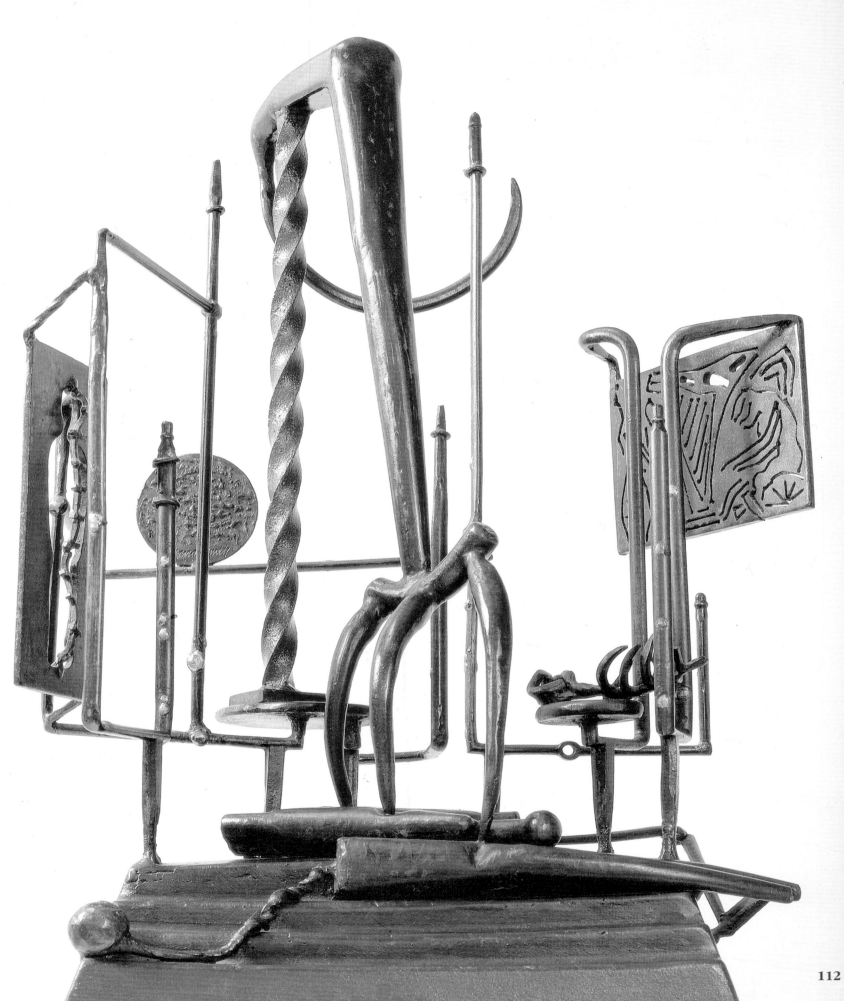

112

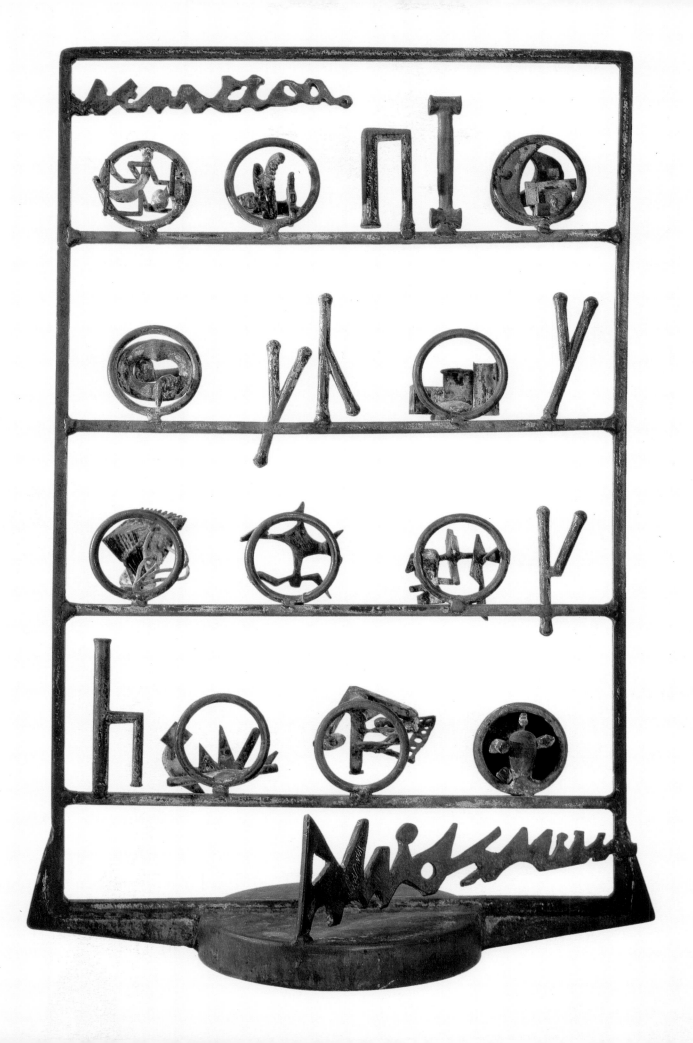

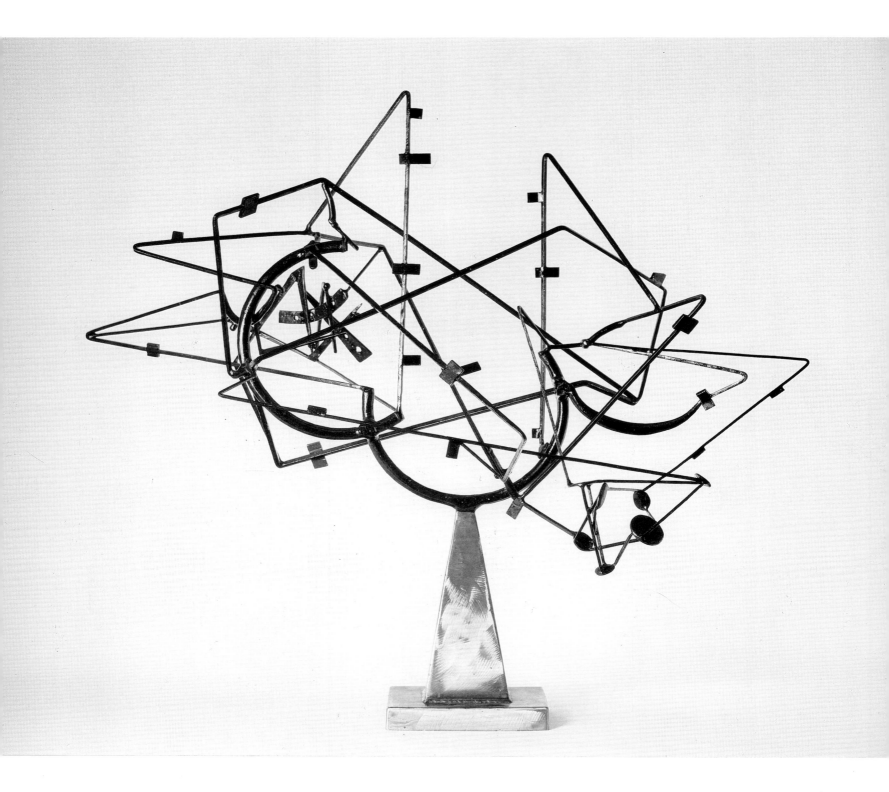

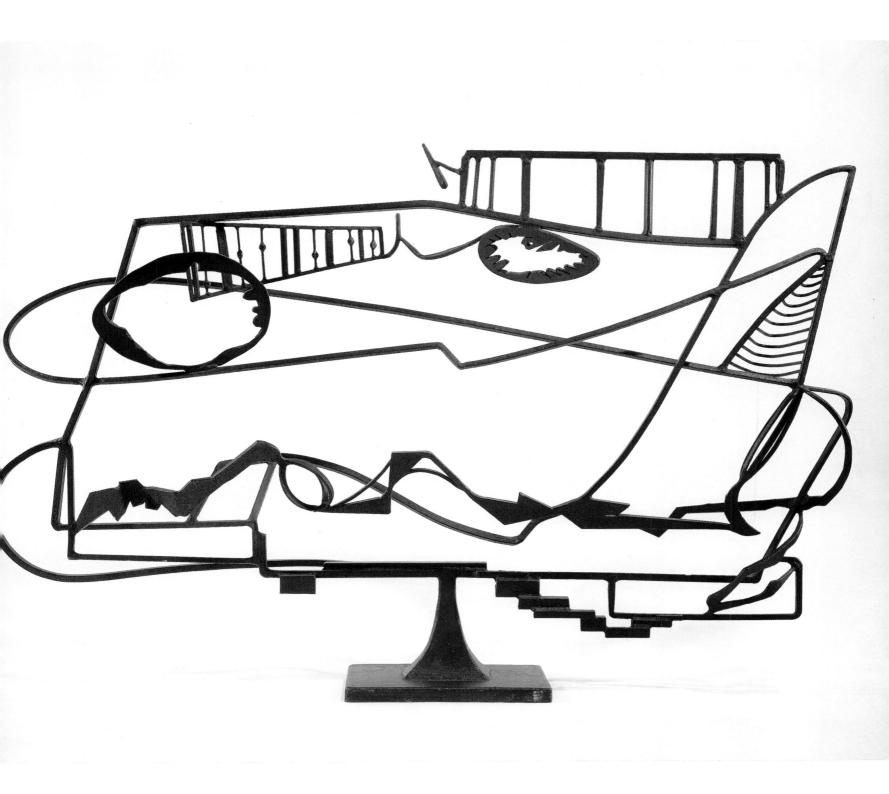

115

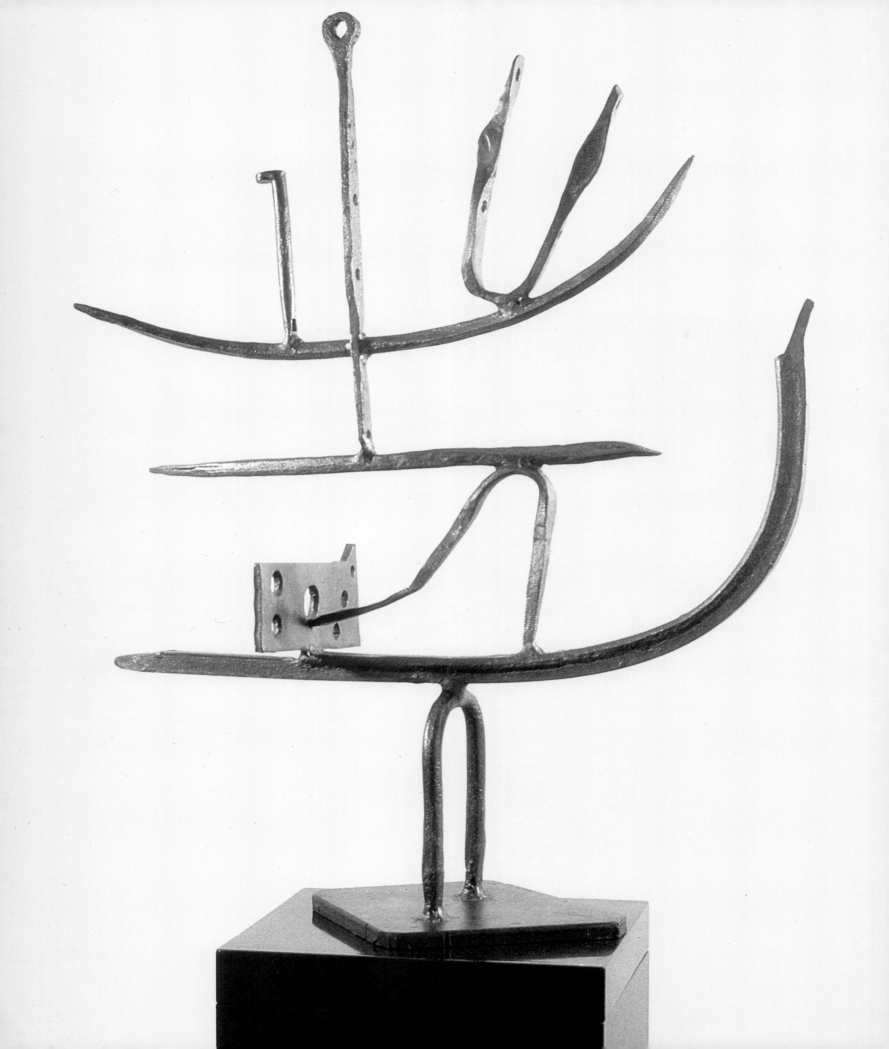

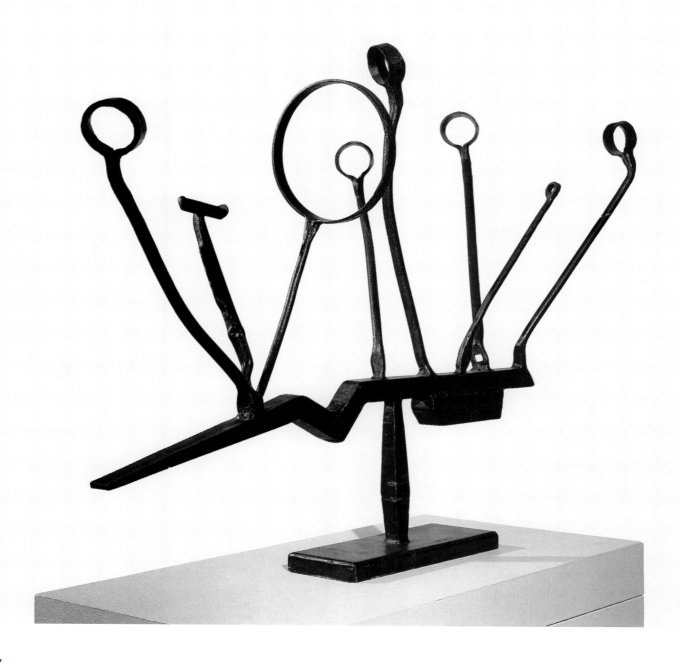

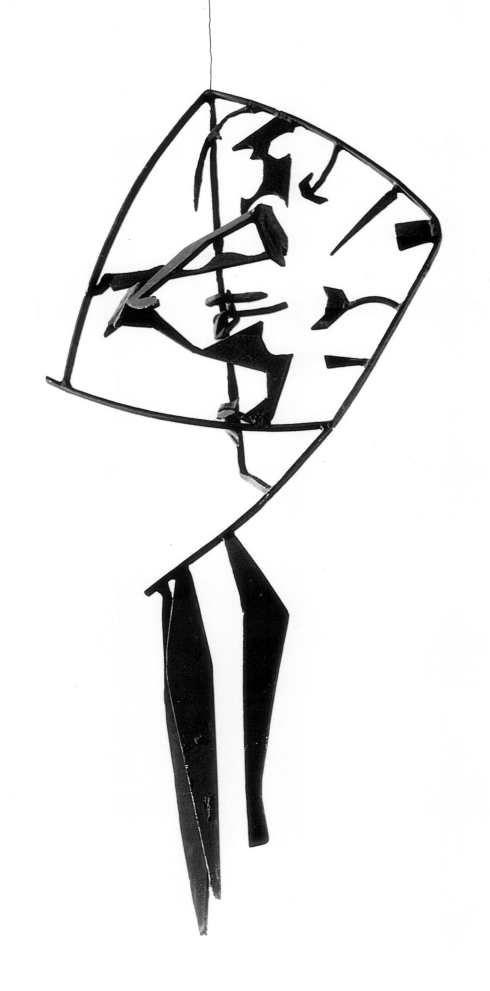

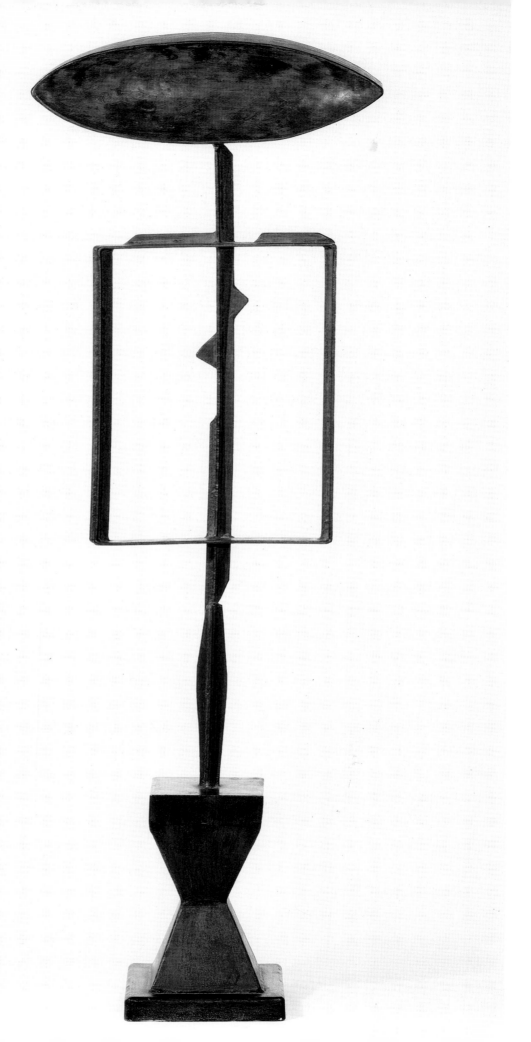

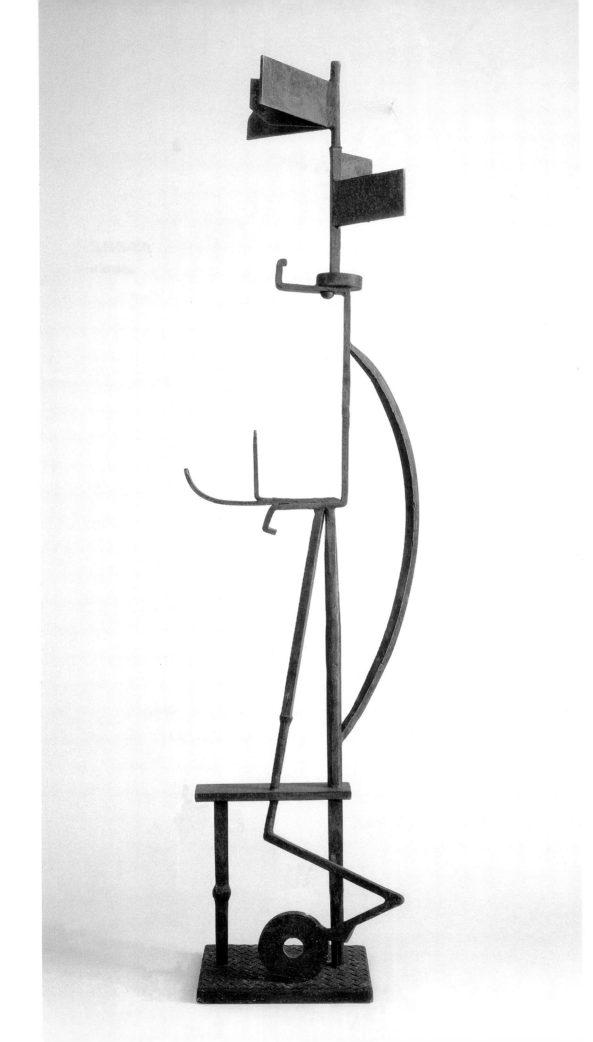

120

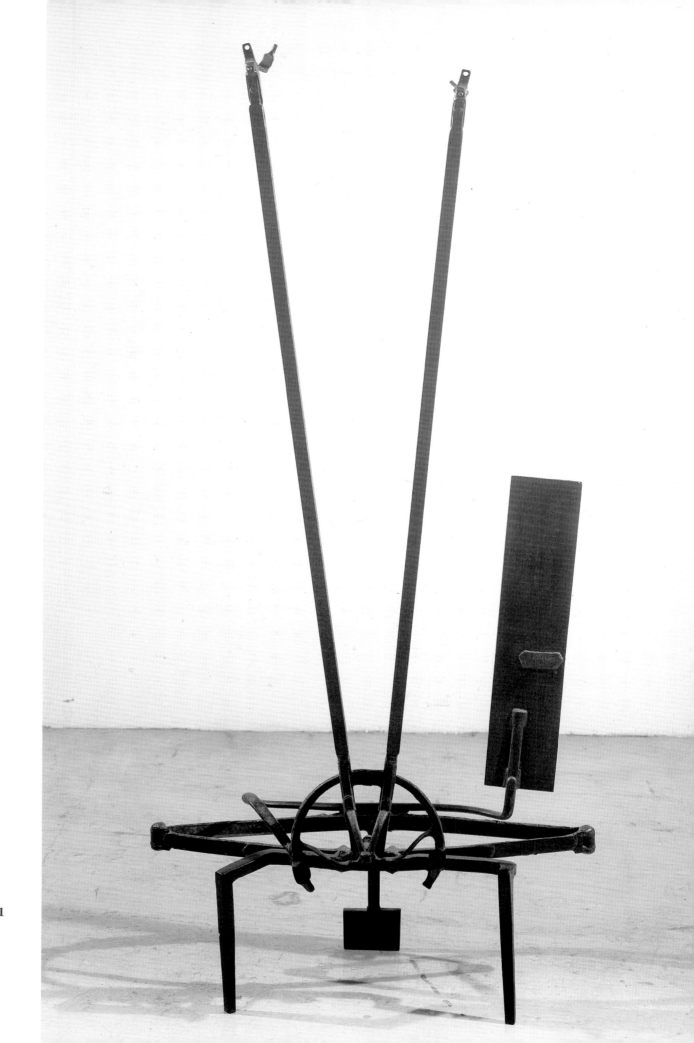

121

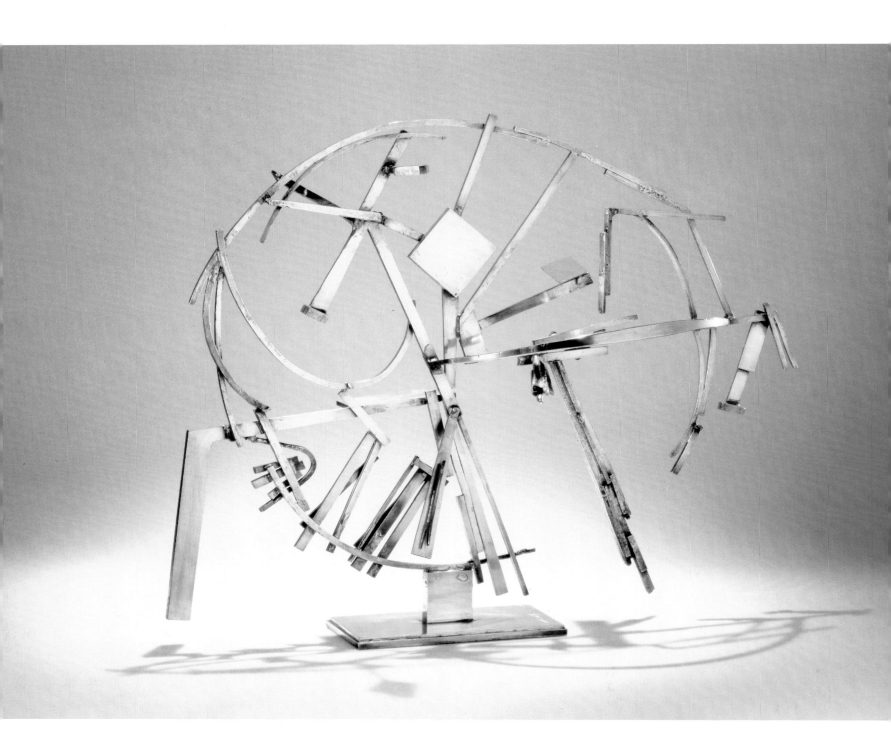

123

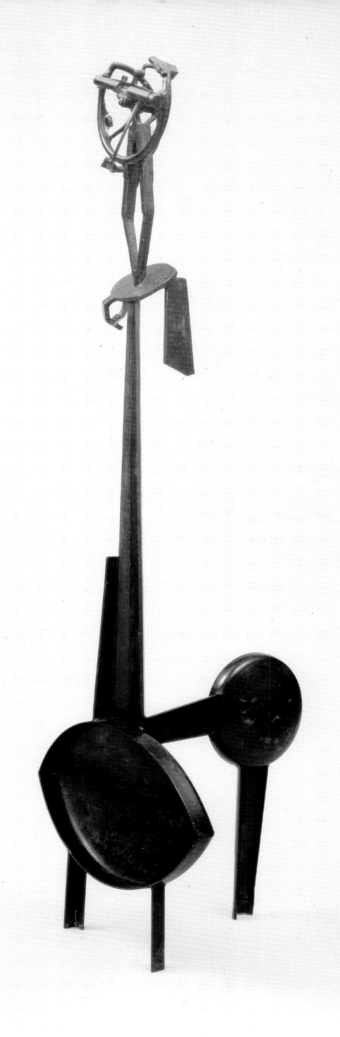

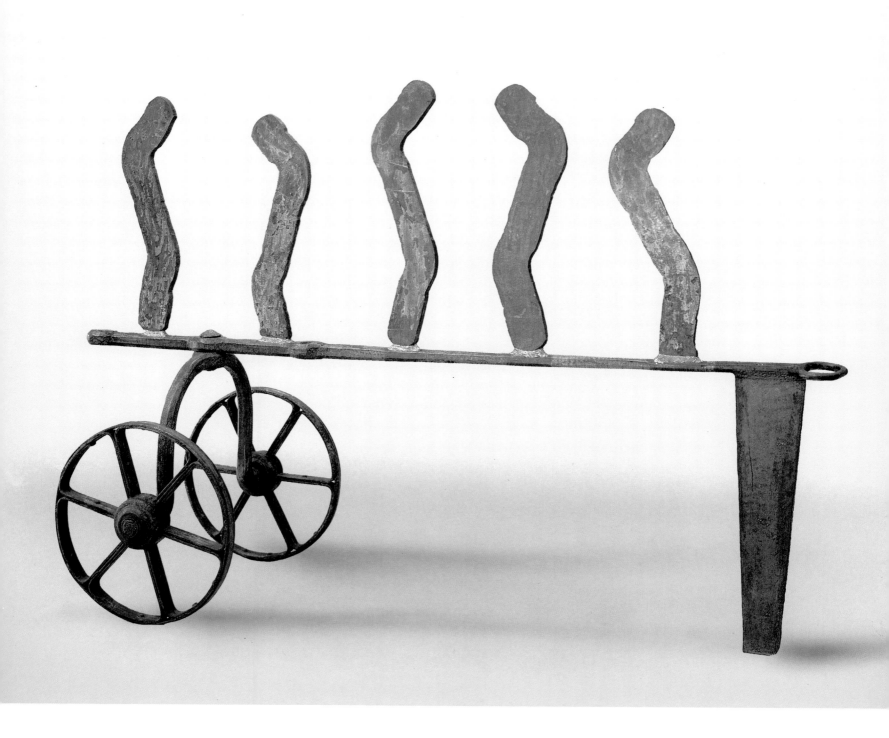

Chronology

This chronology focuses on those events relevant to the concept of this exhibition. Other information may be found in the artists' biographies and the bibliography.

The following abbreviations appear in the text:

MP: Musée Picasso, Paris.

WS: Werner Spies, *Picasso: Das Plastische Werk*, catalogue for the exhibition *Picasso Plastiken* held at the Nationalgalerie Berlin in 1983 and the Kunsthalle Düsseldorf in 1983-84.

Z: Christian Zervos, *Pablo Picasso: Oeuvres*, vols. I-XXXII (Paris, 1932-77).

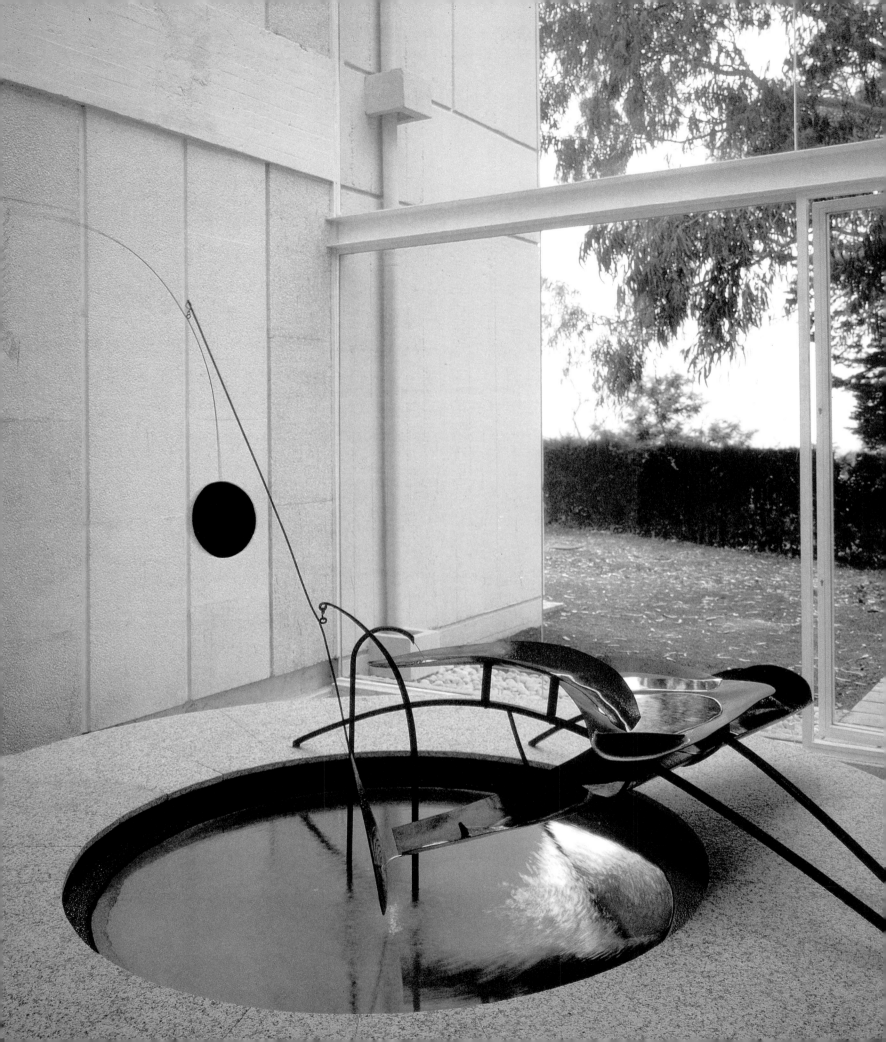

1876

September 21 Julio González is born in Barcelona, Spain.

1881

October 25 Pablo Picasso is born in Málaga, Spain.

1898

July 22 Alexander Calder is born in Philadelphia.

ca. 1897-99

Julio González and his older brother Joan frequent the Barcelona café Els Quatre Gats. Other artists who attend include painters Ramón Casas, Picasso, Santiago Rusiñol, and Joaquín Torres-García and sculptor Manolo Hugué, among others.

1899

Julio and Joan González move to Paris, where they maintain their friendship with Picasso. Julio González and Picasso devote themselves chiefly to painting. González later meets Picasso's friends Francisco [Paco] Durrio and Pablo Gargallo, who are metal sculptors, as well as Max Jacob, André Salmon, and Maurice Raynal. González also comes to know Constantin Brancusi.

1901

October 10 Alberto Giacometti is born in Borgonovo, Grisons, Switzerland.

Picasso shares González's living quarters in Paris while he looks for a studio.

1902

Summer González and Picasso meet in Barcelona and Picasso draws González's portrait.

1903

Picasso goes back to Barcelona again in January and stays there until spring of 1904.

1904

Spring Picasso returns to Paris. In Montmartre, he moves into a studio building, which becomes known as the Bateau-Lavoir.

August 23 In a letter to Picasso, Julio González responds to a quarrel that has occurred between

Joan and Picasso. The relationship between Picasso and González is disrupted for a number of years following this incident (letter from González to Picasso, MP Archives).

Fall Picasso meets Salmon and, some months later, befriends Guillaume Apollinaire. Along with Jacob, they become Picasso's closest friends and the first defenders of Cubism, later to be joined by Pierre Reverdy.

1906

Picasso becomes familiar with pre-Roman Iberian sculpture at the Louvre (in an exhibition of recently excavated sculpture from Osuna and Cerro de los Santos). His paintings soon reflect their robust proportions and archaic features.

March 9 David Smith is born in Decatur, Indiana.

Spring Picasso meets Henri Matisse, and then André Derain.

1907

Picasso begins painting *Les Demoiselles d'Avignon* in April-May. In May or June he discovers historic African sculpture at the Musée ethnographique du Trocadéro. Unknown to Picasso, African sculpture is already being collected by Derain, Maurice de Vlaminck, and Matisse. He finishes *Demoiselles* in early July. Picasso meets dealer Daniel-Henry Kahnweiler that summer. Picasso and Georges Braque are introduced by Apollinaire in October or November.

March-April González exhibits paintings, including *Mother and Child*, in the Salon des Indépendants, Paris.

1908

González is deeply affected by the death of his brother Joan. Experiencing a profound crisis, he isolates himself and ceases to work: "He abandoned his work for many months, refused to see his friends. He quarreled with Picasso" (Roberta González, "Julio González, My Father," in *Arts* 30, no. 5, p. 22).

< *Alexander Calder's* Mercury Fountain *on view in the Spanish Pavilion at the Paris World's Fair, 1937.*

Picasso and Braque form a closer relationship. When Braque shows his landscapes at Galerie Kahnweiler, Paris, critics speak of "cubes" and the term "cubism" is coined.

1909

González exhibits paintings at the Salon d'Automne and Salon de la Nationale, Paris.

Summer Picasso travels to Barcelona, and to Horta de Ebro for the second time, where he paints landscapes and portraits that mark the beginning of Analytic Cubism. He also starts experimenting with sculpture.

September or October Picasso moves into a studio and apartment at 11, boulevard de Clichy, where he lives with Fernande Olivier.

Fall Picasso models his *Head of a Woman*, a sculpted portrait of Olivier closely related to his drawings and paintings in the Analytic Cubist style, in González's studio in Paris. Of this work, Picasso said: "I thought the curves you see on the surface should continue in the interior. I had the idea of doing them in wire, (but) it was too intellectual, too much like painting" (quoted in Roland Penrose, *The Sculpture of Picasso*, New York, 1967, p. 19).

1910

Making a tentative return to sculpture following his crisis over the loss of his brother, González produces his first masks in metal repoussé, an assemblage of pieces of cut sheet metal. (He had received his training in metalwork from his father, a sculptor and goldsmith.)

Picasso has a solo exhibition at Galerie Nôtre-Dame-des-Champs, Paris, and is included in a group show at Grafton Galleries, London. He and Braque are represented in group shows in Düsseldorf and Munich.

1911

March 28-April 25 *Pablo Picasso: An Exhibition of Early and Recent Drawings and Watercolors* is held at the Little Galleries of the Photo-Secession (later renamed Gallery 291), New York. Selected by Edward Steichen, Mario de Zayas (author of the catalogue preface), and Frank Burty Havilland, this is the first exhibition of Picasso's work in the United States. Alfred Stieglitz, owner of the gallery, acquires the drawing *Nude Woman* of 1910 (Z II, 208) from the show.

Summer Picasso and Braque work in close collaboration in Céret, in the French Pyrenees.

1912

Picasso takes part in the second exhibition of Der blaue Reiter at Galerie Goltz, Munich, and later exhibits at the Berliner Sezession. Spends the summer with Braque in Sorgues, in the south of France. He moves with Eva Gouel from Montmartre to the Montparnasse area of Paris, and produces his first construction, *Guitar*, and first collage, *Still Life with Chair Caning*. Signs a three-year contract with Kahnweiler.

1913

González takes a studio at 1, rue Leclerc, which he uses until 1920.

February-March Picasso has eight works in the *International Exhibition of Modern Art* (the Armory Show) in New York. By spring, he is developing his Synthetic Cubist style.

November González participates in the Salon d'Automne, Paris, exhibiting one painting and one metal work.

Apollinaire publishes *Les Peintres cubistes: Meditations esthétiques* in Paris, becoming the champion of Cubism and very much involved with avant-garde art.

1914

August World War I begins. Apollinaire, Braque, and Derain are conscripted. Picasso, in Avignon at the time, remains there until the fall, when he returns to Paris.

Fall González exhibits a bronze mask at the Salon d'Automne, and is appointed "sociétaire," allowing

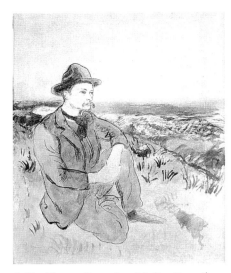

Pablo Picasso, Portrait of Julio González, *ca. 1902. Watercolor and ink on paper, 29 x 24 cm (11 3/8 x 9 1/2 inches). Galerie de France, Paris.*

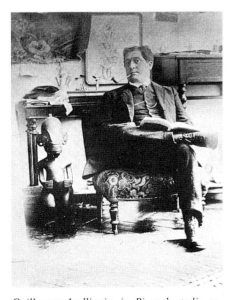

Guillaume Apollinaire in Picasso's studio on boulevard de Clichy, ca. 1910, probably photographed by the artist. Archives Picasso.

him exhibition privileges. He also exhibits painting and metalwork at the Salon des Indépendants.

December 9-January 9, 1915 *Picasso and Braque: An Exhibition of Recent Drawings and Paintings* is held at Gallery 291, New York.

1916

González exhibits three paintings and twelve repoussé bronzes in the Salon des Indépendants.

Apollinaire returns from the front, and Picasso draws several portraits of his friend, who has recently become a French citizen.

Summer Picasso moves from Montparnasse to Montrouge, a neighborhood directly south just outside the city limits. *Les Demoiselles d'Avignon* is shown publicly for the first time in *Art moderne en France* at the Salon d'Antin.

Apollinaire publishes *The Poet Assassinated,* written between 1910 and 1915, in Paris. Its main character, the poet Croniamantal, may be interpreted as Apollinaire, and one of his best friends, "the Bénin bird," as Picasso. When Croniamantal is assassinated, the Bénin bird has the idea of making a statue. Picasso and his friends organize a dinner party to celebrate the publication on December 31.

1917

Picasso goes to Rome for two months and works on his sets and costumes for the ballet *Parade*. While there, he meets and falls in love with Olga Koklova, a dancer in the Ballets Russes. The ballet debuts in Paris in May, to a negative response.

1918

June 10-September 26 González works at La Soudure autogène française metalworks in the Renault plant at Boulogne-sur-Seine, where he learns oxyacetylene welding. He executes his first known work in iron by this method, "a little statue of Christ, forged in secret at the factory by this process" (Roberta González, "Julio González, My Father," p. 23).

July Picasso marries Koklova.

Julio González's contract to work at La Soudure autogène française, Boulogne, 1918.

November 9 Picasso is deeply affected by the death of Apollinaire from Spanish influenza. Serge Férat and other friends of Apollinaire decide to commission Picasso to create a monument to the dead poet.

Mid-November Picasso and Koklova move to 23, rue La Boëtie, on Paris's Right Bank.

November 11: World War I ends.

1919

Calder graduates as a mechanical engineer from the Stevens Institute of Technology in Hoboken, New Jersey. From this year to 1922, he takes various apprentice engineering jobs.

Picasso designs sets and costumes in London for the Ballets Russes performance of *Tricorne*, which opens in July. He works in both a Cubist and realist manner, and exhibits at Paul Rosenberg Gallery, Paris.

1920

January-May Picasso designs the sets and costumes for the Ballets Russes's *Pulcinella*, which opens in Paris on May 15.

November González takes a metalworking studio at 18, rue d'Odessa. He exhibits in the Salle catalane at the Salon d'Automne, submitting three paintings, a silver sculpture titled *Seated Woman* (ca. 1918), two repoussé masks in bronze and silver, and jewelry. He also exhibits works at the Salon d'Automne and the Salon de la Nationale.

1921

April González exhibits paintings and two repoussé bronzes at the Salon des Indépendants.

The first monograph on Picasso's work, by Maurice Raynal, is published in Munich.

May Picasso receives the official commission for his monument to Apollinaire, and a committee is created to raise financial support for the project. However, one of its members, the director of *Le Mercure de France*, asks *s'il n'y avait pas des gens trop bizarres dans le comité, des métèques, des cubistes, des bolchevistes, des dadaïstes et autres sortes de Boches* (that

there not be anyone too bizarre on the committee—foreigners, Cubists, Bolsheviks, Dadaists, and other sorts of Germans) (Christa Lichtenstern, *Picasso, Monument à Apollinaire: Projet pour une humanisation de l'espace*, Paris, 1990, p. 14).

Summer Picasso paints *Three Women at the Spring* and *Three Musicians* in classical and Cubist modes, respectively.

October-November González exhibits four paintings, four forged bronzes, one forged silver, and one sculpture (*Eve*, 1900-10) at the Salon d'Automne. One of the forged bronzes, *Mask of Woman*, is bought by the State for 1,000 francs. Picasso and González reestablish contact around this time.

1922

January 1 Giacometti arrives in Paris and enters the Académie de la Grande Chaumière, where he studies for three years in Antoine Bourdelle's class.

Collector Jacques Doucet buys Picasso's *Demoiselles* for 25,000 francs.

March González's first solo exhibition takes place at the Galerie Povolovsky, Paris. It includes paintings, watercolors, drawings, sculpture, and jewelry, and is mentioned in *Art News* (May 25, in a review signed "M. C."). The catalogue preface is by Alexandre Mercereau, a lifelong supporter and friend of González.

May González exhibits two portraits in bronze repoussé (*Roger* and *Jean de Neyreïs*, both 1912-14) in the Salon de la Nationale, Paris. His work is mentioned by Gustave Kahn in *Le Mercure* (May 15).

Calder begins to attend evening drawing classes at a public school on East Forty-second Street, New York, under Clinton Balmer.

1923

January 1-15 An exhibition of González's jewelry, objets d'art, repoussé bronzes, paintings, and sculptures is held at Galerie du Caméléon.

Fall Calder enters the Art Students League, New York, where he will study until 1926. He works first under Kenneth Hayes Miller, and later with George Luks, Boardman Robinson, and John Sloan.

González exhibits in the Salon d'Automne, showing two paintings and an iron medallion commissioned by the Musée Pasteur. He also shows work in the Salon de la Nationale.

November In New York, Paul Rosenberg/Wildenstein Gallery exhibits sixteen recent works by Picasso.

1924

Picasso makes a large, painted metal construction, *Guitar*, and paints a series of monumental Synthetic Cubist still lifes.

Summer In Juan-les-Pins, Picasso produces a sketchbook of ink dot-and-line drawings reminiscent of constellations.

October André Breton publishes his *Manifeste du surréalisme* (Surrealist manifesto) (Paris: Editions Sagitaire).

González moves his metalworking studio to 11, rue de Médéah, where he works until January 1935.

1925

January 15 Two pages of Picasso's sketchbook of the previous summer are reproduced in *La Révolution surréaliste* (no. 2, pp. 16-17).

Summer Smith works as a riveter on a frame assembly line in the Studebaker plant at South Bend, Indiana. This experience prepares him for his future production of iron sculpture, and gives him "a feeling for industrial forms, training in the handling of tools and factory equipment, and a sense of identification with working men" (Garnett McCoy, ed., *David Smith*, New York, 1973, p. 18).

July 15 Picasso's *Demoiselles* is reproduced in *La Révolution surréaliste*.

Giacometti ceases to use models and works instead from his imagination, a practice that he follows almost exclusively for ten years. The first works he

Pablo Picasso, untitled drawing, published in La Révolution surréaliste, *no. 2 (January 15, 1925).*

Pablo Picasso, The Painter and His Model, *1926. Oil and charcoal on canvas, 137.5 x 257 cm (54 1/8 x 101 1/8 inches). Musée Picasso, Paris.*

produces using this method (*Torso, The Couple,* 1926, and *Spoon Woman,* 1926) show the influence of Cubism, especially as practiced by Henri Laurens and Jacques Lipchitz, as well as of African and Cycladic art. He sets up an atelier in Paris with his brother Diego, and participates for the first time in the Salon des Tuileries, where he shows a sculpture. Calder makes drawings for the book *Animal Sketching,* which is published the following year.

November Together with Jean Arp, Giorgio de Chirico, Max Ernst, Paul Klee, Man Ray, Joan Miró, and others, Picasso takes part in the first Surrealist painting exhibition, *La Peinture surréaliste,* at Galerie Pierre, Paris.

ca. 1925 Calder makes his first wire sculptures.

1926

January Christian Zervos publishes the first issue of *Cahiers d'art.*

González exhibits at the Salon des Indépendants, submitting, among other works, two repoussé bronzes of 1913.

Commissioned by Ambroise Vollard to illustrate Honoré de Balzac's "The Unknown Masterpiece," Picasso translates his dot-and-line drawings from the summer of 1924 into woodcuts.

May 16 A text attributed to Picasso is published in Moscow, in the magazine *Ogonek.* There is a direct relationship between its descriptive content and the dot-and-line drawings of 1924.

Calder exhibits paintings at The Artist Gallery, New York. He begins wood carving.

June Calder arrives in Paris and enters the Académie de la Grande Chaumière. He begins his *Circus* and makes his first animated toys.

ca. December After a year spent working in Washington, D.C., and taking poetry courses at George Washington University, Smith moves to New York and begins to attend classes at the Art Students League.

Giacometti begins a series of thin, tabletlike works.

1927

Giacometti moves with Diego to a small studio on rue Hippolyte-Maindron, where he lives and works until his death.

Spring Calder exhibits his toys in the Salon des Humoristes, Paris.

Summer During a vacation in Cannes, Picasso executes an album of pen-and-ink drawings, *The Metamorphoses,* in which the bathers that have been a theme in his drawing for some time begin to take on a more monumental and sculptural quality. Although Picasso probably intended them as studies for his monument to Apollinaire, Christian Zervos writes in 1929 (*Cahiers d'art*) that Picasso proposed them as monuments to line the Croisette, the promenade in Cannes.

August Following his return to New York, Calder goes to Oshkosh, Wisconsin, to supervise the manufacture of toys from his models. He continues to make wood sculpture.

Fall Picasso paints *Seated Woman* (Z VII, 77), continuing a series begun in 1925. He explores the double-head motif.

Calder returns for a longer stay in Paris. He meets the Spanish sculptor José de Creeft, in whose studio he first sees forged-iron works by Gargallo.

Winter Picasso begins his painting *The Studio* (1927-28; Z VII, 142), which from 1935 will be on view at the Museum of Modern Art, New York. Formally, it is closely related to contemporaneous drawings for wire sculptures. He also produces the first etchings for "The Unknown Masterpiece."

As a full-time painting student at the Art Students League, Smith studies with John Sloan, and later with Jan Matulka, who introduce him to the work of Vasily Kandinsky, Piet Mondrian, and Picasso.

González produces his first iron sculptures. After years of self-doubt, he decides to concentrate on sculpture rather than decorative objects or painting.

Five illustrations of Gargallo's metal sculptures are

published in *Cahiers d'art* (no. 2, E. Tériade, "Pablo Gargallo," pp. 283-86).

A second edition of Apollinaire's *The Poet Assassinated* is published in Paris.

December 27-February 28, 1928 Picasso has a solo exhibition at Galerie Pierre, Paris.

1928

January-February Picasso models the biomorphic figure *Bather (Metamorphosis I)* (WS 67) on his drawings from Cannes. It is his first three-dimensional sculpture since 1914.

February-March Calder's first solo exhibition takes place at Weyhe Gallery, New York. He shows wire sculptures, such as *Josephine Baker* (1927). He also shows *Romulus and Remus* (1928), which is subsequently exhibited in the New York Salon des Indépendants at the Waldorf Hotel (on Thirty-fourth Street).

March 20 Picasso makes preliminary ink drawings for his painted iron sculpture *Head* (1928; Z VII, 140; MP 263). He perhaps contacts González at this time to ask for his assistance in welding metal sculpture and, presumably, their collaboration begins that spring. This *Head*, completed in the fall, is directly related to Picasso's contemporary oil paintings, and particularly to the figures in *The Studio* (Z VII, 142) and *Painter and Model* (Z VII, 143).

April 21-24, 26 Picasso produces drawings of a full standing figure with a head similar to that of the *Head* produced the previous month. (Josephine Withers, "The Artistic Collaboration of Pablo Picasso and Julio González," in *The Art Journal* 35 [winter 1975-76], p. 109.)

April 28 Picasso executes a drawing that anticipates the composition of *Woman in a Garden* (1929-30). (WS, p. 74, footnote 83.)

May 13 With the death of his mother, González writes to Picasso to tell him of his family's difficult situation (MP Archives). The collaboration between the two artists is temporarily interrupted.

May 14 Picasso sends González a note of condolence with a check for the work already completed (Estate of Julio González, Paris). The note reads: "I have received your letter telling me of the sad news of the death of your mother. Believe me I am very sorry for you and your sisters, but for you whom I love, I am doubly sorry. I am not going to see you for fear of disturbing you. Concerning you, I send you a check since I don't have any ready cash" (reproduced in Josephine Withers, "The Artistic Collaboration of Pablo Picasso and Julio González," p. 109, footnote 12).

Summer Smith makes his first painting trips to Bolton Landing, New York.

August While vacationing in Dinard, Brittany, Picasso makes over a dozen line drawings inspired by bathers at the beach (Sketchbook 1044, Collection, Marina Picasso; Werner Spies, *Sammlung Marina Picasso*, Munich, 1981, pp. 145-48, repr.). One of them, dated August 3, 1928, is a final sketch for his *Construction*, planned as a monument to Apollinaire (Z VII, 206).

October Picasso's *Head* (1928) is completed in González's studio on rue de Médéah, Paris. Picasso also finishes the first of four metal-rod sculptures (*Figure*, also known as *Construction in Wire* or *Wire Construction*) which Kahnweiler later likens to "drawing in space" (Kahnweiler, *The Sculptures of Picasso*, London, 1949, p. 7). According to Josephine Withers, González was paid by Picasso to execute these works (Withers, "The Artistic Collaboration of Pablo Picasso and Julio González," p. 109). Initially, there may have been more than four sculptures (Brassaï, *Conversations avec Picasso*, Paris, 1964, p. 25). Two of these works are submitted by Picasso as maquettes for the monument to Apollinaire, but they are turned down by the committee.

October-November González exhibits four bronze

repoussé masks in the Salon d'Automne.

November Calder returns to Paris, where he meets Giacometti, Miró, and Jules Pascin.

Giacometti continues to develop the tabletlike sculptures and begins to make openwork structures (including *Three Figures Outdoors*, *Man and Woman*, and *Reclining Woman*). He exhibits two tabletlike sculptures, *Head* and *Personage*, at Galerie Jeanne Bucher, Paris. "Eight days later they were sold and I had three contract proposals on my table," Giacometti said to Jean Clay (Yves Bonnefoy, *Alberto Giacometti: A Biography of His Work*, Paris, 1991, p. 553). At the gallery he meets André Masson, who introduces him to Joan Miró, Georges Bataille, and poet Michel Leiris. This exhibition marks the beginning of his notoriety.

1929

January 25-February Calder's constructions in wire are exhibited at Galerie Billet, Paris. The catalogue preface is written by Pascin.

Spring Picasso continues to work in González's studio; he begins work on *Woman in a Garden*, a larger-than-life-size figure originally proposed as a monument to Apollinaire, which he assembles himself (Spies, *Sammlung Marina Picasso*, p. 318). According to González, it was preceded by a large number of studies (González, "Picasso sculpteur et les cathédrales," in Josephine Withers, *Julio González: Sculpture in Iron*, New York, 1978, p. 142, English translation p. 135). González reports that it was made by Picasso "with so much love and tenderness in the memory of his dear friend [that] at the moment he doesn't want to be separated from it" (Withers, "The Artistic Collaboration of Pablo Picasso and Julio González," p. 112). Picasso commissions from González a bronze replica of Picasso's *Woman in a Garden* after realizing that the iron original will rust if placed outdoors.

González produces his first experimental works, attempting to move away from his traditional train-

ing in hammered metal and conventional ornamental imagery (for example, *Don Quixote*).

Calder exhibits at the Salon des Indépendants, Paris, and Galerie Neumann-Nierendorf, Berlin.

June Calder returns to New York. He makes wire goldfish bowls with moving wire fish.

Smith buys a property in Bolton Landing, on the western side of Lake George, New York, which becomes his base for the rest of his life.

September Leiris publishes an article on Giacometti's sculpture in *Documents* ("Alberto Giacometti," no. 4, pp. 209-14).

Fall Giacometti and González are represented in the *International Sculpture Show* at Galerie Georges Bernheim, Paris. The exhibition is reviewed by Zervos in *Cahiers d'art* ("Notes sur la sculpture contemporaine: A propos de la récente exposition internationale de sculpture," no. 10, pp. 465-73), with a reproduction of Giacometti's *Three Figures Outdoors* (1929).

Giacometti begins to develop his transparent or openwork constructions (*Reclining Woman Who Dreams*, 1929, and *Standing Man*) and makes his first "cage" sculpture (*Suspended Ball*). A Giacometti exhibition takes place at Galerie Pierre; work shown includes *Reclining Woman Who Dreams* and *Three Figures Outdoors* (1929).

November González exhibits his forged-iron sculptures for the first time at the Salon d'Automne.

The Museum of Modern Art opens in New York.

Cahiers d'art devotes an entire issue to "primitive" Oceanic art (nos. 2-3), and publishes a number of significant essays by Christian Zervos throughout the year: "Picasso à Dinard, Eté 1928" (no. 1) includes reproductions of *Construction in Wire* (October 1928; MP 266), p. 6, and *Painted Iron Head* (October 1928; MP 263), p. 11; "Les dernières Oeuvres de Picasso" (no. 6) discusses the artist's paintings; and "Projet de Picasso pour un monu-

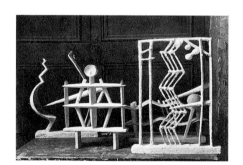

Personnages, composed by Alberto Giacometti and published in Documents *4 (September 1929) as an illustration to Michel Leiris's article "Alberto Giacometti."*

ment" (nos. 8-9) includes reproductions of Picasso's biomorphic, sculptural ink drawings for an imaginary monument of 1928, and one page of linear ink drawings related to his illustrations to "The Unknown Masterpiece" and to his wire constructions (Sketchbook 1044, Collection Marina Picasso).

1930

January 18-March 2 The Museum of Modern Art, New York, presents the exhibition *Painting in Paris*, its first to include work by Picasso.

February González exhibits his iron sculptures at Galerie de France, Paris. The catalogue preface is by Louis Vauxcelles, who also writes about González in *Carnet de la semaine* introducing his work to the Paris art world.

March Calder returns to Paris.

Spring González associates with the Constructivist group Cercle et Carré, organized by Torres-García, as well as with Abstraction-Création (although he never exhibits with either group). His association with both groups lasts until 1932.

May González and Picasso temporarily interrupt their collaboration as González goes to Monthyon for the summer (letter dated May 25, 1930, MP Archives).

November Accompanying the showing of the film *L'Age d'or*, by Luis Buñuel and Salvador Dalí, an exhibition of works by Arp, Ernst, Miró, Man Ray, and other Surrealists is presented at Studio 28, Paris. Members of the Ligue des patriots (League of Patriots) and the Ligue antijuive (League Against Jews) assault the theater and gallery.

November-December Picasso and González work together at González's studio on three assembled iron sculptures: *Figurine* or *Figure of a Woman* (1930), *Head* (1930), and *Head of a Woman* (1930-32). The first two pieces evolve from Picasso's drawings of 1928 (Sketchbook 1044, Collection, Marina Picasso; Werner Spies, *Sammlung Marina Picasso*,

pp. 141-55, repr.). The frequency of their meetings is documented in letters from González to Picasso dated between November 21 and December 30 (MP Archives).

Fall Calder meets Fernand Léger, Piet Mondrian, and Theo van Doesburg, and visits Mondrian's studio in Paris, which impresses him deeply (see Myfanwy Evans, ed., *The Painter's Object*, London, 1937, p. 63); soon after, he experiments briefly with abstract painting and creates his first abstract wire constructions. He also joins the Abstraction-Création group. Calder's constructions in wire—portraits and figures—are exhibited at the Salon des Surindépendants, Paris. In December, he returns to the United States.

Giacometti exhibits *Suspended Ball* at Galerie Pierre, together with works by Arp and Miró. Breton and Dalí see Giacometti's sculpture and invite him to participate in Surrealist activities.

González produces *The Kiss*, *Head*, and *Harlequin*; these sculptures represent a point of departure.

Paintings and Sculptures by Living Americans, at the Museum of Modern Art, New York, includes Calder's wood and wire sculptures.

Smith, still a student at the Art Students League and in private classes with Jan Matulka, meets Stuart Davis, Willem de Kooning, Arshile Gorky, John Graham (who will introduce him to the sculpture of González), and Jean Xceron.

ca. 1930 Graham, a Russian-born painter, theorist, and connoisseur of "primitive" and Modern art, brings three sculptures by González bought directly from the sculptor to New York, making them accessible to young artists like Smith. Two of these sculptures have been identified as *Mask I* (ca. 1927-29) and *Reclining Figure* (ca. 1929). According to Smith, these were the first of González's sculptures to arrive in the United States (Smith, "González: First Master of the Torch," in *Art News* 54, no. 10 [February 1956], pp. 34-37).

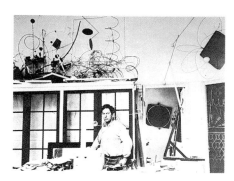

Alexander Calder in his studio on rue de la Colonie, Paris, 1931.

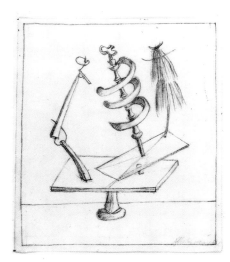

Alberto Giacometti, Surrealist Drawing, Project for a Surrealist Sculpture, *ca. 1931. Pencil on paper, 12 x 10.3 cm (4 ³/₄ x 4 ¹/₁₆ inches). Musée national d'art moderne, Centre Georges Pompidou, Paris.*

Documents (no. 6) includes reproductions of Picasso's drawings from Dinard.

Picasso's *Head* (1930) is reproduced for the first time in Eugenio D'Ors, *Picasso* (Paris, 1930, pl. 48), as "detail of a monument."

1931

Picasso continues to work with González at the latter's studio at rue de Médéah throughout the year (letters dated February 16 and 22, April 2, May 24, June 20, and October 20, MP Archives). Picasso incorporates real objects (colanders) into his sculpture *Head of a Woman.*

Giacometti begins to make sculptures with movable parts, such as *Hand Caught by a Finger* and *No More Play.*

April-May An exhibition of Calder's first abstract wood-and-wire constructions takes place at Galerie Percier, Paris. Entitled *Volumes - Vecteurs - Densités - Dessins - Portraits*, it includes works from the series *Espaces, vecteurs, densités* and the prototype for the motorized mobile *Universe.* At the insistence of the gallery director, the exhibition also includes wire portraits. The catalogue contains a foreword by Léger, entitled "Erik Satie Illustrated by Calder."

May 25 After the show at Percier, Calder writes to his parents: "[The show] didn't sell anything, but it was a very handsome show, and was a real success among the artists. Of course, if we had sold a few things it would have been very much more exciting, but I am not disappointed. Things are very slow right now, and everybody said it was not the year to do it" (Margaret Calder Hayes, *Three Alexander Calders: A Family Memoir*, Middlebury, Vermont, 1977, p. 259).

May An exhibition of González's sculptures takes place at Galerie de France; *Harlequin* (1930) and *Don Quixote* (1930) are shown, among other works. An advertisement for the gallery in *Cahiers d'art* (nos. 5-6) illustrates *Harlequin* (captioned as *Le Pierrot*).

May Picasso moves to the château de Boisgeloup in Normandy, having purchased the villa the previous year. He converts a stable on the property into a sculpture studio, which enables him to produce very large work.

May 30-June 10 An exhibition of seventeen sculptures by González is held at Galerie Le Centaure, Brussels. The show includes *Woman with a Basket, Woman with Amphora, Harlequin, The Kiss, Don Quixote*, and *Reclining Mask*, among others. The catalogue preface, written by Lucien Farnoux-Reynaud, stresses González's Spanish quality and relates his work to that of Picasso: *Ascétisme, spéculation intellectuelle, voilà les deux facteurs de l'oeuvre de González. Ne trouvons-nous pas ces deux facteurs à la base d'un autre artiste, Pablo Picasso?* (Asceticism and intellectual analysis, these are the two factors in Gonzalez's work. Are these not the two factors we find at the foundation of another artist, Pablo Picasso?)

May-June Giacometti exhibits at Galerie Pierre Loeb, Paris.

July 1 Calder sends his parents a letter informing them of his recent membership in the Abstraction-Création group: "I am now a member of the new group called 'Abstraction-Création,' composed solely of people who do abstractions—and who will show in the fall (November). They are also going to publish a journal" (Hayes, *Three Alexander Calders: A Family Memoir*, p. 260).

October-November Calder's and González's works are exhibited in the Salon des Surindépendants. González exhibits eight *sculptures, fer forgé* (forged-iron sculptures). Most reviews of the exhibition single out González and Calder.

November Calder exhibits with the Abstraction-Création group at the Porte de Versailles. He writes a statement for the catalogue that is also published in the magazine *Abstraction-Création.*

Fall Calder meets Marcel Duchamp, who encour-

ages him to experiment with motion in his sculpture and suggests the name "mobiles" for these objects with moving elements.

González produces *Woman Combing Her Hair.*

Giacometti makes a series of sketches entitled *Mobile and Mute Objects,* which echo some of his sculptures of the same period, especially *Cage* (1931), *Suspended Ball* (1930-31), and *Disagreeable Object* (1931). The drawings are reproduced in *Le Surréalisme au service de la révolution* (no. 3 [December], pp. 16-17), with text by Giacometti, and Dalí's essay "Objets surréalistes" (Surrealist objects, in which he discusses *Suspended Ball*). Five works by Giacometti are also reproduced in Carl Einstein's *Histoire de l'art du vingtième siècle* (2nd edition), published during this year.

During a stay in the Virgin Islands, Smith makes his first tentative experiments in free-standing sculpture, utilizing found and carved coral forms.

At the end of his period of collaboration with Picasso, González writes the first draft of his essay "Picasso sculpteur et les cathédrales," which remains unpublished as a whole during his lifetime. (It is finally published in 1978, in Withers, *Julio González: Sculpture in Iron,* pp. 131-45.)

Honoré de Balzac's "The Unknown Masterpiece," illustrated by Picasso, is published by Ambroise Vollard in Paris.

1932

April Arranged by Duchamp, an exhibition of Calder's motor-driven "mobiles" takes place at Galerie Vignon, Paris. Calder also exhibits at the Association Artistique "1940."

May Giacometti's first solo exhibition takes place at Galerie Pierre Colle, Paris. Picasso is one of the first to arrive at the *vernissage.* The exhibition includes the maquette of *The Palace at 4 A.M.,* as well as other recent sculptures that are reproduced in *Cahiers d'art* as illustrations to an article by Zervos in which he defines Giacometti as "the only

young sculptor whose work confirms and prolongs the new directions of sculpture" ("Quelques notes sur les sculptures de Giacometti," nos. 8-10, pp. 337-42). The article includes reproductions of *The Caress (In Spite of the Hands)* (1932), *Courronou-u-animal* (1932), *Woman with Her Throat Cut* (1932), *Fall of a Body on a Diagram* (1932), *No More Play* (1932), *Project for a Square* (1930-31), *The Palace at 4 A.M.* (1932), and *Disagreeable Relations* (1932), all photographed by Man Ray. *The Palace at 4 A.M.* represents a culmination of Giacometti's "cage sculptures," hitherto consisting of single units.

Calder returns to New York for five months.

June Calder has an exhibition at Julien Levy Gallery, New York, which includes some of his motor-driven "mobiles."

June 16-July 30 The first major retrospective of Picasso's work is held at Galeries Georges Petit, Paris. The selection is made by Picasso himself, and includes 236 works, ranging in date from 1901 to 1932, with paintings, etchings, illustrated books, and seven sculptures (among them *Woman's Head* and *Woman in a Garden*). The catalogue essay is written by Charles Vrancken, and Zervos publishes a special issue of *Cahiers d'art* devoted to Picasso (vol. 7, nos. 3-5) to coincide with the exhibition (with 157 illustrations and texts by Apollinaire, Maud Dale, H. S. Ede, Carl Einstein, Ramón Gómez de la Serna, Guéguen, Will Grohmann, Georges Hugnet, Vicente Huidobro, Salmon, Oskar Schürer, Strawinsky, James Johnson Sweeney, Zervos, and others). The retrospective travels to the Kunsthaus Zürich, but is not well received. Carl Jung publishes an article psychoanalyzing Picasso's work in *Neue Zürcher Zeitung* (no. 13), "Picasso [psychoanalyzed]." (Partial translations of Jung's article appear in *Cahiers d'art,* nos. 8-10 [1932] and *Revista de occidente* 12, no. 131 [May 1934].)

Summer González visits Picasso at Boisgeloup.

After returning in June from a stay of several

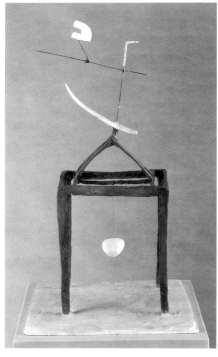

Alberto Giacometti, Hour of the Traces, *1932. Painted plaster and metal, 68.5 x 36 x 28.5 cm (27 x 14 1/8 x 11 1/4 inches). Tate Gallery, London.*

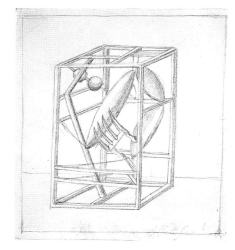

Alberto Giacometti, The Cage, *1930-31. Pencil on paper, 13.6 x 12.2 cm (5 3/8 x 4 3/4 inches). Tate Gallery, London.*

months in the Virgin Islands, Smith experiments with abstract constructions, attaching coral, wood, and soldered lead and iron forms to a wooden base, although he continues to concentrate on painting.

October Zervos publishes the first volume of his catalogue raisonné of Picasso's oeuvre (Paris).

October-November González exhibits three iron sculptures at the Salon des Surindépendants.

November 26-December 30 A joint exhibition at Julien Levy Gallery, New York, shows etchings by Picasso with sculptures by American artist Joseph Cornell.

December Photographer Brassaï goes to Picasso's studios at rue La Boëtie, Paris, and Boisgeloup, Normandy, to photograph his sculptures for the magazine *Minotaure*. He describes them in his book *Picasso and Company*:

Pablo Picasso, Two Small Figures, *1931. Wire, 4 and 5 cm (1 ⁹/₁₆ and 1 ¹⁵/₁₆ inches) high. Whereabouts unknown.*

I . . . photographed several sculptures in iron wire, done in the period 1930-31; linear, geometric constructions in a three-dimensional space most of them triangular. In a way, they formed a sort of sculptural replica of his painted series on l'Atelier of 1927-28, the human form reduced to pure schema. On one of the mantels in Olga's apartment, next to a small bronze sculpture of the blue period, *La Femme à Genoux,* there was a strange wrought-iron piece, tall and skeletal, a sort of scarecrow wearing a fur cap and topped with a little figure of Punch; a long, pointed iron foot, of a type still used by bootmakers, formed its base. Picasso had laden his "Christmas Tree" with all kinds of souvenirs. . . . Just beside the "tree" there was a pot from which emerged the tormented roots of a philodendron whose stalk, shorn of all its leaves, carried a ram's horn and a red plume at its summit. But the majority of Picasso's sculptures were at Boisgeloup. . . . [In Boisgeloup] Picasso insisted on leading us across the park to the edge of the woods, where he had set up two of his wrought-iron stat-

ues—one was called *Le Cerf* (*Woman in a Garden*). They dated from the preceding year. . . . Picasso had watched with curiosity as his friend Julio González, an expert metalworker, hammered and twisted the incandescent metal, and then he had asked him to initiate him into the mysteries of iron and fire (Brassaï, *Picasso and Company*, London, 1966, pp. 15 ff).

Calder begins a series of wind-powered "mobiles" with the standing mobile *Calderberry Bush*.

Smith sees reproductions of welded sculptures by Picasso and González in *Cahiers d'art*. This discovery deeply affects him: "First iron sculptures I made [in 1933] prompted by seeing the work of Picasso which I have been told were created jointly with González (See 1932 *Cahiers d'Art* [sic.]). Constructed Sculptures. . . . When I saw the liberation made by Picasso in the work, I was told González had helped him" (David Smith, brief autobiographical text reproduced in *David Smith by David Smith*, ed. Cleve Gray, London, 1968, p. 24).

Abstraction-Création, Art non figuratif 1932, no. 1 (p. 6), includes a statement by Calder, "Comment réaliser l'art?" (How does art come into being?). Further illustrations of Calder's work appear in nos. 2 and 3.

1933

January Calder visits Madrid and Barcelona, exhibiting in the Sociedad de Cursos y Conferencias, Residencia de Estudiantes of the University of Madrid and in Amics de l'Art Nou and Galeries Syra, Barcelona.

February-March Picasso produces a series of fantastic sculptural studies of bathers, a suite of pencil drawings entitled *An Anatomy*.

March-May Picasso explores the theme of the sculptor's studio, beginning a series of forty etchings that he would finish the following year with a further six.

April 12 González and Giacometti participate in the *Cahiers d'art* Auction. González's *Harlequin* (1930) is illustrated in the accompanying issue of the magazine (nos. 1-2). Other sculptors participating in the event include Laurens and Lipchitz.

May 15 *Le Surréalisme au service de la révolution*, no. 5, publishes Giacometti's "Poème en 7 espaces," "Le Rideau brun," "Charbon d'herbe," and "Hier, Sables mouvants."

Spring Calder is included in a group exhibition at Galerie Pierre, along with Arp, Jean Hélion, Miró, Antoine Pevsner, and Kurt Seligmann, and has a show at Galerie Pierre Colle. In June he returns to the United States.

June Breton publishes his article "Picasso dans son élément" (Picasso in his element) in the first issue of *Minotaure* (June 1, pp. 46-47). He comments on Picasso's new iron sculptures exhibited at Galeries Georges Petit in 1932, and stresses Picasso's liberty and lack of prejudice in his choice of iron and other materials for his sculpture: *Si, comme on l'a vu, Picasso peintre n'a pas de préjugé de la couleur, il faut bien s'attendre à ce que Picasso sculpteur n'ait pas le préjugé de la matière.* (If, as we noticed, Picasso the painter has no prejudices about color, it is to be expected that Picasso the sculptor should have no prejudices about materials.) The article is illustrated with photographs by Brassaï of Picasso's metal sculptures of this period, including the four versions of *Construction in Wire* (1928; pp. 11 and 22), *Painted Iron Head* (1928; p. 11), *Figure* (1930; captioned "Christmas Tree," p. 14), *Woman in a Garden* (1929-30; p. 20), *Head of Woman* (1930; between pp. 20 and 21), *Figure* (1931; p. 22), and the series *An Anatomy*.

Giacometti participates in a Surrealist exhibition at Galerie Pierre Colle, with *Surrealist Table*, a sculpture made especially for the occasion.

August 12-25 Calder exhibits at the Berkshire Museum, Pittsfield, Massachusetts. He writes a state-

ment for the catalogue, discussing "the sense of motion in painting and sculpture."

An exhibition of sculptures by Naum Gabo and Pevsner takes place at Galerie Percier. It concentrates on their abstract reliefs and constructions in plastic and metal.

Fall González exhibits at the Salon des Surindépendants, showing six sculptures—two bronzes (a mask and *The Kiss*), two forged-iron works (*Woman with a Bundle of Sticks* and a mask), and two heads in stone. The Surrealist group also participates en masse.

Conceived in part under the influence of Picasso's metal constructions reproduced in *Cahiers d'art*, to which he had access in Graham's library, and following long discussions with Graham about González's sculpture, Smith creates his first welded sculpture, *Head with Cogs for Eyes*. Also in 1933, he creates a small *Reclining Figure* in forged iron, which (according to Dorothy Dehner, Smith's first wife) was inspired by a sculpture by González that had been in Graham's collection since the late 1920s or early '30s and is now in the Baltimore Museum of Art (Gift of Elinor Graham).

End of the year Smith buys his first oxyacetylene welding torch and establishes his studio at the Terminal Iron Works, a machine shop on the Brooklyn waterfront, where he will continue to work for six years. (In 1950, he creates *Blackburn, Song of an Irish Blacksmith*, in honor of one of the owners of Terminal Iron Works.)

December Giacometti's "Notes on *Palace at 4 A.M.*" is published in *Minotaure* (nos. 3-4, pp. 46-47), with illustrations of *The Palace at 4 A.M.* (1932-33), *Woman with Her Throat Cut* (1932), and *Flower in Danger* (1933). A second text by Giacometti is published in the same issue (p. 109), a response to the question formulated by Breton and Paul Eluard, *Pouvez-vous dire quelle à été la rencontre capitale de votre vie? Jusqu'à quel point cette rencontre vous a-t-elle*

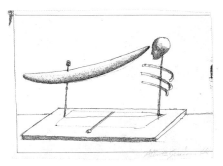

Alberto Giacometti, Point to the Eye, ca. 1932. Pen and ink on paper, 19.2 x 24.3 cm (3 ¹/₂ x 4 ⁹/₁₆ inches). Kunsthaus Zürich, Property of the Alberto Giacometti Foundation.

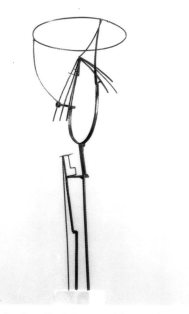

Julio González, Woman with a Basket, 1934. Iron, 180 x 63 x 63 cm (70 ⁷/₈ x 24 ³/₄ x 24 ³/₄ inches). Musée national d'art moderne, Centre Georges Pompidou, Paris.

Alberto Giacometti, Surrealist Drawing, *ca. 1932-33. Iron, 180 x 63 x 63 cm (70 ⅞ x 24 ¾ x 24 ¾ inches). Musée national d'art moderne, Centre Georges Pompidou, Paris.*

Alberto Giacometti, Print from Album Anatole Jakovski, *Paris, G. Orobitz, 1935. Etching in album with twenty-three prints by various artists ²²/₅₀, plate size: 29.6 x 24.2 cm (11 ⅝ x 9 ½ inches); paper size: 38 x 25.8 cm (14 ¹⁵/₁₆ x 10 ³/₁₆ inches). Öffentliche Kunstsammlung Basel, Kupferstichkabinett.*

donné, vous donne l'impression du fortuit? du neces-saire? (Can you say what has been the most important encounter of your life? To what extent did it or does it seem to you that this meeting was the result of chance or of necessity?).

The catalogue for the collection of the Gallery of Living Art, A. E. Gallatin Collection, New York, includes a reproduction of Picasso's painting *Dinard* (1928).

Anatole Jakovski's article "Alexander Calder" is published in *Cahiers d'art* (nos. 5-6, pp. 244-46). Works reproduced include two "mobiles" of 1932 and two of 1933.

González begins construction of a larger studio and home at 8, rue Simon-Barboux in Arcueil, a southern suburb of Paris.

1934

Spring Alfred H. Barr, Jr. purchases a sculpture by Calder from the New York City Art Exposition, for the collection of the Museum of Modern Art, New York. The work, entitled *Mobile Construction Electrically Propelled*, consists of "objects suspended in a vertical circle of wire" (as described by Calder in his *Autobiography with Pictures*, New York, 1966, p. 148). It is reproduced in E. M. Benson, "Seven Sculptors: Calder, Gargallo, Lehmbruck, Lipchitz, Manolo, Moore, Wolf," in *The American Magazine of Art* 28 (August 1935), pp. 454-69 (two works by Calder entitled *Mobile Construction Electrically Propelled* [1934] are illustrated, one captioned as the property of the Museum of Modern Art). This piece was later exchanged for a motorized "universe."

April Calder's first exhibition at Pierre Matisse Gallery, New York, takes place. The catalogue preface is written by Sweeney.

April 25-May 8 González exhibits at Galerie Percier. The catalogue preface is written by Raynal, who calls González *le plasticien du vide* (the sculptor of the void). The exhibition is possibly seen by Graham, who is probably the first American to col-

lect the sculptor's work. Some of the pieces included in the show, *Head Called "The Fireman"* (1933), *Untitled*, and *Small Head with Triangle* (1932-33), are illustrated in *Cahiers d'art* ("Exhibition Julio González à la Galerie Percier," nos. 5-8, p. 209) and in *Abstraction-Création* (no. 3).

Summer Graham spends the summer at Bolton Landing with Smith, and gives him a mask by González (*Mask I*, ca. 1927-29) and a portrait of himself by Calder. González's mask is reproduced in David Smith, "Notes on My Work" (*Arts Magazine* 34, no. 5 [February 1960], pp. 44-49), inscribed by David Smith. Graham shows Smith two other masks by González from his own collection.

October 11-December 4 González and Giacometti are chosen for the exhibition *Was ist Surrealismus* (What is Surrealism?) at the Kunsthaus Zürich. The exhibition also includes works by Arp, Ernst, and Miró. González's entries are *Kiss (Lovers)* (1930), *Dream* (1934), *Don Quixote* (1930), and a mask.

November 20-30 An exhibition of González's sculptures at Galerie Cahiers d'art, Paris, is organized by Yvonne Zervos. Some of the works exhibited are illustrated in *Cahiers d'art* (nos. 1-4, 1935), accompanying his "Réponse à l'enquête sur l'art actuel," including *Woman Combing Her Hair* (ca. 1931), *The Lovers* (1932-33), *Woman with Mirror* (ca. 1934), and *Dancer with the Palette* (ca. 1934). Sweeney visits the exhibition (letter dated November 9, 1936, in González Estate, Paris).

Smith sees Gargallo's welded sculptures at the Brummer Gallery, New York (also reproduced in *Cahiers d'art* 7, nos. 8-10).

Smith takes a position as Technical Supervisor of Mural Painting in the Treasury Relief Art Project, a New Deal art program, and shows some of his *Head* series at a group show at Julien Levy Gallery in the spring.

Giacometti returns to figurative sculpture with works such as *Walking Nude*, *1 + 1 = 3*, and *The Invisible Object*, as well as a series of skull-like heads. Breton writes "Equations de l'objet trouvé," reprinted in *L'Amour fou*, in which he describes his experience of *The Invisible Object*.

December 1-January 1, 1935 Giacometti's first solo exhibition in New York, *Abstract Sculptures by Alberto Giacometti*, is held at Julien Levy Gallery. Overshadowed by an exhibition of Dalí's work in the same gallery, none of the sculptures sell, and the reviews are scarce and mostly negative. Smith visits the show.

Abstraction-Création, Art non figuratif 1934 (no. 3, pp. 9 and 16) reproduces Calder's *Mobile* and González's *Small Head with Triangle* (1932-34).

1935

Cahiers d'art (nos. 1-4, p. 19) includes an illustration of a plaster head by Giacometti.

February-March Giacometti and González are represented in the exhibition *Thèse, Antithèse, et Synthèse* (Thesis, antithesis, and synthesis) at the Kunstmuseum in Lucerne. González's entries are *Woman Combing Her Hair*, in iron, *Maternity*, in bronze, *The Kiss*, in iron, and *Dance*, in iron. Giacometti's *Fragment of a Sculpture* is reproduced in the catalogue.

Galerie Pierre, Paris, exhibits a group of Picasso's 1912-14 collages.

August Albert E. Gallatin, American painter and collector, buys two works by González for his Gallery of Living Art, open to the public in New York since 1927. These works are a silver sculpture, *Resplendence (Standing Figure)* (1932) and an untitled sketch of 1934 for a sculpture (letters from Gallatin dating from August 16, 1935, and August 24, 1935; Estate of Julio González, Paris).

ca. 1935 Gallatin purchases Giacometti's *Sculpture* (1927, carved plaster) for the Gallery of Living Art. It is reproduced in the museum's 1936 catalogue.

September *The American Magazine of Art* 28 (pp. 539-47 and 572) includes an essay by Dorothy Dudley, "Four Postmoderns [A. Alicka, Benno, F. Bores, and J. González]," and reproductions of works by González: *Woman Combing Her Hair* (ca. 1931) and *The Dream* (1934).

Fall Smith leaves New York for an extended trip to Europe. In Paris, Graham introduces him to artists and guides him to museums and private collections. Graham takes Smith to González's studio in Paris, but the Spaniard has already moved to Arcueil. Smith never meets González.

Calder designs his first outdoor "mobile" for the garden of Mrs. Charlotte Allen in Rochester, New York.

Giacometti begins to make sculptures from nature again, working from both life and his imagination henceforth. He is officially expelled from the Surrealist group, and his friendships with Balthus, Francis Gruber, and Pierre Tal Coat begin.

November 20-30 González exhibits iron sculptures at Galeries Cahiers d'art, Paris.

1936

January *Cahiers d'art* devotes a special issue to Picasso's art from 1930 to 1935 (*Picasso 1930-1935*, nos. 7-10), with 92 illustrations accompanying poems and Surrealist texts by Picasso and texts by Breton, Dalí, Eluard, Luis Fernández, González ("Desde París"), Hugnet, Miró, Péret, Man Ray, Jaime Sabartés, and Christian Zervos.

February Calder exhibits at Pierre Matisse Gallery, New York.

February-March González participates in *L'Art espagnol contemporain* (Contemporary Spanish art) at the Musée du Jeu de Paume, Paris. González's entries are *The Acrobats* (1935), two pieces called *Ballarina* (1934-35), and two pieces called *Head* (ca. 1935).

March 2-April 19 *Cubism and Abstract Art*, organized by Barr, is held at the Museum of Modern

David Smith at the Terminal Iron Works, ca. 1934. Courtesy Archives of American Art, Smithsonian Institution, Washington, D.C.

Alberto Giacometti's studio, with Hands Holding the Void. *Photo by Brassaï.*

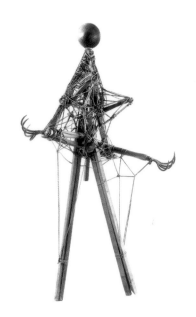

Pablo Picasso, Construction, Figure, *1935. Wood, string, ladle, and rakes, 112 x 62 x 28.5 cm (44 ¹/₂ x 24 ³/₈ x 11 ¹/₄ inches). Musée Picasso, Paris.*

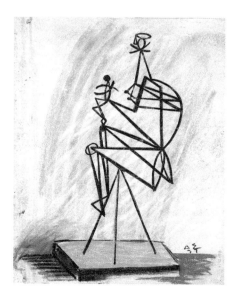

David Smith, Drawing for a Sculpture, 1937. Pastel on paper, 71.5 x 43.2 cm (28 ¹/₈ x 17 inches). Collection of Alvin S. Lane, New York.

Art, New York. It includes works by Calder, Giacometti, González, and Picasso, among others. Works by Giacometti in the exhibition are *Standing Figure* (ca. 1927), *Disagreeable Object* (1931), *Head-landscape* (1932), *Project for a City Square* (1932), and *Sculpture* (1927). *Sculpture* is lent by the A. E. Gallatin Collection. Works by González in the exhibition are *Sculpture* (1932, silver), from the A. E. Gallatin Collection, New York, and *Head* (1935-36, wrought iron), from the collection of Christian Zervos. Twenty-six paintings by Picasso are shown, and three sculptures: *Head* (1909), *Relief Construction: Guitar* (1913), and *Glass of Absinthe* (1914). Works by Calder in the exhibition are *A Mobile* (1934) and *A Mobile* (1936). Calder is also commissioned to make a sign for the exhibition.

May An exhibition of González's work is held at Galerie Pierre.

June An exhibition of Picasso's recent sculpture is held at Galerie Cahiers d'art, Paris. Some of the works exhibited are reproduced in *Cahiers d'art* (nos. 6-7) as illustrations to González's article "Picasso Sculpteur." They include *Head* (1930-31) and seven stick statuettes without captions.

June 26-July 20 A group exhibition is held at Galerie Cahiers d'art, with sculptures and paintings by Picasso, sculptures by González, objects by Miró, and paintings by Fernández. A review of the exhibition appears in *Cahiers d'art* ("Exposition González, Picasso, Miró and Fernandez, Galerie Cahiers d'art"), with reproductions of González's *Woman Combing Her Hair* (ca. 1931) and *Reclining Figure* (1935-36). Only González's works are reproduced.

July 18 The Spanish Civil War begins.

July Upon his return to New York after a trip to Athens, Crete, Paris, London, and the Soviet Union, Smith decides to concentrate primarily on sculpture, although he continues to paint and draw. He is still mentioned as a painter in Graham's book *System and Dialectics in Art*, published in New York

(pp. 75-76; see also letter to Xceron, 1956, in Garnett McCoy, ed., *David Smith*, p. 206).

September When Picasso is appointed director of the Museo del Prado on September 14, Picasso's secretary and friend Sabartés proposes the position of secretary for González (letter dated September 21, 1936, from González to his daughter Roberta; González Estate, Paris).

December 7-January 7, 1937 *Fantastic Art, Dada, Surrealism*, organized by Barr, takes place at the Museum of Modern Art, New York; it includes works by Calder, Giacometti, González, and Picasso. Works by Giacometti in the exhibition are *Disagreeable Object* (1931), *Head-landscape* (1932), and *The Palace at 4 A.M.* (1932). Subsequently purchased by the museum, *The Palace at 4 A.M.* is the first work by Giacometti to enter the collection of an American museum. Works by Calder in the exhibition are *Mantis* (1936) and *Object with a Yellow Background* (1936). One work by González, *Head* (1936), is included. There is no sculpture among the fourteen works by Picasso in the show.

Eight works by Giacometti are included in the *International Surrealist Exhibition* held at New Burlington Galleries in London.

An exhibition of fifty-seven works by Picasso is held at Zwemmer Gallery in London.

Cahiers d'art devotes a special issue (nos. 1-2) to the subject of "L'Objet." Giacometti's *Three Moving Figures on a Plane* (1932) and Calder's *Object Mobile* are illustrated.

1937

February Calder exhibits at Pierre Matisse Gallery.

April 26 The city of Guernica is bombed. Accounts of the bombing and photographs of the destroyed city are published in the Paris newspapers *Ce Soir* and *L'Humanité* in the days that follow.

April Graham's "Primitive Art and Picasso," in which Graham compares Picasso's work with masks from cultures in Africa, Asia, and America, appears

in *The Magazine of Art* 30 (pp. 236-39 and 260).

May Calder returns to Paris.

Barr purchases González's *Head* from the collection of Christian Zervos for the collection of the Museum of Modern Art, New York.

May 12-26 González has a solo exhibition at Galerie Pierre, Paris.

July-October González participates in *Origines et développement de l'art international indépendant* at the Musée du Jeu de Paume, Paris. He enters *Montserrat* (1936-37) and *Woman with a Mirror* (1936).

July 12 The Spanish Pavilion at the Paris World's Fair opens, exhibiting González's *Montserrat*, Calder's *Mercury Fountain*, and Picasso's *Guernica*. Colossal sculptures by Picasso are shown publicly for the first time: *Head of a Woman* and *Woman with Vase* in the garden; the concrete *Head of a Woman* and *Bust of a Woman*; and the bronze *Bather*. This is the last time González will exhibit during his lifetime.

Christian Zervos publishes a special number of *Cahiers d'art* (vol. 12, nos. 4-5) on Picasso's *Guernica*, with sixty-nine illustrations and with texts by José Bergamín, Jean Cassou, Georges Duthuit, Eluard, Leiris, Pierre Mabille, and Zervos.

Smith begins the first of fifteen bronze *Medals for Dishonor*; the series will be completed in 1940. He joins the Federal Arts Project, the Works Progress Administration (WPA) art program, for which he makes sculpture.

The Painter's Object, edited by Myfanwy Evans, is published in London. It includes the statement "Mobiles" by Calder, illustrated with one drawing and two sculptures (one of them is *Dancing Torpedo Shape*, 1932).

Zwemmer Gallery, London, holds two exhibitions featuring works by Picasso.

October 27-November 21 *Picasso from 1901 to 1937*, a retrospective exhibition, takes place at Valentine Gallery, New York.

November 1-20 Jacques Seligmann & Co., New York, holds the exhibition *Twenty Years in the Evolution of Picasso, 1903-1923*, which includes *Les Demoiselles d'Avignon*.

Winter Calder moves to London for several months.

1938

Smith's first solo exhibition is held at Marian Willard's East River Gallery, New York. It includes seventeen abstract sculptures in welded iron (1935-38) and a number of drawings. He also exhibits with American Abstract Artists and works on the Federal Arts Project of the WPA, as well as in the Section of Fine Arts of the Treasury Department.

February Calder has an exhibition at Freddy Mayor's Gallery, London.

Spring Calder returns to the United States.

Giacometti is run over by a motorist and spends months in the hospital recovering from an injured foot, which is threatened with amputation. The intensity of the experience strongly affects him.

August Calder's first retrospective exhibition is held at the George Walter Vincent Smith Art Museum, Springfield, Massachusetts.

Cahiers d'art devotes a special issue to Picasso (nos. 3-10), with 120 illustrations, an article by Zervos, and a poem by Eluard.

Fall *Guernica* is brought to England for exhibitions in London, Leeds, and Liverpool.

October 19-November 11 The Museum of Modern Art, Boston, holds the exhibition *Picasso and Matisse*.

1939

March 30-April 1 Madrid is taken by Franco's army. The Spanish Civil War ends.

May-October *Guernica* is shown in New York, Los Angeles, Chicago, and San Francisco, after which it is included in the Picasso retrospective at the Museum of Modern Art, New York.

July-September González spends the summer with

Julio González at work in his Arcueil studio with Hans Hartung, ca. 1937-38.

Alexander Calder working at his studio on Second Avenue, New York City, 1938.

his family in the Lot Valley in south-central France (Mirabelle-par-Montcuq); he is unable to make sculpture there. He writes to Picasso:

Siguiendo tus consejos me encuentro en el "Mas" en el Lot . . .

Hoy recibo una carta del marido de Roberta pidién-dome un certificado o declaration de sentiments de sym-pathie et loyauté envers la France par une personne con-nue par la police ou des militaires. Si tu peux faire ou le faire faire, il faudrait pour qu'il se reçoive tout de suit lui envoyer à:

Hans Hartung 1ère Cie.

3ème Groupe. Camp des Etrangères

Meslay du Maine

Mayenne

Si te es posible hacerlo te lo agradeceremos mucho. Ya puedes figurarte lo que nos divertimos este verano.

(According to your advice, I find myself in the "Mas" in the Lot. . . . Today I received a letter from Roberta's husband asking me for a certificate or declaration of sympathy and loyalty toward France by a person known to the police or the military. If you can do it or have it done, it should be sent immediately to [address above]. If it is possible to do it, we will be very grateful to you. You can already imagine that we will enjoy ourselves this summer.)

September 1 Germany invades Poland without a declaration of war. Two days later, Great Britain and France declare war on Germany, while Belgium and the United States declare their neutrality. World War II begins.

Calder creates his *Water Ballet* for the New York Edison Company exhibit at the New York World's Fair, but it is not constructed. (It is produced as an elaborate fountain a few years later at the General Motors Technical Center, Detroit). He wins first

prize in the Plexiglas Sculpture Competition at the Museum of Modern Art and exhibits at Pierre Matisse Gallery.

Smith has a solo exhibition at Willard-J. B. Neumann Gallery, and is represented in several group exhibitions in New York, Minneapolis, and at Skidmore College in Saratoga Springs. He continues work on *Medals for Dishonor*.

November 15-January 7, 1940 *Picasso: Forty Years of His Art* is held at the Museum of Modern Art, New York, and subsequently travels to the Art Institute of Chicago; the City Art Museum of St. Louis; the Museum of Fine Arts, Boston; the San Francisco Museum of Art; the Cincinnati Art Museum; the Cleveland Museum of Art; the Isaac Delgado Museum of Art, New Orleans; the Minneapolis Institute of Arts; and the Carnegie Institute, Pittsburgh.

Giacometti meets Jean-Paul Sartre.

1940

March 6 González writes a long letter to Picasso about the technical aspects and difficulties of sculpture in gold. This is the last letter known to be written by González to Picasso (MP Archives).

March A new, expanded catalogue of the Gallery of Living Art is published, with essays by Gallatin, Hélion, and Sweeney, and critical notes by L. K. Morris. One work each by Calder, Giacometti, and González, and eighteen works by Picasso are reproduced.

In March, Smith has his second solo exhibition at Neumann-Willard Gallery, New York. In the summer, he moves permanently to Bolton Landing and begins to build a studio. During wartime he works as a machinist for a short time and then takes a full-time job welding M7 tanks and locomotives in Schenectady, New York. One piece of his work is exhibited at the New York World's Fair.

Picasso resumes sculpting at his studio in Paris; at great risk of having them confiscated by German

patrols, he takes plasters to a foundry at night with the help of friends.

Giacometti begins to work again from his imagination, creating a series of tiny figures.

Early June Just prior to the Germans' entry into Paris, González moves to the Lot, where he remains for more than a year. The shortage of oxygen and acetylene due to the war forces him to abandon welded-metal sculpture, and he turns instead to drawing and modeling in plaster.

At the beginning of the German occupation of Paris, Giacometti and Picasso see each other often, and frequently meet Sartre and Simone de Beauvoir. An exhibition of Calder's work is held at Pierre Matisse Gallery, New York, and his first exhibition of jewelry is held at Willard Gallery, New York.

1941

Picasso writes the play *Desire Caught by the Tail*, reportedly in three days.

Picasso: Epochs of His Art is held at the Museum of Modern Art, New York, and subsequently travels to Durham, Grand Rapids, Hanover, Kansas City, Milwaukee, Minneapolis, Poughkeepsie, and Utica.

Fall Picasso turns the bathroom of his apartment on rue des Grands-Augustins into a sculpture studio, and creates the monumental *Head of Dora Maar* (WS 197), which in 1959 becomes his monument to Apollinaire and is placed in the graveyard of Saint-Germain-des-Prés, Paris.

November González returns to Arcueil in order to continue working. He begins a large version of *Small Frightened Montserrat*, inspired by the horrors of war.

December 7 Pearl Harbor is bombed by the Japanese.

December 31 Giacometti leaves Paris for Geneva. No more visas are issued by the Germans after his departure, and he is unable to return to Paris until 1945. His work in Switzerland continues to be primarily of tiny figures.

1942

March 27 González dies in Arcueil. Picasso, Zervos, and Fernández attend his funeral. Soon after, Picasso paints a still life with a bull's skull and dedicates it, "En hommage à González" (Roberta González, "Julio González: My Father," and David Smith, "González: First Master of the Torch").

Smith is included in *Artists for Victory* at the Metropolitan Museum of Art, New York, and is given a solo exhibition at the Walker Art Center, Minneapolis. He makes a series of drawings, including *The Italian Theme*, an indictment of Mussolini's fascism.

May-June Calder exhibits at Pierre Matisse Gallery.

October-November Giacometti is included in the *Surrealist Exhibition* at Peggy Guggenheim's Art of This Century Gallery, New York.

1943

The Museum of Modern Art acquires Smith's *Head* (1938). Critic Clement Greenberg writes enthusiastically about Smith's sculptures for the first time, concerning his works included in *American Sculpture of Our Time* at the Willard and Buchholz galleries, New York (*The Nation* 156, no. 4 [January 23], pp. 140-41).

February-March Picasso creates assembled sculptures, incorporating actual objects and stamping textures into plaster or clay. He creates the sculpture *Man with Sheep* (MP 331); according to Kahnweiler, it is made in a single day after long forethought and the production of numerous drawings (*The Sculpture of Picasso*, London, 1949, p. [7]).

April A solo exhibition of Smith's work is held at Willard Gallery, New York.

Calder develops his *Constellations*: "[I] devised a new form of art consisting of small bits of hardwood carved into shapes and sometimes painted, between which a definite relation was established and maintained by fixing them on the ends of steel wires.

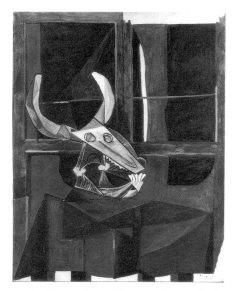

Pablo Picasso, Still Life with Steer's Skull (Homage to González), *1942. Oil on canvas, 130 x 97 cm (51 ¼ x 38 ¼ inches). Kunstsammlung Nordrhein-Westfalen, Düsseldorf.*

After some consultation with Sweeney and Duchamp, who were living in New York, I decided these objects were to be called 'constellations'" (*Calder: Autobiography with Pictures*, p. 179).

September-January 1944 A retrospective exhibition of Calder's work, organized by Sweeney, is held at the Museum of Modern Art, New York.

1944

March 19 A reading of Picasso's *Desire Caught by the Tail* by de Beauvoir, Sartre, Raymond Queneau, and others, under the direction of Albert Camus, is held at Leiris's apartment in Paris.

August 25 Paris is liberated.

October A retrospective exhibition of Picasso's work is held at the Salon d'Automne.

November-December Calder exhibits sculptures in bronze, mobiles, and stabiles at Buchholz Gallery.

Smith finishes his studio at Bolton Landing and begins once again to produce a large number of sculptures. He is introduced to Greenberg.

1945

October Calder's gouaches are exhibited at Samuel M. Kootz Gallery, New York.

Smith meets Jackson Pollock.

February-March Giacometti's exhibition *Sculptures 1931-1935* is held at Art of This Century, New York.

May 8 The Germans collapse under Allied attack and the war in Europe is over.

August 6 and 9 Atomic bombs destroy the cities of Hiroshima and Nagasaki in Japan.

September 2 The formal document of Japan's surrender is signed aboard the U.S.S. Missouri in Tokyo Bay, marking the end of World War II.

September 17 Giacometti leaves Geneva for Paris, where he resumes his friendship with Picasso.

December An exhibition of paintings by Picasso and Matisse is held at the Victoria and Albert Museum, London.

1946

January A retrospective of Smith's work, including fifty-four sculptures from 1936-45, is held at the Willard and Buchholz galleries, New York.

Giacometti begins making tall, slender figures (such as *Walking Man*, *Nose*, and *Head on a Stalk*), and he begins painting again from nature, especially portraits. His autobiographical article "Le Rêve, le sphinx et la mort de T" (The Dream, the sphinx, and T.'s death) is published in *Labyrinthe* (nos. 22-23 [December 15]).

Summer The Museum of Modern Art, New York, publishes Barr's *Picasso: Fifty Years of His Art*.

June-July Picasso shows paintings at Galerie Louis Carré, Paris.

October-November Calder exhibits at Galerie Louis Carré, Paris (with catalogue text by Sartre), and receives a commission for a mobile for the Terrace Plaza Hotel, Cincinnati.

1947

April Smith exhibits his *Specter* series at Willard Gallery, New York, and writes three statements for the catalogue: "The Landscape," "Sculpture Is," and "Specters Are." His retrospective exhibition travels throughout the United States.

Spring-summer Calder exhibits with Léger in Bern and Amsterdam. Calder's mobiles are purchased by the Kunsthalle Basel and the Stedelijk Museum, Amsterdam.

Summer Calder's works are included in the *Exposition internationale du surréalisme* in Paris.

Picasso produces his first ceramics, in Vallauris in the South of France.

Pierre Matisse invites Giacometti to exhibit at his gallery in New York.

Encouraged by Pierre Loeb, Giacometti makes his first engravings since 1935.

1948

January 19-February 14 A retrospective exhibition of Giacometti's work is held at Pierre Matisse

Gallery, New York. The catalogue contains an introduction by Sartre, "The Search for the Absolute," and an autobiographical letter from Giacometti to Pierre Matisse written the previous year.

Abstract-Surrealists is held at the Art Institute of Chicago, and features several sculptures by Smith.

Summer An exhibition of works by Calder is held in Brazil at the Ministerio de Educaçao in Rio de Janeiro, and at the Museo de Arte, São Paulo.

Giacometti begins a series of skeletal figures in motion (including *City Square*, *Three Men Walking*, and *Walking Quickly Under the Rain*) and of small figures set on large bases (*Chariot* and *Four Figurines on a Base*).

Smith begins to teach at Sarah Lawrence College.

Although invited to participate in the Venice Biennale, Giacometti withdraws his work from it.

1949

March 8-April 2 An exhibition of fifty-eight works by Picasso, including twenty-four bronzes from 1945-47, is held at Buchholz Gallery, New York.

Fall Calder exhibits at Buchholz Gallery; Curt Valentin gallery, New York; Margaret Brown Gallery, Boston; and the Virginia Museum of Fine Arts, Richmond.

Kahnweiler publishes the first monograph on Picasso's sculpture, *The Sculptures of Picasso*, in London, with photographs by Brassaï. Kahnweiler adopts González's term "drawing in space" in this book to describe Picasso's wire constructions of 1928, openwork sculptures that he also credits as "the first step towards the conquest, in sculpture, of a field which had never before been claimed by anything but architecture: *the creation of spaces*."

1950

January 29-March 19 *Picasso: The Sculptor's Studio* is held at the Museum of Modern Art, New York. The catalogue includes an essay by William S. Lieberman.

Picasso produces modeled works in ceramic to be cast in bronze, again using found objects. These works include *Pregnant Woman*, *She-Goat*, *Woman with Baby Carriage*, and *Little Girl Skipping Rope*.

Smith receives a John Simon Guggenheim Foundation fellowship, which is renewed the following year. He is given a solo exhibition at the Willard Gallery, for which Robert Motherwell writes the catalogue preface.

May 6-June 11 Giacometti is given his first museum retrospective at the Kunsthalle Basel.

June-July Calder exhibits mobiles at Galerie Maeght, Paris. Several of them are purchased by the Musée d'art moderne, Paris.

November-January 1951 La Maison de la pensée française, Paris, holds an exhibition of forty-three sculptures by Picasso dating from 1932-43 and drawings from the 1940s. The catalogue preface is by Louis Aragon.

Giacometti: Sculpture, Painting, Drawings is held at Pierre Matisse Gallery, New York. The catalogue contains quotes from Giacometti.

December The Massachusetts Institute of Technology, Cambridge, holds an exhibition of Calder's works.

1951

Smith begins his *Agricola* series. He meets painter Kenneth Noland, with whom he later establishes a close friendship.

Giacometti makes sculptures that diverge from his recurrent subjects of standing figures and portrait busts (for example, *Dog*). The first exhibition of his work at Galerie Maeght, Paris, takes place.

Organized by Sweeney, the second retrospective exhibition of Calder's work is held at the Museum of Modern Art, New York.

Calder's statement "What Abstract Art Means to Me" is published in *The Museum of Modern Art Bulletin* 18 (no. 3 [Spring], pp. 8-9), along with statements by Davis, de Kooning, Fritz Glarner,

Cover of D.-H. Kahnweiler's Les Sculptures de Picasso *(published in Paris, 1949), with Brassaï's 1943 photograph* Cast of Picasso's Hand.

Pablo Picasso painting a centaur by flashlight, Vallauris, 1949.

David Smith working on Hudson River Landscape *in Bolton Landing, New York, 1951. Courtesy Whitney Museum of American Art, New York.*

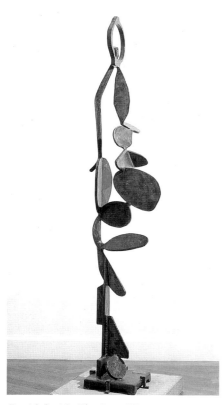

David Smith, The Iron Woman, *1954-58. Steel, painted green, 224.2 x 35.6 x 42 cm (88 ¼ x 14 x 16 ½ inches). Storm King Art Center, Mountainville, New York, Gift of Ralph E. Ogden Foundation.*

George L. K. Morris, and Motherwell.

1952

February 1-March 9 *Julio González: Sculptures* is held at the Musée national d'art moderne, Paris. The catalogue preface is by Jean Cassou.

February 19-March 15 *Pablo Picasso: Paintings, Sculpture, Drawings* is shown at Curt Valentin gallery, New York.

Calder wins first prize at the Venice Biennale. A major exhibition of his work is held at Curt Valentin gallery.

1953

Smith teaches at the University of Arkansas. He begins the *Tank Totem* series. Six of his works are represented in the Museum of Modern Art's traveling exhibition in Europe.

May-July 5 The Galleria nazionale d'arte moderno, Rome, gives Picasso a major retrospective, featuring 135 paintings, 32 sculptures, and 79 other works.

June A Picasso retrospective is held at the Musée de Lyon.

November 24-December 19 *Pablo Picasso: 1950-1953* is held at Curt Valentin gallery. The catalogue preface, "Picasso: Good Master of Liberty," is by Eluard. Sixty-five works, including eighteen sculptures, are exhibited.

Giacometti begins a series of small stubby figures in plaster and bronze and becomes interested in printmaking, especially lithography.

November-December A retrospective exhibition of Giacometti's work is held at the Arts Club of Chicago.

December-February 1954 A retrospective exhibition of Picasso's work is held at the Museo de Arte Moderno, São Paulo.

1954

Spring Picasso begins to work in sheet metal—cut, bent, and painted—to create a series of busts and heads of Sylvette David and Jacqueline Roque.

Smith teaches at the University of Indiana, and is appointed American delegate to UNESCO's First International Congress of Plastic Arts, Venice.

September Derain dies.

November Henri Matisse dies.

Giacometti works after drawings by Matisse in order to design a medal commemorating the artist for the French Mint. Pierre Matisse Gallery, New York, holds its third Giacometti exhibition. Giacometti sees Samuel Beckett and Jean Genet often; the latter will publish *L'Atelier d'Alberto Giacometti* in 1958.

1955

Smith teaches at the University of Mississippi, and begins his *Forging* series.

Large retrospective exhibitions of Giacometti's work are held at the Solomon R. Guggenheim Museum, New York, and the London Arts Council Gallery.

Spring Curt Valentin gallery holds a retrospective of Calder's work.

June A retrospective exhibition of Picasso's work is held at the Musée des arts décoratifs, Paris, and later travels to Munich, Cologne, and Hamburg.

September-October Calder exhibits at the Museo de Bellas Artes de Caracas, Venezuela.

1956

February 8-April 8 A retrospective exhibition of González's work is held at the Museum of Modern Art, New York.

March 3-30 Kleeman Galleries, New York, has an exhibition of González's work.

Spring An exhibition of works by Calder is held in Basel.

Summer Giacometti exhibits at the French Pavilion in the Venice Biennale, and at the Kunsthalle Bern.

Smith writes an article about González's sculpture, "González: First Master of the Torch," which is published in *Art News* (vol. 54, no. 10 [February], pp. 34-37 and 64-65), with reproductions of *Dancer with a Palette* (1933), *Head called "The Tunnel"*

(1933), *Head called "The Big Trumpet"* (1932), *Dancer* (1938), and *Woman with a Mirror* (1936). Calder establishes an association with Perls Galleries, and has the first of regular exhibitions there.

1957

January 9-February 10 *Picasso: Sculptures* is held at Fine Arts Associates, New York, with twenty-six works. The catalogue includes extracts from *The Sculptures of Picasso* by Kahnweiler.

May 4-September 8 *Picasso: Seventy-Fifth Anniversary Exhibition* is held at the Museum of Modern Art, New York. It includes forty-two bronzes from throughout his career. The exhibition subsequently travels to the Art Institute of Chicago, and then to the Philadelphia Museum of Art, where seventy-five ceramics, previously shown in London and Rotterdam, are added.

September 10-October 27 A retrospective exhibition of Smith's work is held at the Museum of Modern Art, New York.

Smith begins his *Sentinel* series.

1958

At the Venice Biennale, Smith represents the United States with an exhibition organized by the Museum of Modern Art. *Royal Bird* (1947-48) is included in *Contemporary American Sculpture* in the United States Pavilion at the Brussels World's Fair.

Calder creates a mobile for New York's Idlewild International Airport and exhibits large stabiles at Klaus Perls Gallery, New York.

Giacometti receives a Guggenheim Prize (national section) for a 1957 painting.

1959

Giacometti is commissioned to create a monumental sculpture for the plaza in front of the Chase Manhattan Bank in New York, but the project is never realized.

Smith begins his *Albany* series. His work is included in Documenta 2, Kassel, West Germany.

In February, Calder exhibits at Galerie Maeght, Paris, and in September at the Museo de Arte Moderno, Rio de Janeiro.

June Picasso's monument to Apollinaire (his *Head of Dora Maar* of 1941) is dedicated in Paris.

December A retrospective exhibition of Calder's work takes place at the Stedelijk Museum in Amsterdam, traveling the following year to several museums in Germany and Switzerland.

1960

April A retrospective exhibition of Calder's work is held at the Palais des Beaux-Arts, Brussels.

July-September A Picasso retrospective is held at the Tate Gallery, London.

Giacometti creates monumental figures (*Walking Man I* and *Tall Figures I-IV*) conceived in connection with an outdoor project.

1961

Giacometti is awarded the Carnegie Prize for sculpture at the Pittsburgh International Exhibition of Contemporary Painting and Sculpture.

1962

May-July Smith goes to Voltri, near Genoa, to make sculptures for the Fourth Festival of the Two Worlds at Spoleto. He makes twenty-seven works in thirty days.

Summer Giacometti exhibits again at the Venice Biennale and is awarded the Grand Prix for sculpture.

July-August A retrospective exhibition of Calder's work, organized by the Arts Council of Great Britain, is held at the Tate Gallery, London.

December-March 1963 Smith makes his *de Voltri-Bolton* series of twenty-five works from machine parts shipped from Italy.

1963

March 9 The Museo Picasso opens in Barcelona.

August 31 Braque dies.

November Galerie Maeght, Paris, holds an exhibition of large stabiles by Calder.

Alexander Calder's studio in Saché, France, 1961.

1964

A retrospective of Picasso's works, 1899-1963, is held in Tokyo, Kyoto, and Nagoya.

Picasso completes the maquette for *Head of a Woman (Kazbec)* commissioned for the Civic Center, Chicago (WS 643).

Giacometti receives a Guggenheim International Award for his painted work. The Tate Gallery, London, holds a retrospective exhibition of his work.

Alexander Calder: A Retrospective Exhibition is held at the Solomon R. Guggenheim Museum, New York, and at the Musée d'art moderne, Paris.

A solo exhibition of Smith's work is held at Marlborough-Gerson Gallery, New York.

1965

May 23 Smith dies in a car accident near Bennington, Vermont.

October A retrospective exhibition of Giacometti's work is held at the Museum of Modern Art, New York. Giacometti visits the United States for the first time on the occasion. A retrospective is also held at the Louisiana Museum, Humlebaek, Denmark.

1966

January 11 Giacometti dies in Chur, Switzerland.

November *Hommage à Pablo Picasso*, a comprehensive exhibition of his drawings, ceramics, and sculpture, is held at the Grand Palais and Petit Palais, Paris.

1967

June 9-August 13 *The Sculpture of Picasso*, organized by Sir Roland Penrose, is held at the Tate Gallery, London, showing 204 sculptures and thirty-two ceramics. The accompanying catalogue includes an essay by Penrose. The exhibition travels to the Museum of Modern Art, New York, where it is on view October 11-January 1, 1968.

1969

March-May *David Smith*, a retrospective exhibition, is held at the Solomon R. Guggenheim Museum, New York, and subsequently travels to the Dallas Museum of Fine Arts and the Corcoran Gallery of Art, Washington, D.C.

1970

An exhibition of Picasso's recent work at the Palais des papes, Avignon is organized by Yvonne Zervos with a catalogue by Christian Zervos.

1971

Picasso gives his first construction in metal, *Guitar* (1912), to the Museum of Modern Art, New York.

October 25 An exhibition of works by Picasso is held in the French National Collections at the Grande Galerie du Louvre on the occasion of his ninetieth birthday.

1972

An enlargement of Picasso's *Construction: Monument to Apollinaire* (1928) is placed in the sculpture garden of the Museum of Modern Art, New York.

1973

April 8 Picasso dies in Mougins, France.

1974

A retrospective exhibition, *Alberto Giacometti*, is held at the Solomon R. Guggenheim Museum, New York.

1978

Calder dies.

1980

Pablo Picasso: A Retrospective is held at the Museum of Modern Art, New York.

1983

Julio González: A Retrospective is held at the Solomon R. Guggenheim Museum, New York.

Compiled by M. Dolores Jiménez-Blanco.

Anthology of Writings by the Artists

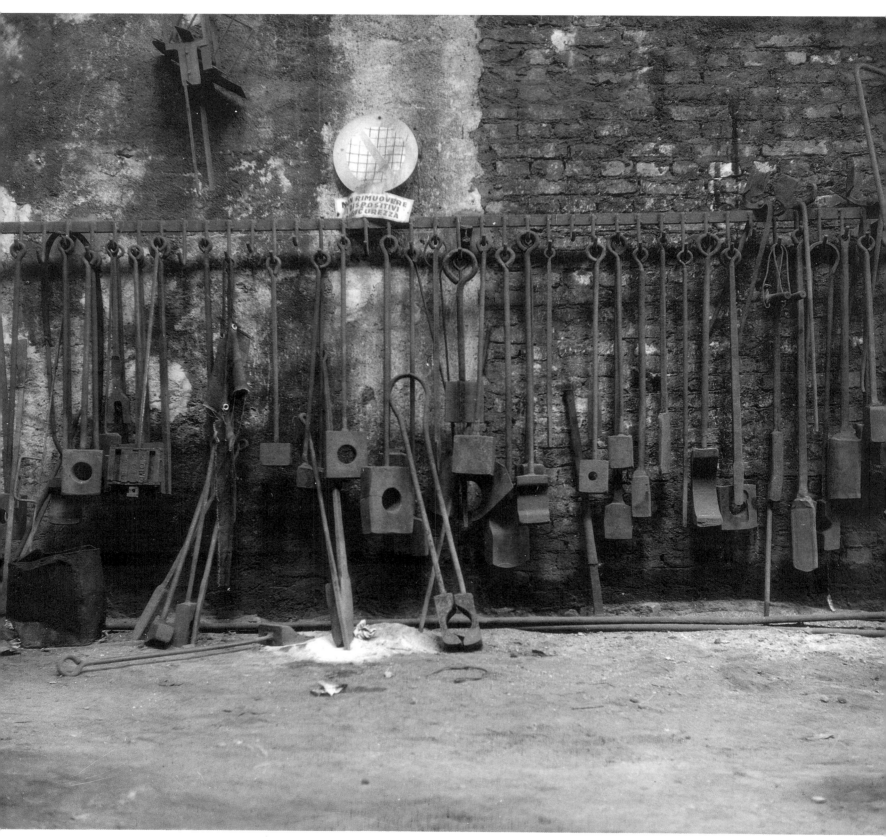

Tongs on Factory Wall *(David Smith's studio). Voltri, 1962.*

The texts in this section of the catalogue were selected to complement the exhibition and to enrich its theme. For other writings by the artists, the reader should refer to the appropriate section of the bibliography.

Julio González

A Few Notes on New Sculpture by Julio González, Written Around 1930.

From the Julio González Estate Archive, Paris.

The modern artist glimpses a new world opening up before him. The path that leads to it is not easy to find: it is full of obstacles and to enter it he must first clear a way. From this step onward on the new path he begins to interpret reality in a different way. A different force and spirit animate his new works. He is carried aloft by a wind hitherto unknown. Upon reaching mysterious heights, he feels alone, he trembles, he is afraid, he is wary. HE SEEKS! But his struggle will be rewarded in his solitude!

In a few years he finds what he was seeking in the mists of his unconscious. He creates, invents forms, designs, contrasting designs, different perspectives, forms in SPACE! He continues to paint, but he thinks only of sculpture. For him, each color is but a means to differentiate one plane from another, light from shade, shapes from other shapes.

•

A painter or a sculptor can each give shape to something imprecise, such as light, color, an idea. These shapes will of course be imagined as referring to the human image. The problems posed by the reinvented planes that create a new architecture are difficult to solve!

•

One may raise the objection that sculpture drawn in space is limited in its possibilities. No more than traditional sculpture—its means of expression are just as great, but different. The Oceanic sculptor who has only a tree trunk with which to carve his totem finds himself obliged to make the arms close up against the body, which gives it its strength and beauty. With rudimentary means he succeeds in expressing himself fully. It is the same for the African artist who makes the thighs too short on his seated fetish, his tree trunk allowing him no more. We the civilized, who isolate all parts from the block, what do we admire most in a torso, if not the tree trunk?

•

A statue of a woman may simply be a woman, the representation of the natural world one sees all around. But if she holds an olive branch in her hand in a certain way, she is no longer a woman; she has become a symbol of peace. As symbol, we must not walk around her, for as soon as we no longer perceive the attribute, she becomes a woman again. Hence this art that one believed to be perfect ceases to be so as soon as it tries to represent an abstract idea, because of its FULL content! A few mere lines, or the marriage of matter and space! The Roman triumphal arch is a fine example; and later the rose windows of our beautiful cathedrals, with their perforations of such varied forms, made a leap in the evolution of artistic creation. By means of color and a circle of panes, celestial and earthly figures appear before us, enclosed in abstract spaces. Drawing inspiration from them, the modern artist frees them, granting them their autonomy through a new sculptural conception.

•

In order to give his work the maximum of power and beauty, the sculptor is obliged to preserve a certain mass, to maintain the exterior contour. It is thus on the conception of this mass that he must concentrate his attention, his imagination, his science, his way of preserving all of its power. In this way the architect and the painter collaborate in sculpture, suppressing, accentuating, and softening certain forms in favor of the mass. For example, in traditional sculpture a leg is formed out of a single block; but in sculpture using SPACE as MATERIAL, this same leg may be conceived of as SCOOPED OUT, designated by a single STROKE in a whole that likewise forms a single block. Traditional sculpture has a horror of holes and empty spaces. This new kind of sculpture uses them to their fullest potential, considering them INDISPENSABLE material now. Would anyone say that the Roman triumphal arch was "full of holes"? Its architect obtained a mass as full as a pyramid! Why doesn't the modern sculptor profit from this example?

(Translated, from the French, by Sophie Hawkes.)

Picasso as Sculptor

From "Statements by Gonzalez," in The Museum of Modern Art, Julio González (exh. cat.), with introduction by Andrew C. Ritchie, nos. 1-2 of The Museum of Modern Art Bulletin *23 (1955-56), pp. 43-44. First published in* Cahiers d'art, *nos. 6-7 (1936), pp. 189-91.*

It gives me great pleasure to speak of Picasso as a sculptor. I have always considered him a "man of form," because by nature he has the spirit of form. Form is in his early paintings and in his most recent.

In 1908, at the time of his first cubist paintings, Picasso gave us form not as a silhouette, not as a projection of the object, but by putting planes, syntheses, and the cube of these in relief, as in a "construction."

With these paintings, Picasso told me, it is only necessary to cut them out—the colors are only the indications of different perspectives, of planes inclined from one side or the other—then assemble them according to the indications given by the color, in order to find oneself in the presence of a "Sculpture." The vanished painting would hardly be missed. He was so convinced of it that he executed several sculptures with perfect success.

Picasso must have felt himself to be of a true sculptor's temperament, because in recalling this period of his life to me, he said: "I have never been so content" or "I was so happy."

Later, in 1931, at the time when he was working on the sculpture—*Monument to Apollinaire*—I often heard him repeat "I feel myself once more as happy as I was in 1908."

I have observed many times that there is no form which leaves him indifferent. He looks at everything, on all sides, because all forms represent something to him; and he sees everything as sculpture.

Again, recently, having gathered some sticks of white wood in his studio, he carved the beautiful sculptures published here with his little pen-knife (retaining the planes and dimensions of each piece, each one of them suggesting a different figure to him), which will undoubtedly arouse a great deal of interest.

To my mind, the mysterious side, the nerve center, so to speak, of the work of Picasso, is in his formal power. It is this power which has caused so much talk of his work, which has gained so much glory for him.

From "Statements by Gonzalez," in The Museum of Modern Art, Julio González (exh. cat.), with introduction by Andrew C. Ritchie, nos. 1-2 of The Museum of Modern Art Bulletin *23 (1955-56), pp. 42. First published in Andrew C. Ritchie,* Sculpture of the Twentieth Century *(exh. cat.). New York: The Museum of Modern Art, 1952, p. 30.*

The age of iron began many centuries ago by producing very beautiful objects, unfortunately for a large part, arms. Today, it provides as well, bridges and railroads. It is time this metal ceased to be a murderer and the simple instrument of a super-mechanical science. Today the door is wide open for this material to be, at last, forged and hammered by the peaceful hands of an artist.

Only a cathedral spire can show us a point in the sky where our soul is suspended!

In the disquietude of the night the stars seem to show to us points of hope in the sky; this immobile spire also indicates to us an endless number of them. It is these points in the infinite which are precursors of the new art: '*To draw in space.*'

The important problem to solve here is not only to wish to make a work which is harmonious and perfectly balanced—No! But to get this result by the marriage of *material* and *space*. By the union of real forms with imaginary forms, obtained and suggested by established points, or by perforation—and, according to the natural law of love, to mingle them and make them inseparable, one from another, as are the body and the spirit.

From "Statements by Gonzalez," in The Museum of Modern Art, Julio González (exh. cat.), with introduction by Andrew C. Ritchie, nos. 1-2 of The Museum of Modern Art Bulletin *23 (1955-56), p. 42. First published in* Julio González (exh. cat.). *Amsterdam: Stedelijk Museum, 1955.*

To project and design in space with the help of new methods, to utilize this space, and to construct with it, as though one were dealing with a newly acquired material—that is all I attempt.

The synthetic deformities of material forms, of color, of light; the perforations, the absence of compact planes, give the work a mysterious, fantastic, indeed diabolical aspect. The artist, in the very process of transposing the forms of nature, in breathing new life into them, collaborates at the same time with the space which ennobles them.

From Josephine Withers, "Gonzalez's Unpublished Manuscript, 'Picasso sculpteur et les cathédrales,'" in Julio Gonzalez: Sculpture in Iron. *New York: New York University Press, 1978, pp. 131-38.*

"From one point to another, the straight line is the shortest," Picasso has said.

Picasso has caused a great deal of talk since [the time of] his first artistic activities up to this day. If in the criticism, since 1902, many have disliked him, there have been many more, among intellectuals, who have praised him. We shall limit ourselves to showing by some statements, the new merits which complement his work, for [even if] he had done only painting, we would still gladly place laurels on his brow.

We shall, then, be concerned with him from this date [of] 1903. Picasso is twenty-two years old, he begins to feel a new world opening up to him. The road which leads there, it is not easy to enter into it; a thousand obstacles oppose him, [the road] is full of impediments. In order to enter there more freely, whether to free the route, or to deliver himself of an annoying burden, he begins to burn his drawings, entire albums! He even warms himself in this way one winter. By the thousands, the fireplace of his hotel room in the Rue de Seine in Paris reduces them to ashes.

So restored to work he continues to be the same idealist, [and] from that moment [in] 1906, [when] he begins to translate reality in a new way, his canvases take on a strange direction; a new force, a very different spirit animates them, and for these reasons, they have greater breadth.

Having reached mysterious regions, he feels *alone*, trembles, fears, mistrusts himself. He searches, *for he has never searched*, but, in his solitude, he immediately sees his effort rewarded.

1911

Later on, perhaps unconsciously, in order to give air to his paintings, it occurs to him to execute these separately with cutout papers.

The alert is given! He doesn't stop, he works more than ever, he searches always, he contrives to make little boxes out of cardboard [which are] joined together with string. He succeeds in making works of art full of emotion with a *new technique*: these assembled papers give the impression of things carved in rock.

1914

After this, with primitive tools, scratching his hands a thousand times with a stubborn tenacity, he makes his first [construction in] sheet metal, as beautiful as they are original, the powerful and masterly still lifes.

He had just created his first sculptures. One can imagine the satisfaction which a real artist would feel in creating these works, but, when the *painter* Picasso, recalling this period of his life, still says of himself: "I have never been so pleased! That was my point of departure. The departure on a new road to follow, I was happy." [If he can say that,] it surely means that this was of great importance to him!

In his abundant production, there is enough to nourish generations of artists who are willing to seriously study his drawings.

In only a few years, he found, created, invented, [and] drew new forms (we speak of sculpture), new planes, opposition of planes, perspectives, *forms in space*. He is *still* looking, still working, he foresees something, he himself doesn't yet know what. He continues to paint, but, he thinks only of sculpture, because each color for him is only a means of distinguishing one plane from another, the light from the shadow, or yet other forms.

A painter or a sculptor can, the first on his canvas, the second on his block, make a form appear or disappear, that is to say a thing which does not have a precise form (shape) in itself, since it begins and ends nowhere, but as here the sculptor must give form not to the imitation of another real form, but to a light, to a color, or to an idea, this [new, or sculptural] form, even the most human, will be altered from the model. Hence a new source of problems to solve, created by unexpected situations and an *architecture to be created by the artist.*

El gran Homero no escribió en latin, porque era griego, ni Virgilio escribió en griego, porque era latino. Cervantes.

Picasso was born in Málaga, (Spain) where he stayed until he was four years old. This man of astonishing activity, whose brain measures and weighs everything, gifted with a limpid intelligence, who ponders endlessly, this man, who, obedient to his own ideal, is aware that he must leave the tranquil Mediterranean, drawn by the charms of the Seine which always beguile him, can only speak of the city where he passed his youth, of its simple peasants of rough tongue, of its blue sea. He is the direct son of this land through his *heart*, through his *works*, and through his *direct ways of realizing them.* He lived until his departure for Paris, in this barbaric land, as beautiful as it is wretched—in this country which since its begin-

ning, was always subjugated to new conquerors, and which destiny finished by cutting in two, making of its mystic Montserrat the vassal of Spain and of its high Canigou the vassal of France—in this martyred people, oppressed, without their own liberty, without the hope of ever obtaining it. No matter! Attached to it as to a [gravely] ill person whom one loves, one holds him the more dear because he suffers, one always wants to relieve him of his ills, endure them for him, and in that sad impossibility, one is painfully resigned and lives with bitterness in the heart. The stigmata of these moral miseries, Picasso carried deeply [within himself] and, as with his proud brothers from over there, laughs often in order not to cry: *Like a pure Catalan*.

One would never say that Gothic art is geometric. When the architect of a cathedral conceives of one of his magnificent spires, it is not of geometry that he thinks; at this moment, it is only a question of giving it a beautiful form which, while responding to architectural requirements, can at the same time idealize that which his imagination and heart inspire in him. The aesthetic geometry which results is only secondary, and the geometry of each stone, so to speak, depends only on the laws of construction and of the quality and resistance of the materials used.

Only a cathedral spire can indicate a point in the sky where our soul rests in suspension.

As in the restlessness of the night, the stars mark out points of hope in the sky, [so too] this immobile spire marks out an infinite number of them to us. It is these points in the infinite which are the precursors of this new art: *To draw in space*.

The real problem to be solved here is not only to wish to make a harmonious work, of a fine and perfectly balanced whole—No! But to get this [result] by the marriage of *material* and *space*, by the union of real forms with imagined forms, obtained or suggested by established points, or by perforations, and, according to the natural law of love, to mingle and make them inseparable one from another, as are the *body* and the *spirit*.

The *Roman triumphal arch* is a striking example of this [union]. Later on the first great step in this order of ideas was the execution of the rose windows of our beautiful cathedrals, in which, by perforations in the stone, appear the heavenly and earthly figures; owing to the windows, [their] shapes [are] created both by the color and the outline. Why then, with a sort of evolution, should these spaces

not one day become themselves directly human, without recourse to painting? Hence, Christian art of purely Latin tradition, born of the spirit of faith in the mystery of the Trinity.

In a picture, a certain distortion of an optical-geometric nature is accepted. If this distortion is general, deliberate, completely of a scientific order, it could be *interesting*, but not *serious*. On the other hand, the distortion resulting from a synthesis can be both serious and beautiful, and more, being purely (entirely) a psychological creation, it can become a geometric distortion, if the realization of the work depends on it.

If the synthetic deformities of material, of color, and of light, the perforations, the lack of material planes, give to the work a mysterious, fantastic, and diabolical appearance, then the artist, in addition to idealizing a material to which he gives life, is at the same time working with the ennobling space.

The Age of Iron began many centuries ago, by producing (unhappily) arms—some very beautiful. Today it makes possible the building of railroads. It is time that this metal cease to be [a] murderer and [the] simple instrument of an overly mechanical science. The door is opened wide to this material to be at last! forged and hammered by the peaceful hands of artists.

1931

Picasso never finds the time to execute one of his projects. If, rarely, he makes up his mind, he settles on his most recent idea. For he is so restless, always wanting to improve, he only succeeds in filling new pages of his sketchbook. This is why, in spite of the thousands of studies, he took not a one the morning of the day he went to work at the forge; his hammer alone was enough to try to bring into being his monument to Apollinaire. He worked on it long months at a time and he finished it. He would often say, "Once again I feel as happy as I was in 1912."

This original work is a purely sculptural interpretation to its maximum of expression of a spiritual vision of nature, combining organic forms—primordial characteristic of life. So full of fantasy and of grace, so well balanced, so human, so personal, this work is made with so much love and tenderness in the memory of his dear friend, at the moment he doesn't want to be separated from it, or to think of its being at Père Lachaise in that collection of monuments where people seldom go. He wished that this monument become the reliquary which would keep the ashes of the lamented

poet and that he be authorized to place them near his house, in his garden—And often with friends, gather round him who is no longer.

Some critics have maintained that Picasso was mad, that he was joking, and that his art wasn't serious. They have only seen in it [some] strange fantasy, [or] bad painting. They haven't taken into account—the blindmen—the value of this treasure, this abundance in new means of expression.

If it is true that Picasso is gifted with an exceptional imagination which complements (perhaps) his work, it is also possible that he not have it and remain just as personal. The realist Velasquez, faithful interpreter of his model, is as great an artist as the spiritual El Greco in his fanciful compositions. The works of *Despiau*, full of reality, as well as the spiritual sculptures of the cathedral of Chartres, have the same force, and breathe the same beauty. Picasso, who always idealizes, simultaneously or separately (this doesn't depend on him, it is unconscious with the artist), but he always keeps in his work his force and his personality.

One could object that this kind of sculpture is limited, [but] it is no more so than the other (the full); there, the artist must express himself by other means. The Oceanian sculptor, who has only a tree trunk for carving his *totem*, must press the arms to the body which is what gives the statue its force and its beauty: he succeeds in expressing himself; in the same way, the Negro makes the thighs of his seated fetish too short, his tree trunk not permitting him any more. We, the civilized ones, who have at our disposal the whole block, what do we most admire in a torso, if it is not the tree trunk?

With great humility, Picasso will limit himself—in his art—to the inspiration of Nature and to interpret it faithfully. It is for that reason, that he is original and ceaselessly renews himself; he wants to attain to perfection: unhappily one will never attain it.

"Try to draw by hand a perfect circle—a useless task—only the imperfections will reveal your personality," Picasso says.

One will not produce great art in making perfect circles and squares with the aid of compass and ruler, or in drawing one's inspiration from New York skyscrapers. The truly novel works, which often look bizarre, are, quite simply, those which are directly inspired by *Nature*, and executed with love and sincerity.

In order to give the most power and beauty to his work, the sculptor must be aware of the exterior contour, in order to preserve its sense of mass. So it is in the *center* of this mass that he must concentrate all his effort, all his imagination, [and] all his science, so that its power won't be weakened. It's there (at that point) that architecture and painting can come together with sculpture. That is, one will eliminate, exaggerate, or soften various details in order to preserve this sense of mass. For example: in a statue, we take into account that the contour of a leg or of an arm is as beautiful from one side as the other. There, the artist must respect both [sides], even though one side may be attached to the block.

On the other hand, for sculpture [which does not originate with] the block, the block results from the execution of the work and it is [then] possible (if the material permits) to draw in space a single side of this arm which will enclose the [whole] block. That a drapery should hide one side of this arm is commonly accepted, we are not really saying anything new.

Our *material*, then, being *space*, this block can be formed around a void [which taken together] form a single block. With sculpture of *stone*, *holes* are not necessary. With sculpture having to do with space, they are necessary. It has never been claimed that the Triumphal Arch of Tiberius was *perforated*. Its architect knew how to obtain a [sense of] *mass* as *solid* as a pyramid.

One might claim that in architecture this is permitted; but why shouldn't this be true of sculpture, since we already have in front of our eyes Picasso's examples.

A statue of a woman can also be a woman (a portrait) which one should be able to see from all sides; from all aspects, she is a representation of Nature.

But, if in a certain attitude, she is holding an olive branch, she is no longer a woman. She has become the symbol of Peace. [Once she has] become a symbol, do not walk around her, for as soon as you no longer see the attribute, she again becomes [simply] a woman. So this classic art, which was thought complete, actually is not, simply because of its *solid* material.

Only certain lines or planes can give the necessary emphasis to the attribute. These essential lines, these *tracings* of paint on the canvas, ["traiteé de fausse peinture, ou de peinture fantaisiste . . . " (omitted)], purely sculptural in conception and realization, will one day be replaced by Picasso with iron bars which he will take and arrange in such a way as to interpret the subject of one of his paint-

ings, and *soldering them together*, he shall have obtained the best expression to give to his attribute Peace, which will become symbol as well as a statue of a woman, by the synthesis of the human being, thanks to certain forms (constructed—perhaps—in space) or by planes indicated on his canvas with colors (perhaps also constructed in space).

Picasso, then, realized *his most cherished dream*, that by this *incomplete art*, his attribute might be seen from all sides.

It is normal for painters to make sculpture, or sculptors to paint; it is, so to speak—to rest oneself, to have a *change of pace*. With Picasso, paintings as well as drawings, once they have taken tangible form [and] have been transformed into sculpture properly speaking, once again become paintings—that is to say color, or the black and white of drawings, according to the model. Painting, drawing, and sculpture finally become one with Picasso.

26-2-31

Picasso paints as always.

In looking at his latest painting—very restful—one notices that he [has] become more sensitive to color. These colors are not deliberately chosen, they are sensitive harmonies, delicate contrasts, where the color makes the ensemble vibrate.

But, this abstract painting, so very flat (perhaps more so than ever) is also his most beautiful sculpture. And as, astonished, we ask him why, Picasso answers, "Because in this painting, there is in its plasticity a perspective. One must create the planes of a perspective. Yes, it is the colors which do it."

[Draft, pages unnumbered]

In the Romanesque portals of our basilicas, the arch and tympanum, sculpted or not with living subjects, are brutally supported by abstract lines, by the rigid columns.

.

In this central portal of the Cathedral of Paris [illustrated in ms.] we see the architect make the traditional columns rise up, like a graft, a new column at each one. One, the Ancient, "material," abstract form: Architecture. The other, the New, "spiritual," animated form: Sculpture. Inseparable, the two complement each other.

.

The first [the architectural columns], discreetly attached to the wall, their capitals forming a frieze, powerfully support the abstract, logical ogive. The others, better yet, those which wonderfully give the illusion, these are the Saints, at the same time "Spiritual" columns, "divine" statues and "mystical" Caryatids of our cathedrals, which support this void, this space full of mystery (this horizontal bar of shadow made by the projecting canopy on the previously mentioned capital frieze) on which rises miraculously like a prayer, the sculptural (voussoirs), the living, pious ogive.

To fill out the ensemble of the marvelously realized (conceived) work, we should add that the saints rest not on socles, but on culs de lampe, and that these, projecting shadows on themselves, also form a horizontal bar of space which gives the impression that these saints rest on the infinite!

When the architect of a cathedral conceives one of his magnificent spires, he is not thinking in terms of geometry; at this moment, it is only a question of giving a satisfactory form which, while responding to architectural necessities, can at the same time idealize the promptings of his heart and imagination. The resulting aesthetic geometry of each stone depends, as it were, only on the laws (rules) of construction and on the resistance of the materials used.

By contrast, the principle of the arabesque in the Alhambra is purely objective geometry. The result is a marvel of art of a simply optical beauty.

Every religion has its temple, but the only one which through the mystery of its architectural lines, purifies our thoughts and raises them above the world, is Gothic (ogival) art. This is what the architect of the Ile de France, faithful interpreter of his country's spirit, has succeeded so well with such grandeur in expressing!

Alexander Calder

How Can Art Be Realized?

From H. H. Arnason and Ugo Mulas, Calder. *London: Thames and Hudson, 1971, p. 25. First published as "Comment réaliser l'art?" in* Abstraction-Création, Art non figuratif, *no. 1 (1932), p. 6.*

Out of volumes, motion, spaces carved out within the surrounding space, the universe.

Out of different masses, tight, heavy, middling—achieved by variations of size or color.

Out of directional line—vectors representing motion, velocity,

acceleration, energy, etc.—lines which form significant angles and directions, making up one, or several, totalities.

Spaces and volumes, created by the slightest opposition to their mass, or penetrated by vectors, traversed by momentum.

None of this is fixed. Each element can move, shift, or sway back and forth in a changing relation to each of the other elements in this universe.

Thus they reveal not only isolated moments, but a physical law of variation among the events of life.

Not extractions, but abstractions:

Abstractions which resemble no living thing, except by their manner of reacting.

Mobiles

From The Painter's Object, *ed. by Myfanwy Evans. New York: Arno Press, 1970, pp. 62-67. First edition, London: Curwen Press, 1937.*

When an artist explains what he is doing he usually has to do one of two things: either scrap what he has explained, or make his subsequent work fit in with the explanation. Theories may be all very well for the artist himself, but they shouldn't be broadcast to other people. All that I shall say here will be about what I have already done, not about what I am going to do.

I began by studying engineering. But after four years I decided that engineering did not allow enough play of ingenuity on my part. When I was working in a logging camp I first started painting. I went to New York, and then to Paris, where I started making wire toys—caricatures of people and animals, some of them articulated. Then I made things in wood, taking a lump of wood and making very little alteration in its shape—just enough to turn it into something different. Then I made a circus with elephants, horses, a lion, Roman chariots and so on: basically of wire, but with cork and wood and bright colours added. Most of these objects also were articulated, so that they made characteristic gestures. The material for this was based on my observation at the circus, and on drawings of it. I was always interested in circuses.

My father was a sculptor and my mother a painter, but it was quite accidentally that I became mixed up with modern art. Through a neighbour who knew about modern art—he had read the books, and so on—I went to see Mondrian. I was very much moved by Mondrian's studio, large, beautiful and irregular in shape as it was, with the walls painted white and divided by black lines and rectangles of bright colour, like his paintings. It was very lovely, with a cross-light (there were windows on both sides), and I thought at the time how fine it would be if everything there *moved*; though Mondrian himself did not approve of this idea at all. I went home and tried to paint. But wire, or something to twist, or tear, or bend, is an easier medium for me to think in. I started with a few simple forms. My first show was at the Galerie Percier, of simple things ranged on a plank against a wall. In a way, some of those things were as plastic as anything I have done. They did not move, but they had plastic qualities. Then I made one or two things that moved in a slight degree. I had the idea of making one or two objects at a time find actual relationships in space.

I did a setting for Satie's *Socrate* in Hertford, U.S.A., which I will describe, as it serves as an indication of a good deal of my subsequent work.

There is no dancing in it. It is sung by two people—a man and a woman. The singing is the main thing in it. The proscenium opening was 12 feet by 30 feet. There were three elements in the setting. As seen from the audience, there was a red disc about 30 inches across, left centre. Near the left edge there was a vertical rectangle, 3 feet by 10 feet, standing on the floor. Towards the right, there were two 7 foot steel hoops at right angles on a horizontal spindle, with a hook one end and a pulley the other, so that it could be rotated in either direction, and raised and lowered. The whole dialogue was divided into three parts: 9, 9, and 18 minutes long. During the first part the red disc moved continuously to the extreme right, then to the extreme left (on cords) and then returned to its original position, the whole operation taking 9 minutes. In the second section there was a minute at the beginning with no movement at all, then the steel hoops started to rotate toward the audience, and after about three more minutes they were lowered towards the floor. Then they stopped, and started to rotate again in the opposite direction. Then in the original direction. Then they moved upwards again. That completed the second section. In the third, the vertical white rectangle tilted gently over to the right until it rested on the ground, on its long edge. Then there was a pause. Then it fell over slowly away from the audience, face on the floor. Then it came up again with the other face towards the audience;

and that face was black. Then it rose into a vertical position again, still black, and moved away towards the right. Then, just at the end, the red disc moved off to the left. The whole thing was very gentle, and subservient to the music and the words.

For a couple of years in Paris I had a small ballet-object, built on a table with pulleys at the top of a frame. It was possible to move coloured discs across the rectangle, or fluttering pennants, or cones; to make them dance, or even have battles between them. Some of them had large, simple, majestic movements; others were small and agitated. I tried it also in the open air, swung between trees on ropes, and later Martha Graham and I projected a ballet on these lines. For me, increase in size—working full-scale in this way—is very interesting. I once saw a movie made in a marble quarry, and the delicacy of movement of the great masses of marble, imposed of necessity by their great weight, was very handsome. My idea with the mechanical ballet was to do it independently of dancers, or without them altogether, and I devised a graphic method of registering the ballet movements, with the trajectories marked with different coloured chalks or crayons.

I have made a number of things for the open air: all of them react to the wind, and are like a sailing vessel in that they react best to one kind of breeze. It is impossible to make a thing work with every kind of wind. I also used to drive some of my mobiles with small electric motors, and though I have abandoned this to some extent now, I still like the idea, because you can produce a *positive* instead of a fitful movement—though on occasions I like that too. With a mechanical drive, you can control the thing like choreography in a ballet and superimpose various movements: a great number, even, by means of cams and other mechanical devices. To combine one or two simple movements with different periods, however, really gives the finest effect, because while simple, they are capable of infinite combinations.

From "What Abstract Art Means to Me: Statements By Six American Artists," in The Museum of Modern Art Bulletin *18, no. 3 (spring 1951), pp. 8-9.*

My entrance into the field of abstract art came about as the result of a visit to the studio of Piet Mondrian in Paris in 1930.

I was particularly impressed by some rectangles of color he had tacked on his wall in a pattern after his nature.

I told him I would like to make them oscillate—he objected. I went home and tried to paint abstractly—but in two weeks I was back again among plastic materials.

I think that at that time and practically ever since, the underlying sense of form in my work has been the system of the Universe, or part thereof. For that is a rather large model to work from.

What I mean is that the idea of detached bodies floating in space, of different sizes and densities, perhaps of different colors and temperatures, and surrounded and interlarded with wisps of gaseous condition, and some at rest, while others move in peculiar manners, seems to me the ideal source of form.

I would have them deployed, some nearer together and some at immense distances.

And great disparity among all the qualities of these bodies, and their motions as well.

A very exciting moment for me was at the planetarium—when the machine was run fast for the purpose of explaining its operation: a planet moved along a straight line, then suddenly made a complete loop of 360° off to one side, and then went off in a straight line in its original direction.

I have chiefly limited myself to the use of black and white as being the most disparate colors. Red is the color most opposed to both of these—and then, finally, the other primaries. The secondary colors and intermediate shades serve only to confuse and muddle the distinctness and clarity.

When I have used spheres and discs, I have intended that they should represent more than what they just are. More or less as the earth is a sphere, but also has some miles of gas about it, volcanoes upon it, and the moon making circles around it, and as the sun is a sphere—but also is a source of intense heat, the effect of which is felt at great distances. A ball of wood or a disc of metal is rather a dull object without this sense of something emanating from it.

When I use two circles of wire intersecting at right angles, this to me is a sphere—and when I use two or more sheets of metal cut into shapes and mounted at angles to each other, I feel that there is a solid form, perhaps concave, perhaps convex, filling in the dihedral angles between them. I do not have a definite idea of what this would be like, I merely sense it and occupy myself with the shapes one actually sees.

Then there is the idea of an object floating—not supported—the

use of a very long thread, or a long arm in cantilever as a means of support seems to best approximate this freedom from the earth.

Thus what I produce is not precisely what I have in mind—but a sort of sketch, a man-made approximation.

That others grasp what I have in mind seems unessential, at least as long as they have something else in theirs.

Alberto Giacometti

Notes on "Palace at 4 A.M."

From Minotaure, *nos. 3-4 (Dec. 1933), p. 46. English excerpt from* The Museum of Modern Art, *Alberto Giacometti (exh. cat.), with introduction by Peter Selz. New York: The Museum of Modern Art, 1965, p. 44.*

I can only speak *indirectly* about my sculptures and can only hope to partially describe what motivated them.

For years now I have created only sculptures that presented themselves to my mind fully formed. I have limited myself to reproducing them in space without changing anything, without asking myself what they might mean (if I even attempt to alter part of one or try to figure out its significance, I am completely lost and the object ruined.) Nothing has ever appeared to me in the form of a painting; rarely do I see in the form of a drawing. The occasional attempts I have made at the conscious realization of a painting or even a sculpture have always failed.

Once the object is made I have a tendency to find in it, transformed and displaced, images, impressions, and events that have moved me deeply (often without my knowing it), shapes that I sense to be close to me, although I am often incapable of identifying them, which makes them all the more disturbing to me.

I use the sculpture reproduced here, which represents a palace, as an example.* This object took shape little by little in the late summer of 1932; it revealed itself to me slowly, the various parts taking their exact form and their precise place within the whole. By autumn it had attained such reality that its actual execution in space took no more than one day.

It is related without any doubt to a period in my life that had come to an end a year before, when for six whole months hour after hour was passed in the company of a woman who, concentrating all life in herself, magically transformed my every moment. We used to construct a fantastic palace at night—days and nights had the same color, as if everything happened just before daybreak; throughout the whole time I never saw the sun—a very fragile palace of matchsticks. At the slightest false move a whole section of this tiny construction would collapse. We would always begin it over again. I don't know why it came to be inhabited by a spinal column in a cage—the spinal column this woman sold me one of the very first nights I met her on the street—and by one of the skeleton birds that she saw the very night before the morning in which our life together collapsed—the skeleton birds that flutter with cries of joy at four o'clock in the morning very high above the pool of clear, green water where the extremely fine, white skeletons of fish float in the great unroofed hall.

In the middle there rises the scaffolding of a tower, perhaps unfinished or, since its top has collapsed, perhaps also broken.

On the other side there appeared the statue of a woman, in which I recognize my mother, just as she appears in my earliest memories. The mystery of her long black dress touching the floor troubled me; it seemed to me like a part of her body, and aroused in me a feeling of fear and confusion. All the rest has vanished, and escaped my attention. This figure stands out against the curtain that is repeated three times, the very curtain I saw when I opened my eyes for the first time. In search of an infinite enchantment I fixed my gaze upon this brown curtain, above which a thin thread of light filtered across the floor.

I can't say anything about the red object in front of the board; I identify it with myself.

*(Translated, from the French, by Sophie Hawkes.)

"Enquête," response to André Breton's and Paul Eluard's questions, Pouvez-vous dire quelle a été la rencontre capitale de votre vie? Jusqu'à quel point cette rencontre vous a-t-elle donné, vous donne-t-elle l'impression du fortuit? du nécessaire? *(Can you say what has been the most important encounter of your life? To what extent did it or does it seem to you that this meeting was the result of chance or of necessity?), in* Minotaure, *nos. 3-4 (Dec. 1933), p. 109.*

A white string in a puddle of cold liquid pitch haunts me, but at the same time, one October night in 1930, I see pass before me the gait and the profile—a small part of the profile, the concave line between forehead and nose—of a woman, who from that moment

on unfolds like a continuous line through each space in the rooms where I have been. This encounter gave me and gives me still, in spite of the surprise and the shock, an impression of necessity. It seems to me that every encounter that has ever affected me has taken place in daytime, at the precise moment it had to.

(Translated, from the French, by Sophie Hawkes.)

From Alberto Giacometti: Schriften, Fotos, Zeichnungen. Essais, photos, dessins, *ed. by Ernst Scheidegger. Zurich: Sammlung Horizont, 1958, p. 8. First published in "Témoignages," XXe Siècle, no. 2 (Jan. 1952), pp. 71-72.*

Space . . .

Words cannot express the perceptions of the eye and hand. Words distort thoughts, writings distort words: they become unrecognizeable. I do not believe in spatial problems; space is created by objects; a mobile which turns with no point of its surface touching the surface of another object has no sensation of space. It's the subject that counts. Space, form, canvas, plaster, bronze . . . so many means. The important thing is to re-create an object that can produce the closest sensation to the sensation felt at the sight of the subject . . .

Sculpture is built on empty space. It is the space one makes in the process of constructing an object, and, in turn, the object creates a space. It is the very space between the subject and the sculptor.

(Translated, from the French, by Sophie Hawkes.)

My Reality*

"Ma Réalité," from Alberto Giacometti: Ecrits, *ed. by Michel Leiris and Jacques Dupin. Paris: Hermann, 1990, p. 77. First published in* XXe Siècle, *no. 9 (June 1957), p. 35.*

I certainly make paintings and sculpture and, ever since I first painted or drew, it has always been to bite into reality, to defend myself, to nourish myself, to get bigger; to get bigger the better to defend myself, the better to be able to attack, to capture, to make as much progress as possible on every front, in all directions, to protect myself from hunger, cold, death, to be as free as possible; as free as possible to try—with the means most suitable to me today—to see better, to understand better the things around me, to understand better to be more free, as big as possible, in order to spend, to

expend myself as much as possible in what I'm doing, to take my chances, to discover new worlds, to wage my war, for pleasure? for joy? for war, for the pleasure of gain and loss.

*Response to a survey conducted by Pierre Volboudt, *A chacun sa réalité* (To each his own reality), to which seventeen artists responded.

(Translated, from the French, by Sophie Hawkes.)

Way to Draw a Figure

From Alberto Giacometti: Ecrits, *ed. by Michel Leiris and Jacques Dupin. Paris: Hermann, 1990, p. 114.*

Different elements together may create a work of art:

I. Mass.

II. Direction of the masses: the relationships among them, contrasts, direction of one with regard to another in the surrounding space.

III. Composition of the masses, the clarity of drawing, and logical composition down to the last square centimeter.

IV. Lines or arabesques, shapes of the masses in space and shapes of the spaces resulting from the composition, and fullness in relation to lines in the opposite direction.

V. Harmony of the whole and the composition through mass, of the masses through drawing, the drawing as a whole, general harmony.

(ca. 1924)

(Translated, from the French, by Sophie Hawkes.)

From Alberto Giacometti: Ecrits, *ed. by Michel Leiris and Jacques Dupin. Paris: Hermann, 1990, pp. 129-30.*

The boundless vanity of everything. And mystery exists for everything, in everything. Man has always expressed his concept of the universe through art, which is more direct than philosophy.

(ca. 1931/32)

I can only find myself in objects, in sculpture, in drawings (perhaps in paintings) and much less in poetry. And in nothing else.

(ca. 1931/32)

(Translated, from the French, by Sophie Hawkes.)

David Smith

Letter, in French, to Roberta González, written from Bolton Landing, N.Y. [n.d., prior to Nov. 4, 1955]. Solomon R. Guggenheim Museum Archives, New York.

Madame,

For its forthcoming December issue the magazine *Art News* has asked me to write an article on your father, Julio Gonzalez. I have admired his work since 1932 when I was a student and saw a reproduction of his sculpture for the first time.

In 1934, my friend John Graham (a Russian-American painter and collector) gave me a small head that he had bought from your father. It is an early mask in iron, smaller than a hand, with "strings" across the brow forming the lines of the features. I am going to have it photographed and will send you a copy.

In 1936 John Graham and I met in Paris and wanted to visit your father, but he had moved. I had just returned from Greece, and was on my way to the Soviet Union; I went home without passing through Paris again. To my great regret I never met him; otherwise I would not have to trouble you for this article.

The painter Herman Cherry lent me the information you sent him regarding the dates of your father's work, and I own the catalogue "Amsterdam-Bruxelles." I have a few translated notes, but I would like to ask you a few questions about the personal and intimate things that artists talk about, which are always very different from official museum reports.

I wish to speak of the artist Gonzalez and write as if I were conversing with other artists.

I come to you with profound respect and great admiration for your father's work. My friends Graham and Xceron were his friends and long-standing admirers of his father.

Any personal and unpublished material you might wish to communicate to me will be treated with the greatest care, and I will send you several copies of the magazine. Please believe me that I shall be entirely at your disposal for any similar favor I might do for you in the United States, being an iron sculptor myself. You will find the questions on the pages enclosed herein; please excuse me for asking so many questions, I shall use your answers to the best of my ability to write an article appreciating the work of the artist and the man Julio Gonzalez as much as they deserve.

I would like to stress a point that museum officials will never make:

Why was your father not appreciated when he was still alive?

Why did no one buy when the money from the sales would have allowed him to make more sculptures?

Why must an artist die to be recognized?

What is wrong with the connoisseurs, given that artists have always known and loved the works of your father?

Fraternally yours,

David Smith

[Appendix to the letter]

1. Who were your father's close friends? With whom did he talk about aesthetics? Did he spend time in certain cafés, etc.?

2. Could you speak a little of your mother, the year of their marriage, her feelings about your father's work? Where your parents lived? What you remember of your father's devotion to his art and his eternal struggle as an artist?

How did he make a living and obtain the funds necessary for his sculpting materials?

Can you tell me if there were difficulties—without forgetting that I am always on your father's side?

I think that there are certain parallels to my own life and my struggles as well.

3. Approximately how many sculptures did he make? How many in iron?

In a work dating from 1936, *Woman with a Sickle, la Monserrat*, was there a political sympathy with the Popular Front? (In 1936 I marched in the Père Lachaise cemetery with the Cultural Institute of Artists.) Was he part of this cultural group? During the Spanish Civil War, did your father's sympathies lie with the royalists? Did he make posters or other works for this cause?

4. Did he like music? What kind was his favorite?

5. I would say that your father was a kind and gentle man, a poet, but I cannot write this unless you confirm it for me. I see these qualities and more in his work, but if you speak to me of his character I can write more truthfully.

6. What can you tell me about his studios (the size of the rooms, kind of buildings)? About his tools? Did he use power tools? Did he use an electric welder, the type we call an "arc welder" here, or was all his iron work done with gas welding?

7. Did the French critics take his work seriously? Did many French collectors buy his work? Did the French museums buy and show his work during his lifetime?

8. I am very perplexed about the years from 1929-31, when Picasso made sculptures with welded iron. Some friends told me that "Gonzalez welded for Picasso"—information on this seems to vary.

An American catalogue states that your father taught Picasso how to use a welder. Please be kind enough to give the exact circumstances.

Did your father teach Picasso to weld his own sculptures? Did he weld for Picasso out of friendship—or did he work for him on iron sculptures and construction during this period 1929-32?

I do not ask this question to make a point, but to establish their true relationship.

9. May I mention your name if necessary?

10. Could you lend me some photographs not previously published in the Amsterdam-Brussels catalogue for the *Art News* article?

Do you have a personal photograph of your father, your mother, and yourself, or of Gonzalez with his friends? I would like to reproduce an intimate, unpublished image of your father. I do not want to repeat the documentation in the catalogue.

I would like to broaden the knowledge of his life and work.

I promise to take great care of any documents you might be so kind to entrust to me with, and to return them; or, if you must make copies, I would be happy to reimburse you for them, as well as any costs incurred in sending them.

If you do me the honor of answering my questions I wish to thank you in advance. I will do my very best for your father's sake.

David Smith

(Translated, from the French, by Sophie Hawkes.)

Letter, in French, to Roberta González. Solomon R. Guggenheim Museum Archives, New York.

Madame Roberta Gonzalez

Arcueil, France

Nov. 4, 1955

Madame,

I thank you sincerely for such prompt and complete information. My delay in answering you is explained by my search for a transla-

tor for this letter.

I will take great care of your photographs and will send them to you as soon as I have written the article and as soon as the plates for the magazine are ready.

The article has been announced for January, and I will send you a few copies. I will make every effort to show the importance and the truth of your father's life and work.

Please find enclosed a photo of the little mask I own. I do not know the date. It is of approximately the same size as the photo. The silver sculpture in the Philadelphia Museum was purchased in 1933 by Mr. E. Gallatin. Your father had donated a drawing to Mr. Gallatin, and the American painter George L. K. Morris owns a drawing purchased from your father. You know about the works in the Museum of Modern Art, and you must know and approve of the show of pastels and bronzes at the Henry Kleeman Gallery.

A large number of New York artists knew your father, especially between 1930 and 1935 when they met at the studio of J. Torres-García.

I have written to Picasso and Brancusi and many others and hope to be able to add to what has already been published on your father and his work.

I have read a laudatory article on a show of your work and your artistic talent.

Soon I shall have some photos of my work from 1955 and I will be pleased to send them to you.

Please accept my gratitude and most respectful regards.

David Smith

(Translated, from the French, by Sophie Hawkes.)

Gonzalez: First Master of the Torch

From Art News 54, no. 10 (Feb. 1956), pp. 35-37, 64-65.

The Bull in its symbolic action has stood for many things in Picasso's history, things Spanish and things noble. The Bull has been the artist, the people of Spain, the open-eyed conscience of free men, the disemboweler of the lie of Franco, the aggressive protector of women, and among other symbols, the lover of woman.

But after the death of Julio Gonzalez, Picasso's friend of forty-five years, the Bull becomes a skull on a green and blue fractioned table before the window curtained in violet and black.

Coming home from the funeral Picasso had done this picture

of a bull's skull and dedicated it: "En hommage à Gonzalez."

To the wall of his studio was tacked a snapshot of his friend. For Picasso all source of life becomes the nature of painting.

On what peaks did memory ride—for they were friends from youth, from the days of the Barcelona café. "Els Quatre Gats." In 1901 Picasso shared Gonzalez' living quarters in Paris until he found a studio. Throughout the succeeding years they remained on good terms, visiting each other, even working together; and then, the end at Arcueil in March of 1942.

The youngest of four children (the others, his sisters Pilar and Lola, his brother Juan), Gonzalez was born in Barcelona in 1876. Both Juan and Julio were apprenticed in their father's metal shop, becoming third-generation smiths. With other ideas in mind, the brothers studied painting at night at the Barcelona School of Fine Arts, which Miro was to attend fifteen years later. They knew "Els Quatre Gats," the Spanish counterpart of the Parisian "Chat Noir" and gathering-point of the local avant-garde. Here the youthful Picasso had decorated the walls with twenty-five portraits of writers and artists who frequented the café.

During the 1890s the tension between the impoverished multitudes and the wealthy few of prosperous Barcelona manifested itself in a series of strikes, reprisals and acts of anarchy. Dispossessed refugees pouring in from Cuba increased the degree and extent of the economic problem.

The intellectual reaction to the social distress and rebellious temper of the times was to revolt against tradition and authority and embrace the attitudes of "modernism." Thus Barcelona awoke to the romanticism of the age, Art Nouveau, the Gothic Revival, Wagner's music, Lautrec's presentation of Paris and the Bohemian life, Maeterlinck's drama, the Pre-Raphaelites and the climaxing monument to the new art, Gaudi's cathedral.

I feel Gonzalez coming from Barcelona and looking back lovingly at Gaudi's Cathedral of the *Sagrada Familia*, respecting Gaudi's source in nature and the unities of iron and stone.

Gonzalez' notebook contains statements about the new art which seem to parallel ideals for the Catalonian Gaudi's cathedral: "To project and draw in space with new methods . . . Only the pinnacle of a cathedral can show us where the soul can rest suspended . . . These points in infinity were the precursors of the new art." In another reference to a cathedral he speaks of "the motionless arrow"

which to me seems more the arrowhead *Excelsis Hosanna* towers of the *Sagrada Familia* than the Gothic or Romanesque spires which he loved in France. His notes several times speak of form by established "points or perforations." There is a marked unity in his stone bases and the iron sculpture, a sensitive feeling for material and proportion. I feel the kinship with Gaudi's stone angels, their iron trumpets and iron arm supports, in the feeling of flying form and unorthodox balance. Work by the Gonzalez shop may even be in the cathedral. I can find no verification for this, but José de Creeft, who worked on it as a plasterer's helper at the age of twelve, says that every craftsman in Barcelona did.

The craft work of both brothers progressed so well that it was shown in the Chicago World's Fair, 1893, and in the same year took a gold medal in the Barcelona Exposition.

The period from his arrival in Paris around 1899 until 1927 did not show strong sculptural conviction. This, perhaps the most difficult and dramatic period of his life, was the least fruitful. Unproductive months followed the death of his brother. Then, repoussé masks, drawings and painting proceeded out of his struggle for some fifteen years.

There seems to have been conflict between the divided identities of painter and metal-smith.

When a man is trained in metal-working and has pursued it as a labor with the ideal of art represented by oil painting, it is very difficult to conceive that what has been labor and livelihood is the same means by which art can be made. (Perhaps I am basing this more on sympathy than fact in Gonzalez' case, because it is a reconstruction of my own experience. Before I had painted very long I ran across reproductions in *Cahiers d'Art* of Gonzalez' and Picasso's work which brought my consciousness to this fact that art could be made of iron. But iron-working was labor, when I thought art was oil paint.)

In this period of groping Gonzalez felt the need of men strong and firm in their destiny, like Brancusi and Picasso. Undoubtedly their encouragement played a part in his slow battle with himself. At the same time the very closeness to these two titans personally could not permit any influence in his own work.

It seems true that something kept his painting from flowering. At the same time he pursued metal work, which apparently represented the sculptural part of his nature before it had asserted its sin-

gular self. From the chronology of his life and from the knowledge of friends, as soon as he accepted his true identity as that of the sculptor, his expression became more challenging and his works more prolific. Concurrent to this came the use of the acetylene torch which was not, I think, a part of his early apprenticeship or of the metal-craft period.

He was past fifty when he accepted the sculptor's identity, discarded the silversmith's scale and purpose and abandoned oil painting formally, accepting drawing as the complement of sculpture. Some of the finer parts of craftsmanship were dropped, a casual approach technically developed with the dominance of conceptual ends. Craft and smithery became submerged in the concept of sculpture. The esthetic end was not dependent upon its mode of travel.

The period in which Gonzalez worked for Picasso has not been determined by the statement of either as far as I can learn. It does not seem important. The technical collaboration made neither change nor influence in the conception of either artist. During the several years it existed, each pursued his own work in his own way, Picasso with his concepts for Mediterranean monument houses, the elongated bronze stick figures, etc.; Gonzalez reaching his prolific period with *Don Quixote*, a number of still-lifes, the best of his masks and a large number of flying iron drawings, like *Standing Personage* and *Woman Combing Her Hair*. The possible dates of this intermittent collaboration lie somewhere between 1928 and 1932.

Gonzalez was encouraged by Picasso to continue and expand; something very definite was gained by their union, but it was more abstract than a recognizable influence.

The best of Gonzalez is in his abstract work, but existing concomitantly is a socially conscious theme of realism. These are the *Montserrats* or her variations. They start in 1932 with a small head, *Montserrat*, continue to the full-sized figure in 1936 and end with a bronze head in 1942. *La Montserrat* is the symbol of Catalonian woman in her nobility, her cries against injustice, her suffering. She is the symbol of things noble and things Spanish, analogous to Picasso's bull.

Of the two unfinished plaster works begun in 1941, one was abstract; the other a screaming woman on her knees, which parallels the *Montserrat* series in its realism and sympathy.

I have learned of no notes relating to the realist approach.

There are no poetic "directions to carve space," no "motionless arrows pointing towards the stars where the soul can rest suspended or indicate points of hope," as he gives his ideals for sculpture. These are volume sculptures, arrived at with great love and patience. They show the tremendous urge to speak out in the way the quiet man and artist could best present his statement.

A man as withdrawn as Gonzalez was ordinarily not given to fraternizing. An exception was his attendance at weekly meetings held at the studio of Torrès-García in the late 'twenties and early 'thirties. To these discussion evenings came an interesting group, mostly young, almost exclusively expatriate: Mondrian, Arp, Bissière (later Hélion), van Doesburg, Seuphor, Daura, Xceron, John Graham, Vantongerloo, Queto, Charchoune, Cyaky, Brummer and others. From the same address was published the magazine "*Cercle et Carré*," edited by García and Seuphor. The painter Xceron, then writing art reviews for the Paris edition of the *Chicago Tribune*, was probably the first American to write about Gonzalez' work, which he did most favorably and understandingly. Graham, another painter-member of the group, was probably the first American to buy Gonzalez' sculpture. The three pieces he bought in 1930 were, as far as I know, the first in this country.

A. B. Gallatin, who was known to most of this group, in 1934 bought a silver sculpture done two years earlier and a drawing for his Museum of Living Art. Graham describes the noted sculptor as he remembers him in 1930: "Small, dignified, dressed in black like a real Mediterranean, lean, greying, a quiet and modest person, dreamy and detached, in the way of many thoughtful Spanish men, an attractive person looking more in than out. He commanded sympathy and respect."

One of those who knew him best during the last years of his life was Henri Goetz, an American painter living in France. In 1937 Goetz became acquainted with Gonzalez, his wife and sisters through Hans Hartung, who married the sculptor's daughter Roberta. A strong family friendship developed, with Sunday dinners at Arcueil in the house Gonzalez had built according to his own plans, and drives through the countryside to look at Gothic churches in an old Citroën Gonzalez bought in 1938. Indicating the sculptor's gentle humor, Goetz recalls the way he used to pass the weekly dish of carrots and slyly say, "Do take a wing."

Gonzalez was not much given to art talk or theory and in these

family discussions of abstraction, Mondrian, Kandinsky, etc. he was at esthetic odds with Hartung and Goetz, who took the favorable view.

In one of his infrequent confidences of an esthetic nature he told Goetz that he sometimes used the Golden Section (1.6180). This mathematical ideal of the relationship of the diagonal with the side of the square may be homage to Cézanne and the 1912 *Section d'Or* exhibition or something very personal from his painting period. The Golden Section has always been a constant in the eye of man. It may have been a personal method of evaluating, but it is certainly not the inspiration.

Regarding his own work Gonzalez was adamant in pointing out the relationship between his sculpture and the real elements—such as hair, teeth, eyes—which in a very indirect way composed them. Goetz recalls him buying what was for his circumstances a very costly tool—possibly a shearing tool—to work on the teeth of a sculpture. The beautiful head of 1936 which Alfred Barr acquired in 1937 from Christian Zervos for the Museum of Modern Art collection clearly illustrates his preoccupation with features.

Gonzalez was extremely prudent. Early in the war he gave up welding, fearing that if bombs dropped his oxygen and acetylene tanks would blow up, although the lorry factory less than a hundred yards away had many tanks in constant use.

Gonzalez never became a French citizen. He was Spanish, but insisted on the distinction of being a Catalonian.

Critical accent has been placed upon who was first in iron or welding. This speculation is no more valid than the Renaissance oil paint controversy. Gonzalez was an apprentice in his father's shop, his work with metal starts in childhood. It is not innovation that makes art but inspiration. On the relationship with Picasso, Xceron recalls that he came to Gonzalez' studio in *rue de Médéah* around 1928 to work on the statue for the tomb of Apollinaire. In Picasso's iron sculpture the concept and the forms are strictly his, as are Gonzalez' in his own work. With Gargallo, whom Gonzalez instructed, the technique becomes developed in a spectacular way, but the concept remains essentially academic.

The Cubists used iron (i.e. Laurens' *Composition*, 1914) as did the Constructivists (Tatlin in 1917, Meduniezky in 1919, etc.). De Creeft made an iron stove pipe *Don Quixote* in 1925; Lipchitz told me of a 1928 iron sculpture he exhibited in his 1930 Paris retro-spective show. No one was first. All materials have properties by which they are shaped, art lies in the concept, not the technique. You can find more art in paper scraps than in crafted gold.

Wrought metal sculpture goes back to the Bulls of El-Ubaid (3000 B.C.) and the life-sized figure of Pepi I from Heirakoupolis (2300 B.C.). A whole age of iron welding and forming flowered in Syria in the eleventh to ninth century B.C. The iron head-rest of Tutankhamen (1350 B.C.), believed to have come from Syria, was welded. In Genesis, Tubal Cain, husband of Zilah, is referred to as the instructor of every artificer in bronze and iron. Iron welding and working has been in evidence in almost every period of culture in both art and function.

Letter to Roberta González. Solomon R. Guggenheim Museum Archives, New York.

Feb. 28, 1956

Dear Roberta Gonzalez,

I have received your letter. I need help in translating in the meantime, I enclose your photographs and express much gratitude for your help in the article in *Art News*.

I have asked the magazine to send you some copies. I did not write a good article. I am not a good writer and much was speculation without facts but I hope it will add to the prestige of your father's work and make his name better known. How I wish he could have had this exhibition and esteem in his lifetime.

I have just returned from New York, and the beautiful exhibition of your father's work. The Museum has installed the exhibition expensively and tastefully. It really looks beautiful. The artists of New York, and there are many, have all expressed admiration and enthusiasm. But, there are a dozen of us who have always recognized the genius and beauty, the innovation, of Gonzalez since 1930. In the case of John Xceron since he met your father about 1927, and wrote about him in the Boston Transcript, and the Chicago Tribune (Paris edition).

I enjoyed your article in the *Arts*. The same magazine will have an article on my work, March issue. My exhibition at the Willard Gallery opens March 6.

My relationship to 'Sagrada Familia' and the Gonzalez shop was speculation. Would his sister know? I'm still searching to learn. But certainly he knew the cathedral in Barcelona and had affection for

it as he apparently loved all cathedrals.

A concluding paragraph was cut by the magazine, in which I summed up the contribution but that was due to space. The magazine had asked for 1500 words and I wrote 2500.

I hope my admiration was evident throughout the text of the article.

Thank you Madame Roberta and success to you in your own work.

Fraternally,

David Smith

Letter to Roberta González. Solomon R. Guggenheim Museum Archives, New York.

June 11, 1956

Dear Roberta Gonzalez,

I visited Edgar [] and gave him the *Arts* with your article. He was very pleased. He showed me a drawing your father made of his father and also a ring your father had made for him. The [] drawing of his father was a realistic portrait but he did not mention whether it was done from life. [] played a tape recording of a new work which was beautiful. It was made of cut sounds, shaped like asculptural forms thrown and perfectly placed in unities like I wish to make sculpture. It was compiled from contemporary sounds and scores which he had written for orchestra, harmoniously arranged.

I have written Hilton Kramer to send you the March *Arts* which has the article on my work. It will probably arrive later by boat mail.

It takes me time to have your letter accurately translated. My French is not good.

John Graham has no photos, nor does he remember to whom he sold or gave the early Gonzalez sculptures. The photo I sent you of the work he gave me is the only record of these three. My friend Graham is an odd Russian, a painter, a collector, a writer, a trader and has never kept a record of his transactions. At the same time he bought these works from your father he also was a friend of Char[ceu]nne and had a number of his paintings. I'm sorry we cannot trace the other two works, but if he should ever remember or if they appear, I'll write you.

When I came to New York to study in 1927, so much new art came at once—Constructivism, di stijl, cubism etc. I am not sure of my first iron influence. It was probably the reproductions in "Cahier d'Art" of Picasso which your father had done for him. But certainly I soon saw reproductions of your father's work and was told about him by Graham and later by John Xceron.

Andrew Ritchie [] Modern Museum show [] within the next two years so I shall think hard and try to solve this for the catalog.

I worked as a welder, riveter and did ironworking in general at the Studebaker automobile factory before I came to New York to study art. During the war I worked as an armor plate welder on tanks and locomotives. I do much of my work by electric or arc-welding. But I started in 1933 on gas welding. I still use gas for cutting and other work where it is more functional than electric. Sculptors who use welding exist here by the hundreds. I am about the only electric welder as far as I know. My first electric welding was in 1939. I attach no importance to this, it is merely trade talk between artists.

Of course I would like a show in Paris but the cost is beyond my means. I will have to wait until my work is important enough for some museum or some other agency to arrange it.

I have loaned the photo of your father's studio (photo which was obtained for me in Paris, Marc Vaux photo), to my friend, the sculptor Theodore Roszak, who is writing a section on new sculpture for the Encyclopedia Brittanica. He will use it along with individual works of your father which I also sent him for the Encyclopedia. I presume he will record Gonzalez as the father of all iron sculpture of this century. When it is published I shall tell you and it may be obtainable at the U.S. Information office in Paris. It may not be published for several years.

You should not underestimate the high position Gonzalez' work has in U.S. art life. I wish your father could have lived to enjoy his position here and I know we all would have loved him as a person. I regret very much that I was unable to locate him in 1935-36 when Graham tried to take me to his studio. I think he had left Paris for the new studio at Arcueil.

I have read about your work. My friend Herman Cherry showed me a review and I should be pleased to see photos which I shall return to you.

Sometime I hope to sell enough work or receive a fellowship

and come to Europe. If so, I hope we can meet, I would like to see your work and know you.

In my reconstruction of possibilities in the article on Gonzalez, was I mistaken in surmising that work by the Gonzalez family must have been in the "Sagrada Familia"? Would your father's sister remember if this is true?

My fraternal greetings,
David Smith

Notes on My Work

From Arts *34, no. 5 (Feb. 1960; special issue on David Smith), p. 44.*

I cannot conceive a work and buy material for it. I can find or discover a part. To buy new material—I need a truckload before I can work on one. To look at it every day—to let it soften—to let it break up in segments, planes, lines, etc.—wrap itself in hazy shapes. Nothing is so impersonal, hard and cold as straight rolling-mill stock. If it is standing or kicking around, it becomes personal and fits into visionary use. With possession and acquaintance, a fluidity develops which was not there the day it was unloaded from Ryersons' truck.

•

For bronze castings that are parts, although I have made the foundry patterns, I need this perceptual curing. Very often in bronze, the parts do not take their original order.

•

Rarely the Grand Conception, but a preoccupation with parts. I start with one part, then a unit of parts, until a whole appears. Parts have unities and associations and separate afterimages—even when they are no longer parts but a whole. The afterimages of parts lie back on the horizon, very distant cousins to the images formed by the finished work.

•

The order of the whole can be perceived, but not planned. Logic and verbiage and wisdom will get in the way. I believe in perception as being the highest order of recognition. My faith in it comes as close to an ideal as I have. When I work, there is no consciousness of ideals—but intuition and impulse.

•

To identify no ideal—to approach each work with new order each time. I try to let no sequence or approach in daily living repeat from the day before, but like my work, my day can be identified by others. My rebellion is against putting on the right sock and punching time clocks. Mozart said after Opus 30 that he had seen the light, it would be all different now, but Opus 31 sounds consistent to me. The view is not so important, nor the ideal—but the inner conviction which sparks the drive for identity. To me apples are fruit—to Cézanne they were mountains.

•

My sculpture grew from painting. My analogy and reference is with color. Flash reference and afterimage vision is historied in painting. I chew the fat with painters. My student days, WPA days, Romany Marie and McSorley days were with painters—Graham, Davis, Resnikoff, De Kooning, Xceron, Edgar Levy, Gorky, Stella, etc. In these early days it was Cubist talk. Theirs I suppose was the Cubist canvas, and my reference image was the Cubist construction. The lines then had not been drawn by the pedants—in Cubist talk, Mondrian and Kandinsky were included.

•

Probably what turned me most toward sculpture, outside my own need, was a talk with Jean Xceron walking down 57th Street in 1935, the day his show opened the Garland Gallery. That fall my wife Dorothy and I went to Greece.

•

Most of my sculpture is personal, needs a response in close proximity and the human ratio. The demand that sculpture be outdoors is historic or royal and has nothing to do with the contemporary concept. It needn't be outside any more than painting. Outdoors and far away it makes less demand on the viewer—and then it is closer in scale to the most vociferous opinion-makers today whose acquaintance is mostly from reproductions.

An exception for me started in 1957 with a series of stainless-steel pieces from nine to fifteen feet tall. They are conceived for bright light, preferably the sun, to develop the illusion of surface and depth. Eight works are finished, and it will take a number of years on the series to complete it. Stainless steel seems dead without light—and with too much, it comes car chrome.

•

Jan Matulka influenced me last and most as a teacher, yet Richard Lahey's encouragement after the first year of art school was decisive.

I got anarchy and cones and cubes from John Sloan. John Graham means much to me, as he did to De Kooning and Gorky. He introduced me to Davis, Xceron, Gorky and to De Kooning, whom he presented as the best young painter in the U.S. He included us all in his book, *System and Dialectics of Art*, finished in 1936. In the beginning thirties we drank coffee and hung around together in New York like expatriates. Graham lived summers at Bolton Landing. His annual trips to Paris kept us all apprised of abstract events, along with *Cahier d'Art* and *Transition*. In 1935 we were both in Paris. His introductions and entry to private collections made my world there. On Bastille Day we all paraded with the Maison de Culture to Père Lachaise Cemetery. Though I often declaim against things French (except art and wine), Paris for a few months meant much to me. I was against the current desire of artists for expatriation. After going to the USSR and visiting Graham's former wife and children and Benno's sister, I matured enough to realize that no matter how inhospitable New York was to my work, my life and destiny and materials were here. I was also very bad at speaking French.

.

In 1934 Graham had given me a Gonzalez, one of three he had bought in '28 or '29. These were the first Gonzalez sculptures in America I think. When we were in Paris in '35, he took me to Gonzalez' studio, but he had moved to Arcueil. I never met Gonzalez. Henri Goetz (American painter who lives in Paris), a friend of Herman Cherry, sent me photos and told me much about him. My first liberation toward iron, which I was acquainted with manually, was from Picasso's sculpture of '28-'29. At the time I did not know that Gonzalez had done the welding for him. Nor did I know when I saw the Gargallo exhibition at Brummer's that Gonzalez had taught him welding. Many of us now pay homage to Gonzalez. I often think about it, and wish Gonzalez, Gorky and Pollock could have had some of the homage sales during their lives.

From David Smith by David Smith, *ed. by Cleve Gray. London: Thames and Hudson, 1968, p. 34.*

When I lived and studied in Ohio, I had a very vague sense of what art was. Everyone I knew who used that reverent word was almost as unsure and insecure.

Mostly art was reproductions, from far away from an age past and from some garden shore, certainly from no place like the mud banks of the Auglaze or the Maumee, and there didn't seem much chance that it could come from Paulding County.

Genuine oil painting was some highly cultivated act, that came like the silver spoon, born from years of slow method, applied drawing, water coloring, designing, art structure, requiring special equipment of an almost secret nature, that could only be found in Paris or possibly New York.

And when I got to New York and Paris I found that painting was made with anything at hand, building board, raw canvas, self-primed canvas with or without brushes, on the easel, on the floor, on the wall, no rules, no secret equipment no anything, except the conviction of the artist, his challenge to the world and his own identity.

Discarding the old methods and equipment will not of course make art. It has only been a symbol in creative freedom, from the bondage of tradition, and outside authority.

Sculpture was even farther away. Modeling clay was a mystic mess which came from afar. How a sculpture got into metal was so complex that it could only be done in Paris. The person who made sculpture was someone else an ethereal poetic character divinely sent, who was scholar, aesthetician, philosopher, continental gentleman so sensitive he could unlock the crying vision from a log, or a Galatea from a piece of imported marble.

I now know that sculpture is made from rough externals by rough characters or men who have passed through all polish and are back to the rough again.

The mystic modeling clay is only Ohio mud, the tools are at hand in garages and factories. Casting can be achieved in almost every town. Visions are from the imaginative mind, sculpture can come from the found discards in nature, from sticks and stones and parts and pieces, assembled or monolithic, solid form, open form, lines of form, or like a painting the illusion of form and sculpture can be painting and painting can be sculpture and no authority can overrule the artist in his declaration. Not even the philosopher, the aesthetician or the connoisseur.

From David Smith by David Smith, *ed. by Cleve Gray. London: Thames and Hudson, 1968, p. 50.*

My reverence for iron is in function before technique. It is the

cheapest metal. It conceptually is within the scale of my life. And most important before I knew what art was I was an ironmonger. The iron element I hold in high respect. I consider it eidetic in property. The metal particularly possesses no art craft. What it can do in arriving at form economically—no other element can do.

Technics

From David Smith by David Smith, *ed. by Cleve Gray. London: Thames and Hudson, 1968, pp. 52-53.*

I worked in metal before I studied painting. When my painting developed into constructions leaving the canvas, I was then a sculptor, with no formal training in sculpture. When the constructions turned into metals, first lead, brass, and aluminum, combined with stone and coral in 1932, nothing technically was involved outside of factory knowledge. In the summer of 1933 I made the first group of iron sculptures (shown in this country?), two of which were exhibited in the winter of 1933 and spring of 1934. My first show in 1938 was comprised of work from 1935 on. This work was primarily gas welded. The first arc welded piece was made in 1939. My method of shaping material or arriving at form has been as functional as making a motor car or a locomotive. The equipment I use, my supply of material, come from what I learned in the factory, and duplicate as nearly as possible the production equipment used in making a locomotive. I have no aesthetic interest in tool marks, surface embroidery, or molten puddles. My aim in material function is the same as in locomotive building: to arrive at a given functional form in the most efficient manner. The locomotive method bows to no accepted theory of fabrication. It utilizes the respective merits of castings, forging, riveting, arc and gas welding, brazing, silver solder, bolts, screws, shrink fits, all because of their efficiency in arriving at an object or form in function. I make no claim for my work method over other media. It is not one of my private experience. It is one part of art that can definitely be taught or learned by the American aptitude for technics. A course in industrial high schools or an 8 week course in trade school suffices. The direct method, the part to the whole concept, quantity to quality, is not an exclusive approach, and does not exclude my use of other media.

A certain feeling for form will develop with technical skill, but imaginative form or aesthetic vision is not a guarantee for high technique. I have seen paper cut-outs that were finer art than piles of precious metals.

My own workshop is a small factory with the same make and quality tools used by production factories.

•

Steel . . . can be stainless, painted, lacquered, waxed, processed and electroplated with molybdenum. It can be cast. Steel has mural possibilities which have never been used. It has high tensile strength, pinnions [sic] can support masses, soft steel can bend cold, both with and across its grain, yet have a tensile strength of 30,000 lbs. to one square inch. It can be drawn, cupped, spun and forged. It can be cut and patterned by acetylene gas and oxygen and welded both electrically and by the acetylene oxygen process. It can be chiseled, ground, filed and polished. It can be welded the seams ground down leaving no evidence. The welds can possess greater strength than the parent metal. It can be formed with various metals by welding, brazing and soldering. Metals fall naturally to my use and [are] useful to my concept.

Between periods of trying to get an art education in three midwestern colleges I worked as a telephone linesman, stringing cable, laying cable, potting lead for joints etc. I used to dig holes in the ground of figures and form my own lead casts. I still like to, but in molds. After four months in department 346 at the Studebaker plant alternating on a lathe, spot welder and milling machine, I was transferred to 348 on Frame Assembly. This was worked on a group plan, payment made to 80 men in proportion to the completed frames which were riveted and assembled on an oval conveyor track. It was necessary for each man to be able to handle at least six operations. Riveting, drilling, stamping etc. all fell into my duties but my interest was the $45 to $50 per week which would enable me to study in New York. In a year I did, off and on for five years. Painted 5 years. Years ago while working on constructions of various materials in aluminum, stone, brass etc. I realized the inadequacy of their strength was apparent when trying to make them conform; as I result I turned to steel.

The medium has been used by Gonzalez and Gargallo and others. Both men have used it in an abstracted manner from a personalized viewpoint. The mental process and the metal both take shape in [an] abstract point of view. The objects I had worked with in the factory were abstract. They were always functional pieces, having

relationships but were not objects of realism, gears, cross members, brackets, the triangle in a circle, spare tire carrier etc. were all abstract parts.

This work with abstract mechanical parts did not consciously exert their influence on an abstract concept developed from realism. It resulted in a concept recalling the use of the material.

From David Smith by David Smith, *ed. by Cleve Gray. London: Thames and Hudson, 1968, p. 68.*

After my student period in painting finishing with the abstract painter Jan Matulka, my painting had turned to constructions which had risen from the canvas so high that a base was required where the canvas should be, I now was a sculptor.

I had seen the Picasso-Gonzalez iron constructions of 1931 in the magazine Cahier d'Art. This was the liberating factor which permitted me to start with steel which before had been my trade, and had until now only meant labor and earning power for the study of painting.

My first steel sculptures were made in 1933. They were partly made from found objects, agricultural machine parts of past function. To a relative degree they relate to my Agricola series, thirteen pieces of this group having been completed within the past two years.

My work of 34, 35, 36 was often referred to as line sculpture. My first show in 1938 included this work with the balance being painted planal [sic] constructions.

I have always considered line contour as being a comment on mass space and more acute than bulk, and that the association of steel retained steel function of shapes moving, circumscribing upon axis, moving and gearing against each other at different speeds, as the association of this material suggests.

The overlay of line shapes, being a cubist invention, permits each form its own identity and when seen thru each other highly multiplies the complex of associations into new unities.

I do not accept the monolithic limit in the tradition of sculpture. Sculpture is as free as the mind, as complex as life . . .

•

Some critics refer to certain pieces of my sculpture as "two-dimensional." Others call it "line drawing." I do not admit to this, either conceptually or physically. It may be true in part, but only as one attribute of many, and that by intention and purpose. There are no rules in sculpture. This particular criticism is not sufficient or valid ground for dismissal.

I make no apologies for my end-views. They are as important as they are intended to be. If a sculpture could be a line drawing, then speculate that a line drawing removed from its paper bond and viewed from the side would be a beautiful thing, one which I would delight in seeing in the work of other artists. The end-view or profile of an interesting person or object arouses the mind to completion of the imagined personality and physiognomy, since a work of art or an object of interest is always completed by the viewer and is never seen the same by any two persons.

From David Smith by David Smith, *ed. by Cleve Gray. London: Thames and Hudson, 1968, pp. 132-33.*

I believe that my time is the most important in the world. That the art of my time is the most important art. That the art before my time has no immediate contribution to my aesthetics since that art is history explaining past behaviour, but not necessarily offering solutions to my problems. Art is not divorced from life. It is dialectic. It is ever changing and in revolt to the past. It has existed from the minds of free men for less than a century. Prior to this the direction of art was dictated by minds other than the artist for exploitation and commercial use. That the freedom of man's mind to celebrate his own feeling by a work of art parallels his social revolt from bondage. I believe that art is yet to be born and that freedom and equality are yet to be born.

If you ask me why I make sculpture, I must answer that it is my way of life, my balance, and my justification for being.

If you ask me for whom do I make art, I will say that it is for all who approach it without prejudice. My world, the objects I see are the same for all men of good will. The race for survival I share with all men who work for existence.

•

Yes, masterpieces are made today. Masterpieces are only works of art that people especially like. The twentieth century has produced very many. Present day contemporary America is producing masterpieces—a virile, aggressive, increasing number of painters and sculptors not before produced here. Let us not be intimidated by the pretending authorities who write books and term only this or that

Mona Lisa as the only masterpiece. Masterpieces are only especially considered works of art. They occur now and they occurred 30,000 years ago.

·

Art is a paradox that has no laws to bind it. Laws set can always be violated. That confuses the pragmatic mind. There may exist conventionalized terminologies and common designations for periods, but no rules bind, either to the material substances from which it is made or the mental process of its concept. It is created by man's imagination in relation to his time. When art exists, it becomes tradition. When it is created, it represents a unity that did not exist before.

·

I feel no tradition. I feel great spaces.
I feel my own time. I am disconnected.
I belong to no mores—no party—no religion—
no school of thought—no institution.
I feel raw freedom and my own identity. I feel a
belligerence to museums, critics, art historians, aesthetes
and the so called cultural forces in a commercial order.

Compiled by M. Dolores Jiménez-Blanco.

Biographies

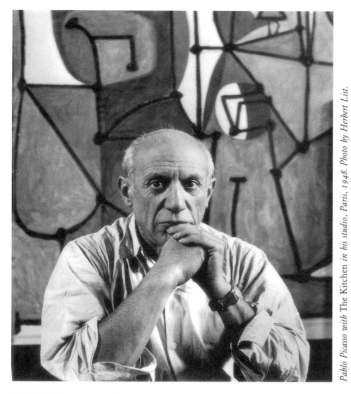

Pablo Picasso

1881 October 25: Born in Málaga, Spain, to José Ruiz Blasco, drawing teacher at the Escuela de Artes y Oficios de San Telmo, and María Picasso.

1888-90 Begins to draw and paint.

1891 His family moves to La Coruña, on the Atlantic coast of Spain. Studies drawing and painting under his father.

1892 Enrolls in the Escuela de Bellas Artes in La Coruña.

1895 Makes his first visit to the Museo del Prado, Madrid. September: Family moves to Barcelona, where Pablo attends the Escuela de Bellas Artes.

1897 His work *Science and Charity* receives an honorable mention in the National Exhibition of Fine Arts in Madrid. September: Leaves Barcelona for Madrid, and enters the Royal Academy of San Fernando, which he leaves in the winter.

1898 Makes his first trip to Horta de Ebro, where he remains for eight months.

1899 Frequents the Barcelona café Els Quatre Gats, where he meets painters Ramón Casas, Santiago Rusiñol, Isidro Nonell, Julio and Joan González, and Carlos Casagemas, sculptor Manolo Hugué, and poet Jaime Sabartés, among others.

1900 Picasso and Casagemas leave for Paris. They become part of its Spanish community, which includes sculptors Hugué and Francisco [Paco] Durrio. December: Picasso goes back to Barcelona and then Málaga.

1901 Casagemas commits suicide in Paris in February while Picasso is in Spain. After returning to Paris in May, Picasso installs himself in Casagemas's studio on the boulevard de Clichy and begins his Blue Period.

1902 January: Goes back to Barcelona, where he remains until October. Picasso probably meets Julio González again at this time. October: returns to Paris and stays with poet Max Jacob for several months. His works are included in two exhibitions at Galerie Berthe Weill.

1903 January: Returns to Barcelona and moves into studio he had shared there with Casagemas. Settles into a new studio, formerly that of Pablo Gargallo, sharing it with González.

1904 Spring: Moves permanently to Paris, into a studio building in Montmartre, which becomes known as the Bateau-Lavoir. Meets Fernande Olivier. Paints last Blue Period works. October: Exhibits at Galerie Berthe Weill.

1905 Begins Rose Period, and series of paintings on circus theme. Exhibits at Galeries Serrurier. Frequents La Closerie des Lilas, along with André Salmon and Guillaume Apollinaire. Fall: Meets Leo and Gertrude Stein, and becomes a frequent visitor to their salons, where he will be introduced to Henri Matisse in 1906.

1906 Dealer Ambroise Vollard purchases the majority of his paintings of the Rose Period. Spring: Meets Matisse, and then André Derain. Summer: Spends some months in the Catalan town of Gosol in the Pyrenees with Olivier, where he paints works such as *La Coiffure* using an almost monochromatic, ocher palette. His work begins to reflect the influence of Iberian sculpture. Ten of his paintings are shown at the Salon d'Automne in November. Makes the first studies for *Les Demoiselles d'Avignon*.

1907 April-May: Starts working on the canvas of *Les Demoiselles d'Avignon*, which is finished by early July. May or June: Discovers the Musée ethnographique du Trocadéro, which incites his great interest in African sculpture. Summer: Daniel-Henry Kahnweiler, who opened a gallery in February, visits the Bateau-Lavoir for the first time. Fall: Apollinaire takes Georges Braque to the Bateau-Lavoir.

1908 Stays some months at La Rue des Bois, sixty kilometers north of Paris, painting landscapes and figures. Forms a closer relationship with Braque, whose landscapes of L'Estaque had been rejected by the jury of the Salon d'Automne. When Braque subsequently shows his paintings at Galerie Kahnweiler, Paris, critics speak of "cubes" and the term "cubism" is coined.

1909 Travels to Barcelona with Olivier, and to Horta de Ebro for the second time, where he paints landscapes and portraits that mark the beginning of Analytic Cubism. Starts experimenting with sculpture. Models his *Head of a Woman* in González's studio in Paris.

1910 Solo exhibition is held at Galerie Nôtre-Dame-des-Champs, Paris. He and Braque have works included in group shows in Düsseldorf and Munich. Takes part in *Manet and the Post-Impressionists* at Grafton Galleries, London.

1911 Exhibits at Little Galleries of the Photo-Secession, New York. Alfred Stieglitz purchases one drawing. Shows four works at the Berliner Sezession exhibition. Summer: Works in close collaboration with Braque in Céret. October: As in the previous year, Picasso and Braque are absent from the Cubist section of the Salon d'Automne. Fall: Meets Eva Gouel (Marcelle Humbert), whom he refers to as "Ma Jolie" on his canvases.

1912 Takes part in the second exhibition of Der blaue Reiter at Galerie Goltz, Munich, and later exhibits at the Berliner Sezession. Spends the summer with Braque in Sorgues, in the south of France. Returns to Paris with Eva Gouel and moves from Montmartre to Montparnasse. Produces his first construction, *Guitar*, and first collage, *Still Life with Chair Caning*. Signs a three-year contract with Kahnweiler.

1913 Paints his Cubist portrait of Apollinaire, whose book *Les Peintres cubistes: Méditations esthétiques* is published on March 17. February-March: Has eight works in the *International Exhibition of Modern Art* (the Armory Show) in New York. Begins to develop Synthetic Cubist style. His father dies in May.

1914 Produces new constructions. Spends the summer in Avignon with Gouel. August 2: War is declared, and Apollinaire, Braque, and André Derain are mobilized shortly after. Returns to Paris in the fall. December 9-January 9, 1915: *Picasso and Braque: An Exhibition of Recent Drawings and Paintings* is held at Gallery 291, New York.

1915 Series of Harlequin paintings marks a new direction within Synthetic Cubist style. December 14: Gouel dies.

1916 Moves from Montparnasse to Montrouge, a neighborhood directly south of Paris just outside the city limits. *Les Demoiselles d'Avignon* is shown publicly for the first time in *Art moderne en France* (Modern Art in France) at the Salon d'Antin. Starts working on the design for *Parade*, a ballet with music by Erik Satie, for Diaghilev's Ballets Russes. December 31: Dinner party is held on the occasion of the publication of Apollinaire's *The Poet Assassinated*.

1917 Meets up with the Ballets Russes in Rome, where he stays for two months working on his sets and costumes for *Parade*. Meets Igor Stravinsky and Olga Koklova, one of the dancers in the troupe. Visits Naples and Pompeii. May: Opening performance of *Parade* in Paris receives a negative response from the public.

1918 January 23-February 15: A joint exhibition of work by Matisse and Picasso is held at Galerie Paul Guillaume, Paris. Picasso joins the higher social milieu surrounding the Ballets Russes. July: Marries Koklova. November: Apollinaire dies. Picasso and Koklova move to 23, rue de la Boëtie, on Paris's Right Bank.

1919 Designs sets and costumes in London for the Ballets Russes performance of *Tricorne*, which opens in July. Works in both a Cubist and realist manner. Exhibits at Paul Rosenberg Gallery, Paris.

1920 May 15: Opening performance of *Pulcinella* by the Ballets Russes, with scenery and costumes by Picasso, takes place. Spends summer at Saint Raphael and Juan-les-Pins.

1921 February: His son Paulo is born. First monograph on his work, *Pablo Picasso* by Maurice Raynal, is published in Munich. Summer: Paints *Three Women at the Spring* and *Three Musicians* in classical and Cubist modes, respectively. Reestablishes contact with González.

1922 Collector Jacques Doucet buys *Demoiselles* for 25,000 francs. Summer: Stays in Dinard. Paints *Women Running on the Beach*.

1923 Paints *The Pipes of Pan* and a number of studies of bathers. Frequently meets with American artist Gerald Murphy. November: In New York, Paul Rosenberg/Wildenstein Gallery exhibits sixteen of his recent works.

1924 Makes a large, painted metal construction, *Guitar*, and paints a series of monumental Synthetic Cubist still lifes. Works on the ballet *Mercure*, the premiere of which in June is received negatively by the public and critics. Summer: Stays in Juan-les-Pins.

1925 January 15: Two pages of abstract drawings from his sketchbooks of the previous summer in Juan-les-Pins are published in *La Révolution surréaliste*. July 15: *Demoiselles* is reproduced in *La Révolution surréaliste*. November: Takes part in the first exhibition of Surrealist painting at Galerie Pierre, Paris.

1926 Exhibits works from the previous twenty years at Galerie Paul Rosenberg. Spends the summer at Juan-les-Pins. October: Visits Barcelona.

1927 Meets Marie-Thérèse Walter. Summer: In Cannes produces the sketchbook *The Metamorphoses*, with drawings of monstrous, aggressive bathers. In Paris produces etchings on the theme of the artist's studio, the first of the series for Honoré de Balzac's "The Unknown Masterpiece" commissioned by Vollard. December 27-February 28, 1928: Has solo exhibition at Galerie Pierre, Paris.

1928 Makes his first three-dimensional sculpture since 1914, *Bather (Metamorphosis I)*. Fall: Produces his first iron sculptures with González, *Head* and *Figures*. The two collaborate closely until 1932. Picasso submits two metal-rod sculptures, with accompanying drawings, as possible maquettes for the monument to Apollinaire, but the committee that is planning the monument turns them down.

1929 Picasso and González start working on *Woman in a Garden*, which Picasso assembles himself. Relationship with Koklova deteriorates.

1930 January-February: Retrospective of paintings by Picasso and Derain is held at Reinhardt Galleries, New York. April: Special issue of *Documents* is devoted to Picasso. June: Purchases the château of Boisgeloup, near Gisors, France, which contains a large space he devotes to a sculpture studio when he moves there the following year. September: Albert Skira commissions him to do a series of etchings to illustrate Ovid's *Metamorphoses*.

1931 Produces a series of monumental sculpted heads inspired by Walter. Incorporates real objects (colanders) in his sculpture *Head of a Woman*. Summer: In Juan-les-Pins works on a series of engravings, which are later included in the *Suite Vollard*. Fall: Continues to concentrate on sculpture.

1932 First major retrospective exhibition takes place at Galeries Georges Petit, Paris, then travels to Kunsthaus Zürich. Fall: First volume of the catalogue raisonné by Christian Zervos is published.

1933 Produces a series of etchings on the theme of the sculptor's studio, and a series of pencil drawings of surrealistic bathers, *An Anatomy*. Summer: Travels to Barcelona. Fall: Olivier publishes the book *Picasso et ses amis* (Picasso and his friends). Bernhard Geiser publishes the first volume of *Picasso, peintre-graveur*, a catalogue raisonné of his engravings and lithographs of 1899-1931, in Bern.

1934 Travels to Madrid, Zaragoza, and Barcelona, where he admires Romanesque paintings in the Museum of Catalan Art. Continues working on the sculptor's studio series.

1935 Exhibits collages at Galerie Pierre, Paris. Ceases painting until February 1936. Begins producing Surrealist poems. June: Separates from Koklova. October: Maya, daughter of Picasso and Marie-Thérèse Walter, is born.

1936 Special issue of *Cahiers d'art* is devoted to Picasso, and an exhibition of his recent sculpture is held at the Galerie Cahiers d'art. Retrospective exhibition at Sala Esteva in Barcelona is organized by Amigos de las Artes Nuevas (Friends of New Arts). July 18: Spanish Civil War begins. Picasso is appointed director of the Museo del Prado. Zwemmer Gallery, London, holds an exhibition of fifty-seven works by Picasso.

1937 Produces etchings and a poem entitled *Dream and Lie of Franco*. Moves to a new studio at 7, rue des Grands-Augustins. Is invited by the Spanish Republican government to execute a painting for the Spanish Pavilion at the Paris World's Fair, which opens on July 12. April 27: Sees images of the bombing of Guernica and starts working on the painting *Guernica*. Travels to Switzerland, where he meets Paul Klee. Christian Zervos publishes a special number of *Cahiers d'art* (vol. 12, nos. 4-5) on *Guernica*.

1938 Spends the summer at Mougins with Dora Maar and Paul and Nusch Eluard. Fall: Burlington Galleries, London, exhibits *Guernica* and more than sixty studies; exhibition moves to Whitechapel Art Gallery and then on to Leeds and Liverpool. Museum of Modern Art, Boston, holds retrospective exhibition *Picasso and Matisse*.

1939 End of the Spanish Civil War. May-October: *Guernica* and its studies are shown in New York at Valentine Gallery, then travel to Los Angeles, San Francisco, and Chicago. September: World War II begins. November: *Picasso: Forty Years of His Art* opens at the Museum of Modern Art, New York.

1940 Moves to a studio at 40, rue des Grands-Augustins. Resumes sculpting there; at great risk of having his sculpture confiscated by German patrols, he takes plasters to a foundry at night with the

help of friends.

1941 Writes *Desire Caught by the Tail*, a piece of automatic writing in six acts. Sculpts *Head of Dora Maar*.

1942 González dies. Picasso attends his funeral, and dedicates his *Still Life with Steer's Skull* to his friend.

1943 Creates assembled sculptures, incorporating actual objects and stamping textures into plaster or clay. Executes *Man with Sheep*. Meets Françoise Gilot. Returns to painting.

1944 Reading of *Desire Caught by the Tail* takes place at Michel Leiris's Paris apartment. Albert Camus, Simone de Beauvoir, Maar, and Jean-Paul Sartre are among the participants. August 25: Paris is liberated. October: Joins the French Communist Party. Retrospective exhibition of Picasso's work is held at the Salon d'Automne.

1945 Returns to lithography at the workshop of Fernand Mourlot. December: Exhibition of paintings by Picasso and Matisse is held at the Victoria and Albert Museum, London.

1946 Completes *Homage to the Spaniards Who Have Died for France* and a series of canvases and lithographs portraying Françoise Gilot. Alfred H. Barr, Jr. publishes *Picasso: Fifty Years of His Art*. Produces a series of in situ panels with a Mediterranean theme for the Antibes museum in the palais Grimaldi (which later becomes the Musée Picasso).

1947 Claude, the son of Picasso and Gilot, is born. Summer: Produces his first ceramics in Vallauris in the South of France. Juan Larrea publishes the book *Guernica: Pablo Picasso*, with photographs by Dora Maar.

1948 Participates in the Congress of Intellectuals for Peace in Wroclaw, Poland. November: Exhibits ceramics at the Maison de la pensée française.

1949 Kahnweiler publishes *Les Sculptures de Picasso* in Paris, with photographs by Brassaï (published later in English as *The Sculptures of Picasso*). March 8-April 2: An exhibition of fifty-eight works is held at Buchholz Gallery, New York. April 19: Paloma is born. April 20: Peace Congress opens in Paris, with Picasso's image of a dove as its symbol. Fall: Concentrates primarily on sculpture.

1950 Works on a series of sculptures using found objects, such as *Girl Jumping Rope* and *She-Goat*. Continues working on ceramics. Attends the Second World Peace Congress in Sheffield, Great Britain. November: Receives the Lenin Peace Prize. Exhibits sculp-

tures and drawings at the Maison de la pensée française.

1951 January: Produces *Massacre in Korea*. Visits the chapel decorated by Matisse in Vence.

1952 February 19-March 15: *Pablo Picasso: Paintings, Sculpture, Drawings* is shown at Curt Valentin gallery, New York. Starts working on the decoration of a fourteenth-century chapel at Vallauris, producing two panels, one of which represents war and the other peace.

1953 After the controversy over his portrait of Stalin for the magazine *Les Lettres françaises*, Picasso distances himself from the Communist Party. May-July: Retrospective exhibitions are held at the Galleria nazionale d'arte moderna, Rome, and the Musée de Lyon. Summer: Meets Jacqueline Roque in Perpignan. November: Produces his first drawings on the theme of the painter and his model. December-February 1954: Retrospective exhibition is held at the Museo de Arte Moderno, São Paulo.

1954 Spring: Picasso begins to work in sheet metal—cut, bent, and painted—to create a series of busts and heads of Sylvette David and Jacqueline Roque. July: *Picasso: Deux Périodes, 1900-1914, 1950-1954* is held at the Maison de la pensée française, Paris.

1955 Koklova dies in Cannes. June: Retrospective exhibition is held at the Musée des arts décoratifs, Paris, and later travels to Munich, Cologne, and Hamburg. Purchases a new villa, La Californie, in the south of France near Cannes.

1956 Explores the theme of bathers in painting and sculpture.

1957 January 9-February 10: *Picasso: Sculptures* is held at Fine Arts Associates, New York, with twenty-six works. The catalogue includes extracts from *The Sculptures of Picasso* by Kahnweiler. May-September: *Picasso: 75th Anniversary Exhibition* is held at the Museum of Modern Art, New York, and later travels to Chicago and Philadelphia.

1958 Works on a panel for the new UNESCO building in Paris, which is installed in September.

1959 Writes a long poem in Spanish, *Trozo de piel*. June: The monument to Apollinaire (his *Head of Dora Maar* of 1941) is dedicated in Paris. September: Chapel in Vallauris is officially inaugurated.

1960 July-September: Retrospective exhibition is held at the Tate Gallery, London. October: Starts working on the panels for the Colegio Oficial de Arquitectos de Barcelona (Barcelona College of

Architects).

1961 Marries Jacqueline Roque. Moves to the villa Notre-Dame-de-Vie, near Mougins.

1962 Receives the Lenin Peace Prize for the second time. Starts working on the sculptural model for *Head of a Woman*, commissioned by the architects of the Civic Center in Chicago.

1963 The Museo Picasso in Barcelona opens.

1964 Works on a series of canvases on the theme of the painter and his model. Brassaï publishes *Conversations avec Picasso*, illustrated with his photographs (published in English as *Picasso and Company*). Completes maquette for *Head of a Woman (Kazbec)* for the Civic Center, Chicago.

1965 Continues working on the painter and model series. Gilot publishes *Life with Picasso*.

1966 Returns to printmaking. November: *Hommage à Pablo Picasso*, a comprehensive exhibition of his drawings, ceramics, and sculpture, is held at the Grand Palais and Petit Palais, Paris.

1967 Refuses the Légion d'Honneur. Returns to painting, working on nudes and self-portraits.

1968 Creates a large series of engravings on different subjects, including the circus, bullfight, and theater, and erotic scenes.

1969 Publication of *The Burial of the Count of Orgaz*, written and illustrated by Picasso and with a preface by Rafael Alberti.

1970 Exhibition of recent work at the Palais des Papes, Avignon is organized by Yvonne Zervos with a catalogue by Christian Zervos.

1971 Gives his first construction in metal, *Guitar* (1912), to the Museum of Modern Art, New York. October 25: Exhibition of works by Picasso is held in the French National Collections at the Grande Galerie du Louvre on the occasion of his ninetieth birthday. Fernando de Rojas's *La Celestina*, illustrated by Picasso, is published.

1973 Exhibition of engravings is held at Galerie Louise Leiris, Paris. April 8: Dies at his home, Notre-Dame-de-Vie, in Mougins.

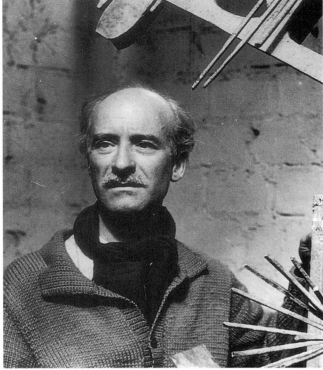

Julio González in his studio in Arcueil, Paris, 1937. Photo by Claude Gaspari.

Julio González

1876 September 21: Born, the youngest of three children, in Barcelona to Concordio González and Pilar Pellicer.

ca. 1891 Begins working in his father's metalsmithing studio on Rambla de Catalunya, Barcelona.

1892-93 Takes evening drawing classes with his brother Joan at the Escuela de Bellas Artes, Barcelona. Both aspire to become painters. They probably meet Joaquín Torres-García about this time. Family workshop probably executes wrought-iron works for the cathedral of the Sagrada Familia in Barcelona, begun by Antoni Gaudí in 1882. They also send prizewinning decorative metalwork to national and international exhibitions.

1896 September 3: Father dies.

1897-99 Julio and Joan frequent the Barcelona café Els Quatre Gats with artists Ricardo Canals, Carlos Casagemas, Ramón Casas, Manolo Hugué, Picasso, Santiago Rusiñol, and Jaime Sabartés, among others. The brothers move to Paris.

1900 Family joins Julio and Joan in Paris, settling in Montparnasse. Thereafter, Julio and Joan maintain their friendships with Picasso and Hugué, through whom they will come in contact with the Parisian intellectual avant-garde.

1902 Spring-summer: Julio and Joan travel to Catalonia. They meet Picasso, who draws Julio's portrait. Julio meets sculptor Pablo Gargallo in Paris.

1903-04 Uses Gargallo's studio in Paris at 3, rue Vercingétorix until early 1904. The same studio was also used by Picasso. Frequents the Café Versailles, where he meets other Spanish artists living in Paris, including Paco Durrio. Possibly meets Constantin Brancusi about this time. Exhibits in the Salon d'Automne, Paris.

1906 Joan, very ill, returns to Barcelona. Julio takes a studio at 11, impasse Ronsin, working there until early 1907. Becomes friendly with composer Edgard Varèse.

1907 Moves to 282, rue St. Jacques. Exhibits in the Salon des Indépendants, Paris. Summer: Visits Varèse's grandfather M. Cortot, a blacksmith, in Le Villars, near Tournous.

1908 Joan dies and is buried on April 1. Family returns to Barcelona. September: Julio returns to Paris alone. Deeply affected by the death of his brother, goes through a profound crisis and isolates himself from other artists.

1909 May: Visits family in Barcelona. Meets Jean Berton. Daughter Roberta is born. Exhibits paintings at the Salon d'Automne and Salon de la Nationale, Paris.

1910 Visits Barcelona. Makes first metal repoussé masks.

1911 Travels to Barcelona, where sister Pilar marries Josep Basso.

1913 Takes a studio at 1, rue Leclerc, which he uses until 1920. Exhibits one metal work and one painting at the Salon d'Automne.

1914 Exhibits a bronze mask at the Salon d'Automne, and painting and metalwork at the Salon des Indépendants. By this time he is friendly with Alexandre Mercereau, who will be a lifelong supporter.

1915 Family moves back to Paris to join Julio. They take an apartment together at 40, rue Friant, which they keep until 1936, and open a shop at 136, boulevard Raspail, where they sell decorative objects, laces, and the like until at least 1919.

1918 June-September: González works at La Soudure autogène française metalworks in the Renault plant at Boulogne-sur-Seine, where he learns oxyacetylene welding techniques.

1920 Takes a metalworking studio at 18, rue d'Odessa. Begins exhibiting more regularly at various Parisian salons, including the Salon d'Automne (1920-25, 1928, 1929), Salon de la Nationale (1920-23), Salon des Indépendants (1920-21, 1926), and Salon des Surindépendants (1931-33).

1921 González and Picasso reestablish contact.

1922 First solo exhibition is held at Galerie Povolovsky, Paris.

1923 Solo exhibition is held at Galerie du Caméléon, Paris.

ca. 1924 Moves his metalworking studio to 11, rue de Médéah, where he works until January 1935.

1927 Produces his first iron sculptures. Seriously considers concentrating on sculpture rather than decorative objects.

1928 With a series of metal sculptures, begins his collaboration with Picasso, which continues until at least 1932. May 13: Mother dies.

1929 Picasso commissions from González a bronze replica of Picasso's *Woman in a Garden*. González produces his first experimental works, attempting to move away from his traditional training in hammered metal and conventional ornamental imagery (for example, *Don Quixote*). Fall: Represented in the *International Sculpture Show* at Galerie Georges Bernheim, Paris. November: Exhibits his forged-iron sculptures for the first time at the Salon d'Automne.

1930-32 Associates with artists of the Cercle et Carré and Abstraction-Création groups in Paris, but does not exhibit with them. Solo exhibitions are held at Galerie de France in Paris (1930 and 1931), with which he signs a contract, and at Galerie Le Centaure in Brussels (1931). Writes "Picasso sculpteur et les cathédrales" (it remains unpublished until its inclusion in Josephine Withers, *Julio González: Sculpture in Iron*, New York, 1978, Appendix I, pp. 131-45).

1933 April 12: Participates in the *Cahiers d'art* auction, along with Giacometti, Laurens, and Lipchitz. Begins construction of a larger studio and home at 8, rue Simon-Barboux in Arcueil, a southern suburb of Paris.

1934 Solo exhibition is held in April-May at Galerie Percier, Paris, and another in November at Galerie Cahiers d'art, Paris. October 11-December 4: Shows six sculptures at Kunsthaus Zürich in a group exhibition that also includes works by Jean Arp, Max Ernst, Alberto Giacometti, and Joan Miró. In Madrid, Ricardo Pérez Alfonseca publishes a monograph on González's metal sculpture. Meets painter Alberto Magnelli.

1935 February-March: Three works are shown in a group exhibition at the Kunstmuseum in Lucerne. November: Solo exhibition is held at Galerie Cahiers d'art, Paris.

1936 February-March: Participates in *L'Art espagnol contemporain* (Contemporary Spanish art) at the Musée du Jeu de Paume, Paris. March 2-April 19: Two of his sculptures are included in *Cubism and Abstract Art* at the Museum of Modern Art, New York. The museum purchases one, *Head Called "The Snail"* (ca. 1935). May: Solo exhibition is held at Galerie Pierre, Paris. June 26-July 20: Included in a group exhibition with Luis Fernández, Miró, and Picasso at Galerie Cahiers d'art. When Picasso is offered the directorship of the Museo del Prado, Jaime Sabartés proposes the position of secretary to González (letter from González to his daughter Roberta, dated September 21, 1936, González Estate Archive, Paris). October-November: Family moves into new house in Arcueil. December-January, 1937: Has one work in *Fantastic Art, Dada, Surrealism* at the Museum of Modern Art, New York.

1937 Marries Marie-Thérèse Roux, his companion of many years. Solo exhibition is held at Galerie Pierre, Paris. *Montserrat* (1936-37) is shown in the Spanish Pavilion at the Paris World's Fair, which opens on July 12. July-October: González participates in *Origines et développement de l'art international indépendant* (Origins and development of international independent art) at the Musée du Jeu de Paume, Paris.

1938 Lends studio space to German painter Hans Hartung.

1939 Spends summer with his family in the Lot Valley in south-central France. Hartung marries González's daughter Roberta.

1940 January: Family moves to the Lot during the German occupation of France. Unable to work as a sculptor during this period, executes many drawings and plaster models.

1941 November: Returns with Marie-Thérèse to Arcueil in order to continue working. Begins working in plaster on a large version of *Small Frightened Montserrat*.

1942 March 27: Dies of a heart attack at home in Arcueil. The small funeral procession includes Fernández and Picasso.

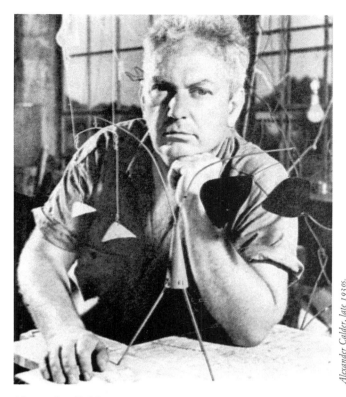

Alexander Calder, late 1930s.

Alexander Calder

1898 July 22: Born in Lawnton, Pennsylvania, which is now part of Philadelphia.

1919 Graduates as a mechanical engineer from the Stevens Institute of Technology, Hoboken, New Jersey.

1919-23 Works as an engineer, draftsman, insurance-company investigator, and a variety of other jobs.

1923-26 Studies at the Art Students League, New York, with George Luks, John Sloan, and others. Works free-lance producing drawings for the *National Police Gazette*.

1926 First paintings are exhibited in New York at the Artist Gallery. Travels to Paris and studies at the Académie de la Grande Chaumière. Begins *Circus*, and makes his first wood sculpture, wire sculpture, and animated toys.

1927 His toys are exhibited at the Salon des Humoristes, Paris. Goes back to New York.

1928 Returns to Paris, where he meets Alberto Giacometti, Joan Miró, and Jules Pascin. First solo exhibition of wire animals and portraits is held at the Weyhe Gallery, New York.

1929 Goes back to New York. Produces first jewelry, and a wire goldfish bowl with moving wire fish. Exhibits at the Galerie Billet,

Paris, and the Galerie Neumann Nierendorf, Berlin.

1930 In Paris again, meets Piet Mondrian and Fernand Léger. Influenced by Mondrian, experiments briefly with abstract painting and begins making abstract sculpture. Participates in the Salon des Surindépendants, Paris. Joins the Abstraction-Création group.

1931 First abstract constructions are shown at Galerie Percier, Paris. Meets Marcel Duchamp, who coins the word "mobile" for Calder's hanging sculptures.

1932 First mobiles are exhibited at Galerie Vignon, Paris, and Julien Levy Gallery, New York. Visits Madrid and Barcelona, where he shows *Circus*, objects, and drawings.

1933 Goes back to the United States and purchases a farm in Roxbury, Connecticut.

1934 Establishes an association with Pierre Matisse Gallery, New York, and holds his first of regular exhibitions there.

1935 Designs the set for Martha Graham's *Panorama*, performed in Bennington, Vermont.

1936 Designs the set for a performance of Erik Satie's *Socrate* at the Wadsworth Atheneum, Hartford, Connecticut. Designs "Plastic Interludes" for Martha Graham's *Four Movements*, performed in New York.

1937 Returns to Paris. Designs *Mercury Fountain* to be exhibited at the Paris World's Fair, which opens on July 12. Exhibits at Mayor Gallery, London.

1938 Retrospective exhibition is held at the George Walter Vincent Smith Art Museum, Springfield, Massachusetts.

1939 Receives first prize in the Plexiglas Sculpture Competition at the Museum of Modern Art, New York.

1940 Has an exhibition at Pierre Matisse Gallery, New York, and his first jewelry exhibition at Willard Gallery, New York.

1943 Makes his *Constellations* sculptures. Major retrospective exhibition is held at the Museum of Modern Art, New York.

1944 Makes modeled sculptures in plaster and bronze. Exhibits at Buchholz Gallery, New York.

1946 Exhibits at Galerie Louis Le Carré, Paris.

1947 Exhibition with Léger is held in Bern and at the Stedelijk Museum, Amsterdam.

1948 Exhibition is held at the Museo de Arte Moderno, Rio de Janeiro, Brazil.

1950 Establishes an association with Galerie Maeght, Paris, and has the first of regular exhibitions there. Visits the caves of Lascaux, then Brittany, Finland, and Sweden. Exhibition is held at the Massachusetts Institute of Technology, Cambridge, Massachusetts.

1952 Receives first prize at the Venice Biennale.

1953 Acquires a house in Saché, France, in the Loire Valley, southwest of Paris.

1954 Constructs *Water Ballet* for the General Motors Technical Center, Detroit. (The sculpture was created in 1939 for the New York Edison Company exhibit at the New York World's Fair but was never shown there.)

1955 Visits India, where he makes several mobiles for Gira Sarabhai in Ahmedabad.

1956 Establishes an association with Perls Galleries, and has the first of regular exhibitions there.

1957 Buys a house in Brittany, in northern France.

1958 Produces a mobile for the United States Pavilion at the Brussels World's Fair, another for UNESCO, Paris, and a third for Idlewild Airport, New York. Receives first prize at the Carnegie International, Pittsburgh.

1959 Exhibition is held at the Museo de Arte Moderno, Rio de Janeiro.

1960 Receives the Gold Medal of the Architectural League of New York.

1961 Receives the American Institute of Architects Medal. Makes a film of *Circus* with Carlos Vilardebó. Has exhibitions in Amsterdam, Stockholm, and Copenhagen.

1962 Receives the Creative Arts Award for Sculpture from Brandeis University, Waltham, Massachusetts. A retrospective exhibition organized by the Arts Council of Great Britain is held at the Tate Gallery, London.

1963 Exhibition of large stabiles is held at Galerie Maeght, Paris.

1964 Five stabiles are included in Documenta 3, Kassel, Germany. *Circus Drawings, Wire Sculpture and Toys*, organized by James Johnson Sweeney, is held at the Museum of Fine Arts, Houston. Major exhibition is held at the Solomon R. Guggenheim Museum, New York, and then travels throughout the United States.

1965 Exhibition is held at the Musée national d'art moderne, Paris. The stabile *Le Guichet* is installed at the Lincoln Center for Performing Arts, New York. Participates in a march against the Vietnam War in Washington, D.C.

1966 Donates *Object in Five Planes (Peace)* to the United States Mission to the United Nations, New York. Installs the stabile *La Grande Voile*, commissioned by I. M. Pei for the Massachusetts Institute of Technology, where an exhibition of Calder's work is held in April.

1967 Donates the stabile *Frisco* to the Havana Museum and gives another, *Mont-Saint-Michel*, to raise funds for the Vietnam peace movement. Travels to Italy to make stage designs for the Rome Opera House. Exhibitions are held at the Museum of Modern Art, New York, and the Phillips Collection, Washington, D.C. Major retrospective is held at the Akademie der Kunste, Berlin.

1968 Calder's ballet, *Work in Progress*, is organized by Giovanni Carandente and presented at the Rome Opera House. Large retrospective is held at the Maison de la Culture, Bourges, France.

1969 Construction begins on a house adjacent to his new hilltop studio in Saché. Major retrospective is held at the Fondation Maeght, Saint-Paul-de-Vence, France. The Museum of Modern Art, New York, presents *A Salute to Alexander Calder*.

1970 Family moves into their new house in Saché. *Circus* is installed at the Whitney Museum of American Art, New York.

1971 The American Academy of Arts and Letters, New York, awards him a Gold Medal for Sculpture and holds an exhibition of his work. Designs costumes and scenery for *Amérique*, presented by the Ballet théâtre contemporain d'Amiens, France.

1972 The Whitney Museum of American Art, New York, holds an exhibition of works based on the circus theme and circulates the film *Calder's Circus* throughout schools, museums, and libraries in the United States.

1973 Galerie Maeght, Zurich, organizes a retrospective of Calder's work held at the Palais des Beaux Arts, Charleroi. The downtown branch of the Whitney Museum of American Art, New York, presents *Three Sculptors: Calder, Nevelson, Smith*. Braniff International Airline commissions Calder to paint a DC-8, for which he paints eight models that are shown at the Solomon R. Guggenheim Museum, New York. The plane's name is to be *Flying Colors*.

1974 Large retrospective is held at the Museum of Contemporary Art in Chicago. Awarded the Grand Prix National des Arts et des Lettres by the French Ministry of Culture.

1975 Joins other artists to protest against the expulsion of Israel from UNESCO. Large retrospective is organized by the Haus der Kunst, Munich, and travels to the Kunsthaus Zürich.

1976 *Calder's Universe*, a major retrospective, is held at the Whitney Museum of American Art, New York, which names Calder its Bicentennial Artist. November 11: Dies in New York.

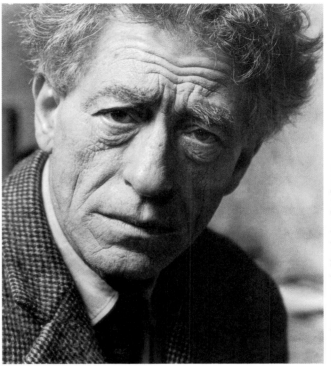

Alberto Giacometti, 1961. Photo by Jean-Régis Roustan.

Alberto Giacometti

1901 October 10: Born in Borgonovo, Grisons, in Italian-speaking Switzerland, into a family of artists. His father, Giovanni, is a well-known Post-Impressionist painter. Alberto will be the eldest of four children, and will always be very close to his brother Diego.

1906 Family moves to Stampa, a few kilometers south of Borgonovo.

1915-16 Attends secondary school in Schiers; father allows him to leave before final examinations to work in his studio as a painter.

1919 Enrolls in the Ecole des Beaux-Arts, Geneva, attending David Estoppey's painting classes; studies sculpture and drawing at the Ecole des Arts et Métiers, Geneva, with Maurice Sarkissoff.

1920 May: Visits the Venice Biennale, where his father is an exhibitor. There, sees works by Paul Cézanne and Alexander Archipenko. He discovers Tintoretto and, in Padua, sees Giotto's frescoes in the Arena Chapel, which deeply impress him.

1921 Spends some months in Rome, studying independently and

sketching in museums after Egyptian, early Christian, early Renaissance, and Baroque art.

1922 January: Arrives in Paris and enrolls in the Académie de la Grande Chaumière, where he stays intermittently for five years, attending Antoine Bourdelle's sculpture class.

1925 Sets up an atelier in Paris with his brother Diego. Participates for the first time in the Salon des Tuileries, where he shows a sculpture. Gives up painting (in favor of sculpting) in Paris for nearly twenty years, but continues to paint in Stampa.

1926 Begins a series of thin, tabletlike works.

1927 Moves to a small studio on rue Hippolyte-Maindron with Diego, where he lives and works until his death. Participates in group exhibitions in Paris with Italian painter friends; visits Henri Laurens; sees Surrealist paintings, works by Raymond Duchamp-Villon, and African, Oceanic, Cycladic, and Sumerian sculpture.

1928 His sculpture shown at Galerie Jeanne Bucher, Paris, attracts much attention, immediately bringing him in contact with the Parisian avant-garde. He meets André Masson and his circle.

1929 Becomes friendly with Michel Leiris, Joan Miró, Max Ernst, and many other artists and writers associated with Surrealism. Participates in a sculpture exhibition at Galerie Georges Bernheim, Paris, and receives critical acclaim. He signs a contract with Pierre Loeb, who is by then the Surrealists' preferred dealer.

1930 Exhibits *Suspended Ball* at Galerie Pierre, together with works by Arp and Miró. Breton and Dalí see his sculpture and invite him to participate in Surrealist activities.

1930-31 An exhibition at Galerie Pierre, *Miró-Arp-Giacometti*, leads to Giacometti's acceptance as a central figure in Breton's Surrealist circle. Participates irregularly in Surrealist activities. Begins to make sculpture with movable parts. Exhibits at Galerie Pierre Loeb, Paris. Assisted by Diego, makes furniture for Jean-Michel Frank for a number of years.

1932-33 May 1932: First solo exhibition is held at Galerie Pierre Colle, Paris. Begins to work from the model. Participates in a Surrealist exhibition at Galerie Pierre Colle, but begins to break away from the Surrealist group.

1934 First solo exhibition in New York is held at Julien Levy Gallery.

1935-40 Works from the model and paints. Officially expelled from the Surrealist group. His work is shown in group exhibitions at the Kunstmuseum in Lucerne, the Museum of Modern Art in New York, and the New Burlington Galleries in London.

1939-41 Stays in Paris after the outbreak of World War II and associates with Picasso, Jean-Paul Sartre, and Simone de Beauvoir. Begins to create a series of tiny imaginary figures.

1941-45 Leaves Paris on the last day of 1941 to spend the remaining war years in Geneva. Becomes a member of the circle of Albert Skira, publisher of *Minotaure* and *Labyrinthe*, to which he contributes articles. Makes sculptures—heads and standing figures—from memory. These works become smaller and smaller. Exhibits at Peggy Guggenheim's Art of This Century gallery, New York, in the *Surrealist Exhibition* in 1942 and a solo show in 1945. Returns to Paris, where he is able to make sculptures of normal dimensions.

1946 Begins making tall, slender figures and resumes painting from nature, especially portraits.

1947 Encouraged by Pierre Loeb, makes his first engravings since 1935.

1948 A retrospective exhibition is held at Pierre Matisse Gallery, New York. Although invited to participate in the Venice Biennale, he withdraws his work from it.

1950 First museum retrospective is held at Kunsthalle Basel. First acquisition by public collection is made by the Kunstmuseum Basel (*The Square*, 1948-49), through funds from Emanuel Hofmann.

1951-55 Makes his first lithographs at the urging of Edouard Loeb. Signs an exclusive European contract with Aimé Maeght, who subsequently organizes numerous sculpture and painting exhibitions. Has regular sculpture and drawing exhibitions at Pierre Matisse Gallery. Begins association with Samuel Beckett.

1955 Major retrospectives take place at the London Arts Council Gallery and the Solomon R. Guggenheim Museum, New York.

1956 Exhibits at the French Pavilion in the Venice Biennale and at the Kunsthalle Bern.

1958 Receives the Guggenheim Prize, Swiss National Section.

1959-60 Undertakes the Chase Manhattan Bank plaza project.

1961 Awarded the Carnegie Prize for sculpture at the Pittsburgh International Exhibition of Contemporary Painting and Sculpture.

1962 Awarded the Grand Prix for sculpture at the Venice Biennale.

1963 Operated on for cancer of the stomach. The cancer does not recur.

1964 Visits London on the occasion of a major retrospective at the Tate Gallery.

1965 Receives the Grand Prix National des Arts from the French Ministère de culture and an honorary doctorate degree from the University of Bern. Major retrospectives are held at the Louisiana Museum, Humlebaek, Denmark, and the Museum of Modern Art, New York, both of which Giacometti visits. Inspects the Chase Manhattan Plaza site in New York. The Alberto Giacometti Foundation (Giacometti-Stiftung) is founded in Zurich.

1966 January 11: Dies at the cantonal hospital of Chur, Switzerland.

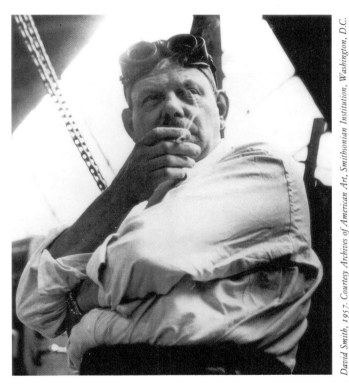

David Smith, 1957. Courtesy Archives of American Art, Smithsonian Institution, Washington, D.C.

David Smith

1906 March 9: Born in Decatur, Indiana. His father works for the telephone company, and his mother is a teacher.

1921 Family moves to Paulding, Ohio.

1924-25 Studies art at Ohio University, Athens.

1925 Summer: Works in South Bend, Indiana, at the Studebaker car factory, giving him a feel for industrial forms and a basic knowledge of factory tools and equipment. Fall: Moves to Washington, D.C., where he works for a bank.

1926 Enrolls in poetry courses at George Washington University, Washington, D.C. Transferred to New York branch of Morris Plan Bank. In New York he meets Dorothy Dehner, an art student who encourages him to study at the Art Students League. Smith enrolls immediately, and studies there intermittently for the next five years, while continuing to work in various jobs.

1927 At the Art Students League, studies painting with John Sloan, the woodcut with Allen Lewis, and, later, painting with Jan Matulka. December 24: Marries Dehner.

1928-29 Through his friends at the Art Students League, meets Russian painter and writer John Graham, who puts him in contact with the European avant-garde and introduces him to the sculpture of Picasso and González. Buys a property in Bolton Landing, on the western side of Lake George, New York, his base for the rest of his life.

1931-32 Spends time in the Virgin Islands, where he makes sculpture with found objects and coral, which he then paints.

1932 June: Returns to New York. Begins work with forge at Bolton Landing. Sees reproductions of work by González and Picasso in *Cahiers d'art*.

1933 Spring: Makes iron sculptures in Bolton Landing. Produces his first welded piece, a head, although his chief interest is still painting. End of the year: Establishes his studio at Terminal Iron Works in Brooklyn. Associates with Stuart Davis, Willem de Kooning, Arshile Gorky, and Jean Xceron.

1934 Shows two iron sculptures at Julien Levy Gallery. Enters the Treasury Relief Art Project, a New Deal art program, supervising technical procedures on murals.

1935-36 Travels to Europe, partly under Graham's guidance. Visits Athens, London, Malta, Marseilles, Moscow, Naples, and Paris. Visits museums and private collections. Returns to New York in July 1936. Commits himself to sculpture, although he continues to paint and draw.

1937 Outbreak of Spanish Civil War deeply influences him. Begins a series of antiwar medallions he calls *Medals for Dishonor*. Joins the Federal Arts Project, the Works Progress Administration (WPA) art program, for which he makes sculpture. Works on iron with encaustic color.

1938 First solo exhibition is held at Marian Willard's East River Gallery, New York.

1939 Solo exhibition is held at the Willard-J. B. Neumann

Gallery. Represented in several group exhibitions in New York, Minneapolis, and at Skidmore College in Saratoga Springs. Continues work on *Medals for Dishonor*.

1940 One piece by Smith is exhibited at the New York World's Fair. His connection with the Federal Arts Project comes to an end, and he establishes himself permanently in Bolton Landing. Works as a machinist in Glenn Falls. March: Exhibits at the Neumann-Willard Gallery, New York. November: *Medals for Dishonor* are shown at the Willard Gallery, New York.

1941 Solo exhibitions are held in Minneapolis, Minnesota, and Kalamazoo, Michigan. Begins building a studio in Bolton Landing.

1942 Works as a welder in the American Locomotive Company plant in Schenectady. Solo exhibition is held at the Walker Art Center, Minneapolis.

1943 Continues working in Schenectady. His *Interior*, shown in a group exhibition at Willard and Buchholz galleries in January, receives a highly favorable review from Greenberg in *The Nation*. Solo exhibition is held at Willard Gallery in April.

1944-45 Finishes his studio in Bolton Landing in 1944, and works intensely on sculpture there. Meets Greenberg and Jackson Pollock.

1946 Concurrent exhibitions at Willard Gallery, showing early work, and Buchholz Gallery, showing recent work, take place.

1947 April: Smith exhibits his *Specter* series at Willard Gallery, New York. Traveling retrospective exhibition of his work sponsored by the American Association of University Women. Speaks at Skidmore College, Saratoga Springs, and participates in First Woodstock Art Conference.

1948 Takes teaching position at Sarah Lawrence College, Bronxville.

1950 Receives a John Simon Guggenheim Foundation fellowship. Smith and Dehner separate. Has a solo exhibition at Willard Gallery, New York.

1951 Guggenheim fellowship is renewed.

1951-52 Begins his *Agricola* series. Meets painter Kenneth Noland, with whom he later establishes a close friendship. Lectures at conferences at colleges and universities. Several solo exhibitions are held. He and Dehner divorce.

1953 Teaches at University of Arkansas, Fayetteville. Six works are presented in the Museum of Modern Art's traveling exhibition in Europe. Marries Jean Freas.

1954 Teaches at Indiana University. Is American delegate to UNESCO's First International Congress of Plastic Arts, held in Venice. April 4: Daughter, Rebecca, is born.

1955 Teaches at University of Mississippi, Oxford, and begins his *Forging* series. August 12: Daughter, Candida, is born.

1956 February: His article "González: First Master of the Torch" is published in *Art News*.

1957 Retrospective exhibition is held at the Museum of Modern Art, New York. Begins his *Sentinel* series.

1958 Exhibits at the Venice Biennale.

1959 Begins his *Albany* series. His work is included in the Documenta 2 exhibition in Kassel, Germany.

1961 Smith and Jean Freas are divorced. Begins *Cubi* series.

1962 Goes to Italy, invited by Italian government to produce sculpture for the Fourth Festival of Two Worlds in Spoleto. Stays in Voltri, near Genoa, where factories, tools, machine parts, and a work crew are placed at his disposal.

1962-63 Makes his *Voltri-Bolton* series from machine parts shipped from Italy.

1964 Solo exhibition is held at Marlborough-Gerson Gallery, New York. Receives Brandeis University's Creative Arts Award.

1965 February: Appointed member of National Council on the Arts. May 23: Dies in a car accident near Bennington, Vermont.

Compiled by M. Dolores Jiménez-Blanco.

Bibliography

Alexander Calder, Red Lily Pads, *1956. Painted sheet metal, metal rods, and wire, 106.7 x 510.6 x 276.9 cm (42 x 201 x 109 inches). Solomon R. Guggenheim Museum.*

General Books and Articles

Alloway, Lawrence. *Iron Sculpture*. London, 1960.

Arnason, H. H. *Modern Sculpture from the Joseph H. Hirshhorn Collection* (exh. cat.). New York: Solomon R. Guggenheim Museum, 1962.

Ashton, Dore. *Modern American Sculpture*. New York: Abrams, 1968.

Ashton, Dore, ed. *Twentieth-Century Artists on Art*. New York: Pantheon Books, 1985.

Barr, Alfred H., Jr. *Cubism and Abstract Art* (exh. cat.). New York: The Museum of Modern Art, 1936. Reprint, 1974.

Barr, Alfred H., Jr., ed. *Fantastic Art, Dada, Surrealism* (exh. cat.). New York: The Museum of Modern Art, 1936. Rev. ed., 1937.

——. *Painters and Sculptors in the Museum of Modern Art* (exh. cat.). New York: The Museum of Modern Art, 1942.

——. *Masters of Modern Art* (exh. cat.). New York: The Museum of Modern Art, 1954.

Butler, Ruth. *Western Sculpture: Definitions of Man*. New York: Graphic Society, 1975.

Cassou, Jean. *Panorama des arts plastiques contemporains*. Paris: Gallimard, 1960.

Chipp, Herschel B., ed. *Theories of Modern Art: A Source Book by Artists and Critics*. Berkeley and Los Angeles: University of California Press, 1968.

Elsen, A. E. *Origins of Modern Sculpture: Pioneers and Premises*. New York: Braziller, 1974.

——. *Modern European Sculpture, 1918-1945: Unknown Beings and Other Realities*. New York: Braziller, 1979.

Evans, Myfanwy, ed. *The Painter's Object*. London: Curwen Press, 1937.

Giedion-Welcker, Carola. *Contemporary Sculpture: An Evolution in Volume and Space*. Rev. ed. New York: George Wittenborn; London: Faber and Faber, 1961.

——. "New Roads in Modern Sculpture." *Transition* (New York) 23 (Feb. 1935).

——. "Sept Pionniers de la sculpture moderne." *Erk-Chronik* (Bern) 41 (1954).

Gischia, Léon, and Nicole Védrès. *La Sculpture en France depuis Rodin*. Paris: Editions du seuil, 1945.

Goldwater, Robert. *What is Modern Sculpture?* New York: The Museum of Modern Art, 1969.

Hammacher, A. M. *The Evolution of Modern Sculpture*. New York: Abrams, 1969.

Hess, Thomas B. "Many-sided Look at Modern Sculpture." *Art News* (New York), Oct. 1952.

Hildebrand, Adolf. *The Problem of Form in Painting and Sculpture*. New York: Haffner, 1945.

Hughes, Robert. *Barcelona*. New York: Alfred A. Knopf, 1992.

Hunter, Sam. *Cubism to the Present*. New York: Harry N. Abrams, 1957.

Krauss, Rosalind. *Passages in Modern Sculpture*. New York: Cambridge University Press, 1977.

——. *The Originality of the Avant-Garde and Other Modernist Myths*. Cambridge, Mass.: M.I.T. Press, 1985.

Metken, Günther. "La Fin de l'age du fer?" *Revue de l'art* (Paris) no. 12 (1971), pp. 45-54.

Moholy-Nagy, L. *The New Vision*. Rev. ed. New York: Wittenborn, 1946; Wittenborn Schultz, 1955.

Musée d'art moderne de la ville de Paris. *Le Siècle de Picasso* (exh. cat.). With texts by Pierre Daix, Tomás Llorens, and Francisco Calvo Serraller. Paris: Musée d'art moderne de la ville de Paris, 1987-88.

Museo Nacional Centro de Arte Reina Sofía. *Pabellón Español: Exposición Internacional de París, 1937* (exh. cat.). With texts by Román Gubern and Josefina Alix Trueba. Madrid: Centro de Arte Reina Sofía, 1987.

The Museum of Modern Art. *Art in Our Time* (exh. cat.). New York: The Museum of Modern Art, 1939.

Palacio de Velázquez and Palacio de Cristal. *Escultura Española, 1900-1936* (exh. cat.).

With texts by Josefina Alix, Enrique Azcoaga, Jaime Brihuega, and Carmen Giménez. Madrid: Palacio de Velázquez y Palacio de Cristal, 1985.

Penrose, Roland. "Espaço e volume na escultura contemporânea." *Cóloquio* (Lisbon), Feb. 1960, pp. 1-8.

Philadelphia Museum of Art. *A. E. Gallatin Collection: Museum of Living Art* (exh. cat.). Reprint. Philadelphia: Philadelphia Museum of Art, 1955.

Ragon, Michel. *L'Aventure de l'art abstrait*. Paris: Laffont, 1956.

Ramsden, E. H. *Twentieth-Century Sculpture*. London: Pleiades Books, 1949.

——. *Sculpture: Theme and Variations, Towards a Contemporary Aesthetic*. London: L. Humphries, 1953.

Read, Herbert. *The Art of Sculpture*. New York: Bollingen Series; London: Faber and Faber, 1956.

——. *Art Now: An Introduction to the Theory of Modern Painting and Sculpture*. London: Faber and Faber, 1963.

——. *A Concise History of Modern Sculpture*. London: Thames and Hudson; New York: Praeger, 1964. Rev. ed. London: Thames and Hudson, 1985.

Ritchie, Andrew C. *Sculpture of the Twentieth Century* (exh. cat.). New York: The Museum of Modern Art, 1952; London: Mayflower Books, 1953.

Rose, Barbara. *Readings in American Art*. New York: Frederick A. Praeger, 1968.

Rosenblum, Robert. *Cubism and Twentieth-Century Art*. London: Thames and Hudson; New York: Harry N. Abrams, 1960.

Rowell, Margit. *Qu'est-ce que l'esculture moderne?* (exh. cat.). Paris: Musée national d'art moderne, Centre Georges Pompidou, 1986.

Rubin, William, ed. *Primitivism in Twentieth-Century Art: Affinity of the Tribal and the Modern* (exh. cat.). 2 vols. New York: The Museum of Modern Art, 1984.

Selz, J. *La Découverte de la sculpture moderne*. New York, 1963.

——. *Modern Sculpture: Origins and Evolution.* New York: G. Braziller, 1963.

Seuphor, Michel. *The Sculpture of This Century.* New York: Braziller, 1960.

Seymour, Charles. *Tradition and Experiment in Modern Sculpture.* Washington, D.C.: American University Press, 1949.

Sylvester, David. *Modern Art: From Fauvism to Abstract Expressionism, A Pictorial Encyclopedia of Painting, Drawing and Sculpture.* Montreal, 1965.

Trier, Eduard. *Moderne Plastike.* Frankfurt: Büchergilde Gutemberg, 1955.

Tucker, William. *Early Modern Sculpture: Rodin, Degas, Matisse, Brancusi, Picasso, González.* New York: Oxford University Press, 1974.

——. *Space, Illusion, Sculpture: Three Talks Given at St. Martin's School of Art.* London, 1974.

——. "Four Sculptors." *Studio International* (London) 179 (April 1970), pp. 156-61; 179 (May 1970), pp. 201-05; 180 (Sept. 1970), pp. 82-87; 180 (Jan. 1971), pp. 24-29.

Turner, Elisabeth Hutton. *American Artists in Paris, 1919-1929.* Ann Arbor, Mich.: U.M.I. Research Press, 1988.

University of St. Thomas. *Made of Iron* (exh. cat.). Houston: Art Department, University of St. Thomas, 1966.

Valentiner, W. R. *Origins of Modern Sculpture.* New York: Wittenborn, Schultz, 1946.

Zervos, Christian. "Sculptures des peintres d'aujourd'hui." *Cahiers d'art* (Paris) 4, nos. 8-9 (1929).

Pablo Picasso

Writings by the Artist :

Writings by Picasso appear in the following anthologies:

Scritti di Picasso, ed. by Mario de Michelis. Milan: Feltrinelli Editori, 1964.

Picasso on Art: A Selection of Views, ed. by Dore Ashton. New York: Da Capo, 1972.

Picasso: Ecrits, ed. by Marie-Laure Bernadac and Christine Piot. Paris: Gallimard, Réunion des musées nationaux, 1989.

Statements by Picasso also appear in:

Barr, Alfred H., Jr. *Picasso: Fifty Years of His Art* (exh. cat.). New York: The Museum of Modern Art, 1946.

Parmelin, Hélène. *Picasso dit . . .* Paris: Gonthier, 1966. Published in English as *Picasso Says.* London: Allen and Unwin, 1969.

Monographs and Solo-Exhibition Catalogues:

Argan, Giulio Carlo. *Scultura de Picasso.* Venice: Alfieri, 1935.

Barr, Alfred H., Jr. *Picasso: Forty Years of His Art* (exh. cat.). New York: The Museum of Modern Art, 1939.

Barr, Alfred H., Jr., ed. *Picasso: Seventy-Fifth Anniversary Exhibition* (exh. cat.). New York: The Museum of Modern Art, 1957.

Besnard-Bernadac, Marie-Laure. *Le Musée Picasso, Paris.* Paris: Ministère de la Culture, édition de la Reunion des musées nationaux, 1985.

Block, Georges. *Pablo Picasso: Catalogue of the Graphic Work 1904-1967.* Bern: Kornfeld and Klipstein, 1968.

Boeck, Wilhelm, and Jaime Sabartés. *Picasso.* Stuttgart: Kohlhammer, 1955; London: Thames and Hudson, 1955.

Brassaï. *Conversations avec Picasso.* Paris: Gallimard, 1946. Published in English as *Picasso and Company.* Garden City, N.Y.: Doubleday, 1966.

Caizergues, Pierre, and Hélène Seckel, eds. *Picasso/Apollinaire Correspondance.* Paris: Gallimard, Réunion des musées nationaux, 1992.

Calvo Serraller, Francisco. *Pablo Picasso: El Guernica.* Madrid: Alianza Cero Ocho, 1981.

Daix, Pierre. "Le Cubisme de Picasso." In *Catalogue raisonné de l'oeuvre peint, 1907-1916,* by Pierre Daix and J. Rosselet. Paris: Neuchâtel, 1979.

Duncan, Douglas D. *Picasso's Picassos.* London: MacMillan; New York: Harry N. Abrams, 1967.

Elgar, Frank, and Robert Maillard. *Picasso.* New York: Praeger, 1956.

Fitzgerald, Michael. *Pablo Picasso's Monument to Guillaume Apollinaire: Surrealism and Monument Sculpture in France 1918-1959.* Ph.D. diss., Columbia University, New York, 1987.

Fló, Juan, ed. *Picasso, Pintura y Realidad: Textos, entrevistas y declaraciones.* Montevideo: Libros del Astillero, 1973.

Galeries nationales du Grand Palais. *Picasso: Une Nouvelle Dation* (exh. cat.). Paris: Galeries Nationales du Grand Palais. Paris: Ministère de la Culture, édition de la Réunion des musées nationaux, 1990-91.

Gaya Nuño, Juan Antonio. *Bibliografía Crítica y Antológica de Picasso.* San Juan: Ediciones de la Torre, Universidad de Puerto Rico, 1966.

Gedo, Mary Mathews. *Picasso: Art as Autobiography.* Chicago: University of Chicago Press, 1980.

Geiser, Bernhard. *Picasso Peintre-graveur: Catalogue illustré de l'oeuvre gravé et des monotypes, 1899-1931.* Bern: Berhard Geiser, 1933. Reprint, 1955.

——. *Picasso Peintre-graveur: Catalogue illustré de l'oeuvre gravé et des monotypes, 1932-1934.* Bern: Kornfeld and Klipstein, 1968.

Gervis, Daniel. *Picasso: L'Oeuvre gravé, 1899-1972.* Paris: Daniel Gervis, 1984.

Gilot, Françoise, and Carlton Lake. *Life with Picasso.* New York: McGraw Hill, 1964.

Glimsher, A., and M. Glimsher, eds. *Je suis le cahier: The Sketchbooks of Picasso* (exh. cat.). New York: The Pace Gallery; London: Royal Academy of Arts, 1986.

Hunter, Sam. *Picasso: Cubism to the Present.* New York: Harry N. Abrams, 1957.

Kahnweiler, Daniel-Henry. *Les Sculptures de*

Picasso. With photographs by Brassaï. Paris: Editions du Chêne, 1948; London: Rodney Phillips, 1949.

Lichtenstern, Christa. *Picasso: Monument à Apollinaire, Projet pour une humanisation de l'espace*. Paris: Adams Biro, 1990.

McCully, Marilyn, ed. *A Picasso Anthology: Documents, Criticism, Reminiscences*. London: Arts Council of Great Britain, in association with Thames and Hudson, 1981.

O'Brian, Patrick. *Picasso: A Biography*. New York: G. P. Putnam Sons, 1975.

Parmelin, Hélène. *Picasso sur la Place*. Paris: Julliard, 1959.

Penrose, Roland. *Portrait of Picasso*. London: Lund Humphries, 1956.

——. *Picasso*. Universe Sculpture Series. New York: Universe Books, 1961.

——. *Picasso: Sculptures*. Petite Encyclopedie de l'Art. Paris: Fernand Hazan, 1965.

——. *Picasso: Sculpture, Ceramics, Graphic Work* (exh. cat.). London: Tate Gallery, 1967.

——. *The Sculpture of Picasso* (exh. cat.). New York: The Museum of Modern Art, 1967.

Penrose, Roland, and Edward Quinn. *Picasso: Works and Days*. Garden City, N.Y.: Doubleday, 1964.

Petit Palais and Grand Palais. *Hommage à Pablo Picasso* (exh. cat.). Paris: Petit Palais and Grand Palais, 1966-67.

Prampolini, Enrico. *Picasso Scultore*. Rome: Libreria Fratelli Boca, Serie Arti, 1943.

Raynal, Maurice. *Picasso*. Geneva: Skira, n.d.; Paris; Crès, 1922.

Richet, Michele. *Musée Picasso, Paris: Catalogue sommaire des collections*. Vol. I: *Peintures, papiers collés, tableaux, reliefs, sculptures, céramiques*. Vol. II: *Dessins, acquarelles, gouaches, pastels*. Paris: Ministère de la Culture et de la Comunication, éditions de la Réunion des musées nationaux, 1987.

——. *The Picasso Museum, Paris: Drawings, Watercolors, Gouaches and Pastels*. New York: Harry N. Abrams, 1989.

Rubin, William. *Picasso in the Collection of the Museum of Modern Art*. New York: The Museum of Modern Art, 1972.

——. *Pablo Picasso: A Retrospective* (exh. cat.). New York: The Museum of Modern Art, 1980.

Sabartés, Jaime. *Picasso: Portraits et souvenirs*. Paris: Louis Carré et Maximilien Vox, 1946.

Spies, Werner. *Picasso: Das Plastische Werk* (exh. cat.). Stuttgart: Verlag Gerd Hatje, 1983.

Stein, Gertrude. *Picasso*. London: Scribner's and Batsford, 1938.

Through the Eye of Picasso, 1928-1934: The Dinard Sketchbook and Related Paintings and Sculpture (exh. cat.). With text by John Richardson. New York: William Beadleston and Jan Krugier, 1985.

Tinterow, Gary. *Master Drawings by Picasso*. New York: Braziller, in association with the Fogg Art Museum, 1981.

Vallentin, Antonina. *Pablo Picasso*. Cologne: Kiepenheuer und Witsch, 1958.

Zervos, Christian. *Pablo Picasso: Oeuvres*. Vols. I-XXXII. Paris: Cahiers d'art, 1932-77.

Periodicals, Books, and Group-Exhibition Catalogues:

Argan, Giulio Carlo. "Cubismo e Surrealismo nella Scultura di Picasso." *Letteratura* (Rome) 1, no. 4 (1953), pp. 11-16.

Ashton, Dore. "Sculptures de Picasso." *XXe Siècle* (Paris), June 1968, pp. 25-40.

——. "Pour faire une Colombe il faut d'abord lui tordre le cou." *Hommage à Picasso* (special issue of *XXe Siècle* [Paris]), 1971, pp. 109-16.

Barr, Alfred H., Jr. *Cubism and Abstract Art* (exh. cat.). New York: The Museum of Modern Art, 1936.

Barr, Alfred H., Jr., ed. *Fantastic Art, Dada, Surrealism* (exh. cat.). New York: The Museum of Modern Art, 1936. Rev. ed., 1937.

Bowness, Alan. "Picasso's Sculpture." In *Picasso in Retrospect*, ed. by Roland Penrose and J. Golding. New York: Paul Elek, 1973. Reprint. New York: Icon, 1980.

Breton, André. "Picasso dans son elément." *Minotaure* (Paris), no. 1 (1933), pp. 8-29.

Cahiers d'art (Paris) 7, nos. 3-5 (1932) (special issue on Picasso). With texts by Guillaume Apollinaire, Jean Cocteau, Maud Dale, Ramón Gómez de la Serna, H. S. Ede, Carl Einstein, Will Grohmann, Guéguen, Hugnet, Vicente Huidobro, Salmon, Giovanni Scheiwiller, Oskar Sehürer, Strawinsky, J. J. Sweeney, Zervos, and others.

Chevalier, Denys. "Propos autour d'une sculpture de Picasso." *Arts de France* (Paris), no. 8 (1946), pp. 77-79.

Daix, Pierre. "Picasso et l'invention de la sculpture moderne." In *Pablo Picasso*, ed. by Jean Cassou. Paris: Somogy, 1975, pp. 123-44.

Décaudin, M. "Apollinaire et Picasso." *Esprit*, no. 61 (Jan. 1982), p. 81.

Elsen, Albert. "The Many Faces of Picasso Sculpture." *Art International* (Lugano), summer 1969, pp. 24-34.

Gaffe, René. "Sculpteur, Picasso?" *Artes* (Antwerp) 2, nos. 3-4 (1947-48), pp. 36 ff.

González, Julio. "Picasso sculpteur." *Cahiers d'art* (Paris) 9, nos. 6-7 (1936), p. 189 ff.

——. "Picasso sculpteur et les cathédrales." In *Julio González: Sculpture in Iron*, by Josephine Withers. New York: New York University Press, 1978, appendix I, pp. 131-45 (in French and English).

Gowing, Lawrence. "Object Lesson in Object Love: A Great Survey of Picasso Sculptures at the Museum of Modern Art." *Art News* (New York), Oct. 1967, pp. 24-27.

Henze, Anton. "Neue Plastiken von Picasso." *Das Kunstwerk* (Baden-Baden) 13 (March 1960), pp. 17-26.

Johnson, Ronald. "Primitivism in the Early Sculpture of Picasso." *Arts Magazine* (New York) 49 (June 1975), pp. 64-68.

Jung, C. G. "Picasso." *Neue Zürcher Zeitung* (Zurich), no. 13 (1932).

Porter, Fairfield. "Picasso Also as a Sculptor."

Art News (New York), March 1952, p. 26.

Prejger, Lionel. "Picasso découpe le Fer." *L'Oeil* (Paris), Oct. 1961, pp. 28-33.

"Retrospective of Picasso's Sculpture at the Museum of Modern Art." *The Art Journal* (New York), fall 1967, p. 87.

Riedl. *Masque d'homme*: ein Frühwerk Pablo Picassos." *Jahrbuch der Hamburger Kunstsammlungen* (Hamburg) 7 (1962), pp. 83-92.

Rosenblum, Robert. "Notes on Picasso's Sculpture." *Art News* (New York), Jan. 1983, pp. 60-66. Reprinted in *The Sculpture of Picasso* (exh. cat.). New York: Pace Gallery, 1982.

Rosenthal, Mark. "The Nietzschean Character of Picasso's Early Development." *Arts Magazine* (New York) 55, no. 2 (Oct. 1980), pp. 87-91.

Rowell, Margit. *The Planar Dimension: Europe 1912-1932* (exh. cat.). New York: Solomon R. Guggenheim Museum, 1979.

———. *Qu'est-ce que l'esculture moderne?* (exh. cat.). Paris: Musée national d'art moderne, Centre Georges Pompidou, 1986.

Smith, L. E. "Iconographic Issues in Picasso's *Woman in the Garden.*" *Arts Magazine* (New York) 56, no. 5 (Jan. 1982), pp. 142-47.

Spies, Werner. *Pablo Picasso: Sammlung Marina Picasso* (exh. cat.). Munich: Prestel-Verlag, 1981.

Sweeney, James Johnson. "Picasso and Iberian Sculpture." *Art Bulletin* (New York), Sept. 1941, pp. 191-98.

Tucker, William. "Picasso: Cubism and Construction." In *The Language of Sculpture.* London, 1974.

Withers, Josephine. "The Artistic Collaboration of Pablo Picasso and Julio González." *Art Journal* (New York) 35, no. 2 (winter 1975-76), pp. 107-14.

Zervos, Christian. "Projets de Picasso pour un monument." *Cahiers d'art* (Paris) 4, nos. 8-9 (1929), p. 342 ff.

———. "Conversation avec Picasso." *Cahiers d'art* (Paris), no. 10 (1935), p. 174 ff.

———. "Sculptures des peintres d'aujourd'hui." *Cahiers d'art* (Paris) 20-21 (1945-46), pp. 84-112.

Julio González

Writings by the Artist:

"Desde Paris." *Cahiers d'art* (Paris) 10 (1935), pp. 7-10.

"Réponse à une enquête sur l'art actuel." *Cahiers d'art* (Paris) 10 (1935), pp. 1-4.

"Picasso Sculpteur." *Cahiers d'art* (Paris) 11 (1936), pp. 6-7.

"Reply to a Question on Contemporary Art." *The Museum of Modern Art Bulletin* (New York) 23, nos. 1-2 (1955-56) (exh. cat., *Julio González*), p. 43. First published in *Cahiers d'art* (Paris), nos. 1-4 (1935), pp. 32-34.

"Picasso as Sculptor." *The Museum of Modern Art Bulletin* (New York) 23, nos. 1-2 (1955-56) (exh. cat., *Julio González*), pp. 43-44. First published in *Cahiers d'Art* (Paris), nos. 6-7 (1936), pp. 189-91.

"Notations." In *Julio González* (exh. cat.). Paris: Galerie de France, 1959.

Monographs and Solo-Exhibition Catalogues:

Aguilera Cerni, Vicente. *Julio González.* Rome: Edizioni dell'Ateneo, 1962.

———. *Julio González.* Madrid, 1971.

———. *Julio, Joan, Roberta González: Itinerario de una dinastía.* Barcelona: Polígrafa, 1973.

Ainaud de Lasarte, J. *Donación Julio González* (exh. cat.). Barcelona: Museo de Arte Moderno, 1974.

Areán, Carlos Antonio, ed. *Julio González.* Cuadernos de Arte del Ateneo de Madrid, vol. 200. Madrid: Ateneo de Madrid, 1965.

Cassou, Jean. *Julio González: Sculptures* (exh. cat.). Paris: Musée national d'art moderne, 1952.

———. "Julio González." In *XXXII Biennale de Venezia* (exh. cat.). Venice, 1964.

Cirici Pellicer, Alexandre. "Julio González a Barcelona." In *Julio González: Escultures i Dibuixos* (exh. cat.). Barcelona: Capella de l'Antic Hospital de la Santa Creu, 1980.

Degand, Léon. "González." *Europäische Bildhauer* (Amsterdam, Cologne, Berlin), no. 6 (1956).

———. *González.* Universe Sculpture Series, vol. 3. New York: Universe Books, 1959.

Descargues, Pierre. *Julio González.* Paris: Le Musée de poche, 1971.

Gibert, Josette. *Catalogue raisonné des dessins de Julio González.* 9 vols. Paris: C. Martinez, 1975.

Julio González: Catalogue raisonné des sculptures. Established by Jörn Merkert; with preface by Tomás Llorens and introduction by Margit Rowell. Milan: Electa, 1987.

Kramer, Hilton. *Julio González* (exh. cat.). New York: Galerie Chalette, 1961.

Llorens, Tomás. "La Colección de esculturas de Julio González en el IVAM." In *Julio González* (exh. cat.). Madrid: Centro de Arte Reina Sofía, 1986.

Merkert, John. "Julio González." In *Julio González: Sculptures et dessins* (exh. cat.). Basel: Galerie Beyeler, 1982.

———. "Spintisierende Eisenklitterei oder Die Risiken individualler Erfahrung." In *Julio González 1876-1942: Plastiken, Zeichnungen, Kunstgewerbe* (exh. cat.). Berlin, 1983.

The Museum of Modern Art. *Julio González* (exh. cat.). With introduction by Andrew C. Ritchie. *The Museum of Modern Art Bulletin* (New York) 23, nos. 1-2 (1955-56).

Pérez Alfonseca, Ricardo. *Julio González: Escultor en Hierro y Espacios Forjados.* Madrid: Editorial Cartillas, 1934.

Pradel de Grandy, Marie N. *Julio González.* I Maestri della Scultura, vol. 25. Milan, 1966.

Raynal, Maurice. *Julio González* (exh. cat.). Paris: Galerie Percier, 1934.

Reid, Norman. "Julio González." In *Julio González* (exh. cat.). London: Tate Gallery, 1970.

Roig, Alfonso. *Julio González* (exh. cat.). Cuadernos de Arte del Ateneo de Madrid, vol. 60. Madrid: Ateneo de Madrid, 1965.

Rowell, Margit. "Julio González: Technique, Syntax, Context." In *Julio González: A Retrospective* (exh. cat.). New York: Solomon R. Guggenheim Museum, 1983.

Schmalenbach, Werner. "Julio González." In *Julio González* (exh. cat.). Hannover: Kestner-Gesellshaft, 1957.

Stedelijk Museum. *Julio González* (exh. cat.). Amsterdam: Stedelijk Museum, 1955.

Tate Gallery. *Julio González* (exh. cat.). London: Tate Gallery, 1970.

Viatte, Germain. "Libertad: El grito de Julio González." In *Julio González: Escultures i Dibuixos* (exh. cat.). Barcelona: Capella de l'Antic Hospital de la Santa Creu, 1980.

Withers, Josephine. *Julio González: Sculpture in Iron*. New York: New York University Press, 1978.

Periodicals, Books, and Group-Exhibition Catalogues:

Aguilera Cerni, Vicente. "La Sculpture abstraite espagnole." *Aujourd'hui* (Paris), Dec. 1959.

——. "Julio González." *L'Europa letteraria* (Rome), nos. 30-32 (June-Sept. 1964).

——. "Julio González en la XXXII Biennale de Venecia." *Papeles de son Armadans* (Madrid, Palma de Mallorca) 107 (Feb. 1965).

Alley, Ronald. *The González Gift to the Tate Gallery*. London: Tate Gallery, [1974].

Areán, Carlos Antonio. "Julio González y la problemática de la escultura del siglo XX." In *Julio González*. Cuadernos de Arte del Ateneo de Madrid, vol. 60. Madrid: Ateneo de Madrid, 1965.

——. "Julio González y la búsqueda de nuevos caminos." In *Escultura Actual en España: Tendencias No Imitativas*. Madrid, 1967.

Arnason, H. H. "González." In *Modern Sculpture from the J. H. Hirshhorn Collection*

(exh. cat.). New York: Solomon R. Guggenheim Museum, 1962.

Barbier, Nicole. *González: Dessins et sculptures des années 30* (exh. cat.). Rennes, France: Musée des Beaux-Arts de Rennes, 1982.

Baumann, Felix Andreas. "Hinweis auf einige Neuerwerbungen, Julio González: *Arlequin, 1929.*" In *Jahresbericht der Zuricher Kunstgesellshaft*. Zurich, 1970.

Brest, Jorge Romero. "González 1876-1942." In *Les Sculpteurs célèbres*, ed. by Pierre Francastel. Paris, 1954.

Bruguière, P. G. "Julio González: Les Etapes de l'oeuvre." *Cahiers d'art* (Paris) 27, no. 1 (July 1952), pp. 19-31.

C., A. "La 'Tentative' de Julio González: Une Poétique du fer forgé." *Le Monde* (Paris), Feb. 22, 1952.

Cabanne, Pierre. "Quatre Sculpteurs sur le retour." *L'Actualité* (Paris), April 16, 1970.

Calvo Serraller, Francisco. "Julio González: El Impetu Revolucionario de una Modernidad Intempestiva." In *Julio González* (exh. cat.). Madrid: Galería Theo, 1978.

Cassou, Jean. "Julio González." *Cahiers d'art* (Paris) 22 (1947), pp. 135-41.

Chevalier, Denys. "Julio González: Un Précurseur." *Les Lettres françaises* (Paris), May 6, 1970.

Cirlot, Juan Eduardo. "El Escultor Julio González." *Goya* (Madrid), no. 4 (Jan.-Feb. 1955), pp. 206-12.

Danieli, Fidel. "Julio González: A Representative Showing at the Landau Gallery." *Artforum* (New York) 4 (Dec. 1965), pp. 28-29.

Darzacq, Dominique. "Julio González et le fer." *Connaissance des arts* (Paris), April 1970.

Degand, Léon. "Julio González, 1876-1942." *Art d'aujourd'hui* (Paris), no. 6 (Jan. 1950), pp. 16-20.

——. "Julio González." *Museum Journal* (London) 3, no. 3 (Sept. 1957), pp. 62-63.

Descargues, Pierre. "González, Sculpteur du fer." *XXe Siècle* (Paris), no. 35 (Dec. 1970), pp. 151-56.

Dudley, Dorothy. "Four Postmoderns." *Magazine of Art* (Paris), no. 9 (1934).

Fernandez, Luis. "El Escultor Julio González." *AC* (Barcelona), no. 2 (Jan. 5, 1932), pp. 30-31.

Galy-Carles, Henri. "González, l'Homme du fer." *Art vivant* (Paris), no. 9 (March 1970).

Gaya Nuño, Juan Antonio. "De Picasso y Julio González y de lo Magistral y lo Fácil." *Arbor* (Madrid), no. 46 (1960).

González, Roberta. "Julio González: My Father." *Arts* (New York), no. 5 (Feb. 1956), pp. 21-24.

Hale, Barrie. *First, There Was the Sculptor González* (exh. cat.). Zurich: Gimpel und Hanover Galerie, 1969.

Hartung, Hans. "Brief in die Galerie de France." In *Julio González* (exh. cat.). London: Tate Gallery, 1970.

——. "Las Funciones." *Guadalimar* (Madrid), no. 14 (June 10, 1976).

Hughes, Robert. "Misunderstood Master of Iron." *Time Magazine* (New York), June 18, 1983.

Jakovski, Anatole. "Julio González." *Cahiers d'art* (Paris) 9, nos. 5-8 (1934).

——. "Julio González." *D'Aci i D'Allá* (Barcelona) 22, no. 191 (Dec. 1934).

——. "Inscriptions under Pictures." *Axis* (London), no. 1 (1935).

Kozloff, Max. "Julio González." In *Renderings: Critical Essays on a Century of Modern Art*. New York: Simon and Schuster, 1968.

——. "González." *The New York Times Magazine*, March 6, 1983.

Krauss, Rosalind. "This New Art: To Draw in Space." In *Julio González: Sculpture and Drawings* (exh. cat.). New York: Pace Gallery, 1981.

Kuspit, Donald. "Julio Gonzáles." *Artforum* (New York) 21 (summer 1983), pp. 80-81.

Marin Medina, José. "1876-1976: Centenario de Julio González, la Nueva Edad de Hierro." *Gazeta de Arte* (Barcelona) 4, no. 59 (1976).

Martinie, A. H. "Julio González au Musée d'art moderne." *Arts* (Paris), no. 345 (Feb. 8, 1952).

Nieto Alcaide, Victor. "Julio González." *Artes* (Madrid) 74 (March 1966).

Pérez Alfonseca, Ricardo. "Julio González." *Cahiers d'art* (Paris) 9, nos. 5-8 (1934).

——. "Julio González." *Cahiers d'art* (Paris) 10, nos. 1-4 (1935).

Pradel, M.-N. *La Donation González au Musée d'art moderne.* Paris: Tournon, 1966.

Prat, Jean-Louis. *Donation González* (exh. cat.). St.-Paul-de-Vence, France: Fondation Maeght, 1972.

Ragon, Michel. "Julio González." In *L'Aventure de l'art abstrait.* Paris: Laffont, 1956, pp. 216-19.

Restany, Pierre. "Julio González." *Art International* (New York) 3, nos. 3-4 (1959), pp. 30-31.

Rowell, Margit. "Metal Draw in Space: González at Guggenheim." *Art World* (New York) 7, no. 6 (March 1983).

Schnell, W. "Zeichnen als bildhauerisches Prinzip: Julio González 1876-1942." *Kunstforum international* 156 (Oct. 1983), pp. 149-52.

Smith, David. "González: First Master of the Torch." *Art News* (New York) 54, no. 10 (Feb. 1956), pp. 34-37, 64-65.

Torres-García, Joaquín. "Julio González." *Empori* (Barcelona), no. 24 (Aug. 1909).

Tucker, William. "The Sculpture of González." *Studio International* (London) 180 (Dec. 1970), pp. 236-39.

——. "The González Exhibition." *The New Criterion* (New York), May 1983.

van Gindertael, Roger. "González." *Cimaise* (Paris) 3, nos. 7-8 (June-Aug. 1956).

——. "González." *XXe Siècle* (Paris), no. 24 (June 1962), pp. 30-32.

Withers, Josephine. "Julio González." *Art and Artists* (London) 5, no. 7 (Oct. 1970), pp. 60-69.

——. "Julio González." *Bellas Artes* (Madrid) 70, no. 1 (1970).

——. "The Artistic Collaboration of Pablo Picasso and Julio González." *The Art Journal* 35, no. 2 (winter 1975-76), pp. 107-14.

——. "Julio González: Los Materiales y la Técnica." *Guadalimar* (Madrid) 2, no. 14 (June 10, 1976).

Alexander Calder

Writings by the Artist:

"Comment réaliser l'art?" *Abstraction-Création, Art non figuratif* (Paris), no. 1 (1932), p. 6. Translated as "How Can Art Be Realized?" In H. H. Arnason and Ugo Mulas. *Calder.* London: Thames and Hudson, 1971, p. 25.

"Mobiles." In *The Painter's Object*, ed. by Myfanwy Evans. London: Curwen Press, 1937, pp. 62-67. Reprint. New York: Arno Press, 1970, pp. 62-67.

"Seventeen Mobiles by Calder." In *Maud and Patrick Morgan/Alexander Calder* (exh. cat.). Andover, Mass.: The Addison Gallery of American Art, 1943.

"The Ideas of Art: Fourteen Artists Write." *The Tigers Eye* (Westport, Conn.) 1, no. 4 (June 15, 1948), p. 5.

"What Abstract Art Means to Me: Statements by Six American Artists." *The Museum of Modern Art Bulletin* (New York) 18, no. 3 (spring 1951), pp. 8-9.

Calder: An Autobiography with Pictures. With foreword by Robert Osborn. New York: Pantheon, 1966.

Calder, Alexander, and Jean Davidson. *Calder: An Autobiography.* New York, 1977.

Statements by Calder also appear in:

Calder, Matisse, Matta, Miró: Mural Scrolls. [New York]: Katzenbach and Warren, 1949.

Museo de Bellas Artes de Caracas. *Calder* (exh. cat.). Caracas, Venezuela: Museo de Bellas Artes de Caracas, 1955.

Monographs and Solo-Exhibition Catalogues:

Akademie der Künste. *Alexander Calder* (exh. cat.). With texts (in German) by Calder, Willem Sandberg, Jean-Paul Sartre, Hans Scharoun, Stephan Waetzold, Bruno E. Werner, and Paul Westheim. Berlin: Akademie der Künste, 1967.

Arnason, H. H., and Pedro E. Guerrero. *Calder.* New York: Van Nostrand, 1966.

Arnason, H. H., and Ugo Mulas. *Calder.* London: Thames and Hudson, 1971. New York: Viking, 1971.

Bellew, Peter. *Calder.* Ed. by J. Portas Vallés; with photographs by Clovis Prevost. Barcelona: Ediciones Polígrafa, 1969.

Bourdon, David. *Calder: Mobilist, Ringmaster, Innovator.* New York: Macmillan, 1980.

Bruzeau, Maurice. *Calder à Saché.* Paris: Editions Cercle d'art, 1975.

——. *Calder.* New York: Abrams, 1979.

Calder: L'Artiste et l'oeuvre. With introduction by James Johnson Sweeney. Archives Maeght, no. 1. Paris: Maeght, 1971.

Carandente, Giovanni. *Calder: Mobiles and Stabiles.* New York: The New American Library, by arrangements with UNESCO, 1968.

——. "Calder." In *Calder: Mostra Retrospettiva* (exh. cat.). Turin: Palazzo a Vela, 1983.

di San Lazzaro, Giovanni, ed. *Homage to Calder* (special issue of *XXe Siècle* [Paris]). With articles by G. Carandente, Ch. Chabaud, J. Davidson, P. Descargues, J. Dupin, S. W. Hayter, A. Jouffroy, G. Lascaux, D. Lelong, San Lazzaro, Yvon Taillandier, and P. Waldberg. Trans. by Bettina Walda. New York: Tudor, 1972.

Elsen, Albert E. "Calder on Balance." In *Alexander Calder: A Retrospective Exhibition, Work from 1925 to 1974* (exh. cat.). Chicago: Museum of Contemporary Art, 1974.

Fondation Maeght. *Calder* (exh. cat.). With texts by Gabrielle Buffet-Picabia, Pol Bury, Michel Butor, Giovanni Carandente, Jean

Davidson, Fernand Léger, Francis Miroglio, Jean-Paul Sartre, and James Johnson Sweeney. Saint-Paul-de-Vence, France: Fondation Maeght, 1969.

Haus der Kunst. *Calder* (exh. cat). With introduction by Maurice Besset. Munich: Haus der Kunst, 1975.

Hayes, Margaret Calder. *Three Alexander Calders: A Family Memoir.* Middlebury, Vermont: Paul S. Eriksson, 1977.

Léger, Fernand. "Eric Satie illustré par Calder—Pourquoi pas?" In *Alexander Calder: Volumes-vecteurs-densités* (exh. cat.). Paris: Galerie Percier, 1931.

Lipman, Jean. *Calder's Universe.* New York: Viking Press, with the Whitney Museum of American Art, 1976. Reprint, 1989.

Lipman, Jean, and Nancy Foote, eds. *Calder's Circus.* New York: E. P. Dutton, with the Whitney Museum of American Art, 1972.

Mancewicz, Bernice Winslow. *Alexander Calder: A Pictorial Essay.* Grand Rapids, Mich.: William E. Eerdsman, 1969.

Marchesseau, Daniel. *The Intimate World of Alexander Calder.* Paris: Solange Thierry, 1989.

Marter, Joan. *Alexander Calder: Artist as Engineer* (exh. cat.). Cambridge, Mass.: List Visual Arts Center, M.I.T., 1986.

——. *Alexander Calder.* New York: Cambridge University Press, 1991.

Masson, André. Untitled poem. In *Alexander Calder* (exh. cat.). New York: Buchholz Gallery, 1949.

Musée de Rennes. *Alexander Calder: Mobiles, gouaches, tapisseries* (exh. cat.). With preface by Jean Cassou. Rennes, France: Musée de Rennes, 1962-63.

Musée national d'art moderne. *Calder* (exh. cat.). With preface by Jean Cassou. Paris: Musée national d'art moderne, 1965.

Museo de Bellas Artes. *Calder* (exh. cat.). With statement by Calder; essays by James Johnson Sweeney and Fernand Léger. Caracas, Venezuela: Museo de Bellas Artes, 1955.

The Museum of Fine Arts, Houston. *Alexander Calder: Circus Drawings, Wire Sculpture and Toys* (exh. cat.). With introduction by James Johnson Sweeney. Houston: The Museum of Fine Arts, 1964.

The Museum of Modern Art. *A Salute to Alexander Calder* (exh. cat.). New York: The Museum of Modern Art, 1969-70.

Ragon, Michel. *Calder: Mobiles and Stabiles.* Petite Encyclopédie de l'Art, no. 87. New York: Tudor, 1967.

Sartre, Jean-Paul. "Les Mobiles de Calder." In *Alexander Calder: Mobiles, stabiles, constellations* (exh. cat.). Paris: Galerie Louis Carré, 1946.

——. "Calder's Mobiles." In *Alexander Calder* (exh. cat.). New York: Buchholz Gallery, 1947.

Solomon R. Guggenheim Museum. *Alexander Calder: A Retrospective Exhibition* (exh. cat.). New York: Solomon R. Guggenheim Museum, 1964.

Sweeney, James Johnson. *Alexander Calder* (exh. cat.). New York: The Museum of Modern Art, 1943. Rev. ed., 1951.

——. *Alexander Calder: Sculpture, Mobiles* (exh. cat.). London: Tate Gallery, 1962.

Periodicals, Books, and Group-Exhibition Catalogues:

Andersen, Wayne. "Calder at the Guggenheim." *Artforum* (New York) 3, no. 6 (March 1965), pp. 37-41.

Cate, Curtis. "Calder Made Easy." *Horizon* 14, no. 1 (winter 1972), pp. 44-57.

Derrière le miroir, nos. 69-70 (exh. cat.). With poem by Henri Pichette and essay by Frank Elgar. Paris: Galerie Maeght, 1954.

Derrière le miroir, no. 113 (exh. cat.). With essays by Jean Davidson and Georges Salles. Paris: Galerie Maeght, 1959.

Derrière le miroir, no. 156 (exh. cat.). With poem by Jacques Prevert and essays by Nicholas Guppy and Meyer Shapiro. Paris: Galerie Maeght, 1966.

Derrière le miroir, no. 173 (exh. cat.). With essays by Giovanni Carandente and Jacques Dupin. Paris: Galerie Maeght, 1968.

Derrière le miroir, no. 190 (exh. cat.). With essay by Carlos Franqui. Paris: Galerie Maeght, 1971.

Derrière le miroir, no. 201 (exh. cat.). With essays by André Balthazar and Maurice Vesset. Paris: Galerie Maeght, 1973.

Derrière le miroir, no. 212 (exh. cat.). With essay by Mario Pedrosa. Paris: Galerie Maeght, 1975.

Gray, Cleve. "Calder's Circus." *Art in America* (New York) 52, no. 5 (Oct. 1964), pp. 23-48.

Hellman, Geoffrey T. "Calder Revisited." *The New Yorker* (New York), Oct. 22, 1960, pp. 163-64, 167-72, 175-78.

Kuh, Katherine. "Alexander Calder." In *The Artist's Voice: Talks with Seventeen Artists.* New York: Harper and Row, 1962, pp. 38-51.

Lemon, Richard. "Mobiles: The Soaring Art of Alexander Calder." *Saturday Evening Post,* Feb. 27, 1965, pp.30-35.

Osborn, Robert. "Calder's International Monuments." *Art in America* (New York) 57, no. 2 (March-April 1969), pp. 32-49.

Rodman, Selden. *Conversations with Artists.* New York: Devin-Adair, 1957.

Root, Wawerly. "The Greatest Living American Artist—The Picasso of Iron." *New York Journal-American,* Sept. 9, 1965.

Rose, Barbara. "Joy, Excitement Keynote Calder's Work." *Canadian Art* (Toronto) 22 (May-June 1965), pp. 30-33.

Staempfli, George W. "Interview with Alexander Calder." *Quadrum* (Brussels), no. 6 (1959), pp. 9-11.

Sweeney, James Johnson. "Alexander Calder: Work and Play." *Art in America* (New York) 44, no. 4 (winter 1956-57), pp. 8-13. Reprinted in *What is American in American Art,* ed. by Jean Lipman. New York: McGraw Hill, 1963, pp. 87-93.

Tuchman, Phyllis. "Alexander Calder's

Almadén Mercury Fountain." *Marsyas/Studies in the History of Art* 16 (1972-73), pp. 91-107.

Alberto Giacometti

Writings by the Artist:

"Objets mobiles et muets." *Le Surréalisme au service de la révolution* (Paris), no. 3 (Dec. 1931), pp. 18-19.

"Charbon d'herbe." *Le Surréalisme au service de la révolution* (Paris), no. 5 (May 15, 1933), p. 15.

"Hier, sables mouvants." *Le Surréalisme au service de la révolution* (Paris), no. 5 (May 15, 1933), pp. 44-45.

"Poème en sept espaces." *Le Surréalisme au service de la révolution* (Paris), no. 5 (May 15, 1933), p. 15.

"Le Rideau brun." *Le Surréalisme au service de la révolution* (Paris), no. 5 (May 15, 1933), p. 15.

"Enquête: 'Pouvez-vous dire quelle a été la rencontre capitale de votre vie? Jusqu'à quel point cette rencontre vous a-t-elle donné, vous donne-t-elle l'impression du fortuit? du nécessaire?'" *Minotaure* (Paris), nos. 3-4 (Dec. 1933), p. 109.

"Je ne puis parler *qu'indirectement* de mes sculptures." *Minotaure* (Paris), nos. 3-4 (Dec. 1933), p. 46.

"Le Dialogue en 1934." *Documents* (Brussels), no. 1 (June 1934), p. 25.

"Le Rêve, le sphinx et la mort de T." *Labyrinthe* (Geneva), nos. 22-23 (Dec. 15, 1946), pp. 12-13.

"Lettre à Pierre Matisse." In *Alberto Giacometti* (exh. cat.). New York: Pierre Matisse Gallery, 1948.

"[Deuxième] Lettre à Pierre Matisse." Excerpted in *Alberto Giacometti* (exh. cat.). New York: Pierre Matisse Gallery, 1950.

"Ma Réalité." *XXe Siècle* (Paris), no. 9 (June 1957), p. 35.

"My Artistic Intentions." In *New Images of Man* (exh. cat.), by Peter Selz. New York: The Museum of Modern Art, 1959.

Writings by Giacometti appear in the following anthologies:

Alberto Giacometti: Schriften, Fotos, Zeichungen. Essais, photos, dessins. Ed. by Ernst Scheidegger. Zurich: Sammlung Horizont, 1958.

Alberto Giacometti: Ecrits. Ed. by Michel Leiris and Jacques Dupin. Paris: Hermann, 1990.

Monographs and Solo-Exhibition Catalogues:

Alberto Giacometti: Zeichnungen und Druckgraphik (exh. cat.). With texts by Reinhold Hohl and Dieter Koepplin. Túbingen: Kunsthalle; Hamburg: Kunstverein; Basel: Kunstmuseum; Krefeld: Kaiser Wilhelm Museum; Nijmegen, Pays Bas: Museum Commander van Sint Jan, 1981.

Art of This Century Gallery. *Alberto Giacometti* (exh. cat.). With texts by André Breton, Georges Hugnet, and Jean Levy. New York: Art of This Century Gallery, 1945.

Bernoulli, Christoph. *Alberto Giacometti, Erinnerungen und Aufzeichnungen.* Bern: Verlag Hans Huber, 1974.

Bonnefoy, Yves. *Alberto Giacometti: Biographie d'une oeuvre.* Paris: Flammarion, 1991.

Brenson, Michael F. *The Early Works of Alberto Giacometti 1925-1935.* Ph.D. diss., John Hopkins University, Baltimore, 1974.

Bucarelli, Palma. *Giacometti.* Rome: Editalia, 1962.

Derrière le miroir, nos. 39-40 (exh. cat.). With text by Michel Leiris. Paris: Galerie Maeght, 1951.

Derrière le miroir, no. 65 (exh. cat.). With text by Jean-Paul Sartre. Paris: Galerie Maeght, 1954.

Dupin, Jacques. *Alberto Giacometti.* Paris: Maeght, 1962.

———. *Alberto Giacometti: Textes pour une approche.* Paris: Aimé Maeght, 1962. Reprint. Paris: Editions Fourbis, 1991.

Genet, Jean. *L'Atelier d'Alberto Giacometti.* Décines: Ed. Marc Barbezat, 1958.

Hirshhorn Museum and Sculpture Garden. *Alberto Giacometti* (exh. cat.). Washington, D.C.: Hirshhorn Museum and Sculpture Garden, 1988.

Hohl, Reinhold. *Alberto Giacometti.* Stuttgart: Verlag Gerd Hatje, 1971; New York: Abrams, 1972.

———. "Form and Vision: The Work of Alberto Giacometti." In *Alberto Giacometti: A Retrospective Exhibition* (exh. cat.). New York: Solomon R. Guggenheim Museum, 1974.

Huber, Carlo. *Alberto Giacometti.* Zurich: Ex-Libris, 1970.

Klemm, Christian. *Die Sammlung der Alberto Giacometti-Stiftung.* Zurich: Kunsthaus, 1990.

Lamarche-Vadel, Bernard. *Alberto Giacometti.* Paris: Nouvelles Editions françaises, 1984.

Leiris, Michel. *Alberto Giacometti: Les Murs de l'atelier et de la chambre.* Paris: Galerie Maeght, 1979.

Lord, James. *Giacometti: A Biography.* New York: Farrar, Straus and Giroux, 1985.

Matter, Herbert, and Mercedes Matter. *Giacometti.* New York: Abrams, 1987.

Megged, Matti. *Dialogue in the Void: Beckett and Giacometti.* New York: Lumen, 1985.

Meyer, Franz. *Alberto Giacometti: Eine Kunst existentieller Wirklichkeit.* Frauenfeld: Huber, 1968.

Musée d'art moderne de la ville de Paris. *Alberto Giacometti* (exh. cat.). With texts by Yves Bonnefoy, Jean Clair, Rosalind Krauss, Franz Meyer, Danielle Molinari, and Pierre Schneider. Paris: Musée d'art moderne de la ville de Paris, 1991-92.

Musée de l'Orangerie et Tuileries. *Alberto Giacometti* (exh. cat.). With introduction by Jean Leymarie. Paris: Musée de l'Orangerie et Tuileries, 1969-70.

Museo Nacional Centro de Arte Reina Sofía. *Alberto Giacometti: Dibujo, Escultura, Pintura* (exh. cat.). Madrid: Centro de Arte Reina

Sofía, 1990.

The Museum of Modern Art. *Alberto Giacometti* (exh. cat.). With introduction by Peter Selz. New York: The Museum of Modern Art, 1965.

Tate Gallery. *Alberto Giacometti: Sculptures, Paintings, Drawings* (exh. cat.). With introduction by David Sylvester. London: Tate Gallery, 1965.

Periodicals, Books, and Group-Exhibition Catalogues:

Bonnefoy, Yves. "L'Etranger d'Alberto Giacometti." *L'Ephémère* (Paris), no. 1 (1966), pp. 79-91.

——. Resumé du cours "La Présence et le signe: Giacometti." *Annuaire du Collège de France 1981-1982.* Paris: Collège de France, 1982, pp. 643-55. *Annuaire du Collège de France 1982-1983.* Paris: Collège de France, 1983, pp. 647-62.

Borja, Manuel José. "Alberto Giacometti, Julio González and the Open Form." In *Alberto Giacometti in America*, ed. by Tamara S. Evans. New York: The Graduate School and University Center, City University of New York, 1984, pp. 75-91.

Brenson, Michael F. "The Embryo and the Club: The Early Work of Giacometti." *The Journal of Arts* 1, no. 3 (Feb.-March 1989), pp. 14-18.

Breton, André. "L'Equation de l'objet trouvé." *Documents* (Brussels) 34, no. 1 (June 1934), pp. 17-24.

Charbonnier, Georges. "Entretien avec Alberto Giacometti." *Les Lettres nouvelles* (Paris), n.s., no. 6 (April 8, 1959), pp. 20-27.

Clair, Jean. "Giacometti le saveur." *La Nouvelle Revue française* (Paris), no. 202 (Oct. 1969), pp. 545-57.

——. "Alberto Giacometti: *La Pointe à l'oeil.*" *Cahiers du Musée national d'art moderne* (Paris), no. 11 (1983), pp. 62-99.

Dalí, Salvador. "Objets surréalistes." *Le Surréalisme au service de la révolution* (Paris)

no. 3 (1931), pp. 15-17. Reprinted in *XXe Siècle*, no. 3 (1952), p. 69.

Dupin, Jacques. "Giacometti, Sculpteur et peintre." *Cahiers d'art* (Paris), Oct. 1954, pp. 41-45.

Glover, Margaret A. "Giacometti, Isamu Noguchi, and David Smith." In *Alberto Giacometti in America*, ed. by Tamara S. Evans. New York: The Graduate School and University Center, City University of New York, 1984, pp. 92-96.

Koepplin, Dieter. "Alberto Giacometti: *Les Pieds dans le plat* (1933)." *Jahresbericht der Gottfried-Keller-Stiftung.* Bern, 1973-76.

Kramer, Hilton. "Giacometti." *Arts Magazine* (New York), no. 2 (Nov. 1963), pp. 52-59.

Krauss, Rosalind. "Giacometti." In *Primitivism in Twentieth-Century Art: Affinity of the Tribal and the Modern* (exh. cat.), vol. 2, ed. by William Rubin. New York: The Museum of Modern Art, 1984. Reprinted in *The Originality of the Avant-Garde and Other Modernist Myths*, by Rosalind Krauss. Cambridge, Mass.: M.I.T. Press, 1985, pp. 42-85.

Leiris, Michel. "Alberto Giacometti." *Documents* (Brussels), no. 4 (1929), pp. 209-14.

Lord, James. "Giacometti and Picasso: Chronicle of a Friendship." *The New Criterion* (New York), June 1983, pp. 16-24.

Ponge, Francis. "Reflexions sur les statuettes, figures et peintures d'Alberto Giacometti." *Cahiers d'art* (Paris) 26 (1951), pp. 74-90.

Sartre, Jean-Paul. "La Recherche de l'absolu." *Les Temps modernes* (Paris) 3, no. 28 (Jan. 1948), pp. 1153-63.

Sylvester, David. "Fragments d'un entretien avec Alberto Giacometti, 1965." *L'Ephémère* (Paris), no. 18. (fall 1971), pp. 183-89.

Waldberg, Patrick. "Alberto Giacometti: L'Espace et l'angoisse." *Critique*, no. 141 (April 1959), pp. 328-40.

Zervos, Christian. "Quelques Notes sur les sculptures de Giacometti." *Cahiers d'art* (Paris), nos. 8-10 (1932), pp. 337-42.

David Smith

Writings by the Artist:

"Abstract Art." *New York Artist* (New York) 1, no. 2 (April 1940), pp. 5, 6, 11.

"The Landscape: Specters Are, Sculpture Is." In *David Smith Sculpture 1946-1947* (exh. cat.). New York: Willard Gallery, 1947.

"H's, Y's, Birdsheads, The Letter." In *David Smith* (exh. cat.). New York: Willard Gallery, 1951.

"Language is Image." *Arts and Architecture* (Los Angeles) 69 (Feb. 1952), pp. 20-21, 33-34.

"Thoughts on Sculpture." *College Art Journal* (New York) 13, no. 2 (winter 1954), pp. 96-100.

"Second Thoughts on Sculpture." *College Art Journal* (New York) 13, no. 3 (spring 1954), pp. 203-07.

"Gonzalez: First Master of the Torch." *ArtNews* (New York) 54, no. 10 (Feb. 1956), pp. 34-37, 64-65.

"Sculpture and Architecture." *Arts* (New York) 31 (May 1957), p. 20.

"False Statements" (letter to the editor). *Arts* (New York) 31 (June 1957), p. 7.

"Notes on My Work." *Arts* (New York) 34, no. 5 (Feb. 1960) (special issue on David Smith), pp. 44-49.

"Memories to Myself." *Journal of the Archives of American Art* 8 (April 1968), pp. 11-16.

"Notes for David Smith Makes a Sculpture." *Art News* (New York) 67 (Jan. 1969), pp. 46-48, 56.

Statements by Smith are also found in:

"Who Is the Artist? How Does He Act?" *Everyday Art Quarterly* (Walker Art Center, Minneapolis) 23 (1952), pp. 16-21.

"Symposium: Art and Religion." *Art Digest* (New York) 28 (Dec. 15, 1953), pp. 8-11, 31-32.

The Museum and His Friends: Eighteen Living American Artists Selected by Friends of the Whitney Museum (exh. cat.). New York:

Whitney Museum of American Art, 1959.

Monographs and Solo-Exhibition Catalogues:

Budnick, Dan. *The Terminal Iron Works: Photographs of David Smith and His Sculpture* (exh. cat.). Albany: University Art Gallery, State University of New York, 1974.

Carmean, E. A., Jr. *David Smith* (exh. cat.). Washington, D.C.: National Gallery of Art, 1982.

Clark, Trinkett. *The Drawings of David Smith* (exh. cat.). Washington, D.C.: International Exhibitions Foundation, 1985.

Cone, Jane Harrison. *David Smith 1906-1965: A Retrospective Exhibition* (exh. cat.). Cambridge, Mass.: Fogg Art Museum, 1966.

Cummings, Paul. *David Smith: The Drawings* (exh. cat.). New York: Whitney Museum of American Art, 1979.

Dehner, Dorothy, and James K. Kettlewell. *David Smith of Bolton Landing, New York* (exh. cat.). Glens Falls, N.Y.: The Hyde Collection, 1973.

Fry, Edward F. *David Smith* (exh. cat.). New York: Solomon R. Guggenheim Museum, 1969.

Fry, Edward F., and Miranda McClintic. *David Smith: Painter, Sculptor, Draftsman* (exh. cat.). New York: George Braziller; Washington, D.C.: The Hirshhorn Museum and Sculpture Garden, 1982.

Gray, Cleve, ed. *David Smith by David Smith.* London: Thames and Hudson, 1968.

Hunter, Sam. "David Smith." *The Museum of Modern Art Bulletin* (New York) 25, no. 2 (1957) (exh. cat.).

Institute of Contemporary Art, University of Pennsylvania. *David Smith: Sculpture and Drawings* (exh. cat.). With foreword by Clement Greenberg. Philadelphia: University of Pennsylvania, Institute of Contemporary Art, 1964. Reprinted as "David Smith's New Sculpture." *Art International* (Lugano) 8 (May 1964), pp. 35-37.

Johnson, Una E. *David Smith in the Storm King Art Center* (exh. cat.). Mountainville, N.Y.: Storm King Art Center, 1971.

Krauss, Rosalind. *David Smith: Eight Early Works 1935-1938* (exh. cat.). New York: Marlborough-Gerson Gallery, 1967.

——. *David Smith: Small Sculpture from the Mid-Forties* (exh. cat.). New York: Marlborough-Gerson Gallery, 1968.

——. *Terminal Iron Works: The Sculpture of David Smith.* Cambridge, Mass.: M.I.T. Press, 1971.

——. *The Sculpture of David Smith: A Catalogue Raisonné.* New York: Garland, 1977.

Lampert, Catherine. *David Smith: Sculpture and Drawings* (exh. cat.). London: Arts Council of Great Britain, 1980.

Los Angeles County Museum of Art. *David Smith: A Memorial Exhibition* (exh. cat.). With foreword by Hilton Kramer. Los Angeles: Los Angeles County Museum of Art, 1956.

McClintic, Miranda. *David Smith: The Hirshhorn Museum and Sculpture Garden Collection* (exh. cat.). Washington, D.C.: Smithsonian Institute Press, 1979.

McCoy, Garnett, ed. *David Smith.* New York: Praeger, 1973.

——. *From the Life of the Artist: A Documentary View of David Smith* (exh. cat.). Washington, D.C.: Archives of American Art and Smithsonian Institute Press, 1982.

Marcus, Stanley E. *David Smith: The Sculptor and His Work.* Ithaca, N.Y.: Cornell University Press, 1983.

Merkert, Jörn, ed. *David Smith: Sculpture and Drawings* (exh. cat.). Munich: Prestel-Verlag, 1986.

Motherwell, Robert. *David Smith* (exh. cat.). New York: Willard Gallery, 1950.

The Museum of Modern Art. *David Smith 1906-1965* (exh. cat.). With introduction by Frank O'Hara. New York: The Museum of Modern Art, 1966.

Otto Gerson Gallery. *David Smith: Recent Sculpture* (exh. cat.). With foreword by Sam Hunter. New York: Otto Gerson Gallery, 1961.

Sandler, Irving. *The Prospect Mountain Sculpture Show: An Homage to David Smith* (exh. cat.). Lake George, N.Y.: Lake George Arts Project, 1979.

Storm King Art Center. *David Smith: Drawings for Sculpture, 1954-1964* (exh. cat.). With introduction by Gordon J. Hazlitt. Mountainville, N.Y.: Storm King Art Center, 1982.

Wilkin, Karen. *David Smith: The Formative Years, Sculptures and Drawings from the 1930's and 1940's* (exh. cat.). Edmonton, Alberta: Edmonton Art Gallery, 1981.

——. *David Smith.* New York: Abbeville Press, 1984.

Periodicals, Books, and Group-Exhibition Catalogs;

Alloway, Lawrence. "3-D: David Smith and Modern Sculpture." *Arts Magazine* (New York) 43 (Feb. 1969), pp. 36-40.

Ashton, Dore. "David Smith." *Arts and Architecture* (Los Angeles) 82 (Feb. 1965), pp. 26-28.

Bannard, Darby. "Cubism, Abstract Expressionism, David Smith." *Artforum* (New York) 6 (April 1968), pp. 22-32.

Baro, Gene. "David Smith: The Art of Wholeness." *Studio International* (London) 172 (Aug. 1966), pp. 69-75.

Budnick, Dan. "Issues and Commentary: David Smith, A Documentation." *Art in America* (New York) 62 (Sept.-Oct. 1974), pp. 30-33.

Carmean, E. A., Jr. "David Smith: The Voltri Sculpture." In *American Art at Mid-Century: The Subjects of the Artist* (exh. cat.). Washington, D.C.: National Gallery of Art, 1978, pp. 214-41.

Cherry, Herman. "David Smith." *Numero: Arte e Letteratura* (Florence) 5 (May-June 1953). Reprinted in *Sculpture by David Smith*

(exh. cat.). New York: Fine Arts Associates, 1957.

Cone, Jane Harrison. "David Smith." *Artforum* (New York) 5 (June 1967), pp. 72-78.

Dehner, Dorothy. "*Medals for Dishonor*: The Fifteen Medallions of David Smith." *The Art Journal* (New York) 37 (winter 1977-78), pp. 144-50.

——. "Memories of Jan Matulka." In *Jan Matulka 1890-1972* (exh. cat.). Washington, D.C.: National Collection of Fine Arts and Smithsonian Institute Press, 1980.

Dehner, Dorothy, and Marian Willard. "First Meetings." *Art in America* (New York) 54 (Jan.-Feb. 1966), p. 22.

de Kooning, Elaine. "David Smith Makes a Sculpture." *ArtNews* (New York) 50 (Sept. 1951), pp. 38-41, 50-51.

Fourcade, Dominique. *Julio González, David Smith, Anthony Caro, Tim Scott, Michael Steiner* (exh. cat.). Bielefeld, Germany: Kunsthalle, 1980.

Gray, Cleve. "Last Visit." *Art in America* (New York) 54 (Jan.-Feb. 1966), pp. 23-26.

Greenberg, Clement. "American Sculpture of Our Time: Group Show." *The Nation* 156 (Jan. 23, 1943), pp. 140-41.

——. "Art" (review of exhibitions at Willard and Buchholz Galleries). *The Nation*, Jan. 26, 1946, pp. 109-10.

——. "Art" (review of exhibition at Willard Gallery). *The Nation* 164 (April 19, 1947), pp. 459-60.

——. "David Smith." *Art in America* (New York) 44 (winter 1956-57), pp. 30-33, 66. Reprinted in *Art in America* (New York) 51 (Aug. 1963), pp. 112-17.

Hughes, Robert. "Dream Sculptures in Ink and Paper." *Time* (New York) 114 (Dec. 24, 1979).

——. "Iron Was His Name." *Time* (New York) 121 (Jan. 31, 1983), pp. 70-71.

Jacobs, Jay. "David Smith Sculpts for Spoleto." *Artnews Annual* (New York) 29 (1964), pp. 42-29, 156-58.

Kozloff, Max. "David Smith at the Tate." *Artforum* (New York) 5 (Nov. 1966), pp. 28-30.

Kramer, Hilton. "The Sculpture of David Smith." *Arts Magazine* (New York) 34 (Feb. 1960) (special issue on Smith), pp. 22-43.

——. "David Smith: Stencils for Sculpture." *Art in America* (New York) 50 (winter 1962), pp. 32-43.

——. "Guggenheim Gives Scope to Genius of David Smith." *New York Times*, March 29, 1969, p. 28.

——. "A Critic Calls David Smith Greatest of All American Artists." *New York Times Magazine*, Feb. 16, 1969, sec. 6, pp. 1, 40, 54, 59-62.

——. "Art: David Smith Master Draftsman." *New York Times*, Dec. 7, 1979, sec. C, p. 20.

——. "Art: David Smith in Washington." *New Criterion* (New York) 1 (Jan. 1983), pp. 62-66.

Krasne, Belle. "A David Smith Profile." *Art Digest* (New York) 26 (April 1, 1952), pp. 12-13, 26, 29.

Krauss, Rosalind. "The Essential David Smith." *Artforum* (New York) 7 (Feb. 1969), pp. 43-49; (April 1969), pp. 43-51.

Kuh, Katherine. "David Smith." In *The Artist's Voice: Talks with Seventeen Artists*. New York: Harper and Row, 1962, pp. 219-34.

Lipman, Howard W. "Sculpture Today: With Statements by Alexander Calder, Richard Lippold, Louise Nevelson, David Smith." *Whitney Review* (New York), 1961-62, n.p.

McCoy, Garnett. "The David Smith Papers." *Journal of Archives of American Art* 8 (April 1968), pp. 1-11.

Motherwell, Robert. "David Smith: A Major American Sculptor, A Major American Painter." *Studio International* (London) 172 (Aug. 1966), pp. 65-68.

The Museum of Modern Art Junior Council. *The New Sculpture: A Symposium*. With moderator A. C. Ritchie and participants Lippold, Ferber, Noguchi, Roszak, and Smith. New York: The Museum of Modern Art, 1952.

O'Hara, Frank. "David Smith: The Color of Steel." *Artnews* (New York) 60 (Feb. 1961), pp. 32-34, 69-70.

Pomeroy, Ralph. "David Smith in Depth." *Art and Artist* 4 (Sept. 1969), pp. 28-30.

Riley, Maude. "David Smith: Courtesy American Locomotive." *Art Digest* (New York) 17 (April 15, 1943), p. 13.

Rubin, William. "David Smith." *Art International* (Lugano) 7 (Dec. 1963), pp. 48-49.

Russell, John. "Sculpture: David Smith." *New York Times*, April 30, 1982, sec. C, p. 24.

S., J. M. [Schuyler, James?] "Is Today's Artist with or against the Past?: Part 2" (interview with Smith). *Artnews* (New York) 57 (Sept. 1958), pp. 38-62.

Shirley, David L. "Man of Iron." *Newsweek* (New York) 69 (March 31, 1969), pp. 78-79.

——. "David Smith: Man of Iron, A Portfolio of Works and Words." *Dialogue* 3 (1970), pp. 46-57.

Silver, Jonathan. "The Classical Cubism of David Smith." *Artnews* (New York) 82 (Feb. 1983), pp. 100-03.

Tucker, William. "Four Sculptors: Part 4, David Smith." *Studio International* (London) 181 (Jan. 1971), pp. 24-29.

Valentiner, William R. "Sculpture by David Smith." *Arts and Architecture* (Los Angeles) 65 (Aug. 1948), pp. 22-23, 52.

Wilkin, Karen. "David Smith." In *Abstract Painting and Sculpture in America 1927-1944* (exh. cat.), ed. by John R. Lane and Susan C. Larsen. Pittsburgh: Museum of Art, Carnegie Institute, 1983.

Selected by M. Dolores Jiménez-Blanco.

Photo credits

Most photographs are reproduced courtesy of the owners of the works of art as given in the captions. Additional or alternate credit information appears below. Courtesy Josephine Alix, pp. 66-68; Shigeo Anzai, p. 44; Brassaï, Paris, pp. 12, 75, 270; Geoffrey Clements, pp. 179, 187, 190, 244; Phillip A. Charles, p. 238; J. R. Farley, p. 241; Claude Gaspari, p. 162; Roberta González, p. 89; Carmelo Guadagno and David Heald, p. 194; Pedro E. Guerrero, p. 174; Irene Grünwald, p. 151; Peter Guggenbühl, p. 155; David Heald, pp. 25, 80, 82, 196, 215, 220; Walter Klein, p. 274; J. L'Hoir, p. 258; Rafael Lobato, pp. 209, 217; J. L. Losi, p. 166; Gilbert Mangin, p. 56; Agustín Martínez, Madrid, pp. 58, 71, 83, 88, 90-92, 259, 260, 276; Robert E. Mates, p. 81; Gion Mili, p. 276; André Morin, p. 218; Ugo Mulas, pp. 49, 278; Maggie Nimkin, New York, p. 117; Christian Poite, p. 122; A. S. C. Rower, pp. 180, 181, 183, 184, 186, 189, 193, 195, 197, 201-03; Ernst Scheidegger, Zurich, p. 204; Pascal Simonet, pp. 85, 157, 171, 172; Werner Spies, p. 100; Willy Spiller, p. 156; Jim Strong, Inc., New York, pp. 200, 235; John Tennant, pp. 228, 237; Jerry L. Thompson, New York, pp. 185, 198, 199, 243; F. Walch, p. 161; Sabine Weiss, p. 21.